American Paintings and Sculpture

AT THE
STERLING AND
FRANCINE CLARK
ART INSTITUTE

American Paintings and Sculpture

AT THE STERLING AND FRANCINE CLARK ART INSTITUTE

MARGARET C. CONRADS

HUDSON HILLS PRESS
New York

FIRST EDITION
© 1990 by Sterling and Francine Clark Art Institute

Published in the United States by Hudson Hills
Press, Inc., Suite 1308, 230 Fifth Avenue,
New York, NY 10001-7704.

Distributed in the United States, its territories and
possessions, Canada, Mexico, and Central and
South America by Rizzoli International
Publications, Inc.

Distributed in the United Kingdom and Eire by
Thomas Heneage & Co. Ltd.

Distributed in Japan by Yohan (Western
Publications Distribution Agency).

Editor and Publisher: Paul Anbinder

Copy Editor: Sheila J. Schwartz

Indexer: Gisela S. Knight

Designer: Binns & Lubin/Betty Binns

Manufactured in Japan by Toppan Printing Company

Library of Congress Cataloguing-in-Publication Data

Conrads, Margaret C., 1955–
 American paintings and sculpture at the Sterling and Francine
Clark Art Institute/ Margaret C. Conrads. — 1st ed.
 p. cm.
 Includes bibliographical references and index.
 1. Art, American—Catalogues. 2. Art—Massachusetts—Williamstown—
Catalogues. 3. Sterling and Francine Clark Art Institute—Catalogues.
I. Sterling and Francine Clark Art Institute. II. Title.
N6505.C645 1990 90-80949
759.13′074′7441—dc20 CIP

ISBN: 1-55595-051-5 (alk. paper)

Cover illustration:
John Singer Sargent, *Fumée d'Ambre Gris* (detail), 1880

Contents

American Paintings and Sculpture at the Sterling and Francine Clark Art Institute

The Sterling and Francine Clark Art Institute, long recognized for its French nineteenth-century paintings, is less well known for its American pictures of the same period, perhaps because Mr. Clark's collecting in this area focused more on individual favorites than on American late nineteenth-century painting in general. Sargent and Homer, whom Clark once referred to as "the two best American artists," are especially well represented; Inness, Remington, and Cassatt have a few pictures each; and the rest of the collection is almost entirely made up of the intimately scaled genre and landscape pictures of which the Clarks were so fond.

An opportunity to publish this highly personal collection came in 1981, when the Luce Fund for Scholarship in American Art, a program of the Henry Luce Foundation, Inc., was established "to encourage the growth of serious scholarship in every aspect of American fine and decorative arts." Forty-three major American museums were invited to present proposals for the funding of "projects that advanced the cause of scholarship on any aspect of American art," and the Clark Art Institute was honored to be included in this group. We are grateful to the Luce Foundation, without whose generous support a book of this scale would not have been possible.

When Alexandra Murphy was appointed as curator of paintings in 1985, she was quick to enter a grant application to the Luce Fund for the publication of a catalogue of our American paintings. This was approved in 1986, and the following year we welcomed Margaret C. Conrads as American Art Research Fellow to work on this project. A doctoral candidate at the Graduate Center of the City University of New York, Margi is a specialist in later nineteenth-century American art. For two years she has devoted herself to the demanding task of researching and writing about our sixty-eight paintings and six sculptures by American artists. The proof of her hard work and considerable abilities lies in this catalogue, which has been most handsomely produced by Hudson Hills Press.

A number of people have helped bring this project to completion and their contributions are acknowledged on pages 9–10. I owe a particular debt of thanks to Alixe Murphy for initiating the project, to Margi Conrads for the infinite and loving care she has taken in researching and writing the catalogue, and to Mary Jo Carpenter, who has coordinated its production. We hope that this will be the first in a series of catalogues that will make the Clark collection, in all its components, better known to scholars and the general public alike.

David S. Brooke
Director

The scope and pace of this project demanded that I call upon a large number of professional colleagues, librarians, dealers, private collectors, and friends for assistance. I am very grateful to them for sharing their expertise and collections with good humor at every step of the way. My thanks go to: The Academy of Motion Picture Arts and Sciences, Los Angeles; Gerald Pepper, Adirondack Museum, Blue Mountain Lake, New York; Tammis Groft, Albany Institute of History and Art; Carol Clark, Amherst College; Robert Taylor, Androscoggin Historical Society, Auburn, Maine; Archives of American Art, Smithsonian Institution, New York, Boston, and Washington offices; Milo Naeve and Mary Woolever, The Art Institute of Chicago; Frederick Berlew; Stephen Bleezarde; Doreen Bolger; Keith Morgan, Boston University; William Briesky; Barbara Dayer Gallati, The Brooklyn Museum; Angela M. Conran, Bucks County Historical Society, Doylestown, Pennsylvania; Peter Hassrick and Melissa Webster, Buffalo Bill Historical Center, Cody, Wyoming; Russell Burke; Paul Clemens; Odile Duff, Coe Kerr Gallery, New York; Helen McLallen, Columbia County Historical Society, Kinderhook, New York; Gail S. Davidson and Dianne Pilgrim, Cooper-Hewitt Museum, Smithsonian Institution, New York; David B. Dearinger; Cheryl Wagner, The Detroit Institute of Arts; Caroline Godfroy, Durand-Ruel & Cie., Paris; David McCann, The Fine Arts Museum of The South at Mobile; Sally Mills, The Fine Arts Museums of San Francisco; Mark van Benschoten, Frederic Remington Art Museum, Ogdensburg, New York; Helen Sanger, Frick Art Reference Library, New York; Abigail B. Gerdts; Peter Gibian; George Heard Hamilton; Kathleen Burnside and Heatherly Vermillion, Hirschl & Adler Galleries, New York; Catherine Ricciardelli Davis, Indianapolis Museum of Art; John Ollman, Janet Fleischer Gallery, Philadelphia; Alexander Katlan; Elaine Kilmurray; Paula Kozol; H. Nichols B. Clark, Lamont Gallery, Phillips Exeter Academy, Exeter, New Hampshire; Nancy Little; Michael Quick, Los Angeles County Museum of Art; Carol Lowery; Asbjorn Lunde; Melissa de Medeiros, M. Knoedler & Co., New York; Alexander Mackay-Smith; Donna Hassler, Walter A. Liedtke, Lisa Messinger, and Catherine Hoover Voorsanger, The Metropolitan Museum of Art, New York; Barbara Stole, Missouri Historical Society, St. Louis; Merl Moore, Jr.; Trevor J. Fairbrother, Museum of Fine Arts, Boston; Deborah Chotner and Nicolai Cikovsky, Jr., National Gallery of Art, Washington, D.C.; K. Sandra Inglis, National Museum of Racing and Hall of Fame, Saratoga Springs, New York; Carolyn Carr, National Portrait Gallery, Smithsonian Institution, Washington, D.C.; Kenneth Neal; Eileen O'Brien and C.R. Jones, New York State Historical Association, Cooperstown; Kenneth M. Newman, Old Print Shop, New York; Richard Ormond; Marietta Bushnell and Cheryl Liebold, Pennsylvania Academy of the Fine Arts, Philadelphia; Ronald Pisano; Lewis Rabbage; Polly Cox and Michael Shapiro, The Saint Louis Art Museum; David Tatham, Syracuse University; Gwendolyn Owens, University of Maryland Art Gallery, College Park; Elizabeth M. Browning, Valley Forge Historic Park, Pennsylvania; Ruth Vose; S. Morton Vose; Ann Schmoll, Robert Vose, Sr., and Robert Vose, Jr., Vose Galleries, Boston; Linda Ayres, Wadsworth Atheneum, Hartford, Connecticut; Margaret Johnson Ware; Bruce Weber; Katherine Weimer; H. Barbara Weinberg; Michael McAfee, West Point Museum of the United States Military Academy, New York; Hildegard Cummings, William Benton Museum of Art, University of Connecticut, Storrs; John Wright; and James Yarnall.

In Williamstown, staff members of Williams College, the International Repertory of the Literature of Art (RILA), the Williamstown Regional Art Conservation Laboratory, and particularly at the Clark willingly assisted me whenever needed. The staff at Williams's Sawyer Library, especially Lee Dalzell, Alison Roe O'Grady, Sarah McFarland, and Jo-Ann Irace, were always helpful, as were Nancy Mowll Mathews and Vivian Patterson at the Williams College Museum of Art and Darlene Bonner and Ted Gilley at RILA. My understanding of the Clark's American collection would not be as complete as it is without the help of Michael Heslip, associate conservator of paintings, Williamstown Regional Art Conservation Laboratory, whose keen eye, knowledge of painting technique, and interest in this project as we examined every painting were unfailing. His colleagues Tom Branchick, Cynthia Luk, Rika Smith, and Sandra Webber are also to be thanked for their ideas about particular technical matters. At the Clark, my fellow staff members Merry Armata, Martha Asher, Harry Blake, Rosalie Buckley, Paige Carter, Alan Chamberland, Peter Erickson, Arthur Evans, Robert Gageant, Sarah Gibson, Beverly Hamilton, Lisa Jolin, Jennifer Lovett, Susan Roeper, Micheline Toureille, and J. Dustin Wees provided every kind of needed support throughout the project. I would also like to thank former staff members Moira Jones, Margaret Moore, Mary Ann McSweeny, and Alexandra Murphy and my part-time assistants, Diane Dillon, Marion Goethals, Colleen Cowles Heslip, Patricia Ivinski, Shelley Langdale, and Mary Ross, for their help in a variety of capacities. Four people at the Clark deserve special mention and recognition. This project would not have begun, thrived, and been completed without David Brooke, director; Steven Kern, curator of paintings; Beth Carver Wees, curator of decorative arts; and especially Mary Jo Carpenter, director of public relations and membership.

Many thanks, too, are due to Sheila Schwartz, my editor, who immensely improved the style of the manuscript with grace, wit, and an admirable sense of perfection.

Betty Binns, whose sympathetic design enhances the text, and Paul Anbinder of Hudson Hills Press deserve thanks for guiding the manuscript through publication.

My deepest appreciation goes to William H. Gerdts, professor of art history, Graduate Center, City University of New York. Much of what is successful in this text reflects his fine teaching, support, and careful reading. Lastly, but most important, loving thanks are due to David A. Conrads, who, as always, did everything possible to aid my work, and to Lee H. Conrads, who patiently timed her arrival to our family until after the manuscript had been edited.

M.C.C.

Robert Sterling Clark was the second of four sons of Alfred Corning and Elizabeth Scriven Clark. As one of the heirs of the sizable Singer Sewing Machine Company fortune he would have adequate funds to follow any calling in life. The example set by his parents, however, as both connoisseurs and patrons of the arts, helped kindle an early passion that would consume his entire life. As a collector—alone and, later, with his wife, Francine—Robert Sterling Clark was guided neither by advisers and experts nor by a blind devotion to a single artist or period. His sole criterion was his eye, the arbiter of his own taste; the result is a collection that is as diverse as the paintings are good. The Sterling and Francine Clark Art Institute collection of American paintings and sculpture does not present a chronology or survey of American art, but serves rather as a document of the drive and taste of a very private collector.

After their mother's death in 1909, Robert Sterling Clark and his brothers inherited the collection of paintings their parents had accumulated during the last quarter of the previous century. The collection was an eclectic one, including works by nineteenth-century French masters, popular with many American collectors at that time, as well as canvases by American painters. By 1913, Théodore Géricault's *Trumpeter of the Hussars* and Jean-François Millet's *The Water Carrier,* along with Gilbert Stuart's *George Washington* and, perhaps, William Baer's *Portrait of Alfred Corning Clark* had passed into Clark's growing collection of predominantly Old Master paintings.

It was in 1913, too, that Clark purchased his first American painting, John Singer Sargent's *A Venetian Interior,* from Knoedler's in Paris. Three years later he purchased Winslow Homer's *Two Guides* from Scott and Fowles in New York. As with his acquisitions of Old Master and nineteenth-century French paintings, Clark's purchases were conservative. When he acquired the Sargent and the Homer, the artists' reputations had been firmly established on the art market. Clark occasionally bought pictures that were out of fashion, particularly nineteenth-century French academic paintings by artists such as Jean-Léon Gérôme and William Bouguereau, but these purchases were always in keeping with his philosophy: "I like all kinds of art, if it is good of its kind" (March 26, 1942).

In 1913, as he made his first confident steps as an art collector, Robert Sterling Clark, with his brother Stephen, engaged George Grey Barnard—a sculptor patronized by their father, Alfred Corning Clark—as a guide and adviser on an art-buying trip through Europe. This association was short-lived, and there are no purchases with which Clark credited Barnard. Years later, in fact, Clark would say of art experts, "a funny lot . . . they know art history, the stories of painters, study their special manners of painting, but for an eye which appreciates all sorts of artists who are craftsmen, they lack that entirely in many cases" (March 26, 1942). Clark was his own adviser and followed the advice he gave to others: "Look, look, and look again, and not be influenced by anyone in . . . likes and dislikes" (April 26, 1945).

Dealers, however, were a different story, and Clark entered eagerly into their circle, feeling a kinship with these men who shared his passion for acquiring masterpieces. There was a special relationship with the houses of Knoedler and Durand-Ruel, the source of nearly three-fourths of the paintings now in the collection of the Clark Art Institute. At Knoedler's Clark wrote checks for Old Master and American works (in 1923, for example, he purchased six paintings: one Degas, one Rembrandt, one Sargent, and three Homers), and in the galleries of Durand-Ruel he competed with such

"Of Course It Is a Matter of Taste & No More"
*Robert Sterling Clark and American Paintings**

* The title is quoted from Robert Sterling Clark's diary, June 10, 1932. All diaries and correspondence are in the archives of the Sterling and Francine Clark Art Institute, Williamstown, Massachusetts.

collectors as his brother Stephen, Dr. Albert Barnes, and Mrs. David Bruce for French Impressionist paintings.

In addition to providing him with a New York source for French Impressionist works, Durand-Ruel introduced Clark to Paul Clemens, a young American painter who would become the only artist for whom Clark acted as a true patron. In 1924 Clark had purchased *At the Hill's Top— Lumberville* by Clarence Johnson from the Dudensing Galleries in New York "to encourage the young man" (January 26, 1924). But Clark's relationship with Clemens was different, and the two maintained contact from the time of Clemens's exhibition at Durand-Ruel in 1942 until Clark's death in 1956. It was perhaps in Clemens's work that Clark's love of both French and American painting came together. Of one of Clemens's paintings in the Durand-Ruel show Clark wrote: "It was in the manner of Renoir or at least strongly influenced by him—but it was not a copy & was very agreeable & well painted" (January 9, 1942). Comparison of Clemens to Renoir was the highest of praise, for by 1942 Clark already owned thirty-two works by the French artist.

Robert Sterling and Francine Clark collected to please themselves and to bring beauty into their lives. Virtually all the works they acquired were small in scale so as to be easily accommodated in their homes in New York, Paris, and Upperville, Virginia. Clark kept the contents of his collection largely to himself and a small circle of friends, and he lent rarely—and always anonymously. He kept volumes of diaries and notes, but they neither offer concrete information on what specifically appealed to him in an artist's work nor explain such broad interests as Homer, Rembrandt, and Renoir. What exactly Clark saw, for example, in Homer's paintings—other than quality—remains an enigma.

In Homer's character, on the other hand, Clark found an affinity with his own penchant for anonymity and privacy. In his diary he includes a single anecdote about the artist: "A man who had lived near him [Mr. Henschel, Knoedler & Co.] in Maine saw a man digging a hole when the flood tide was about 1/2 way in. Could not make out what the man was doing, so approached & found it was Winslow Homer. Asked Homer what he was doing. Homer, after some urging, replied that he had gotten tired of seeing his medals around & was burying them in the sand where the high tide would obliterate all marks & he would be rid of them!! Homer hated publicity & would never exhibit publicly if he could help it" (February 29, 1924). Even as the Clark Art Institute was nearing completion, on a site deep in the Berkshires, Clark wrote to Paul Clemens: "Do not mention the opening of the Institute to anyone as you will treat me to a cloud of newspapermen to the detriment of my health" (letter to Paul Clemens, 1954). Private to the last, Clark left his collection as the only true document of his taste and spirit.

Steven Kern
Curator of Paintings

American Paintings and Sculpture

AT THE
STERLING AND
FRANCINE CLARK
ART INSTITUTE

Notes to the Catalogue

The catalogue is arranged alphabetically by artists' names. Each work or group of works by a particular artist is preceded by a short biography and bibliography. Multiple works by a single artist are arranged chronologically. In addition to a commentary, each entry includes registration information, provenance, a listing of related works, an exhibition history, and references.

Registration Information

The title of the object as used by the Clark Art Institute is listed first. This title usually reflects the title the artist is known to have given the piece or under which it was first exhibited. Alternative titles, which have appeared in art-historical literature or in records on the work, are listed in parentheses below the main title.

The date of the work is noted on the line with the main title. A *circa* (c.) date followed by a single year indicates a leeway of five years before and after that date; a *circa* date followed by a span of years indicates that the work was executed sometime between the two dates.

The medium of an object is listed before the support. Dimensions are in inches, followed by centimeters; height precedes width precedes depth.

The inscriptions on a work are recorded by quadrant, starting in the lower left and moving clockwise; recto precedes verso. All inscriptions are in the artist's hand unless otherwise noted.

An accession number without a decimal indicates that the work was purchased by Robert Sterling Clark and is part of his original collection. Works purchased after 1955, when the Institute opened, are numbered by year of purchase followed by a decimal and a number that has been assigned chronologically.

Occasionally a work is listed in the Provenance, Exhibitions, and/or Reference section(s) which cannot be positively identified as the work under discussion. In such cases the work is described as "possibly the same work."

Notes

In the notes at the end of each entry citations are given in full the first time, and in a shortened form each subsequent use within that entry.

The following always appear in abbreviated form:

CAI archives
Sterling and Francine Clark Art Institute archives

CAI curatorial files
Sterling and Francine Clark Art Institute curatorial files

Provenance

Each history of ownership is understood to begin with the artist. The names of subsequent owners are separated by semicolons. The word "to" preceding an owner's name indicates direct passage from the previous owner. Passage of objects by descent, inheritance, or estate is noted following the individual's name. Dealer and auction sales are listed in parentheses.

Related Works

Only works that are preparatory or otherwise directly connected to an object are listed. Copies are not included unless by the artist's own hand.

Exhibition Histories

All known exhibitions in which a work was included are listed chronologically by institution, city, title of show, dates, and catalogue number (if known). Unless otherwise indicated, an exhibition was accompanied by a catalogue.

References

This section lists chronologically all known references to the specific object from the time of its execution through 1989, except for those in popular magazines, which have been omitted unless published during the artist's lifetime. For literature published within the same year, the items are ordered by specificity of date: month and day, followed by month only, followed by year only. Checklists or catalogues of auction sales or exhibitions, which appear in the provenance and exhibition histories, have not been repeated in this section.

The following references appear in abbreviated form:

CAI 1955
Exhibit 4: The First Two Rooms, exh. cat. (Williamstown, Massachusetts: Sterling and Francine Clark Art Institute, 1955).

CAI 1957
Exhibit 7: The Regency and Louis XVI Rooms, exh. cat. (Williamstown, Massachusetts: Sterling and Francine Clark Art Institute, 1957).

CAI 1958
Supplement: Miscellaneous 19th Century Artists (Williamstown, Massachusetts: Sterling and Francine Clark Art Institute, 1958).

CAI 1958a
Exhibit 4 and Exhibit 7 (Williamstown, Massachusetts: Sterling and Francine Clark Art Institute, 1958).

CAI 1972
List of Paintings in the Sterling and Francine Clark Art Institute (Williamstown, Massachusetts: Sterling and Francine Clark Art Institute, 1972).

CAI 1980
1955–1980: A Twenty-five Year Report (Williamstown, Massachusetts: Sterling and Francine Clark Art Institute, 1980).

CAI 1981
John H. Brooks, *Highlights of the Sterling and Francine Clark Art Institute* (Williamstown, Massachusetts: Sterling and Francine Clark Art Institute, 1981).

CAI 1984
List of Paintings in the Sterling and Francine Clark Art Institute (Williamstown, Massachusetts: Sterling and Francine Clark Art Institute, 1984).

William Jacob Baer
1860–1941

William Jacob Baer was born January 29, 1860, in Cincinnati. As a young man he served as a lithographer's apprentice for four years and studied drawing at night at the McMicken School of Design. Through the generosity of an uncle, he went to Munich in 1880 for further art training. His great progress and success during his first year there enabled him to stay through 1884. At the Royal Academy in Munich, Baer studied drawing—from the antique and from life—under Alexander Strähuber (1814–1882) and Gyula Benczur (1844–1920) and oil painting with Ludwig Löfftz (1845–1910).

Baer returned to America in late 1884 or early 1885 and for the next decade made his home in northern New Jersey. He supplemented his painting career by teaching drawing and painting at Princeton University and the Cooper Union as well as at summer art schools at Chautauqua, New York, and Round Lake, New York. Like many of his fellow Munich-trained painters, he did figure work in the winter and landscape painting in the summer.

In 1893 Baer set up a studio in New York with his good friend and fellow-Cincinnatian, Robert Blum (1857–1903). Through Blum, Baer met Alfred Corning Clark, who commissioned several works and encouraged Baer to begin painting in miniature. Although the artist never entirely gave up easel painting, miniature work became his primary endeavor after 1894.

A founding member of the American Society of Miniature Painters (1899) and its treasurer for twenty-five years, Baer is one of a handful of artists credited with reviving miniature painting in the last decade of the nineteenth century. He exhibited his miniatures extensively, and his work received awards at the 1900 Paris Exposition Universelle, the 1901 Pan-American Exposition, Buffalo, the 1904 Louisiana Purchase Exposition in St. Louis, and the 1915 Panama-Pacific Exposition in San Francisco. In 1913 Baer was elected an associate of the National Academy of Design. After more than half a century of artistic activity, he died in 1941.

Bibliography: "William Jacob Baer," *The Art Age,* 3 (November 1885), p. 60; Lolita L.W. Flockhart, *Art and Artists in New Jersey* (Somerville, New Jersey: C.P. Hoagland Co., 1938), pp. 8–10; "W.J. Baer, 81, Dead; Miniature Painter," *The New York Times,* September 23, 1941, p. 23.

Portrait of Alfred Corning Clark, 1893 and 1911

Oil on canvas
22¹/₁₆ × 18 (56 × 45.7)
Signed and dated at upper right: Wm J. Baer/ 1893 · 1911
No. 637

Portraiture occupied William Jacob Baer from his student days in Munich to his mature work, whether on easel or miniature scale. *Portrait of Alfred Corning Clark* is a fine example of his portrait style as well as a wonderful memento of a special kind of artist-patron relationship that is rarely found today.

In 1882 Alfred Corning Clark (1844–1896), father of Robert Sterling Clark, inherited the fortune made by his father from the Singer Sewing Machine Company. An extremely private and retiring man, Alfred Clark was nonetheless an exemplary benefactor and patron of the arts. According to his good friend Ned Moran, "it is not too much to say that the chief occupation of his life—growing more and more absorbing as he grew older—was doing good to others."[1] Among those who benefited from Clark's philanthropy were the sculptor George G. Barnard (1863–1938), the pianist Josef Hofmann (1876–1957), and the painter Robert Blum (1857–1903), as well as William Jacob Baer. Blum introduced Clark to Baer in late 1892, and shortly thereafter Clark gave Baer the portrait commission.[2] Clark was so pleased with his portrait that he asked Baer to do a replica in miniature. Though Baer resisted at first, he finally gave in; several other commissions from Clark for miniatures followed.[3]

Portrait of Alfred Corning Clark is curiously inscribed with two dates: 1893 and 1911. An explanation of the double dating is complicated by the fact that Baer seems to have executed two portraits of Clark simultaneously. As recounted by Lolita L.W. Flockhart, "After each sitting the young artist made a replica of his painting in a freer manner, gaining thereby a more flowing result. [Flockhart is referring to a single replica, on which Baer worked after each sitting.] On completion it was the second picture which he presented to his satisfied patron."[4] However, it is a tightly painted work that is in the Clark collection today. Although Baer began the portrait commission in 1892, payments from Clark to Baer in April and November 1893 suggest that the picture Clark received was not finished until sometime in late 1893.[5] Baer also executed the above-mentioned miniature replica, which, along with the more freely painted oil portrait of Clark, is unfortunately unlocated.[6]

Although it is impossible to secure a definitive explanation for the 1911 date, Clark family history suggests what may have occurred. When Elizabeth S. Clark, Alfred's wife and Robert's mother, died in 1909, her estate,

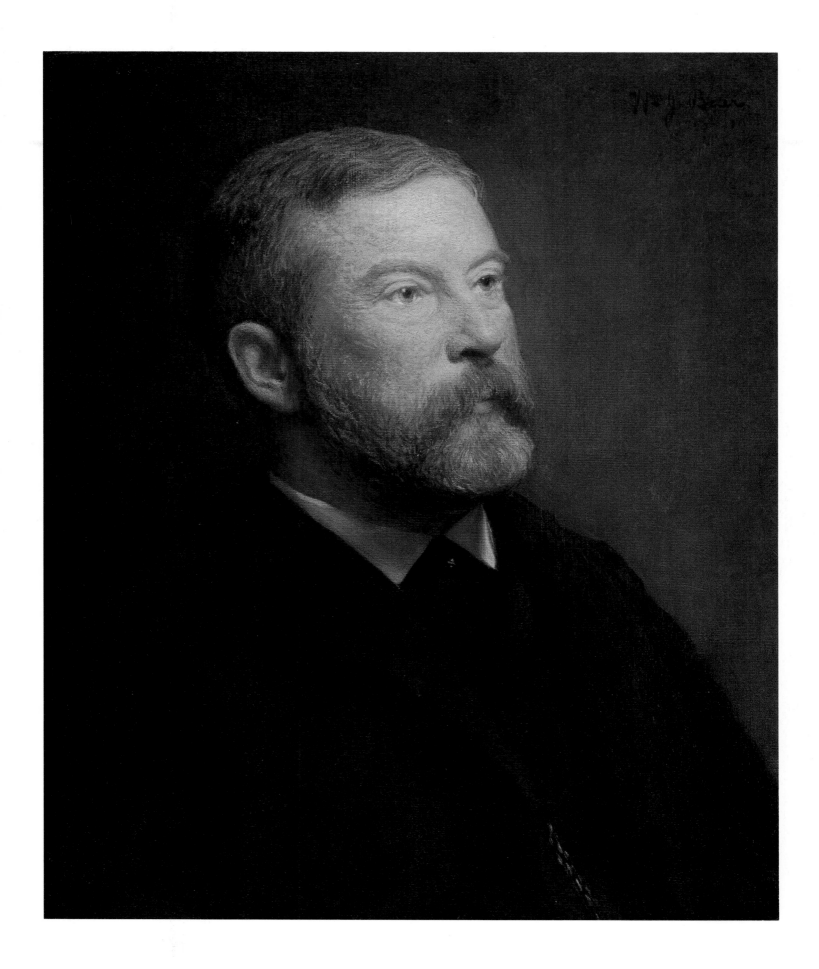

which included Alfred Clark's art collection, was divided among the Clark children. At this time, Robert Sterling Clark was heading an expedition in China, and it was not until the following year that he returned to settle down to a life of art collecting.[7] There was considerable discussion of the estate settlement between Robert and his brother Stephen, who oversaw family matters. Letters written by Robert to Stephen between April and November 1911 indicate that he deeply admired his father and that he very much wanted Baer's miniature *Golden Hour* (whereabouts unknown) from his father's estate. No specific mention is made of the Baer portrait, but in a letter dated April 4, 1911, Robert wrote: "I did not ask anything except that you give me one of the portraits and the miniature. The Baer miniature you were very nice about."[8] This implies that he did not get "one of the portraits" he had requested. Which portrait this was is uncertain. He had received the Gilbert Stuart *George Washington* (p. 195). This enables us to hypothesize that it was the Baer portrait of his father that he was unsuccessful in obtaining—though there is no definitive evidence that it was in the estate. Robert could then have contacted Baer about purchasing the more tightly painted version, which Baer may have kept in 1893.[9] Slight touching up in the sitter's beard and on the left side of his face, visible on the Clark portrait under ultraviolet light, could indicate 1911 additions by the artist at the time of Robert Clark's request to buy the picture. Although it is not a significant amount of work, Baer, a meticulous man, may have felt that a second dating was warranted.[10]

Portrait of Alfred Corning Clark exhibits the style Baer first learned in Munich and practiced throughout his career. Under Ludwig Löfftz (1845–1910) he was exposed to a painting style that depended heavily on a respect for and imitation of the Old Masters, especially Hans Holbein (1497/98–1543).[11] Both the emergence of a lighted head from a dark background and the use of very tight, small brushstrokes reflect Baer's Munich training. Like William Merritt Chase in his Munich-executed *Portrait of Eilif Peterssen* (p. 37), Baer began with a layout of the face in broad areas of brownish tones. However, his training under Löfftz, as opposed to Chase's early alliance with the radical and loose-painting Wilhelm Leibl (1844–1900), led Baer to take the image to a high degree of completion.

Baer's portrait reveals much about the personality of Alfred Corning Clark. The slight upward turn of the head in three-quarter view captures Clark's intensely private but thoughtful character, giving the viewer no psychological contact with the sitter. At the same time, the softness of the light that floods the face parallels his sensitivity.

Portrait of Alfred Corning Clark is a testament to Clark's role as a patron of the arts. Clark died in 1896, but during the three years of his acquaintance with Baer he commissioned no fewer than seven works from the artist.[12] Baer's portrait is a poignant reminder that Robert Sterling Clark's love of art and commitment to philanthropy came from his father.

1 E.T.M. [Ned Moran], *Alfred Corning Clark* (New York: Privately printed, 1896), p. 3.

2 William J. Baer, "Miniature Painting," *Palette and Bench,* 3 (July 1910), p. 17.

3 Ibid.

4 Flockhart, who seems to have known Baer, wrote about the artist on several occasions. This description appears in Lolita L.W. Flockhart, *Art and Artists in New Jersey* (Somerville, New Jersey: C.P. Hoagland Co., 1938), p. 9.

5 A small notebook recording Baer's income for the 1890s has two payments from Clark in April and November 1893, for $500 and $1,200, respectively. I am grateful to Mrs. Katherine Weimer, a descendant of the artist, for checking the record book for me.

6 Stephen C. Clark, Jr. (grandson of Alfred C. Clark) to the author, March 25, 1988, confirming that no Clark family members know of the whereabouts of these two objects; nor are the works in the hands of Baer relatives.

7 CAI 1980, p. 2.

8 Robert Sterling Clark to Stephen C. Clark, April 4, 1911, CAI archives.

9 Unfortunately, Robert Sterling Clark's records of his early purchases are scanty, and William Jacob Baer's papers are incomplete as well. Mrs. Katherine Weimer kindly checked with Baer family members as to the whereabouts of Baer's papers and art works.

10 An alternative possibility is that Robert had Baer paint a copy of his father's portrait from the original owned by one of his siblings, but no such actions are suggested in the existing correspondence.

11 Richard V. West, in *Munich and American Realism in the 19th Century,* exh. cat. (Sacramento: E.B. Crocker Art Gallery, 1978), p. 54.

12 This figure is gleaned from a list of works and a list of income in two of Baer's record books.

Provenance: Robert Sterling Clark.

References: William J. Baer, "Miniature Painting," *Palette and Bench,* 3 (July 1910), p. 17; Lolita L.W. Flockhart, *Art and Artists in New Jersey* (Somerville, New Jersey: C.P. Hoagland Co., 1938), p. 9; CAI 1972, pp. 122, 123; CAI 1984, pp. 3, 101.

Born Annie B. Matthews in 1871, Nanna Matthews Bryant grew up in Boston and in Rome. She first trained as a painter, studying at the Académie Julian in Paris and in 1895–96 at the Boston Museum School. From about 1897 to 1903 she exhibited at the National Academy of Design and at the Boston Art Club. By 1900 she had married the painter Wallace Bryant (active 1900–1925) and for the rest of her life used the name Nanna Matthews Bryant.

From 1903 to 1906 Bryant was again at the Boston Museum School for further instruction in painting. It was not until around 1912 that she turned to sculpture. Having always loved sculpture but hesitant to relinquish color, she resolved to express tonal changes through the use of light and shade in her three-dimensional works.

Bryant was a regular exhibitor at the National Academy of Design and the Pennsylvania Academy of the Fine Arts during the 1920s. She was a longtime member of the National Association of Women Painters and Sculptors. Her work generally received favorable reviews, and in 1921 her exhibition at the Kingore Galleries, New York, was so successful that it traveled to Washington, D.C. Bryant's last solo show was held at Dartmouth College in 1930. When she died at sixty-three on June 29, 1933, she was remembered not only for her art but also for her skill as a violinist and as a gracious hostess at her homes in Boston and Waltham, Massachusetts.

Bibliography: "Pictures Painted in Marble," *International Studio,* 76 (January 1923), pp. 338–41; "Mrs. Annie Bryant, Sculptress, Dies," *Boston Evening Transcript,* June 29, 1933, p. 11; *American Figurative Sculpture in the Museum of Fine Arts, Boston* (Boston: Museum of Fine Arts, 1986), pp. 336–37.

Nanna Matthews Bryant
1871–1933

After Nanna Matthews Bryant turned from painting to sculpture around 1912, she frequently depicted mythological or literary subjects. In addition to Eve, she portrayed Medea, Andromeda, Ariadne, and Leda, in each case using the female nude to express the subject's complex character.[1] In general Bryant blended a naturalism that showed her figure as truly human with an idealism that removed the figure from any direct connection to a specific person.

Eve is undated, but it was certainly finished by December 1, 1925, when it was included in a solo exhibition at Durand-Ruel Galleries in New York. In 1921 Bryant had shown a piece entitled *Little Eve* at the Pennsylvania Academy of the Fine Arts in Philadelphia.[2] No illustrations or dimensions can be found in the Academy records, so that we cannot be certain whether Bryant made one or two Eve pieces. But it is clear she had worked with the Eve subject as early as 1921.

Like most of Bryant's work, *Eve* is intimate in size and sensibility.[3] The sculptor eliminated narrative trappings and concentrated on presenting the inner emotions of the first woman after the fall from grace. To achieve this, Bryant used the figure's body and stance rather than face, which is only visible from the right side, to reveal her spiritual struggle. The S-curved, cringing figure is attached to a rocklike base from her buttocks to her feet, and she seems to be simultaneously pushed from and pulled into the earth form. This tension, however, is tempered by the graceful, sensuous lines of the form and the pristine marble surface.

Eve demonstrates Bryant's considerable skill in handling marble. That she could capture the palpable reality of flesh is particularly visible in the slight ripples of the figure's stomach. At the same time Bryant employed the potential smoothness of the stone to evoke the idealizing beauty of the subject—Eve's arms, legs, and face are carved to a rarefied sleekness.

Bryant's approach to sculpture relied heavily on the work of Auguste Rodin (1840–1917)—on his elongated forms, contrappostos, and bases carved like rough-hewn rocks. Bryant must also have been familiar with Rodin's *Eve* (figs. 1, 2), first conceived in 1881. By the early 1920s a variety of stone and bronze examples could be found in Chicago, Buffalo, Washington, D.C., New York, and Portland, Maine;[4] these works would have been available to Bryant through book and magazine reproductions as well.

Bryant's *Eve* is very close to Rodin's basic format, though there are slight differences in the degree of the figure's slouch and the positioning of the arms that change the psychological effect. In Rodin's *Eve* the arms simultaneously clutch the body and shield the face, making her appear huddled in guilt and sorrow. Bryant lifted one arm away from the body so that the figure is less hunched over and there is an added grace to the overall form. Whereas Rodin neither relieved Eve's inner torment nor hinted at her prior state of purity, Bryant suggested her earlier grace as well as her fallen state of shame.

The 1925 Durand-Ruel exhibition in which *Eve* was shown received brief but favorable

Eve, c. 1921–25
Marble
20 × 8¹⁄₂ × 9³⁄₈ (50.8 × 21.6 × 23.8)
Signed on left side near bottom edge:
Nanna/Matthews/Bryant

No. 1003

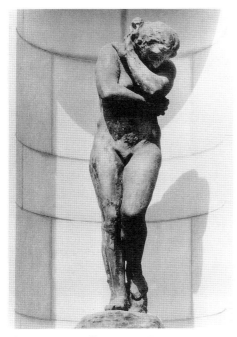

Fig. 1: *Auguste Rodin,* **Eve,** *1881. Bronze, 67×18½×23¼ in. (170.2×47×59.1 cm). Rodin Museum, Philadelphia; Gift of Jules E. Mastbaum, F'29-7-127.*

reviews, in one of which the figure was perceived as expressing the universal state of womanhood.[5]

1 *American Figurative Sculpture in the Museum of Fine Arts, Boston* (Boston: Museum of Fine Arts, 1986), p. 337.

2 Records of the Pennsylvania Academy of the Fine Arts, Philadelphia.

3 *American Figurative Sculpture in the Museum of Fine Arts, Boston,* p. 336.

4 For a complete list of all the known Rodin *Eves* and their histories, see John L. Tancock, *The Sculpture of Auguste Rodin* (Philadelphia: Philadelphia Museum of Art, 1976), pp. 155–57.

5 "Nanna Matthews Bryant," *Art News,* 24 (December 5, 1925), p. 2.

Provenance: (Durand-Ruel Galleries, New York, 1925); to Robert Sterling Clark, July 7, 1926.

Exhibitions: Pennsylvania Academy of the Fine Arts, Philadelphia, "116th Annual Exhibition," February 6–March 27, 1921, no. 607 (as *Little Eve,* possibly the same work); Durand-Ruel Galleries, New York, "Nanna Matthews Bryant," December 1–15, 1925.

References: "The Art of Nanna Matthews Bryant," unidentified magazine clipping, Bryant File, Fine Arts Division, Boston Public Library; "'Eve' (marble). By Nanna Matthews Bryant," *The Studio* (London), 88 (December 1924), p. 355; "Nanna Matthews Bryant," *Art News,* 24 (December 5, 1925), p. 2.

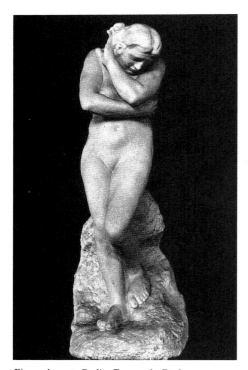

Fig. 2: *Auguste Rodin,* **Eve on the Rock,** *1906–7. Limestone, 68½ in. (174 cm) high. Ny Carlsberg Glyptotek, Copenhagen.*

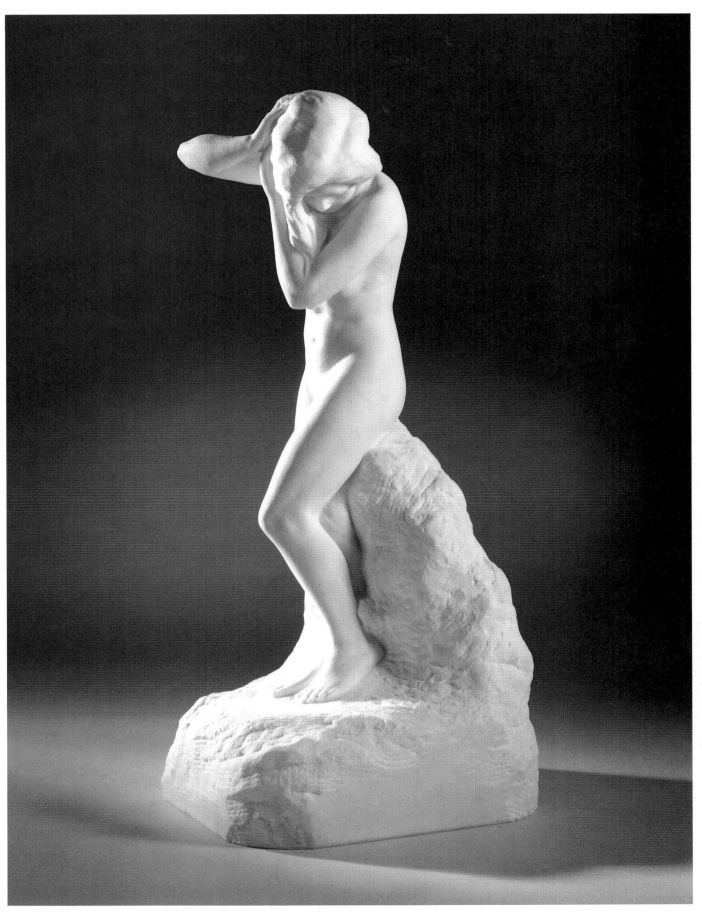

Eve

Edward Clark Cabot
1818–1901

Born into a distinguished Boston family, Edward Clark Cabot showed an early interest in drawing. He was educated privately and neither attended college nor received any artistic training. In the late 1830s Cabot went to the Cairo, Illinois, area to raise sheep, but within a few years that venture failed. He spent time with relatives in 1841 in St. Louis before returning east in 1842. Around 1845 he again tried to farm sheep near Windsor, Vermont. Within a year, however, he received the commission to design the Boston Athenaeum; his farming days ended and his career as an architect commenced. Despite a lack of professional training, Cabot became a prominent architect. His buildings include the Algonquin Club, Boston, many private residences in Boston's Back Bay, and the Johns Hopkins University Hospital in Baltimore. From 1867 to 1896 Cabot served as the first president of the Boston Society of Architects, of which he was a founder.

From the mid-1850s until his death, Cabot also painted landscapes and still lifes, mostly in watercolor. Although this work took a secondary place to his architecture, he exhibited frequently in Boston and occasionally in New York and Philadelphia. In 1902 a memorial exhibition of his work was held at the St. Botolph Club in Boston.

Bibliography: Cabot Family Papers, private collection; Richard L. Elia, "Cabot, Watercolorist," *Antiques,* 114 (November 1978), pp. 1068–75.

The Levee, 1866
(Mississippi Levee)
Oil on academy board
9¼ × 18¹⁵/₁₆ (23.5 × 48.1)
Signed and dated lower left: ☒ /66
No. 666

Fig. 3: Edward Clark Cabot, **Estuary, Little Pabos,** 1882. Watercolor on paper, 4¾ × 7½ in. (12.1 × 19.1 cm). Location unknown.

The arrival or departure of a boat at a landing pier, possibly on the Mississippi River, is the subject of Edward Clark Cabot's *The Levee.* Recent conservation has returned *The Levee* to its original condition. When Robert Sterling Clark purchased the work in 1944, he felt that the black storm cloud was too conspicuous. He hired a restorer to attenuate the blackest areas with white, giving the sky an overall gray cast that significantly modified the original contrast of a stormy and bright sky.[1]

Cabot may have intended this contrast as a reference to the recent Civil War, in which he had served with the Massachusetts Volunteers.[2] Although his places of service are not known, *The Levee* and a drawing, *Cotton Press,*[3] suggest that he spent time around the southern portion of the Mississippi near the end of or just after the Civil War. Cabot's inclusion of an American flag in the upper left of the Clark painting makes clear that he was recording Union soil.

The Levee, though in oil, was executed in a watercolor technique after Cabot drew most of the figures and guidelines for the composition in pencil. The luminosity of the water's reflection particularly exhibits his excellent ability to handle thin transparent layers of color and suggests why watercolor, in which this layering was a common technique, was his preferred medium. The composition of *The Levee* reflects Cabot's acute sense of design. His use of emphatic horizontals, verticals, and diagonals—in the horizon line, the flag and mast poles, the angle of the roof and shoreline, and the thrust of the pier into the water—balances the open river landscape against the inhabited bank to portray a place dependent on river commerce. Nearly twenty years later Cabot was still using a similar type of design and technical approach in works such as the 1882 watercolor *Estuary, Little Pabos* (fig. 3).

Cabot painted few oils and even fewer works that included figures, thus making *The Levee* a rare venture in his career.[4] It may have been a desire to record white and black men living under the American flag in 1866 that led him to depart from his usual medium and composition.

1 The complete story of the restorer's work on the picture and Clark's attitudes toward it is told in Robert Sterling Clark's diary, October 5–20, 1944, CAI archives.

2 Mrs. Ruth Vose kindly shared her family's knowledge of Cabot's army career.

3 *Cotton Press* (whereabouts unknown) was exhibited at the North-Western Sanitary Fair in Chicago in 1865 as number 259; see *Catalogue of Painting, Statuary, Etc. in the Art Department of the Great North-Western Fair* (Chicago: 1865), p. 9, no. 259.

4 *The Levee* is one of the few pre-1875 works by Cabot that survives. Although signed with a variation of the monogram he used in later life, the painting is unquestionably by Cabot. I am grateful to Mrs. Ruth Vose, who compared this work with others by Cabot in her collection.

Provenance: (John Levy Galleries); to (M. Knoedler & Co., New York, October 20, 1943); to Robert Sterling Clark, November 1, 1944.

References: CAI 1972, pp. 124, 125 (as *Mississippi Levee*); CAI 1984, pp. 7, 101.

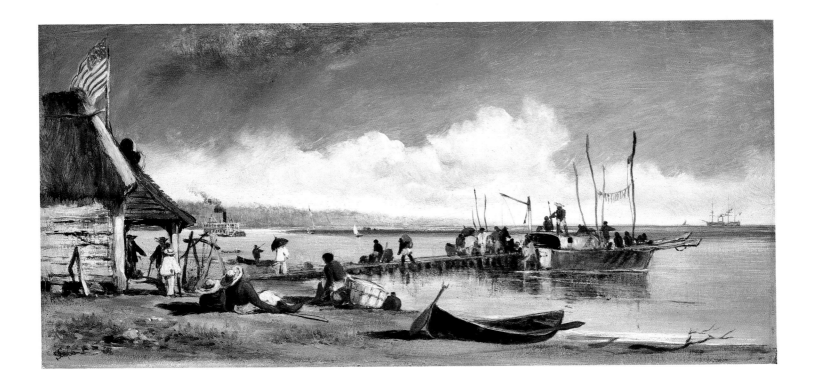

Samuel S. Carr
1837–1908

Samuel Carr, born in England, studied drawing at the Royal School of Design in Chester. He immigrated to the United States in 1863, and by 1865 he had enrolled in a mechanical drawing class at the Cooper Union. From 1870 until his death he lived in Brooklyn with his sister and brother-in-law; during these same years he shared a studio with the landscape painter Clinton Loveridge (1824–1902).

Carr seems to have made his living from painting. From 1871 to 1898 he actively exhibited his work at many New York institutions, including the National Academy of Design, the Brooklyn Art Association, and the Brooklyn Art Club. Throughout his career, he applied a crisp naturalism to scenes of children, beaches, and pastoral landscapes. Although it has been suggested that he may have worked as an illustrator or photographer, no factual evidence has been found to corroborate his employment in either field.

Bibliography: Smith College Museum of Art, *S.S. Carr,* exh. cat. (Northampton, Massachusetts: Smith College Museum of Art, 1976); *An American Perspective: Nineteenth-Century Art from the Collection of Jo Ann and Julian Ganz, Jr.,* exh. cat. (Washington, D.C.: National Gallery of Art, 1981), p. 120.

Children Playing on the Beach, 1879

Oil on canvas
8 × 10 (20.3 × 25.4)
Signed and dated lower right: S.S. CARR. 79
No. 672

Fig. 4: Samuel S. Carr, **Beach Scene,** c. 1879. Oil on canvas, 12 × 20 in. (30.5 × 50.8 cm). Smith College Museum of Art, Northampton, Massachusetts; Bequest of Annie Swan Coburn (Mrs. Lewis Larned Coburn), 1934.

Fig. 5: Samuel S. Carr, **The Beach at Coney Island,** c. 1879. Oil on canvas, 6¼ × 10⅛ in. (15.9 × 25.7 cm). Collection of Jo Ann and Julian Ganz, Jr.

As the amount of leisure time available to Americans increased in the late 1870s, the rural or coastal areas adjacent to urban centers were often appropriated for recreational use. Near New York City, Coney Island and many other seaside towns gained great popularity among the middle classes. Coney Island, one of the most popular beaches for many years, offered restaurants, saloons, variety shows, shooting galleries, bathing pavilions, an iron pier, and band concerts.[1]

From about 1879 to 1881 Carr primarily painted beach scenes. The majority of these works, most likely including *Children Playing on the Beach,* picture Coney Island, the beach resort nearest Carr's Brooklyn residence. In the Clark picture and other beach paintings from this time, he depicted couples strolling, children wading or building in the sand, and families generally enjoying the sea air. The carefully worked out compositions of these pictures were often very similar. A central group of figures was placed in the foreground to create a focal point; surrounding them was a setting of equal parts land and sky, separated by a narrow band of water painted at a slight diagonal. Between the main figures and the water's edge were small figure groups that served to balance the overall composition.

In *Children Playing on the Beach,* the triangle formed by the three older children surrounds a baby who looks directly out at the viewer. The four figures, first lightly drawn in pencil then underpainted in a warm reddish brown, are rendered tightly and opaquely. The entire painting is bathed in a hot, white light that highlights the figures, dissolves the atmosphere over the ocean as on a clear summer day, and unifies the surface of the painting. Carr ensured the spatial unity of the image through the use of pink, which carries the viewer's eye from the left and right middle distances to the center foreground. All these factors, combined with the figures' incidental gestures, create the effect of a frozen moment.

Although the compositional treatment of the beach scenes adheres to accepted artistic norms of the time, Carr's approach to picture making may also have been derived from an increasingly important activity in the late 1870s: photography. That Carr was aware of outdoor portrait photography is revealed in the paintings *Beach Scene* (fig. 4) and *The Beach at Coney Island* (fig. 5), which document the Tucker family at Coney Island having a group portrait taken.[2] The baby's engagement with the viewer in the Clark picture also corresponds to a common motif in portrait photography,[3] while the triangular arrangement of the figures mimics the kinds of groupings often used for family portraits, including that of the Tuckers. The stop-action quality further gives the painting a snapshot character.

The Beach at Coney Island is surely a study for the Smith College *Beach Scene. Children Playing on the Beach,* however, is also related to *Beach Scene.* The configuration of children playing in the left foreground of the Smith College painting is the reverse of that in the Clark picture. The girl with braided hair is copied exactly, in reverse, as are the pail and footprints in the sand. Several of these figures also can be found in other Carr paintings.[4] It is hard to determine in what sequence Carr painted these works since few are dated. *Children Playing on the Beach* is the earliest dated beach picture, and it seems plausible that he painted the smaller Clark and Ganz pictures in preparation for the larger work now at Smith. He may then have reused some of the figures in later works, such as the 1880 *On the Beach* (private collection).

Whether Carr worked from photographs or was only inspired by them remains uncer-

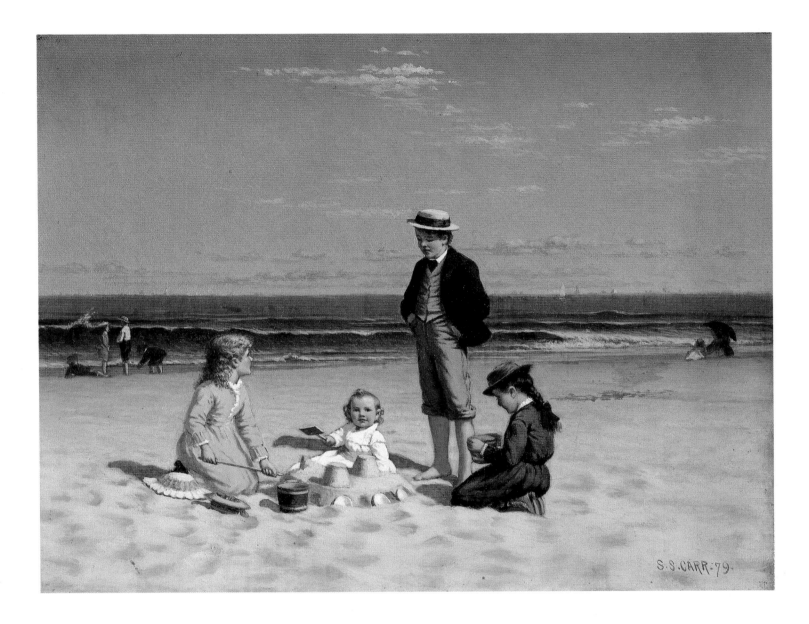

tain. But his strong interest in photography, combined with careful compositional design and an affection for the bright light and life at the seashore, prompted him to render this common scene with an unusual intensity.

1 A concise history of the beach towns and what they offered can be found in Lloyd Morris, *Incredible New York* (New York: Random House, 1951), p. 115.

2 *An American Perspective: Nineteenth-Century Art from the Collection of Jo Ann and Julian Ganz, Jr.*, exh. cat. (Washington, D.C.: National Gallery of Art, 1981), p. 121.

3 *S.S. Carr*, exh. cat. (Northampton, Massachusetts: Smith College Museum of Art, 1976), pp. 6–7.

4 For example, *Beach Scene with Punch and Judy Show* (n.d.; private collection) has the same little girl in a white dress and hat but in a different pose from that in the Clark picture. She

appears with a slightly different hat but the same pose in the Smith College work. *On the Beach* (1880; private collection) twice shows the same boy as in the Clark painting as well as the bucket and seashells.

Provenance: (Victor Spark, New York); to Robert Sterling Clark, November 1, 1943.

Exhibitions: Smith College Museum of Art, Northampton, Massachusetts, "S.S. Carr," April 2–May 20, 1976, no. 2; Sterling and Francine Clark Art Institute, Williamstown, Massachusetts, "Safe Harbor, Smooth Sands, Rough Crossing," March 5–April 17, 1988 (no catalogue).

References: CAI 1958, n.p.; CAI 1972, pp. 20, 21; *S.S. Carr*, exh. cat. (Northampton, Massachusetts: Smith College Museum of Art, 1976), pp. 6, 9, 12; CAI 1984, pp. 7, 101.

Mary Cassatt was born in 1844 in Allegheny City, Pennsylvania (now part of Pittsburgh). She lived in Europe with her family from 1851 to 1855. Her first formal art study was at the Pennsylvania Academy of the Fine Arts in Philadelphia (1861–65). Late in 1865 or early in 1866, she went to Paris, where she received private art instruction from Jean-Léon Gérôme (1824–1904). Her occasional travel into the French countryside took her to Ecouen and the Barbizon region; there she worked under Edouard Frère (1837–1894) and Paul Soyer (1823–1903). She may also have taken some lessons from Thomas Couture (1815–1879) at Villiers-le-Bel.

The Franco-Prussian War forced Cassatt to return to the United States in 1870. She again set out for Europe in 1872, going first with her friend Emily Sartain (1841–1927) to Parma, then alone to Spain, Belgium, and Holland. During this first decade of her career she concentrated on studying and copying Old Master paintings.

After 1873 Cassatt lived in Paris for virtually the rest of her life. Her mother, father, and sister joined her there in 1877. Edgar Degas (1834–1917) invited her that same year to become a member of the avant-garde group now known as the Impressionists. She exhibited with them annually from 1879 to 1881 and again in 1886. During these years the theater, the opera, and her family, especially her sister, Lydia, were her primary subjects. In the late 1880s, working in pastel and a variety of print media as well as oil, she began to focus on mothers with children, the theme that would make her famous.

The 1890s brought a number of changes for Cassatt. The 1890 Japanese exhibition at the Ecole des Beaux-Arts greatly accelerated her involvement with Eastern art, particularly Japanese printmaking. It was also during this decade that she gained considerable fame. In 1891 and 1893 she had her first two one-artist shows at Durand-Ruel, Paris; the New York branch of the gallery presented her first solo show in the United States in 1895. In 1892 she was commissioned to paint a mural, *Modern Woman* (whereabouts unknown), for the Women's Building at the 1893 World's Columbian Exposition in Chicago.

In that same year Cassatt bought Château de Beaufresne at Mesnil-Théribus, fifty miles northwest of Paris. It served as her country home until 1914 and her permanent residence thereafter. During 1898–99 she visited the United States for the first time in almost twenty-five years. It was then that she expanded her role, begun in the mid-1870s, as an art adviser to several Americans. Cassatt made her last trip to America in 1908–9. Failing eyesight curtailed her artistic activities in her final years.

Bibliography: Achille Ségard, *Un peintre des enfants et des mères: Mary Cassatt* (Paris: Librairie Paul Ollendorff, 1913); Frederick A. Sweet, *Miss Mary Cassatt: Impressionist from Pennsylvania* (Norman: University of Oklahoma Press, 1966); Adelyn D. Breeskin, *Mary Cassatt: A Catalogue Raisonné of the Oils, Pastels, Watercolors, and Drawings* (Washington, D.C.: Smithsonian Institution Press, 1970); Nancy Mowll Mathews, ed., *Cassatt and Her Circle: Selected Letters* (New York: Abbeville Press, 1984); Nancy Mowll Mathews, *Mary Cassatt* (New York: Harry N. Abrams, 1987).

Mary Cassatt
1844–1926

Mary Cassatt spent five months during 1872–73 in Spain, mostly in Seville. She financed this trip with orders for copies of religious paintings from the Archbishop of Pittsburgh. Cassatt had many reasons for visiting Spain, not least of which was her desire to keep up her study of European Old Master painting, which had begun in France in the late 1860s and had continued in Parma during the six months immediately, preceding her journey to Spain. In addition, her early training with Jean-Léon Gérôme (1824–1904) pointed her toward Spain. Gérôme, who specialized in exotic subjects and admired the works of Diego Velázquez (1599–1660), frequently suggested trips to Spain for his students. Cassatt was also part of a wave of English-speaking people who, in the nineteenth century, were interested in Spanish life and culture.[2] In 1871 she had written in frustration to her friend Emily Sartain when her trip to Spain was delayed: "I have been abandoning my self to despair and homesickness, for I really feel as if it was intended I should be a Spaniard and quite a mistake I was born in America."[3]

Four oils depicting Spanish life are inscribed "Seville 1873."[4] In addition to *Offrant le Panal au Torero*, Cassatt painted *On the Balcony* (fig. 6), *Toreador* (fig. 7), and *Spanish Dancer Wearing a Lace Mantilla* (fig. 8). Common to all these works is their ambitious size and use of elaborate costumes and recognizably Spanish models. All but *On the Balcony* draw directly on Spanish culture, and all but *Spanish Dancer* feature men, a rare occurrence in Cassatt's art outside of commissioned portraits.

Offrant le Panal au Torero depicts a young woman serving a thirst-quenching confection

Offrant le Panal au Torero, 1873
(Il Torero; Offering the Panale to the Bullfighter; Spanish Matador; Young Girl Offering a Glass of Water to a Torero; Un Torero et une Jeune Fille; Torero and Young Girl)[1]
Oil on canvas
$39^{5}/8 \times 33^{1}/2$ *(100.6 × 85.1)*
Signed, dated, and inscribed lower right: Mary S. Cassatt./Seville./1873
No. 1

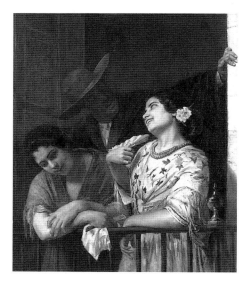

Fig. 6: Mary Cassatt, **On the Balcony**, 1873. Oil on canvas, 39¾ × 32½ in. (101 × 82.6 cm). Philadelphia Museum of Art; W. P. Wilstach Collection, W'06-1-7.

Fig. 7: Mary Cassatt, **Toreador**, 1873. Oil on canvas, 32⅛ × 25³/₁₆ in. (81.6 × 64 cm). The Art Institute of Chicago; Gift of Mrs. Sterling Morton, 1969.332.

to a bullfighter. The *panal*—Spanish for honeycomb or sponge sugar—was dipped in water and then sucked to provide both sugar and liquid. The picture is devoid of any further narrative, but the active postures of the figures heighten the sense of reality and immediacy. Cassatt drew from a variety of older and contemporary European sources for the theme and presentation of *Offrant le Panal au Torero*. Her preference for genre subjects may have been formed during her first years in France when she studied with Edouard Frère (1837–1894) and Gérôme. While Frère leaned toward the sentimental, Gérôme focused on daily life in an exotic world. Where North Africa provided Gérôme with his subjects, Spain served Mary Cassatt. That her subject is Spanish, drawn from modern life and expressed through a sense of the momentary, may also reflect her knowledge of Edouard Manet (1832–1883).[5] No less influential was Cassatt's familiarity with the group of contemporary Spanish painters who depicted their own culture; in Madrid, she had been interested in the possibility that Mariano Fortuny (1838–1874), the most famous of these painters, might pay a visit.[6]

Nancy Mathews has suggested a relationship between the Clark picture and the work of the Scottish painter John Phillip (1817–1867), specifically his painting *La Bomba* (fig. 9).[7] "Spanish" Phillip, as he was known, was patronized by Queen Victoria, and for a short time after his death in 1867 his anecdotal genre scenes of Spanish life were exhibited with success.[8] While it cannot be confirmed that Cassatt knew Phillip's work, the subject, bright coloration, and circular arrangement of figures in *La Bomba* are similar to those in *Offrant le Panal au Torero*. If Cassatt did know *La Bomba*, the Clark painting constitutes another example of her ability to absorb other artists' work; if the visual similarities are coincidental, *La Bomba* still testifies to the popularity of this kind of Spanish theme among Anglo-Saxon audiences of the period.

Fig. 8: Mary Cassatt, **Spanish Dancer Wearing a Lace Mantilla**, 1873. Oil on canvas, 26¾ × 19¾ in. (68 × 50.2 cm). National Museum of American Art, Smithsonian Institution, Washington, D.C.; Gift of Victoria Dreyfus.

Although Cassatt's subject was inspired by her contemporaries, the work's artistic strategies grew out of her close study of Old Master painting. On January 1, 1873, Cassatt wrote to Emily Sartain: "Now that I have begun to paint from life again, constantly the thought of Correggio's pictures returns to my mind and I am thankful for my six months study in Parma."[9] From works such as Correggio's *Madonna della Scodella* (fig. 10) or *Jupiter and Io* (fig. 11), Cassatt adopted back views and turning and interlocking forms that project outward. By using these devices with three-quarter-length figures close to the picture plane in *Offrant le Panal au Torero*, she achieved both a certain grandness and immediacy.

Cassatt's painting technique in *Offrant le Panal au Torero* was in large part influenced by the work of Velázquez, which she encountered on her arrival in Spain. Cassatt exclaimed in a letter: "I think one learns *how to paint* here, Velasquez' manner is so fine and simple."[10] After copying from Velázquez in Madrid, she appropriated his thicker and more freely brushed manner. Although she did not adopt Velázquez's dark palette, her vigorous brushstrokes, especially visible in the bullfighter's costume, announce her understanding of the master's technique and create some of the most beautiful passages in the painting.

Velázquez's art also helped Cassatt shift from idealism to realism. Her early studies in Paris had made her receptive to such a change. Gérôme painted in an almost super-realistic technique, and Manet, also inspired by Velázquez, presented her with a contemporary application of painterly method as a means of realism. In *Offrant le Panal au Torero* neither figure is prettified, and when compared to *Two Women Throwing Flowers during Carnival* (fig. 12), painted in Parma less than a year before under the influence of Correggio's noble idealism, the new frankness in Cassatt's painting is apparent.

In the Clark painting, then, Cassatt combined French nineteenth-century approaches to contemporary subjects, Italian Mannerist composition, and seventeenth-century Spanish technique and realism. The result is the depiction of an everyday occurrence in an exotic land, executed in a richly textured painting style, but with close observation and no idealization. Cassatt's borrowings are recognizable, but she assimilates them in the blending of artifice with reality.

Cassatt sent *Offrant le Panal au Torero* to the 1873 Paris Salon and in the same year to the Cincinnati Industrial Exposition. The following year, along with *On the Balcony*, the picture made the artist's debut at the National Academy of Design in New York. In 1878 it was shown in Philadelphia at the Pennsylvania Academy of the Fine Arts.

Offrant le Panal au Torero

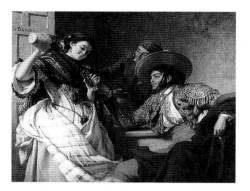

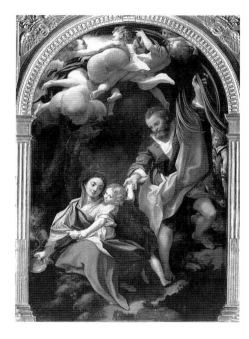

Fig. 10: Correggio, **Madonna della Scodella**, 1530. Oil on panel, 85 × 53¹⁵/16 in. (215.9 × 137 cm). Galleria Nazionale, Parma.

Offrant le Panal au Torero generated little critical commentary at these exhibitions. Cassatt was, first of all, young, unknown, and female. Moreover, as William H. Gerdts has pointed out, in the case of the picture's New York venue, a large figure painting such as this one might have received more attention at the Society of American Artists, where both figure painting and European influence were better appreciated.[11] The few critics who did notice the work praised its paint handling and lifelike figures.[12]

Although the painting shows Cassatt as a talented young artist, it remains a conventional picture that uses popular subject matter and artistic conventions.[13] Problems of construction in the work cannot be ignored. The general spatial conception — especially the woman's elbow thrust out toward the viewer — is good, but there are other parts that fail to convince. In the area between the woman's chin and the bottom of the glass, the articulation of forms and the representation of space are flattened. In addition, the torero's hand at his waist is not well painted. Such faults, though relatively minor, may further explain why the work was overlooked.

Nor did *Offrant le Panal au Torero* sell quickly. At the time of the 1878 Pennsylvania Academy show, the painting was on deposit with Cassatt's Philadelphia agent, Hermann Teubner.[14] The painting's history is murky between 1878 and 1947, but the Paris residence of the first known owner, a Mr. Engrand, suggests that sometime after 1878 the work was returned to Cassatt.[15] The picture thus took at least five years to sell, and it remained out of the public eye until the 1940s.

1 Cassatt sent this painting to the 1873 Salon as *Offrant le Panal au Torero*, to the 1873 Cincinnati Industrial Exposition as *Il Torero*, and in 1874 to the National Academy of Design as *Offering the Panale to the Bullfighter*. At the Pennsylvania Academy of the Fine Arts in 1878, it was registered as *Spanish Matador* by her agent in Philadelphia. From that time until the 1940s the few references to it are various. Since the 1940s, it has commonly been called *Torero and Young Girl*, a name that seems to have been attached by M. Knoedler & Co. prior to its sale to Mr. Clark.

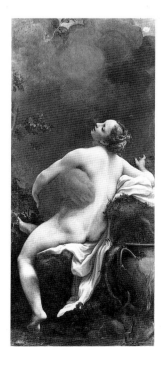

Fig. 11: Correggio, **Jupiter and Io**, c. 1530. Oil on canvas, 64¹/2 × 27³/4 in. (163.8 × 70.5 cm). Kunsthistorisches Museum, Vienna.

2 Eleanor Tufts, "Realism Revisited: Goya's Impact on George Bellows and Other American Responses to the Spanish Presence in Art," *Arts Magazine,* 57 (February 1983), pp. 112–13.

3 Cassatt to Sartain, May 22, 1871, reprinted in Nancy Mowll Mathews, ed., *Cassatt and Her Circle: Selected Letters* (New York: Abbeville Press, 1984), p. 70.

4 Throughout her life, Cassatt painted groups of related images, and contemporary Spanish life was the first subject she explored in such a series; see Nancy Mowll Mathews, "Mary Cassatt and the 'Modern Madonna' of the 19th Century," Ph.D. dissertation, New York University, 1980, p. 8.

5 William H. Gerdts, *American Impressionism* (New York: Abbeville Press, 1984), p. 34.

6 Cassatt to Sartain, October 13, 1872, reprinted in Mathews, *Cassatt and Her Circle*, p. 108.

7 Nancy Mowll Mathews, *Mary Cassatt* (New York: Harry N. Abrams, 1987), p. 16.

8 *La Bomba* was exhibited in 1868 in Leeds and in 1873 at the London Exposition; see David and Francina Irwin, *Scottish Painters: At Home and Abroad, 1700–1900* (London: Faber and Faber, 1975), pp. 326–31. The Aberdeen Art Gallery kindly provided curatorial information on *La Bomba*.

9 Cassatt to Sartain, January 1, 1873, reprinted in Mathews, *Cassatt and Her Circle*, p. 114.

10 Cassatt to Sartain, October 13, 1872, ibid., p. 108.

11 Gerdts, *American Impressionism*, p. 34.

12 See the reference section below for a listing of the reviews.

13 Mathews, *Mary Cassatt*, p. 37.

14 Suzanne Lindsay, *Mary Cassatt and Philadelphia*, exh. cat. (Philadelphia: Philadelphia Museum of Art, 1985), p. 23.

15 Caroline Godfroy, Durand-Ruel & Cie., Paris, assisted me in tracking the provenance of the painting. It was in the Durand-Ruel archives that Mr. Engrand's name was found; Caroline Godfroy to the author, November 22, 1988.

Provenance: Mr. Engrand, Paris; Mr. Parisot; to (Durand-Ruel and Co., New York, May 1947); to (Carroll Carstairs, New York, June 20, 1947); to (M. Knoedler & Co., New York, September 29, 1947); to Robert Sterling Clark, October 2, 1947.

Exhibitions: "Salon de 1873," Paris, May 1873, no. 1372 (as *Offrant le Panal au Torero*); Industrial Exposition, Cincinnati, "Exhibition of Paintings, Engravings, and Drawings," September 3–October 4, 1873, no. 250 (as *Il Torero*); National Academy of Design, New York, "49th Annual Exhibition," 1874, no. 280 (as *Offering the Panale to the Bullfighter*); Pennsylvania Academy of the Fine Arts, Philadelphia, "49th Annual Exhibition," April 22–June 1, 1878, no. 192 (as *Spanish Matador*); Wildenstein and Co., New York, "A Loan Exhibition of Mary Cassatt for the Benefit of the Goddard Neighborhood Center," October 29–December 6, 1947 (as *Young Girl Offering a Glass of Water to a Torero*); Sterling and Francine Clark Art Institute, Williamstown,

Massachusetts, "Exhibit 4: The First Two Rooms," May 17, 1955, no. 1 (as *Un Torero et une Jeune Fille*); Wildenstein and Co., New York, "An Exhibition of Treasures from the Sterling and Francine Clark Art Institute," February 2–25, 1967, no. 2 (as *Torero and Young Girl*).

References: "The National Academy Exhibition," *The Nation*, 18 (May 14, 1874), p. 321; *Daily Evening Telegraph* (Philadelphia), April 25, 1878, p. 4; Achille Ségard, *Un peintre des enfants et des mères: Mary Cassatt* (Paris: Librairie Paul Ollendorff, 1913), p. 7; Forbes Watson, *Mary Cassatt* (New York: Whitney Museum of American Art, 1932), p. 16; Adelyn D. Breeskin, "Mary Cassatt," in *A Loan Exhibition of Mary Cassatt for the Benefit of the Goddard Neighborhood Center*, exh. cat. (New York: Wildenstein and Co., 1947), p. 14; Adelyn D. Breeskin, *The Graphic Work of Mary Cassatt* (New York: H. Bittner and Company, 1948), p. 11; *Sargent, Whistler, and Mary Cassatt*, exh. cat. (Chicago: The Art Institute of Chicago, 1954), p. 12; "19th Century Art in the Berkshires," *Think Magazine*, 5 (October 1955), pp. 18, 19; CAI 1955, n.p., pl. 1; Diggory Venn, "Enigma in Williamstown," *New England Home*, 3 (January–February 1956), p. 16; CAI 1958a, n.p., pl. III (as *Torero and Young Girl*); Julia Carson, *Mary Cassatt* (New York: David McKay, 1966), pp. 9–10; Frederick A. Sweet, *Miss Mary Cassatt: Impressionist from Pennsylvania* (Norman: University of Oklahoma Press, 1966), p. 26 (as *Offrant le Panal au Torero*); *An Exhibition of Treasures from the Sterling and Francine Clark Art Institute*, exh. cat. (New York: Wildenstein and Co., 1967), n.p.; Adelyn D. Breeskin, *Mary Cassatt: A Catalogue Raisonné of the Oils, Pastels, Watercolors, and Drawings* (Washington, D.C.: Smithsonian Institution Press, 1970), pp. 8, 35; Elisabeth P. Myers, *Mary Cassatt: A Portrait* (Chicago: Reilly and Lee Books, 1971), pp. 63, 69; Ellen Wilson, *American Painter in Paris: A Life of Mary Cassatt* (New York: Farrar, Straus and Giroux, 1971), pp. 44, 45; E. John Bullard, *Mary Cassatt: Oils and Pastels* (New York: Watson-Guptill Publications, 1972), pp. 9, 13; CAI 1972, pp. 20, 21; Nancy Hale, *Mary Cassatt* (Garden City, New York: Doubleday & Co., 1975), pp. 52–53, 55 (as *Offrant le Panal au Torero*); *Mary Cassatt and the American Impressionists*, exh. cat. (Memphis, Tennessee: Dixon Gallery and Gardens, 1976), p. 6; Jay Roudebush, *Mary Cassatt* (New York: Crown Publishers, 1979), pp. 8, 10; Nancy Mowll Mathews, "Mary Cassatt and the 'Modern Madonna' of the 19th Century," Ph.D. dissertation, New York University, 1980, pp. 28, 30, 266; Griselda Pollock, *Mary Cassatt* (New York: Harper & Row, 1980), pl. II; William H. Gerdts, *American Impressionism* (New York: Abbeville Press, 1984), pp. 32, 34; *Mary Cassatt: An American Observer. A Loan Exhibition for the Benefit of the American Wing of The Metropolitan Museum of Art*, exh. cat. (New York: Coe Kerr Gallery, 1984), n.p.; Nancy Mowll Mathews, ed., *Cassatt and Her Circle: Selected Letters* (New York: Abbeville Press, 1984), p. 69; CAI 1984, pp. 8, 104; *Mary Cassatt and Philadelphia*, exh. cat. (Philadelphia: Philadelphia Museum of Art, 1985), p. 23; Natalie Spassky, *American Paintings in The Metropolitan Museum of Art* (New York: The Metropolitan Museum of Art, 1985), vol. 2, p. 630; Nancy Mowll Mathews, *Mary Cassatt* (New York: Harry N. Abrams, 1987), pp. 16, 25, 26.

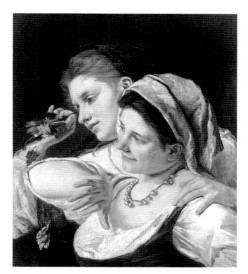

*Fig. 12: Mary Cassatt, **Two Women Throwing Flowers during Carnival**, 1872. Oil on canvas, 25 × 21½ in. (63.5 × 54.6 cm). Collection of James J.O. Anderson.*

Portrait of Mrs. Cyrus J. Lawrence with Grandson R. Lawrence Oakley, c. 1898–99

Pastel on paper
28 × 23 (71.1 × 58.4)
Signed lower left: Mary Cassatt
Gift of Mrs. R. Lawrence Oakley
No. 1973.36

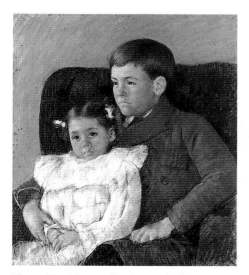

*Fig. 13: Mary Cassatt, **Gardner and Ellen Mary Cassatt**, 1899. Pastel on paper, 25 × 18¾ in. (63.5 × 47.6 cm). The Metropolitan Museum of Art, New York; Gift of Mrs. Gardner Cassatt, 57.182.*

On January 4, 1898, Mary Cassatt arrived in New York City for her first trip to America in more than twenty years. She spent the next eighteen months in the United States, traveling between Philadelphia and Boston to visit family and friends. During this time she restricted her art activities to portraiture and worked exclusively in pastel.[1] *Portrait of Mrs. Cyrus J. Lawrence with Grandson R. Lawrence Oakley* is one of the approximately fifteen pictures produced during this American sojourn.

Emily Amelia Hoe Lawrence (1834–1909) was the wife of the prominent New York stockbroker Cyrus Lawrence (1832–1908). Ralph Lawrence Oakley (1889–1963), pictured here at age nine or ten with his grandmother, graduated from Williams College in 1911 and followed his grandfather to Wall Street.[2] The Lawrences began to buy Mary Cassatt's work in 1895. While she was working on the Clark double portrait, Cassatt also made a pastel sketch of Mary Say Lawrence, the Lawrences' daughter.[3]

Like the other portraits Cassatt executed during her year and a half in America, the Clark portrait shows an almost painstaking attention to the physical details of the sitters.[4] Often Cassatt would include accessories — in this case, Mrs. Lawrence's knitting — that further identified the individual and informalized the portrait setting. Lawrence family members, however, were not entirely satisfied with the results: "We are disappointed in the portrait of Mrs. Lawrence — only because of the rabbit-like expression of the mouth — which none of us remember as being that way — Otherwise it is characteristic — always knitting sweaters for her many grandchildren — and wearing a ring on her left forefinger! and being warm and friendly and patient."[5]

The compositional format Cassatt used in the Lawrence-Oakley portrait relates to that in her many mother and child pictures after 1890. In these works two figures are compactly grouped and silhouetted against a neutral background, a strategy also found in other double portraits done at this time, such as *Gardner and Ellen Mary Cassatt* (fig. 13). In the picture of Mrs. Lawrence and Lawrence Oakley, the child's cheek against his grandmother's hair and their clasped hands add a particularly touching note of affection.

Also common to the pastel portraits of 1898–99 is a restrained technique. As in the Clark portrait, the strokes of pastel appear carefully ordered as they give structure to the forms. The underdrawing was mostly obliterated by the many layers of pastel added to the paper; Cassatt's last step was to reinforce the initial outline of the figures.[6]

Cassatt's pastels can be directly related to those of Edgar Degas (1834–1917),[7] which she first saw in 1875. In the 1890s both artists mixed fixative into the pastel of each successive layer. Thus, each layer of pastel retains its own character, yet together they register as an overall decorative texture. In *Portrait of Mrs. Cyrus J. Lawrence with Grandson R. Lawrence Oakley,* the richness of this method is particularly noticeable in the woman's face and in the garment she knits.

Despite her careful attention to technique, Cassatt's methods always served her subjects, and the Clark portrait speaks clearly of the tender relationship between the elderly woman and her young grandson. As Roger Riordan wrote in 1898, Cassatt's "interest appears to be more in the significance of the subject than in its aspect; and one feels that she would not hesitate, were it necessary, to sacrifice atmospheric effect to significant form."[8]

1 Nancy Mowll Mathews, *Mary Cassatt* (New York: Harry N. Abrams, 1987), p. 114.

2 A. Porter Waterman (great-grandson of the Lawrences) to Charles C. Cunningham, June 24, 1975, CAI curatorial files.

3 Adelyn D. Breeskin, *Mary Cassatt: A Catalogue Raisonné of the Oils, Pastels, Watercolors, and Drawings* (Washington, D.C.: Smithsonian Institution Press, 1970), no. 291.

4 Mathews, *Mary Cassatt,* p. 59.

5 Mrs. Edward D. Payne (granddaughter of Mrs. Lawrence) to David Cass, July 30, 1982, CAI curatorial files.

6 E. John Bullard, *Mary Cassatt: Oils and Pastels* (New York: Watson-Guptill Publications, 1972), p. 64.

7 *Mary Cassatt: Pastels and Color Prints,* exh. cat. (Washington, D.C.: National Collection of Fine Arts, Smithsonian Institution, 1978), p. 17.

8 R[oger] R[iordan], "Miss Mary Cassatt," *The Art Amateur,* 38 (May 1898), p. 130.

Provenance: To Cyrus J. Lawrence by 1899; to R. Lawrence Oakley by descent; to Mrs. R. Lawrence Oakley (his widow), Greenwich, Connecticut; gift to Sterling and Francine Clark Art Institute, February 14, 1973.

Exhibitions: Sterling and Francine Clark Art Institute, Williamstown, Massachusetts, "20th Anniversary Exhibition: Selected Acquisitions since the Founding of the Institute," May 17–October 6, 1975 (no catalogue); Sterling and Francine Clark Art Institute, Williamstown, Massachusetts, "A Tribute to George Heard Hamilton," May 17–July 30, 1978 (no catalogue).

References: Adelyn D. Breeskin, *Mary Cassatt: A Catalogue Raisonné of the Oils, Pastels, Watercolors, and Drawings* (Washington, D.C.: Smithsonian Institution Press, 1970), pp. 17, 133; "La Chronique des Arts: Principales Acquisitions des Musées en 1975," *Gazette des Beaux-Arts,* 87 (March 1976), p. 49; CAI 1980, pp. 39, 40; CAI 1984, pp. 7, 104; Nancy Mowll Mathews, *Mary Cassatt* (New York: Harry N. Abrams, 1987), pp. 114, 118–19.

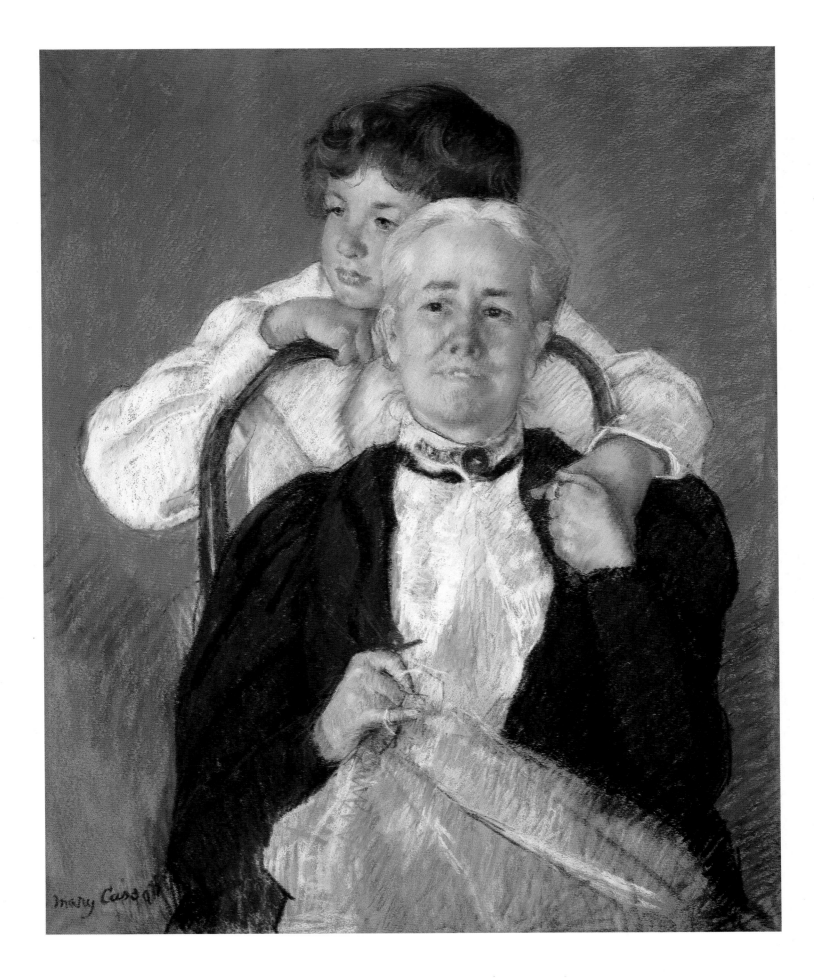

Woman with Baby, c. 1902

*(Jeune Femme et Enfant; Woman with
Orange Wrapper Holding Nude Baby;
Woman in Orange Wrapper Holding Her
Nude Baby; Woman in an Orange Kimono
with a Child)*

Pastel on paper

28³/₈ × 20⁷/₈ (72.1 × 53)

Signed lower right: Mary Cassatt

*Gift of the Executors of Governor Lehman's
Estate and the Edith and Herbert Lehman
Foundation*

No. 1968.301

*Fig. 14: Mary Cassatt, Sketch of Woman in
Light Green Wrapper Holding Her Child,
c. 1902. Pastel on paper, c. 27 × 23 in.
(68.6 × 58.4 cm). Location unknown.*

Although Mary Cassatt lived until 1926, her active career ended around 1911. During her final working decade, her subjects were almost exclusively children, both with and without adult female figures. *Woman with Baby* is typical of her turn-of-the-century mother-and-child images. Most often they depicted a clothed woman with a nude child and focused, usually through interlocking forms, on the pair's close relationship. Cassatt preferred to work in pastel at this time and she capitalized on the soft effect of the medium. A bright range of colors often characterizes these later works. The orange, blue, and green in *Woman with Baby* appeared repeatedly and perhaps reflected the artist's awareness of the explosion of color in early twentieth-century Parisian avant-garde painting.[1]

Reine LeFebvre, Cassatt's favorite adult model in the early 1900s, has long been considered the model in *Woman with Baby*.[2] LeFebvre lived in Mesnil-Théribus, the town nearest Cassatt's country home, Château de Beaufresne. Because the largest number of pictures with LeFebvre were executed around 1902, the Clark painting has always carried that date. The child remains unidentified.

Cassatt began working regularly with mother-and-child imagery around 1890. A variety of reasons may have attracted her to this subject. In the last decades of the nineteenth century, images of women were immensely popular, especially those which idealized motherhood, womanhood, home, and family. Within this context, the theme was sometimes related to that of the Madonna and Child.[3] Cassatt, however, neither idealized her women, as did Puvis de Chavannes (1824–1898) or Kenyon Cox (1856–1919), nor made them fashionable, as did fellow expatriate John Singer Sargent (pp. 177, 185). Instead she focused on the informal, the ordinary, and the realistic. This approach was present in her art from its earliest days and reflects the influence of Edouard Manet (1832–1883), Edgar Degas (1834–1917), and the Impressionist viewpoint that called for everyday subjects. In her mother-and-child pictures and in *Woman with Baby* in particular, Cassatt's use of interlocking figures defines the real physical bond between parent and baby, and, as Griselda Pollock has suggested, can be viewed as a celebration of the family life that was so important in the late nineteenth century.[4]

In the more than fifteen years that Cassatt concentrated on women and children, her style underwent noticeable changes.[5] Around 1900 her figures became more traditionally modeled. *Sketch of Woman in Light Green Wrapper Holding Her Child* (fig. 14), which may be a preliminary sketch for the Clark pastel, exemplifies how she worked at this time. After first outlining the general relationship of the two figures in a sketch, she began to create palpable form. The academic modeling and three-dimensionality of the figures in *Woman with Baby* hark back to the artist's early appreciation of Old Master painting and add a stateliness to the work.[6] In addition, Cassatt achieved the fleshiness of her figures by exploiting the softness of the pastel medium. The child's rounded face and chubby torso and arms are captured through a blending of pinks, white, and blue—a very different ordering of strokes from that in the c. 1898–99 *Portrait of Mrs. Cyrus J. Lawrence with Grandson R. Lawrence Oakley* (p. 32). Although the woman's body in *Woman with Baby* is less clearly articulated than the child's, her orange and blue kimono wraps around the child to give both a sense of her corporeality and of her enveloping motherhood. At the same time the intensely colored and more broadly stroked pattern of the robe and the blue and green background provide a flattened foil for the classically rendered flesh areas. Cassatt joined in *Woman with Baby* her lifelong respect for Old Master figure painting with modern subjects and artistic strategies.

1 *Paintings from the Collection of Governor and Mrs. Herbert H. Lehman*, exh. cat. (Williamstown, Massachusetts: Sterling and Francine Clark Art Institute and Williams College Museum of Art, 1986), no. 22.

2 See Adelyn D. Breeskin, *Mary Cassatt: A Catalogue Raisonné of the Oils, Pastels, Watercolors, and Drawings* (Washington, D. C.: Smithsonian Institution Press, 1970), nos. 398–401, 404–6, 411.

3 That Cassatt's mother-and-child pictures are directly related to the Madonna and Child subject is the thesis of Nancy Mowll Mathews, "Mary Cassatt and the 'Modern Madonna' of the 19th Century," Ph.D. dissertation, New York University, 1980.

4 Griselda Pollock, *Mary Cassatt* (New York: Harper & Row, 1980), p. 14.

5 For a detailed discussion of these changes, see Nancy Mowll Mathews, *Mary Cassatt* (New York: Harry N. Abrams, 1987), pp. 75–100.

6 For Cassatt's interest in Old Master painting, see the entry on *Offrant le Panal au Torero*, pp. 27–30.

Provenance: To (Durand-Ruel, Paris); to M. Manaud, Paris; to (Durand-Ruel, Paris, November 22, 1928); to (Durand-Ruel, New York, December 7, 1928); to Albert E. McVitty, Princeton, New Jersey, March 5, 1929; to (M. Knoedler & Co., New York, February 1954); to (Sidney Schoenberg, St. Louis, February 1954);

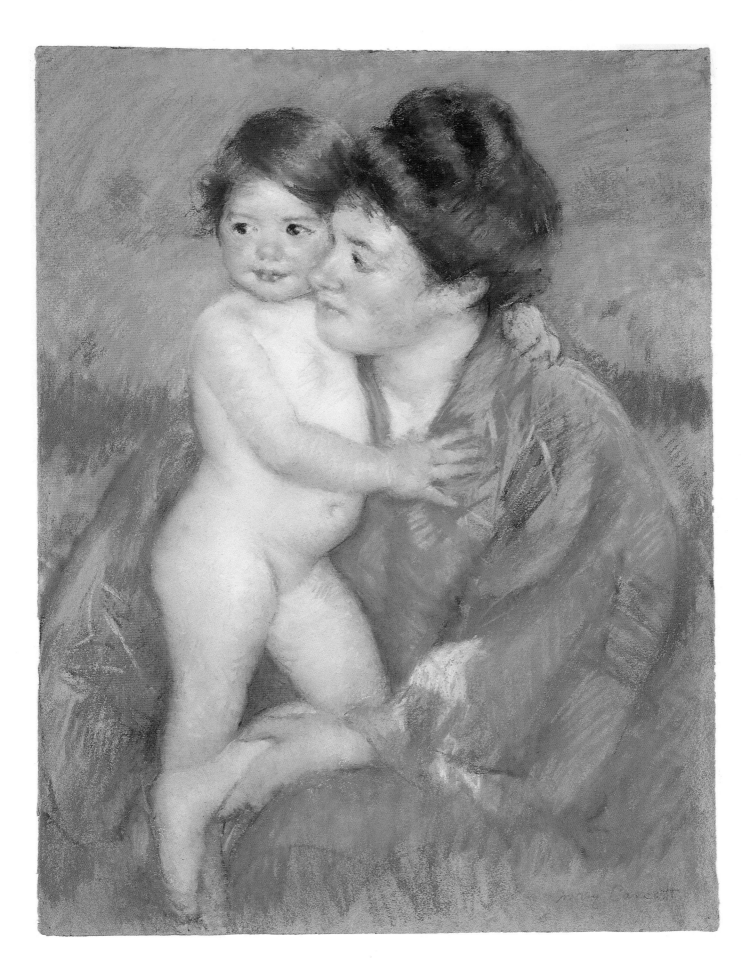

to (M. Knoedler & Co., New York); to Herbert H. Lehman, October 14, 1959; to Herbert H. Lehman Estate; Gift of the Executors of Governor Lehman's Estate and the Edith and Herbert Lehman Foundation to the Sterling and Francine Clark Art Institute, 1968.

Related Work: Sketch of Woman in Light Green Wrapper Holding Her Child, c. 1902, pastel on paper, c. 27 × 23 (68.6 × 58.4), whereabouts unknown (Breeskin, *Catalogue Raisonné,* no. 411).

Exhibitions: Brooklyn Institute of Arts and Sciences, "Leaders of American Impressionism: Mary Cassatt, Childe Hassam, J.H. Twachtman, and J. Alden Weir," 1937, no. 26 (as *Jeune Femme et Enfant*); The New Jersey State Museum, Trenton, "Mary Cassatt," November 19–December 27, 1939, no. 9 (as *Woman with Orange Wrapper Holding Nude Baby*); The Baltimore Museum of Art, "Mary Cassatt: A Comprehensive Exhibition of Her Work," November 28, 1941–January 11, 1942, no. 38 (as *Woman in Orange Wrapper Holding Her Nude Baby*); Sterling and Francine Clark Art Institute, Williamstown, Massachusetts, "A Tribute to George Heard Hamilton," May 17–July 30, 1978 (no catalogue); Williams College Museum of Art, Williamstown, Massachusetts, "Paintings from the Collection of Governor and Mrs. Herbert H. Lehman," 1986, no. 22 (as *Woman in an Orange Kimono with a Child*).

References: Edith Valerio, *Mary Cassatt* (Paris: Les Editions G. Grès, 1930); Adolph Basler and Charles Kunstler, *Modern French Painting: The Post-Impressionists from Monet to Bonnard* (New York: W.F. Payson, 1931), pl. 30; Adelyn D. Breeskin, *Mary Cassatt: A Catalogue Raisonné of the Oils, Pastels, Watercolors, and Drawings* (Washington, D.C.: Smithsonian Institution Press, 1970), no. 412, p. 165 (as *Woman in Orange Wrapper Holding Her Nude Baby*); Joseph T. Butler, "America," *Connoisseur,* 192 (August 1976), pp. 313–14; Karen M. Jones, "Museum Accessions," *Antiques,* 110 (December 1976), p. 1202; CAI 1980, p. 37; CAI 1981, pp. 84–85; Sushil Mukherjee, "Treasures of the Clark Museum," *Berkshire Magazine,* 1 (Winter 1982), p. 41; CAI 1984, pp. 8, 104; *Paintings from the Collection of Governor and Mrs. Herbert H. Lehman,* exh. cat. (Williamstown, Massachusetts: Sterling and Francine Clark Art Institute and Williams College Museum of Art, 1986), n.p.; Rita Gilbert and William McCarter, *Living with Art* (New York: Alfred A. Knopf, 1988), p. 180.

W illiam Merritt Chase was born in Williamsburg, Indiana, but as a young boy moved with his family to Indianapolis, where he received his early artistic training with Barton S. Hays (1826–1914). In 1869 he went to New York to study at the National Academy of Design. Within two years he had relocated to St. Louis and begun to paint predominantly still-life subjects. In the fall of 1872, with financial support from his St. Louis patrons, Chase left for Munich. He remained there for the next five years, becoming an active member of the group of American artists studying at the Royal Academy. By 1874 he was studying with Karl von Piloty (1826–1886) and gaining favorable notice for his endeavors. After a short trip to Venice with his friends Frank Duveneck (1848–1919) and John H. Twachtman (1853–1902), he returned to New York City in 1878 to teach at the newly founded Art Students League.

Chase then began three decades of teaching and international prominence. He soon became famous for his Tenth Street Studio, which was used as a meeting place, for teaching, and for exhibitions of his own work. It was also the subject of a group of his paintings in the 1880s. During his long career he influenced exhibition practices, patronage, and more than one generation of artists.

In 1891 Chase began to summer regularly at Shinnecock, Long Island. Although he never gave up the interiors, portraits, and still lifes

that had made his reputation, landscape began to dominate his work. In addition to painting in oil, he also executed many pastels and a small group of monotypes.

Chase was active in many art societies, including the Society of American Artists, National Academy of Design (N.A., 1890), Society of Painters in Pastel, and The Ten American Painters. He not only taught at the Art Students League but also established his own schools, the Chase School of Art in New York and the Shinnecock Summer School, and did stints as a guest teacher at the Pennsylvania Academy of the Fine Arts, Philadelphia, and The Art Institute of Chicago. From the fall of 1902, when the Shinnecock Summer School closed, through the summer of 1913, Chase often traveled to Europe with students. In 1914 he held his last summer class at Carmel-by-the-Sea, California. At his death in October 1916, his approach to art had been eclipsed by the new interest in abstraction. However, Chase's legacy lived on through his students, the modernists Arthur Dove (1880–1946) and Georgia O'Keeffe (1887–1986).

Bibliography: Katherine Metcalf Roof, *The Life and Art of William Merritt Chase* (New York: Charles Scribner's Sons, 1917); *Chase Centennial Exhibition,* exh. cat. (Indianapolis: John Herron Art Museum, 1949); Ronald Pisano, *A Leading Spirit in American Art: William Merritt Chase,* exh. cat. (Seattle: Henry Art Gallery, 1983).

William Merritt Chase
1849–1916

T he young painter Eilif Peterssen (1852–1928) arrived in Munich from his native Norway in 1873. He spent the next year studying at the Royal Academy, where he was greatly influenced by the history painters Wilhelm von Diez (1839–1907) and Franz von Lenbach (1836–1904). Peterssen, who spent his early career specializing in history painting, left the Royal Academy in 1874 but remained in Munich until his return to Norway in 1878.[1]

Munich was known in the 1870s for its close-knit community of art students.[2] Young artists worked to master the "study head" that formed the core of the Academy's painting curriculum, and making portraits of fellow artists, both in and out of class, was a common practice.[3] Although artists of the same nationality tended to stick together,[4] Chase seems to have thrived on Munich's cosmopolitan atmosphere, as his documented friendships and portraits of many non-Americans attest. In 1875–76 alone, he painted his German colleagues Hugo von Habermann (fig. 15)[5] and Edward Grützner (c. 1875; private collection) and the art dealer Otto Fleischmann (c. 1875; Bowdoin College

Museum of Art, Brunswick, Maine).

There is a date in the upper left corner of the *Portrait of Eilif Peterssen,* but restoration has abraded the last digit. Although the painting came to the Clark with the date having been read as 1878, it now seems more likely that it was executed in 1875. It shares with Chase's Habermann portrait, dated 1875, a very aggressive paint handling, and under microscopic examination the last digit, though still unclear, most closely resembles a 5. Moreover, we know that both Chase and Peterssen resided in Munich in 1875, whereas their whereabouts throughout 1878 are uncertain. In 1877 Chase went to Venice for nine months, returning to Munich only briefly before leaving for America in August or September 1878.[6] Peterssen returned home to Norway sometime in 1878. Thus it is impossible to know whether the two men's paths crossed that year, but the chance would have been less likely than in 1875, when both lived in Munich and Chase was frequently painting portrait heads.

Chase probably painted *Portrait of Eilif Peterssen* in one session. He first covered the cream-colored ground of the canvas with

Portrait of Eilif Peterssen, c. 1875
Oil on canvas
24 × 19 (61 × 48.3)
Signed and dated upper left: 187[5?] *and traces of signature*
Gift of Asbjorn R. Lunde
No. 1980.43

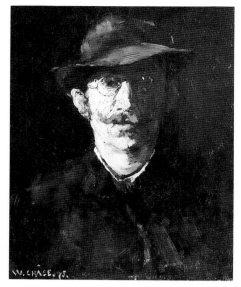

Fig. 15: William Merritt Chase, **Portrait of Hugo von Habermann,** 1875. Oil on canvas, 19¼ × 15 in. (48.9 × 38.1 cm). Städtische Galerie im Lenbachhaus, Munich.

a thin, dark brown paint, out of which the sitter's face would emerge. Then, after blocking out the area of Peterssen's coat in gray, he sketched in the face and hair. He used short, broad strokes to build the facial structure in a variety of brown and flesh-colored tones and alternated between a thin appplication and a fully laden brush. Around Peterssen's forehead and left eye, Chase painted most aggressively to highlight the Norwegian's intense stare and the fall of bright light. Finally, in a painterly shorthand, he delineated Peterssen's coat, vest, and tie, the dark outlines defining the edge of the nostril and ear, and the broad white strip of collar. Chase worked *alla prima* — wet paint onto wet paint — so that the predominant sense of paint application abets the strong characterization of the sitter.

If Chase's choice of subject, the portrait of a fellow artist, was a function of the art life and camaraderie in Munich in the 1870s, his method and style for the *Portrait of Eilif Peterssen* emulated "the dynamic balance of technique and realism" that Michael Quick has characterized as the prevailing artistic approach in Munich at the time.[7] Chase achieved this synthesis by blending what he had learned from his academic mentor, Karl von Piloty (1826–1886), with what he saw in the works of the more radical Wilhelm Leibl (1844–1900). From Piloty, Chase learned the importance of setting off figures against a vague, dark background. By adding strong, flat light, he created contrasts of light and dark that could brightly illuminate portions of the figure to heighten the illusion of reality. In the Peterssen portrait, Chase pushed this aspect of Piloty's style toward its furthest extreme in order to capture the vitality of the sitter without suppressing the richness of the paint.[8] Piloty also instilled in his student a love of the Spanish Baroque masters, particularly Jusepe Ribera (1591–1652), whose manner of describing solid form through modulation of tones Chase adopted.[9]

Although Piloty and Leibl represented opposite factions of the Munich art scene, much of what Chase admired in Leibl's work was supported by what he was learning with Piloty. From Leibl, Chase learned the importance of technical excellence, which could impart the reality of a subject without drama or sentiment. Leibl valued the application of paint on a canvas for its own sake and as a means of depicting subject matter. This attitude, so apparent in *Portrait of Eilif Peterssen,* stayed with Chase throughout his career.

By the late 1870s forward-thinking American critics were praising the Munich style. S.G.W. Benjamin found pleasing in contemporary German art the same elements Chase explored in portrait heads of his fellow artists: "greater breadth in the treatment of details, preferring general effect to excellence in parts of a work, greater boldness and dash, and consequently more freshness in the handling of pigment, the suggestion of texture and substance by masses of paint, and the touch of the brush in accordance with the nature of the object represented, and, finally, a more correct eye in perceiving the relations of the colors to each other — the quality of subtle tints in flesh, for example — and therefore a more just representation of the mysterious harmonies of nature, while there is everywhere apparent a masterly skill in the rudimentary branches of art."[10] A strong and fresh handling of paint and an insistence on representing the facts of the material world, an approach already apparent in *Portrait of Eilif Petersen,* would become the hallmarks of Chase's style.

1 Kirk Varnedoe, *Northern Light: Realism and Symbolism in Scandinavian Painting, 1880–1910,* exh. cat. (New York: The Brooklyn Museum, 1982), p. 203.

2 S.G.W. Benjamin, "Contemporary Art in Germany," *Harper's New Monthly Magazine,* 55 (June 1877), p. 5.

3 Eberhard Ruhmer, "Wilhelm Leibl and His Circle," in *Munich and American Realism in the 19th Century,* exh. cat. (Sacramento: E.B. Crocker Art Gallery, 1978), pp. 10–11; Ronald Pisano, *A Leading Spirit in American Art: William Merritt Chase,* exh. cat. (Seattle: Henry Art Gallery, 1983), p. 27.

4 S.G.W. Benjamin, "Present Tendencies in American Art," *Harper's New Monthly Magazine,* 58 (March 1879), p. 484, noted the formation of a strictly American student art association.

5 Fig. 15 is one of the two portraits Chase painted of Habermann. The other, also dated 1875, is in the Nelson-Atkins Museum of Art, Kansas City, Missouri.

6 Pisano, *A Leading Spirit in American Art,* p. 41.

7 Michael Quick, "Munich and American Realism," in *Munich and American Realism in the 19th Century,* p. 28.

8 Michael Quick, ibid., p. 24, has pointed out that Chase did this in many of his Munich portraits. Particularly noticeable is the highlighting of the forehead, which appears not only in the Peterssen portrait but also in those of Leslie Barnum, Edward Grützner, and Hugo von Habermann (the Lembachhaus, Munich, version).

9 Ibid., p. 31.

10 Benjamin, "Contemporary Art in Germany," p. 7.

Provenance: To Eilif Peterssen to 1928; (Blomquist Auction House, Oslo, c. 1930); to Als S. Bjerke, c. 1930; to Asbjorn R. Lunde, 1968; gift to the Sterling and Francine Clark Art Institute, December 31, 1980.

Exhibition: Sterling and Francine Clark Art Institute, Williamstown, Massachusetts, "Acquisitions and Long-Term Loans, 1977–82," October 28–December 31, 1983 (no catalogue).

Reference: CAI 1984, pp. 8, 100.

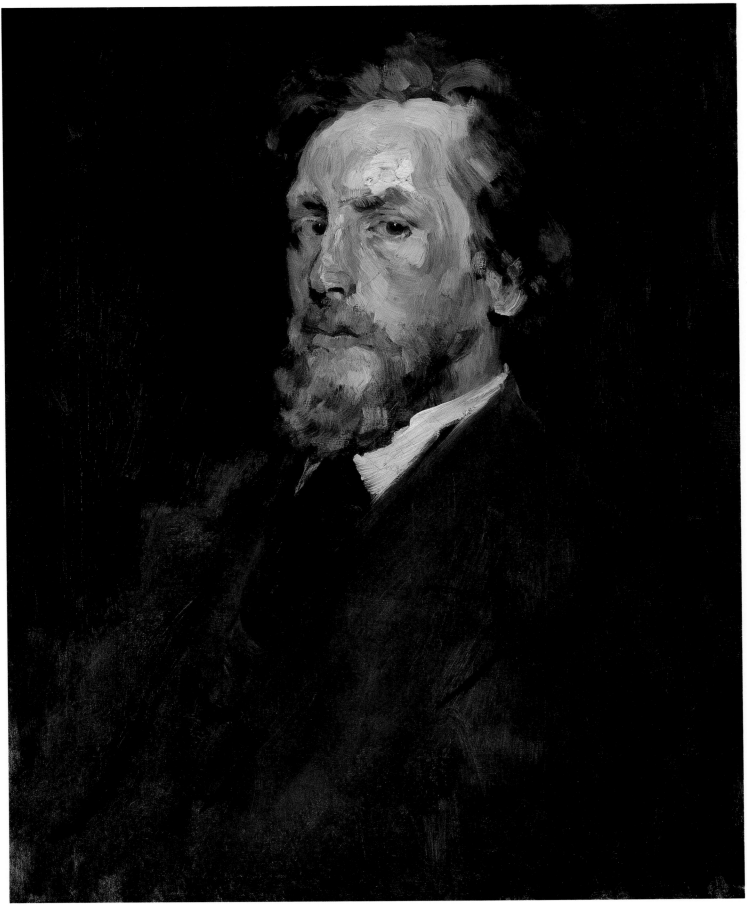

Portrait of Eilif Peterssen

Paul Lewis Clemens
b. 1911

Paul Clemens, born in Superior, Wisconsin, on October 29, 1911, moved to Milwaukee as a child. In 1932 he received a B.A. in art history from the University of Wisconsin. The following year he studied studio art at the School of the Art Institute of Chicago. The young artist returned to Milwaukee in 1933, and for the next five years he worked on a variety of federal arts projects and taught at night. By 1940 he had moved to Los Angeles.

Although in his early years Clemens experimented with different figure genres, portraiture quickly became his favored subject. In his fifty-year career, he has painted some of the best-known Hollywood faces, among them Claudette Colbert, Mia Farrow, former President Ronald Reagan, Frank Sinatra, and Spencer Tracy.

Between 1938 and 1970 Clemens exhibited occasionally on both the East and West coasts. His works appeared in one-man shows at the Frank Perls Galleries, Hollywood, and the Durand-Ruel Galleries, New York, and in group shows at the 1939 New York World's Fair, the 1940 San Francisco World's Fair, and at the Carnegie International Exhibitions from 1939 to 1943. Clemens has exhibited most regularly at the National Academy of Design, where he was elected an academician in 1965. Today he lives and works in southern California.

Bibliography: Notes and correspondence from Paul Lewis Clemens, CAI archives and curatorial files; *Who's Who in American Art,* 17th ed. (New York: R.R. Bowker Co., 1986), p. 184.

Head of Ruth, c. 1941
Oil on wood
8 × 5¹⁵/₁₆ (20.3 × 15.1)
Unsigned
No. 928

Head of Ruth is a bust-length portrait of Ruth Miller, Paul Clemens's first wife, whom he met when they were students at the School of the Art Institute of Chicago. They married in July 1933, and Ruth served as the principal model in much of Clemens's early work.

This informal depiction of Ruth was painted in 1941, most likely around the time of the birth of their daughter Stephanie.[1] The pale, drawn face with ruddy cheeks is rendered carefully and tenderly. In style the portrait displays Clemens's early approach to painting. Inspired especially by Peter Paul Rubens (1577–1640) and Pierre-Auguste Renoir (1841–1919), Clemens focused on the sensuous lines and vitality of the flesh of his model, working up his images from a lean underpainting with glazes and opaque touches. This technique not only demonstrated his respect for Old Master painting, but also perhaps reflected the very thin layering of paint common to tempera, a medium that had enjoyed a renewed interest during the 1930s.

Paintings such as *Head of Ruth* received considerable praise when they were shown at the Frank Perls Galleries in 1941. Clemens's controlled use of color and ability to construct believable form were singled out as the keys to the young artist's contemporary success, even though it was recognized that he was working in a historical style.[2]

1 The painting was dated 1941 in the Durand-Ruel Galleries 1942 catalogue of Clemens's work. In a letter to the author, October 28, 1988, CAI curatorial files, Clemens confirmed the 1941 dating of the picture.

2 For a variety of comments on this exhibition, see "Clemens Repeats Eastern Success in the West," *The Art Digest,* 16 (October 1, 1941), p. 9.

Provenance: To (Frank Perls Galleries, Hollywood, 1941); to (Durand-Ruel Galleries, New York, 1942); to Robert Sterling Clark, April 9, 1942.

Exhibitions: Frank Perls Galleries, Hollywood, "Paul Lewis Clemens," September 18–October 14, 1941, no. 5; Durand-Ruel Galleries, New York, "Paintings by Paul Clemens," March 2–28, 1942, no. 14.

References: D. Brian, "Clemens: Out of the New Education," *Art News,* 41 (March 15, 1942), p. 13; CAI 1984, pp. 9, 112.

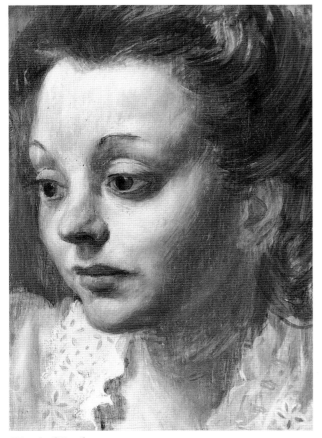

Head of Ruth

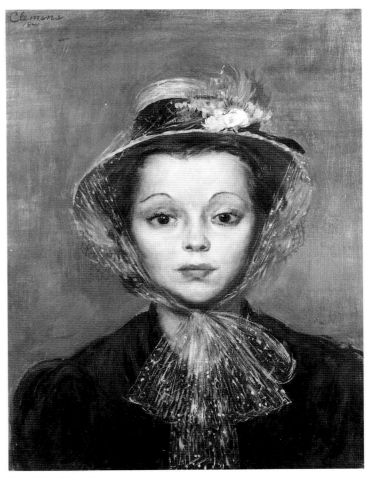

Ruth in Blue Bonnet

R*uth in Blue Bonnet* is one of the many portraits Paul Clemens painted of his first wife, Ruth Miller (see also p. 40). In this painting of 1941 she stares outward from underneath a fashionable hat. Her dreamy gaze gives her a youthful charm that one writer characterized as a "fresh, springtime air."[1] In *Ruth in Blue Bonnet,* Robert Sterling Clark admired both Clemens's personal approach and his ability to portray the "living."[2] As with nearly all his depictions of faces and figures in the early 1940s, Clemens achieved this vitality with tight drawing and modeling through built-up layers of thin paint (see pp. 40, 44).

Clark first saw Clemens's work in early January 1942 at Durand-Ruel Galleries in New York. By the end of February he had bought *Ruth in Blue Bonnet.* To express his enthusiasm for the young artist's work, Clark offered to fly Clemens and his wife from California to New York for the March 2 opening of Clemens's exhibition at Durand-Ruel. They accepted the offer, and it marked the beginning of a warm friendship that lasted until Clark's death in 1956.

1 "Exhibition — Durand-Ruel Galleries," *The Art Digest,* 16 (March 1, 1942), p. 7.

2 Robert Sterling Clark, diary, January 9, 1942, CAI archives.

Provenance: To (Frank Perls Galleries, Hollywood, 1941); to (Durand-Ruel Galleries, New York, January 1942); to Robert Sterling Clark, February 28, 1942.

Exhibitions: Frank Perls Galleries, Hollywood, "Paul Lewis Clemens," September 18–October 14, 1941, no. 4; Durand-Ruel Galleries, New York, "Paintings by Paul Clemens," March 2–28, 1942, no. 2.

References: "Exhibition — Durand-Ruel Galleries," *The Art Digest,* 16 (March 1, 1942), p. 7; Royal Cortissoz, "A Diversity of New Exhibitions," *New York Herald,* March 8, 1942, pp. 6–8; CAI 1984, pp. 9, 112.

Ruth in Blue Bonnet, 1941

Oil on wood

20³/₄ × 16¹/₄ (52.7 × 41.3)

Signed and dated upper left: Clemens/1941.

No. 921

Mr. and Mrs. Clark,
1967 after 1942 original

Oil on canvas
19-3/16 × 14-1/4 (48.7 × 36.2)
Signed lower right: Clemens
No. 1967.84

During their thirty-seven years of marriage, Francine (1876–1960) and Robert Sterling (1877–1956) Clark shared a passion for art. When they were in residence in New York or Paris, their daily life often centered around the viewing of paintings, sculpture, prints, drawings, or the decorative arts. Among the commercial houses they patronized most frequently were the New York and Paris offices of Durand-Ruel. This intimate portrait of Mr. and Mrs. Clark shows them examining a box of prints on the third floor of Durand-Ruel's New York establishment.[1] When asked about this painting in 1966, Clemens remembered that the Clarks were posed while reviewing works removed from France before the German invasion.[2]

It was through Herbert Elfers at Durand-Ruel, New York, that the Clarks were first introduced to Paul Clemens's work in 1942. In appreciation of Clark's support and kindness (p. 41), Clemens offered to paint a portrait of the couple. The idea was first proposed on March 3, 1942.[3] By March 18, the painting had been added to the Clemens exhibition then on view at Durand-Ruel. In 1967, Clemens was commissioned to replicate the painting for the Clark Art Institute so that the original could be sent on extended loan to Miss Javotte Ray, Mrs. Clark's granddaughter.

For the 1942 portrait, Clemens roughed in the composition before setting to work on the individual figures.[4] Clark noted in his diary that it took Clemens two sittings for himself and four for Mrs. Clark, who is placed more prominently in the painting. The proximity of the Clarks and their joint study of a work suggests their shared love of art and partnership in collecting. Although Mr. Clark perhaps had the more learned knowledge of art, Francine Clark's intuitive fine taste was always consulted before a purchase was made. Clemens's depiction of the Clarks in the center of Durand-Ruel's upstairs room, away from the hubbub of gallery visitors and business and surrounded by art and packing materials, is a testament to the collectors' private nature and their intimate relationship with objects.

The Clarks were pleased with Clemens's portrait, as were critics who viewed the painting hanging at Durand-Ruel. One critic, with whom Robert Clark heartily agreed, supposedly remarked: "This sort of picture is what we need. No one does them."[5] Clemens, as if taking the critic's words to heart, turned almost completely to portraiture within the next few years.

1 Charles Durand-Ruel noted in his memoir of Clark that this room at the gallery was always at the Clarks' disposal; unpublished manuscript, 1980. See also Robert Sterling Clark, diary, March 3–13, 1942, CAI archives, and Paul Clemens to George Heard Hamilton, received December 16, 1966, CAI curatorial files.

2 Clemens to Hamilton, received December 16, 1966, CAI curatorial files.

3 Robert Sterling Clark, diary, March 3, 1942.

4 Ibid., March 5, 1942.

5 Clark recounts this remark and his own feelings in his diary, March 18, 1942.

Provenance: To Sterling and Francine Clark Art Institute, June 1967.

References: CAI 1972, pp. 126, 127; "La Chronique des Arts," *Gazette des Beaux-Arts,* 82 (September 1973), supplement, p. 7; CAI 1980, p. 35; CAI 1984, pp. 9, 112.

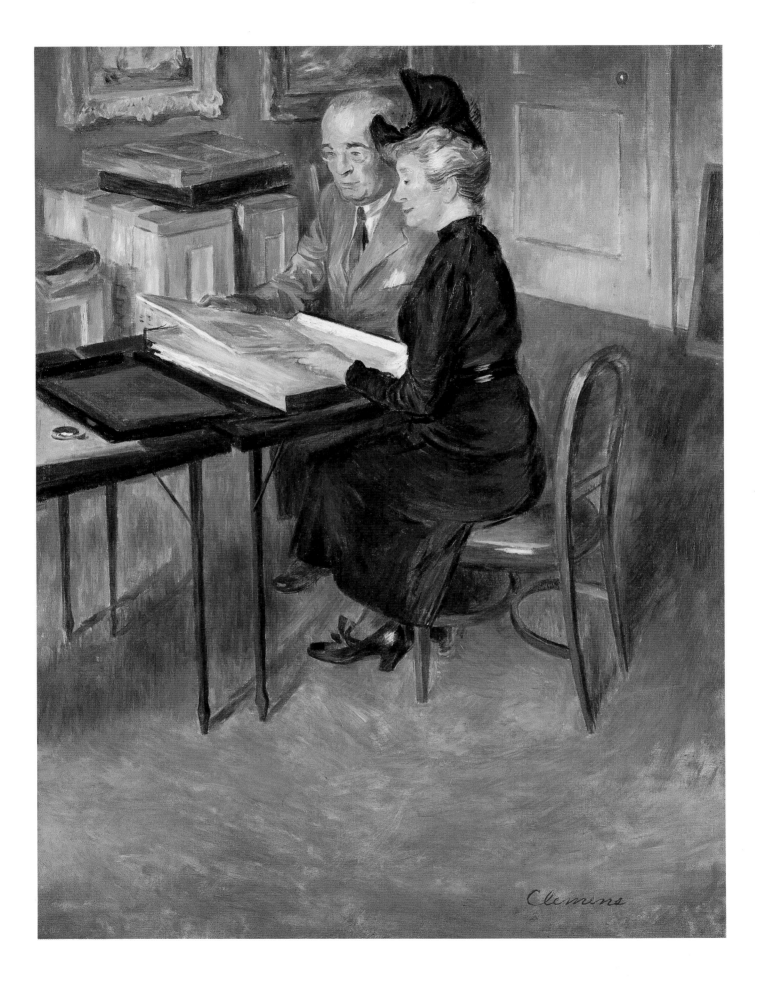

Nude, 1942
Oil on board
22 × 10¹/₂ (55.9 × 26.7)
Signed and dated lower right: Clemens 42.
No. 927

In 1938 Paul Clemens declared: "I believe that if there is a microcosm of art it is the human figure, for it contains mass, rhythm, line, color, it exists in space and has texture and light and shade—in a word, all the pre-requisites of a finished masterpiece."[1] With these ideas forming the basis for his art, the study of the nude became an important part of his early career.

Nude is a typical example of how Clemens depicted the human figure. The forms of the body are carefully modeled through subtle variation of light and shade. The curves of the figure create a rhythm of lines, and the texture of the flesh is suggested through built-up layers of paint. Painted against a monochromatic, dark setting, the woman emerges from the background.

Although Clemens followed the general academic norms for painting the female form, his special appreciation of the figures of Pierre-Auguste Renoir (1841–1919) is very evident in *Nude,* especially in the sensuous flesh-iness of the model and the opalescent radiance of her skin. It is not surprising, then, that Robert Sterling Clark, owner of thirty-three Renoirs by 1942, found Clemens's *Nude* "excellent" and encouraged him to work further in this manner.[2]

1 Paul Clemens, biographical notes, typescript, 1938, CAI curatorial files.

2 Robert Sterling Clark, diary, January 21, 1943, CAI archives.

Provenance: To Robert Sterling Clark, 1943.

Reference: CAI 1984, pp. 9, 112.

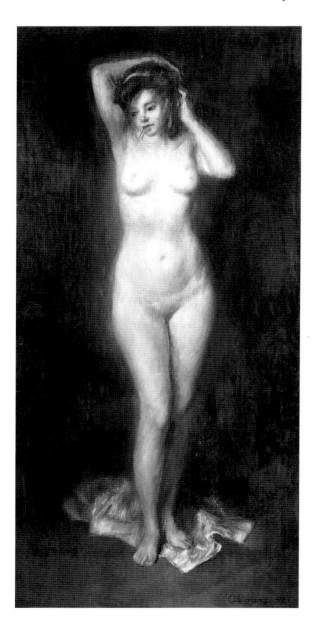

Pastorale shows a group of twelve women on a summer picnic. While some of them are drying off and dressing after a swim, some are waiting for their midday meal to begin, and still others prepare the food and entertainment. The women's clothing and hairstyles as well as their accessories, including a phonograph and record, clearly mark this image as a contemporary scene.

The pastoral theme, however, has a long history in art. In Clemens's version, the light-heartedness and focus on playful relaxation in a wooded setting are derived from the Rococo *fêtes champêtres* of Jean Antoine Watteau (1684–1721).[1] Reminiscing about his reasons for painting the 1945 *Pastorale*, Clemens noted: "I did the painting to challenge myself. Could I do a large group of figures in an imaginary setting using only sketches and studies of individual models and combining them in a manner of such artists as Watteau?"[2] Like Watteau, Clemens drew the figures tightly, created the composition according to the movement of light across the surface, and used a varied palette of bright colors. But the contemporaneity of the setting likens the work to that of Reginald Marsh (1898–1954), while the snapshot effect of the cropping and the implication of a voyeuristic viewer is not unlike that found in the paintings of John Sloan (1871–1951) and Edward Hopper (1898–1954).

Although *Pastorale* does to an extent evoke the feeling of a "modern Watteau," as Robert Clark fondly called the painting, Clemens's method of translating studio figure models to an imaginary setting resulted in a stilted composition. The figures, both individually and in groups, are well painted, but the arrangement appears overly posed and artificial. To Robert Sterling Clark, however, *Pastorale* was Clemens's highest achievement to date.[3] Soon after Clark purchased this painting in May 1945, Clemens nevertheless turned away from such figure subjects and began a long career in portrait painting.

1 Paul Clemens to the author, October 28, 1988, CAI curatorial files.

2 Ibid.

3 Robert Sterling Clark, diary, January 27, 1945, CAI archives; Clark to Paul Clemens, February 12, 1945, CAI archives.

Provenance: To Robert Sterling Clark, May 1, 1945.

Related Work: Study for "Pastorale," 1945, watercolor, pencil, gouache on illustration board, 10 × 12 (25.4 × 30.5), Sterling and Francine Clark Art Institute, no. 678.

Exhibition: Sterling and Francine Clark Art Institute, Williamstown, Massachusetts, "Not Normally on View," January 27–March 11, 1979 (no catalogue).

*Reference:*CAI 1984, pp. 9, 112.

Pastorale, 1945
Oil on canvas
29 × 36 (73.7 × 91.4)
Signed and dated lower left: Clemens/1945
No. 922

Mrs. Clark on a Yacht, 1947

Oil on canvas
$9^{15}/_{16} \times 11^{7}/_{8}$ *(25.2 × 30.2)*
Signed lower right: Clemens
No. 679

In early 1947 the Clarks hosted Paul Clemens and his wife on the "Marmot," a one-hundred-foot diesel boat.[1] The trip, which took them through the Caribbean and lasted about three months, was undertaken to facilitate Ruth Clemens's recovery from typhoid fever.

Mrs. Clark on a Yacht was painted directly from life while the boat was moored in Nevitas, a sugar port in Cuba.[2] Mrs. Clark is depicted relaxing with a book, but what caught Clemens's eye as he quickly executed this little picture was the variety of horizontal and vertical accents in his narrow field of vision. The stripes of Mrs. Clark's dress, the boat's architectural components, the flagpole, and the masts of other boats out in the harbor, all set against the blue sky or the interior of the boat, give a rhythmic pulse to this memento of a sunny day in the Caribbean.

1 Paul Clemens to the author, October 28, 1988, CAI curatorial files.

2 Ibid.

Provenance: Gift to Robert Sterling Clark, 1947.

Exhibition: Sterling and Francine Clark Art Institute, Williamstown, Massachusetts, "Safe Harbor, Smooth Sands, Rough Crossing," March 5–April 17, 1988 (no catalogue).

References: CAI 1972, p. 126; CAI 1984, pp. 9, 112.

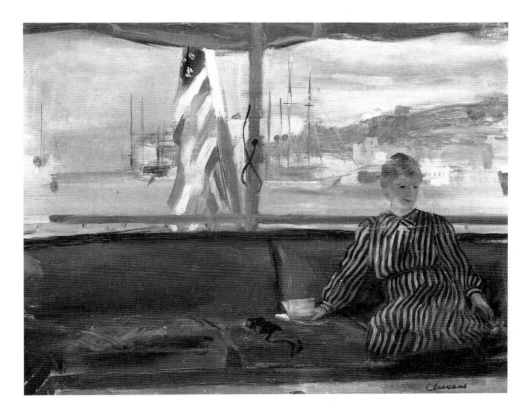

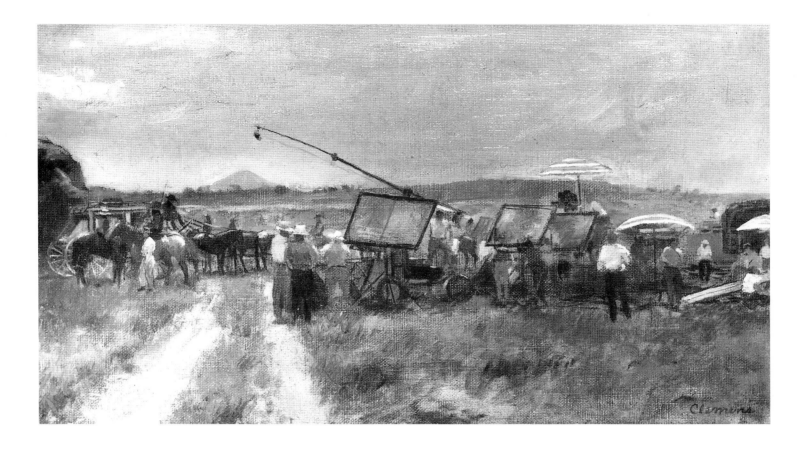

When Paul Clemens moved to southern California in the early 1940s, he made many acquaintances with people involved in the newly booming motion-picture industry. Among his close friends was the actor William Holden. When Holden was filming *Streets of Laredo* (Paramount Pictures, 1949), Clemens visited the set near Gallup, New Mexico.[1] In *Movie Sketch,* Clemens captured the activity of the outdoor location shoots in July 1948.[2] When this sketch was made, preparations were underway for filming a stagecoach robbery.[3] The coach and horses are seen waiting on the left, while on the right cameras, reflectors, and sound equipment are being readied by the crew.

Painted from a distance, *Movie Sketch* gives an overview of the movie-making operation. Clemens used the bright New Mexico sun to heighten the figures, who are notated only with small patches of color. Highlights on straw hats, white shirts, the horses' backs, and the umbrellas more clearly define the individual figures and objects and effectively suggest the hot desert sun.

1 Paul Clemens to the author, October 28, 1988, CAI curatorial files.

2 An article in *Paramount News* dated July 19, 1948, in the library of the Academy of Motion Picture Arts and Sciences, Los Angeles, states that the film was then being shot in the Gallup vicinity for three weeks.

3 Paul Clemens to the author, October 28, 1988, CAI curatorial files.

Provenance: To Robert Sterling Clark.

Reference: CAI 1984, pp. 9, 112.

Movie Sketch, 1948
Oil on canvas
7 × 12 (17.8 × 30.5)
Signed lower right: Clemens
No. 681

Clarence G. Cook
1853–1934

Born February 19, 1853, Clarence G. Cook grew up in Hartwick, New York. At the age of twenty-six, he was admitted to the bar in New York State, and law remained his primary career. In 1883 he moved to Cooperstown, New York, and in 1906 to nearby Middlefield, where he lived until his death.

Although Clarence Cook considered his work in the arts to be solely a hobby, he devoted a considerable portion of his free time to painting and especially to cabinet-making. From the early 1880s until 1930, Cook designed, built, and carved furniture for himself and others in the Cooperstown area. He concentrated on painting between about 1885 and 1896. He seems to have exhibited his work only locally and even then infrequently. In 1889, 1891, and 1896, he won the prize for the best landscape oil at the art show of the Otsego County Agricultural Fair. It was only in 1892 that his occupation was listed in the census as "artist." On the whole, Cook's art was a personal venture.

Bibliography: John H. Wright, "Clarence Green Cook: Cooperstown Craftsman," M.A. thesis, State University of New York at Oneonta, 1972.

Wooded Grove, 1890
(Landscape)
Oil on canvas
16¹/₁₆ × 22¹⁵/₁₆ (40.8 × 58.3)
Signed and dated lower right: Clarence Cook./90
No. 1032

Fig. 16: Clarence G. Cook, **Wooded Grove IV,** 1890. Oil on canvas, 16 × 22 in. (40.6 × 55.9 cm). Collection of John Hardy Wright.

Most of Clarence Cook's paintings date from 1889 to 1892.[1] Completely self-taught, Cook generally followed the style of American mid-nineteenth-century landscape painters. Like Asher B. Durand (1796–1886) or John Kensett (pp. 112–14), Cook sought a truthful depiction of nature. However, more like the landscape painters of the 1880s and 1890s, he favored a painting technique that replaced the hard-edged detailing of the Hudson River School with a softer, more painterly approach.

Wooded Grove, dated 1890, is typical of Cook's work in format, subject, and style. According to John Wright, 16 × 22 inches was the artist's preferred image size. Completely self-sufficient as to his materials, Cook used raw linen which he primed himself. The artist also made his own two-part frames.[2] He often depicted landscapes of wooded areas where a carefully defined foreground of grass or flowers was set against a backdrop of dense woods. The whole was joined by a sun-filled open space in the center, where Cook often placed a single stump. In *Wooded Grove* and at least four other similar oils (fig. 16), the worn edges of a felled tree, located slightly off center, suggest the passage of time and the life cycle of nature in the Cooperstown landscape Cook loved. The dense forest in the background is softly illuminated from behind, and that light also floods the center of the painting to create an ethereal quality. The notion that nature represented a divine presence permeated much of American mid-nineteenth-century art, and Cook seems to have subscribed to that view.

Although it is not known when or how Robert Sterling Clark acquired *Wooded Grove,* its addition to his collection confirms his close connection to Cooperstown and its local residents. The Clark family, summer residents and considerable benefactors of Cooperstown, must have known Cook in some capacity. On at least one occasion the artist fashioned a polo mallet for F. Ambrose Clark, Robert's brother, who made his primary residence in Cooperstown.[3]

1 I am grateful to John Wright for sharing his work on Clarence Cook with me. All the factual information in this entry can be found in John H. Wright, "Clarence Green Cook: Cooperstown Craftsman," M.A. thesis, State University of New York at Oneonta, 1972.

2 Ibid., pp. 74–75. Today only the inner frame of the Clark painting survives.

3 Ibid., p. 48.

Provenance: Robert Sterling Clark.

References: CAI 1972, pp. 126, 127 (as *Landscape*); CAI 1984, pp. 9, 102 (as *Landscape*).

Horace Talmage Day
1909–1984

Horace Day was born in 1909 to missionary parents in Amoy, China. He came to the United States at seventeen. From 1928 to 1932, Day studied painting under Kimon Nicolaides (1892–1938) and Kenneth Hayes Miller (1876–1952) at the Art Students League in New York. He also studied at the Tiffany Foundation in Oyster Bay, Long Island, from 1930 to 1934. While still a student, Day was an artist-in-residence at New York's Henry Street Settlement. For many years he also was active in the Southern Vermont Art Association. Teaching painting was an important part of Day's artistic career. From 1936 to 1941 he served as director of

the Herbert Institute of Art in Augusta, Georgia. Subsequently, he spent most of his teaching career at Mary Baldwin College in Staunton, Virginia.

After retiring from teaching in 1963, Day continued to paint, mainly landscape subjects in oil and watercolor. In 1972 he became director of the Northern Virginia Fine Arts Center in Alexandria, a position he held until his death.

Bibliography: Horace Talmage Day material, Archives of American Art, roll 76, frames 158–418; *Who's Who in American Art,* 17th ed. (New York: R.R. Bowker Co., 1986), pp. 236–37.

Landscape with Cattle, 1934

Oil on canvas
28 × 42⅞ (71.1 × 108.9)
Signed, dated, and inscribed lower right: copy of Cuyp/by Horace DAY—/1934
Gift of the children of Mrs. E. Parmalee Prentice
No. 1962.153

Fig. 17: Jacob van Strij, **Landscape with Cattle,** n.d. Oil on panel, 31½ × 42¼ in. (80 × 107.3 cm). The Metropolitan Museum of Art, New York; Gift of Henry G. Marquand, 91.26.8.

By the early 1930s, E. Parmalee Prentice's Mount Hope Farm in Williamstown, Massachusetts, was a world-famous center for cattle breeding, known particularly for its use of the latest scientific knowledge on genetics for successful breeding. In 1935 Prentice authored *Breeding Profitable Dairy Cattle,* which outlined the history of cattle breeding as well as the modern methods he was using at Mount Hope.

The chapter "Old Dutch Breed" in Prentice's book was illustrated with a painting captioned "Landscape, by Albert Cuyp (1605–1690). Copied from the Painting in the Metropolitan Museum, New York" (fig. 17).[1] It was Day's *Landscape with Cattle* that was reproduced. The painting is stamped on the reverse with a Metropolitan Museum of Art permit to copy, dated January 10, 1934, and was originally owned by Prentice. Day, through his activities in the Southern Vermont Art Association, may have met

Prentice, whose Williamstown farm was close to the Vermont border.

Day copied the Dutch painting faithfully, though his work lacks the original's penetrating clouds and high degree of detail in the animals and figures.

1 E. Parmalee Prentice, *Breeding Profitable Dairy Cattle* (Boston: Houghton Mifflin Co., 1935), opp. p. 44. The Metropolitan's painting is now attributed to Jacob van Strij (1756–1815). Walter A. Liedtke, curator of Dutch and Flemish painting, the Metropolitan Museum of Art, brought this change of attribution to my attention.

Provenance: To Mr. E. Parmalee Prentice; to Mrs. E. Parmalee Prentice (his widow); to her children; gift of the children of Mrs. E. Parmalee Prentice to the Sterling and Francine Clark Art Institute, 1962.

References: E. Parmalee Prentice, *Breeding Profitable Dairy Cattle* (Boston: Houghton Mifflin Co., 1935), opp. p. 44; CAI 1980, p. 35; CAI 1984, pp. II, III.

Born on November 22, 1806, Francis William Edmonds was raised in Hudson, New York. Although at an early age he showed a passion for drawing, in 1823 he was sent to New York City to clerk at an uncle's bank. By 1826 Edmonds had enrolled in night classes at the National Academy of Design, where he met many of the men who would become the most prominent artists of the 1840s, including Asher B. Durand (1796–1886) and William Sidney Mount (1807–1868). At this time Edmonds also was drawing for bank-note engravers, an activity that helped develop his sure hand and skill in manipulating light and shadow.

Between 1829 and 1831 Edmonds's family forced him to give up painting and to work as the cashier of the Hudson River Bank. Subsequently he combined a career in banking with one in art and for the next twenty-five years was very successful in both. Since he was holding a full-time position in a prominent bank and involved in bank-note engraving, his painting career started slowly. In 1836 he began to exhibit regularly at the National Academy of Design. However, in that year and the next he used the pseudonym E.F. Williams lest the bankers think him not serious and the artists call him "amateur." In 1837 Alfred Jones (1819–1900), a fellow artist involved in bank-note engraving, leaked Edmonds's identity, and he was elected an associate of the Academy. From that time forward, his position as an eminent painter of American genre scenes became increasingly secure. He was elected an academician in 1840.

The death of Edmonds's wife in 1840, compounded by bank difficulties, led to a nervous breakdown. A trip to Europe (November 1840–August 1841) restored Edmonds's health. He remarried in 1842. The next decade found the artist holding increasingly important offices in the banking and artistic communities, including the American Art-Union and the Century Club.

In 1855 a scandal involving Edmonds's post as city chamberlain forced his resignation from banking entirely. However, he remained involved in the bank-note engraving business and devoted more time to painting. Having moved his family to Bronxville, New York, Edmonds painted there until his sudden death on February 7, 1863.

Bibliography: Maybelle Mann, *Francis W. Edmonds: Mammon and Art* (New York: Garland Publishing, 1977); *Francis W. Edmonds: American Master in the Dutch Tradition,* exh. cat. (Fort Worth: Amon Carter Museum, 1988).

Francis William Edmonds
1806–1863

In 1840 Francis William Edmonds was elected an academician of the National Academy of Design based on the strength of the two paintings he submitted to that year's annual exhibition, *The City and Country Beaux* and *Sparking* (pp. 54–57). The pair represent prime examples of Edmonds's early mature work, and with their exhibition the artist was placed alongside William Sidney Mount (1807–1868) as a preeminent painter of American life.

The two paintings garnered much praise. For example, the critic Charles Lanman wrote: "[Edmonds's] style of coloring is warm and glowing, and his drawing exceedingly accurate . . . and very few, I think, understand the principles of composition so well [the paintings] are always intended to make you laugh . . . and sometimes possess an undercurrent of poetry and philosophy which make them voiceless preachers to the thinking man."[1] The artist's humorous but thoughtful subjects and the rich coloring and well-designed compositions noted by Lanman were the hallmarks of his painting.

From the mid-1820s, American writers, playwrights, and, to a lesser extent, artists had often used comedy as a venue for the discussion of serious issues. In many stories and plays of Edmonds's day, love triangles where city men were pitted against Yankee farmers in a comedic fashion served to extol the virtues of American rural life.[2] Samuel Woodworth's 1825 *Forest Rose* was among the most popular of these.[3] So prevalent was this scenario that Charles Lanman read exactly the pro-country moral into *The City and Country Beaux:* "We have a charming country lady and her accepted lover, suddenly surprised by the appearance of a city dandy; and while the latter is nettled by the appearance of things, the former, who is rocking himself in an armchair, very cooly puffs the smoke of his cigar into the face of his disappointed rival."[4]

The closest painted source for *The City and Country Beaux* was William Sidney Mount's *The Sportsman's Last Visit* (fig. 18). Edmonds most surely would have seen it on view at the 1835 National Academy of Design exhibition. Mount presents a less comic but nonetheless amusing version of the country and city beaux story, though in his painting the city gentleman is seen successfully wooing the young woman as the country gentleman leaves bewildered.

The outcome in *The City and Country Beaux* is more ambiguous. The two men are painted almost as caricatures. The exaggerated gestures of the woman and the city beau

The City and Country Beaux,
c. 1838–40
Oil on canvas
20 1/8 × 24 1/4 (51.1 × 61.6)
Signed on stool: Edmonds
No. 915

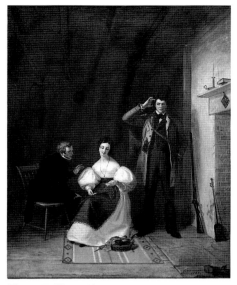

Fig. 18: William Sidney Mount, **The Sportsman's Last Visit,** 1835. Oil on canvas, 21½ × 17½ in. (54.6 × 44.5 cm). The Museums at Stony Brook, Stony Brook, New York; Gift of Mr. and Mrs. Ward Melville, 1958.

Fig. 19: Francis William Edmonds, **Drawing for "The City and Country Beaux,"** c. 1838–40. Pencil on paper, 6⅝ × 8¼ in. (16.8 × 21 cm). The Metropolitan Museum of Art, New York; Sheila and Richard J. Schwartz Fund, 1987.196.3.

Fig. 20: Francis William Edmonds, **Study for "The City and Country Beaux,"** c. 1838. Oil on board, 4¼ × 5¼ in. (10.8 × 13.3 cm). Sterling and Francine Clark Art Institute.

and the sullenness of the country man, all contained in a stagelike setting, create an amusing narrative parallel to fashionable norms. Edmonds even dressed his male figures according to Yankee comic theater standards with the country beau in striped pants and the city beau in black.[5] But behind the lightheartedness of the scene, Edmonds may have been suggesting, through design and color selection, an increasingly controversial issue of the late 1830s: the pros and cons of country and city living. The trio of lovers is placed in a triangle within a small room. The country beau, off to the left, slouching in a chair and in shadow, is separated from the object of his affections. The city beau, although much closer to the young woman, pays little attention to her. Painted in full light, she gestures dramatically toward the seated figure but gazes at the city man. The costumes of the country beau and woman are similarly colored, while the black-suited city beau stands in vivid contrast. The country beau looks comfortable and complacent, but slouches in the shadow, and the city beau seems glamorous and well-heeled but villainous in black — and the young woman appears torn between the two.

In 1830 less than seven percent of all Americans lived in cities with over 8,000 people.[6] By the end of the decade the conversion to city life was well underway. With it came the realization that although America's land was her most precious resource and that the attributes associated with country life — honesty, individuality, and virtuousness — were upheld as American ideals, the city was where the industry flourished that allowed the United States to compete in the international market. Whereas Woodworth, among others, viewed the country as ever victorious and Mount saw the city ways winning, Edmonds, in *The City and Country Beaux,* presented the two in conflict.[7] Edmonds, himself a country boy turned city gentleman, could well understand the intricacies of the times. Within the confines of accepted comic theater and traditional artistic conventions, he created a discerning yet humorous view of American life around 1840.

The artistic strategies at work in *The City and Country Beaux* were ones Edmonds used throughout his career.[8] Usually he began with pencil sketches, as in the small drawing for *The City and Country Beaux* (fig. 19), where he set up the basic compositional structure and arrangement of light and dark. That this drawing is found on a sketchbook page next to a study of the dog in Edmonds's 1838 *The Epicure* (private collection) suggests that the artist may have first conceived *The City and Country Beaux* in that year.

The final work remains remarkably true to Edmonds's initial concept. The few changes, however, serve to heighten the effects of the

painting's narrative. In the drawing the room overshadows the figural elements, a fireplace is in evidence on the back wall, and the city beau is quite corpulent. In an oil sketch (fig. 20),[9] which was typically the second step in Edmonds's working process, the interior space is scaled down. This more stagelike setting increased the dramatic element of the action. The city beau's figure was also trimmed considerably, giving him a more equal status to his rival. With the detailing of the men's clothing and faces in the final picture, their stations in life become obviously exaggerated. Edmonds also replaced the fireplace with a closed door with a feather duster hung from the molding, a change that further narrowed the space of the room and added an apex to the triangle of figures.

Edmonds's composition is primarily dependent upon Old Master, particularly Dutch, painting, which he would have known through private collections, prints, and painting manuals. John Burnet's *A Treatise in Four Parts,* a manual that Edmonds owned and studied carefully, suggested that looking at Dutch art was the best way to learn the grammar of painting.[10] The stage-set space of *The City and Country Beaux,* which also may have had its roots in American theater, is derived from the classical tradition. The interior setting with a door opening into the light reflects Edmonds's knowledge of Dutch seventeenth-century works as does his use of light and shadow and of color, especially red, yellow, and blue, to move the eye across the picture plane.

Harder to document, but surely another source of influence for Edmonds, was the work of the Scottish artist David Wilkie (1785–1841). Prints after Wilkie's paintings were widely disseminated in the United States by 1830.[11] Wilkie, whose own work was partly based on the Dutch tradition, appropriated Old Master technique and structure for modern narratives that often had moral implications;[12] to this end, he focused his paintings around the "pregnant moment" of a situation. Especially for *The City and Country Beaux,* Edmonds seems to have assimilated this feature of Wilkie's work. However, as a contemporary critic realized, both artists drew from the same Old Master sources and their direct connection is hard to pin down.[13]

1 Charles Lanman, *Letters from a Landscape Painter* (Boston: James Monroe and Co., 1845), p. 240.

2 Peter Gibian, McGill University, kindly guided me to the vast bibliography of early nineteenth-century American literature and drama in which this type of story appears.

3 The first of the Yankee plays was *The Contrast* by Royall Tyler (1787). Others included Joseph Jones's *The Green Mountain Boys* (1833) and Cornelius Logan's *The Way of Maine* (1834). For a brief discussion of these, see Sarah Burns, "Yankee Romance: The Comic Courtship Scene

The City and Country Beaux

in 19th-Century American Art," *American Art Journal*, 18 (Autumn 1986), pp. 60–62.

4 Lanman, *Letters from a Landscape Painter*, p. 241.

5 Burns, "Yankee Romance," pp. 60–61.

6 Francis Hodge, *Yankee Theater: The Image of America on the Stage, 1825–50* (Austin: University of Texas Press, 1964), p. 29.

7 H. Nichols B. Clark, *Francis W. Edmonds: American Master in the Dutch Tradition*, exh. cat. (Fort Worth: Amon Carter Museum, 1988), pp. 54–55, and Burns, "Yankee Romance," pp. 60–61, have recently concluded that the city beau is the winner, but the present author finds that the extremely comic, even satirical nature of both male figures leaves the decision a draw.

8 H. Nichols B. Clark's conversations with the author, fall 1987, confirmed her understanding of Edmonds's working process.

9 H. Nichols B. Clark brought this sketch, which the Clark Art Institute purchased in 1987, to my attention.

10 John Burnet, *A Treatise in Four Parts Consisting of an Essay on the Education of the Eye with Reference to Painting and Practical Hints on Composition, Chiaroscuro, and Colour* (London: J. Carpenter and Son, 1827). See Clark, *Francis W. Edmonds*, pp. 37–66, for a full discussion of Burnet's influence on Edmonds.

11 Catherine Hoover, "The Influence of David Wilkie's Prints on the Genre Painting of William Sidney Mount," *American Art Journal*, 13 (Summer 1981), p. 15.

12 See Lindsay Errington, "The Genre Paintings of Wilkie," in *Sir David Wilkie of Scotland (1785–1841)*, exh. cat. (Raleigh: North Carolina Museum of Art, 1987), pp. 3–4.

13 "The Fine Arts—National Academy of Design," *The Knickerbocker*, 16 (July 1840), p. 82.

Provenance: W.R. Betts, Newburgh, New York, by 1844; to F.R. Betts; (Renaissance Galleries, Philadelphia); to (M. Knoedler & Co., New York, January 8, 1943); to Robert Sterling Clark, January 8, 1943.

Related Works: Drawing for "The City and Country Beaux," c. 1838–40, pencil on paper (sketchbook), 6⅝ × 8¼ (16.8 × 21), The Metropolitan Museum of Art, New York; Sheila and Richard J. Schwartz Fund, 1987.196.3. *Study for "The City and Country Beaux,"* c. 1838, oil on board, 4¼ × 5¼ (10.8 × 13.3), Sterling and Francine Clark Art Institute, 1987.109.

Exhibitions: National Academy of Design, New York, "15th Annual Exhibition," April 27–July 8, 1840, no. 230; Whitney Museum of American Art, New York, "The Painter's America: Rural and Urban Life, 1810–1910," September 19–November 10, 1974; Amon Carter Museum, Fort Worth, "Francis W. Edmonds: American Master in the Dutch Tradition," January 9–February 28, 1988.

References: "The Fine Arts—National Academy of Design," *The Knickerbocker*, 16 (July 1840), pp. 82–83; Charles Lanman, *Letters from a Landscape Painter* (Boston: James Monroe and Co., 1845), pp. 240–41; *National Academy of Design Exhibition Record: 1826–1860* (New York: The New-York Historical Society, 1943), vol. 1, no. 230, p. 143; Maybelle Mann, "Francis William Edmonds: Mammon and Art," *American Art Journal*, 2 (Fall 1970), pp. 105–6; CAI 1972, p. 38; Donald Keyes, "Aspects of the Development of Genre Painting in the Hudson River Area before 1852," Ph.D. dissertation, New York University, 1973, pp. 121, 123, 163; *The Painter's America: Rural and Urban Life, 1810–1910*, exh. cat. (New York: Whitney Museum of American Art, 1974), pp. 41–42; Maybelle Mann, "Humor and Philosophy in the Paintings of Francis William Edmonds," *Antiques*, 106 (November 1974), pp. 863, 865; Alfred Frankenstein, *William Sidney Mount* (New York: Harry N. Abrams, 1975), p. 27; Maybelle Mann, *Francis W. Edmonds: Mammon and Art* (New York: Garland Publishing, 1977), p. 22; CAI 1984, pp. 14, 99; Sarah Burns, "Yankee Romance: The Comic Courtship Scene in 19th-Century American Art," *American Art Journal*, 18 (Autumn 1986), pp. 53–54, 64–65; *Francis W. Edmonds: American Master in the Dutch Tradition*, exh. cat. (Fort Worth: Amon Carter Museum, 1988), pp. 52, 54–56, 94; Sarah Burns, *Pastoral Inventions: Rural Life in Nineteenth-Century American Art and Culture* (Philadelphia: Temple University Press), 1989, pp. 171–72, 179.

Sparking, 1839
Oil on canvas
19¹⁵⁄₁₆ × 24 (50.6 × 61)
Signed and dated at lower right:
F W Edmonds/1839
No. 916

Whereas *The City and Country Beaux* (pp. 51–54) revolved around a comedic moment in the rivalry of two suitors, *Sparking* approaches the theme of courtship with tender emotion without being overly sentimental. In 1815 the term "sparking" had been defined as "young men keeping company with young women and sitting by the fire after the family has gone to bed."[1] Except for the fact that in *Sparking* an older woman remains in the background washing dishes, Edmonds adhered to this definition. As Charles Lanman correctly described, the sole story of *Sparking* is "a country damsel . . . peeling apples before a large blazing fire,

while a hearty fellow is talking to her, 'solemnly and slow,' about his heart and other kindred matters."[2]

As American culture became more nationalistic in the 1830s, the humble life-styles of America's middle and lower classes became worthy subjects for representation. Edmonds's choice of such a simple domestic subject was part of this celebration of homespun virtues, also current in both the work of his colleague William Sidney Mount (1807–1868) and in Knickerbocker stories of rural life.[3] Mount, for example, had painted *Winding Up* (The Nelson-Atkins Museum of Art, Kansas City, Missouri) in 1836. Exhibited

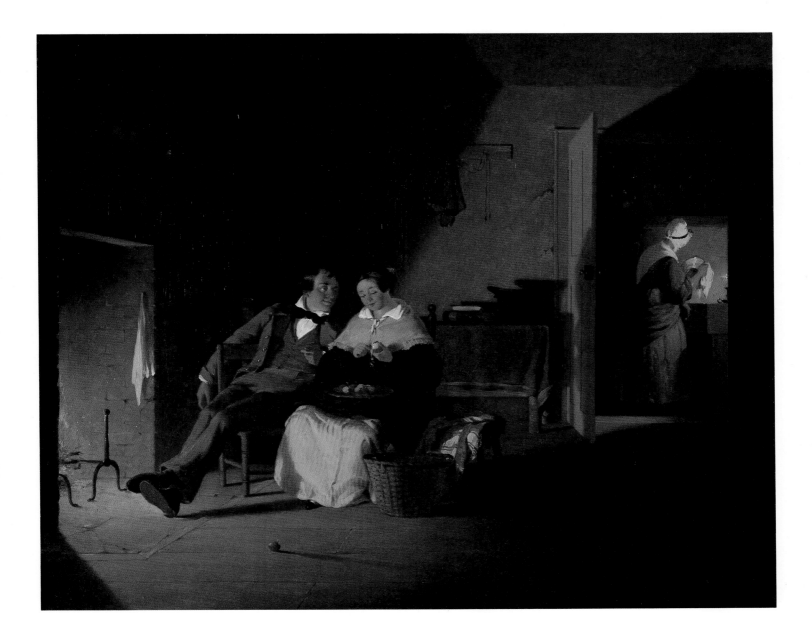

*Fig. 21: Francis William Edmonds, **Drawing for "Sparking,"** c. 1839. Pencil on paper, 6⅝ × 8¼ in. (16.8 × 21 cm). The Metropolitan Museum of Art, New York; Sheila and Richard J. Schwartz Fund, 1987.196.3.*

the next year at the National Academy of Design as *Courting*, it depicts a young man helping a young woman wind her wool as they chat.

Sparking was painted in 1839, when Edmonds's wife was most likely already ailing with the illness that would cause her death in January 1840. The picture must thus have held special meaning for him. Its autobiographical connections are made clear by the fact that the face of the man in the painting is Edmonds's own.[4] The books and top hat on the table behind the couple, attributes of the suitor's high aspirations, may also refer to Edmonds's career in banking. Other symbolic meanings can be seen in the peeled fruit. Exposed to the air and therefore ripe for decay, peeled fruit served as a *vanitas* symbol in the kind of seventeenth-century Dutch painting with which Edmonds was familiar.[5] Therefore the peeled apples on the platter in the woman's lap and the partially peeled one in her hand may allude to Marsha Norman Edmonds's mortality. The apples also associate the scene with everyday American life.[6]

Sparking also exemplifies Edmonds's particular artistic concerns: "I was impressed with the idea that all the fire or lamplight pictures I had seen, seemed to me painted altogether too red — I had observed none of the pictures under this light had attempted to preserve the cool grays that are seen by daylight and which I thought were not lost by candle or fire light. I therefore endeavoured to preserve as far as possible these peculiar tints so indispenible [sic] to a fine picture."[7] Although Edmonds had considered having a fireplace, and therefore possibly the depiction of firelight, at the center of *The City and Country Beaux,* it was with *Sparking* that he put his thoughts into paint. A glowing fire in the left foreground and a candle in the right background frame the sides of the picture to set up a composition that explores the effects of artificial light on color and shadow. Even though no oil sketch for *Sparking* is known, Edmonds most likely planned the basic composition and lighting in a sketch, as he did for *The City and Country Beaux* and many other paintings. A drawing for the seated young woman (fig. 21) does show how carefully he worked out the figure prior to approaching the canvas and suggests that there may have been other studies.

Edmonds divided the pictorial space of *Sparking* according to the dictates of the fire and candle. Each light source illuminates the figures. At the same time large areas are thrown into shadow. It was in these places, where a cool gray dominates, that Edmonds could best demonstrate his belief that interior nighttime lighting retained some of daylight's cool aspects.

Throughout the painting light and dark and warm and cool are juxtaposed. One half of the back wall is in light and the other in shadow. And whereas the firelight reflects a warm reddish glow on the objects nearest to it — the floorboards and the man's clothing[8] — it cools as it disseminates. The candle in the background, however, throws a narrower, more concentrated light, so that where it shines — on the floor behind the woman, the dish being washed, the clothing of the woman washing, and the kettle up on the shelf — it is cooler and whiter.

Edmonds masterfully worked out the broader arrangement of lights and darks to carry the viewer's eye across the canvas from light source to light source. Yet he also included resting points for the eye in the form of carefully painted still-life elements: the rag hanging in the fireplace, the apple on the floor, the group of apples on the platter, the cape and string hung on the back wall, the book and hat, and the kitchenware on the shelves in the back room. Additional bits of color, such as the bright blue of the seated woman's shoe and ribbon, also help tie the composition together.

Edmonds's knowledge of Dutch painting and of what John Burnet had written about the Dutch use of color and light also informed his methods (p. 52). In *Practical Hints on Colour in Painting*, Burnet, using Adriaen van Ostade (1610–1684) and Pieter de Hooch (1629–1684) as examples, strongly suggested that his artist-reader study the way the Dutch artists injected "the highest principles of art into the humblest walks" of life through their management of cool and hot light and color across a canvas.[9] Although Burnet knew that the small-scale, hand-colored plates illustrating his manual could only represent his remarks in a general way, he felt that their study would allow a student to understand the elements needed to achieve both breadth and brilliance in any work.[10] By closely following Burnet's discourse, in *Sparking* Edmonds expanded his achievements in *The City and Country Beaux* to paint his most accomplished work to date.

Edmonds was rewarded with critical acclaim for *Sparking* and *The City and Country Beaux.* The critic for *The Knickerbocker,* reviewing the 1840 National Academy of Design exhibition where the two pictures were shown together, praised the works: "They are *finished* pictures; finished in 'the scope and in the detail.' The whole story is told. No part is omitted or slurred over. . . . The drawing, colouring, arrangement, etc. of these pictures are in excellent keeping."[11] The same critic singled out *Sparking* for its superb light and shadow. Above all, what impressed him was Edmonds's application of "the correct rules of taste," according

to "the principles of the *grand style*," to his common subject matter; from this he hoped Edmonds would never depart.

Edmonds seems to have been particularly attached to both *The City and Country Beaux* and *Sparking*. Against common practice, he apparently did not offer them for sale out of the 1840 Academy exhibition.[12] However, *Sparking* was owned by W.R. Betts of Newburgh, New York, by 1844, when it was chosen by the American Art-Union for engraving and distribution among its members. In subject matter and style, *Sparking* fulfilled the requirements for successful American art in the 1840s. It depicted a subject that glorified American ways within a format that was associated with high art. Recognized as such, its image was spread across the country.

1 The term "sparking" was first used in Royall Tyler's 1787 play *The Contrast*. The 1815 definition appeared in the "glossary of Yankee words" in David Humphrey's play *The Yankee in England*. Sarah Burns gives an excellent discussion of the history of the term in "Yankee Romance: The Comic Courtship Scene in 19th-Century American Art," *American Art Journal*, 18 (Autumn 1986), p. 70.

2 Charles Lanman, *Letters from a Landscape Painter* (Boston: James Monroe and Co., 1845), p. 241.

3 In addition to their well-known literature on urban New York, Knickerbocker authors also wrote tales that presented the virtues of country living; see James Callow, *Kindred Spirits: Knickerbocker Writers and American Artists, 1807–1855* (Chapel Hill: University of North Carolina Press, 1967), p. 176.

4 Edmonds's *Self-Portrait* (c. 1844; private collection) shows a strong resemblance to the figure in *Sparking*. The Edmonds family has also handed down the story that the painting was autobiographical; see letter from Cornelia C. Flagler to Frank Weitenkampf, December 7, 1920 (The New York Public Library, Art Division, Edmonds folder).

5 See H. Nichols B. Clark, "A Fresh Look at the Art of Francis William Edmonds: Dutch Sources and American Meanings," *American Art Journal*, 14 (Summer 1982), pp. 73–94.

6 From the appearance of the Johnny Appleseed legend in the second decade of the nineteenth century, apples were associated with American country life; see Francis Hodge, *Yankee Theater: The Image of America on the Stage, 1825–50* (Austin: University of Texas Press, 1964), passim.

7 "Leading Incidents and Dates of My Life: An Autobiographical Essay by Francis William Edmonds," *American Art Journal*, 13 (Autumn 1981), p. 9.

8 It is interesting that the man's vest was originally green. Edmonds may have changed the color to reflect a warmer glow.

9 John Burnet, *Practical Hints on Colour in Painting* (London: Henry Sotheran and Co., 1880), pp. 60–62. This volume reprints section 3 of the original 1827 edition, for which see p. 54 n. 10.

10 Ibid., p. 62.

11 "The Fine Arts—National Academy of Design," *The Knickerbocker*, 16 (July 1840), p. 82.

12 Abigail Booth Gerdts, National Academy of Design, kindly checked the exhibition catalogue for sale references; letter to the author, August 20, 1987.

Provenance: W.R. Betts, Newburgh, New York, by 1844; to F.R. Betts; (Renaissance Galleries, Philadelphia); to (M. Knoedler & Co., New York, January 8, 1943); to Robert Sterling Clark, January 8, 1943.

Related Works: Drawing for "Sparking," c. 1839, pencil on paper (sketchbook), 6⅝ × 8¼ (16.8 × 21), The Metropolitan Museum of Art, New York; Sheila and Richard J. Schwartz Fund, 1987.196.3.

Steel engraving by Alfred Jones, 1844, 12⅞ × 16⅞ (32.7 × 42.9), for the American Art-Union.

Exhibitions: National Academy of Design, New York, "15th Annual Exhibition," April 27–July 8, 1840, no. 234; Whitney Museum of American Art, New York, "The American Art-Union," November 23, 1977–January 15, 1978 (not in catalogue); Amon Carter Museum, Fort Worth, "Francis W. Edmonds: American Master in the Dutch Tradition," January 9–February 28, 1988.

References: "The Fine Arts—National Academy of Design," *The Knickerbocker*, 16 (July 1840), p. 82; American Art-Union, *Transactions of the Apollo Association, for the Promotion of the Fine Arts in the United States for the Year 1843* (New York: Charles Vintem for the Association, 1843), frontispiece, p. 3; American Art-Union, *Transactions of the American Art-Union, for the Promotion of the Fine Arts in the United States for the Year 1844* (New York: John Douglas, 1844), pp. 9, 24, 46; Charles Lanman, *Letters from a Landscape Painter* (Boston: James Monroe and Co., 1845), pp. 240–41; *National Academy of Design Exhibition Record: 1826–1860* (New York: The New-York Historical Society, 1943), vol. 1, no. 234, p. 143; Maybelle Mann, "Francis William Edmonds: Mammon and Art," *American Art Journal*, 2 (Fall 1970), pp. 105–6; CAI 1972, p. 38; Donald Keyes, "Aspects of the Development of Genre Painting in the Hudson River Area before 1852," Ph.D. dissertation, New York University, 1973, pp. 121, 163, 179; Maybelle Mann, "Humor and Philosophy in the Paintings of Francis William Edmonds," *Antiques*, 106 (November 1974), pp. 863, 865; Alfred Frankenstein, *William Sidney Mount* (New York: Harry N. Abrams, 1975), p. 19; Maybelle Mann, *Francis W. Edmonds: Mammon and Art* (New York: Garland Publishing, 1977), pp. 22, 23, 103; Maybelle Mann, "American Art-Union: Missionaries in the Art World," *American Art and Antiques*, 1 (July–August 1978), p. 65; "Leading Incidents and Dates of My Life: An Autobiographical Essay by Francis William Edmonds," *American Art Journal*, 13 (Autumn 1981), p. 9; CAI 1984, pp. 14, 99; Sarah Burns, "Yankee Romance: The Comic Courtship Scene in 19th-Century American Art," *American Art Journal*, 18 (Autumn 1986), p. 70; *Francis W. Edmonds: American Master in the Dutch Tradition*, exh. cat. (Fort Worth: Amon Carter Museum, 1988), pp. 5, 28, 52–54, 56, 97, 121.

Louis Michel Eilshemius
1864–1941

Louis Michel Eilshemius was born in New Jersey. From 1882 to 1884 he studied agriculture at Cornell University. His art training began around 1884 when he attended the Art Students League in New York City and took private lessons with Robert C. Minor (1898–1954).

Eilshemius's early paintings were landscapes in the popular Barbizon style of Jean-Baptiste-Camille Corot (1796–1875), for which he received brief recognition in the late 1880s and early 1890s. Between 1892 and about 1895, Eilshemius traveled extensively in Europe, North Africa, and the American West. Returning to New York by 1896, he continued to paint despite few sales and no acceptance in the art world. The works painted from the mid-1890s were often of fantastic subjects and employed a cruder style.

After 1910 Eilshemius declined artistically until injury forced him to stop painting around 1920. In the early 1930s he acquired some celebrity when Marcel Duchamp and Katherine Dreier became interested in his work. Ill and bitter, however, Eilshemius shunned the recognition and in 1941 died an impoverished recluse.

Bibliography: William Schack, *And He Sat among the Ashes* (New York: American Artists Group, 1939); Paul J. Karlstrom, "Louis Michel Eilshemius, 1864–1941: A Monograph and Catalogue of the Paintings," Ph.D. dissertation, University of California at Los Angeles, 1973; Paul J. Karlstrom, *Eilshemius* (New York: Harry N. Abrams, 1978).

American Farm, 1900

Oil on canvas
12 × 16⅛ (30.5 × 41)
Signed lower right: Elshemus.; *dated lower left:* 1900
No. 730

Louis Eilshemius painted rural subjects from early in his career. *American Farm* is a typical example of the farm scenes he created around the turn of the century. It is signed with the shortened form of his name—Elshemus—used between about 1897 and 1913.

American Farm is a straightforward image of a large pasture with outbuildings and trees. In the left foreground a man sits on a fence; near the center another man leads a team of animals pulling a wagon. Inspired in general by the French Barbizon artists and directly by the work of George Inness (pp. 101–6), unspecific, bucolic, civilized landscapes like the Clark painting make up a sizable portion of the artist's oeuvre.

Eilshemius employed a self-consciously simple painting style after about 1895.[1] *American Farm,* typical of this phase of his work, is thinly and flatly painted with no modeling of forms and little articulation of space. Whereas the indefiniteness and softness of the forms, especially the trees, hark back to the influence of Barbizon art, the paint application is cruder than that in Eilshemius's earlier pictures. For example, the tree trunks and branches are depicted only with thin lines and their shadows are simply flat puddles of brown-green. Although no identifiable source for Eilshemius's purposefully unrefined style is known, Paul Karlstrom has suggested that it is related to the artist's fragile emotional state at this time.[2]

At some point, *American Farm* sustained considerable damage to the background, which was then poorly repainted. Despite this damage, the simple style that acknowledges a simple life is yet in evidence.

1 Paul J. Karlstrom, "Louis Michel Eilshemius, 1864–1941: A Monograph and Catalogue of the Paintings," Ph.D. dissertation, University of California at Los Angeles, 1973, pp. 105–6.

2 Ibid., p. 106.

Provenance: To (Valentine Gallery, New York); to Robert Sterling Clark, April 17, 1944.

References: Paul J. Karlstrom, "Louis Michel Eilshemius, 1864–1941: A Monograph and Catalogue of the Paintings," Ph.D. dissertation, University of California at Los Angeles, 1973, p. 26; CAI 1984, pp. II, III.

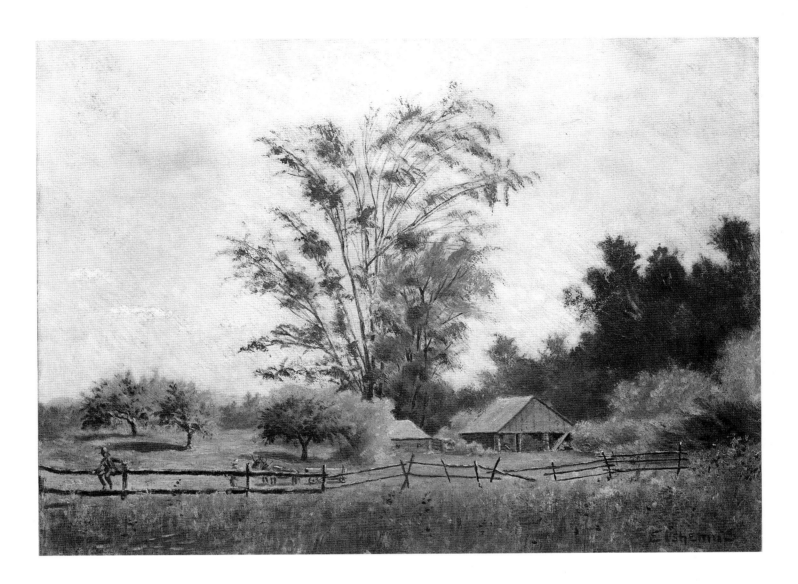

Frederick Childe Hassam
1859–1935

Frederick Childe Hassam, known as Childe, was born in Dorchester, Massachusetts (now part of Boston), in 1859. He began his career in art as an illustrator for newspapers, magazines, and, by 1883, books. The young artist attended classes at the Boston Art Club and also took private lessons with Ignaz Gaugengigl (1855–1932). At the end of 1883 he made a brief trip to Europe. During 1885 and 1886 he began to gain a reputation for his oil paintings of Boston street scenes.

Hassam returned to Europe in 1886. He spent the next three years mostly in Paris. Studying at the Académie Julian under Gustave Boulanger (1824–1884) and Jules-Joseph Lefebvre (1836–1911), the young artist followed traditional academic norms in his painting. However, his work also reflected the influence of the more avant-garde Impressionist movement in its looser brushwork.

Hassam arrived back in Boston in 1889 and shortly thereafter moved to New York, becoming successful with his own style of Impressionism. From the late 1880s on he worked not only in oil, but also in pastel, watercolor, and, by 1898, in the print medium. Like many of his colleagues, he spent his summers in the country. At different times in his life, he frequented the Isles of Shoals off the Maine–New Hampshire coast; Old Lyme, Connecticut; Gloucester, Massachusetts; and East Hampton (Long Island), New York.

In 1897 Hassam spent about a year in Europe and also resigned from the Society of American Artists to become a member of the Ten American Painters. In 1902 he became an associate member of the National Academy of Design, and in 1906 he was elected a full member. His first one-man show in New York took place in 1905. He spent part of 1904 and 1908 in Oregon, and in 1910 he made a final trip to Europe. During the 1920s and 1930s Hassam's best work was in printmaking. He died in East Hampton.

Bibliography: "Childe Hassam—Painter and Graver," *Index of 20th Century Artists,* 3 (October 1935), pp. 169–83 (reprint, with supplement [New York: Arno Press, 1970], pp. 461–75, 477); Adeline Adams, *Childe Hassam* (New York: American Academy of Arts and Letters, 1938); *Childe Hassam, 1859–1935,* exh. cat. (Tucson: University of Arizona Museum of Art, 1972); Donelson F. Hoopes, *Childe Hassam* (New York: Watson-Guptill Publications, 1979).

Little Girl with a Pear, c. 1889–93
(A Child with a Pear)

Pastel on paper
16⁷/₁₆ × 13⅛ (41.8 × 33.3)
Signed upper right: Childe H[illegible]
No. 761

America in the last quarter of the nineteenth century saw an expansion of acceptable media for works of art. The formation in 1882 of the Society of Painters in Pastel announced the strength of the renewed interest in this chalky crayon.[1] The attraction to pastel for late nineteenth-century American artists was directly related to the influence of Impressionism, which created a greater interest in the swift execution of images, in light and color, and in the depiction of the intimate and spontaneous.[2] In the eighteenth century pastel had been used primarily for portraiture, but from the 1880s it was employed for a wide variety of subjects.

Childe Hassam began to use pastel in 1887.[3] Between 1887 and 1889, he executed approximately eight pastels. Only five pastels have been attributed to 1890. Nearly thirty works, however, can be assigned to 1891. After this initial preoccupation with pastel, Hassam did not return to the medium with any regularity until 1902.

Hassam executed his few pastel portraits of children in the 1890s. Only four are known today: the Clark *Little Girl with a Pear,* *Portrait of Master Sterling Turner* (fig. 22), *Portrait of Elizabeth Wolcott Tuckerman* (1892; private collection), and *Portrait of Katharine Thaxter* (1893; private collection). The sitter and the circumstances of *Little Girl with a Pear* are not known. Sterling Turner and Katharine Thaxter were children of Hassam's friends. He most likely created the portraits when visiting the Isles of Shoals, off the Maine–New Hampshire coast, in the summers of 1890 and 1893. *Portrait of Elizabeth Wolcott Tuckerman* was a commissioned work.[4]

The exact date of *Little Girl with a Pear* is problematic. It appears with a title sufficiently descriptive for identification only in a February 1896 sale at the American Art Association.[5] Yet the paucity of pastels produced by Hassam between 1894 and 1896, none of them portraits or of children, leaves no question that *Little Girl with a Pear* should be dated earlier, between 1889 and 1893.

In June 1890 Hassam exhibited at the fourth exhibition of the Society of Painters in Pastel "a small study of a girl's head 'At the Races.'"[6] The following February a *Head at the Races* appeared in a Hassam exhibition at Doll and Richards Gallery in Boston.[7] Although it is uncertain whether these two titles refer to the same picture, the racing theme suggests that it (or they) was (or were) part of the group of pastels Hassam created in France in 1889.[8] All the other pastels from this group depict adult spectators along a

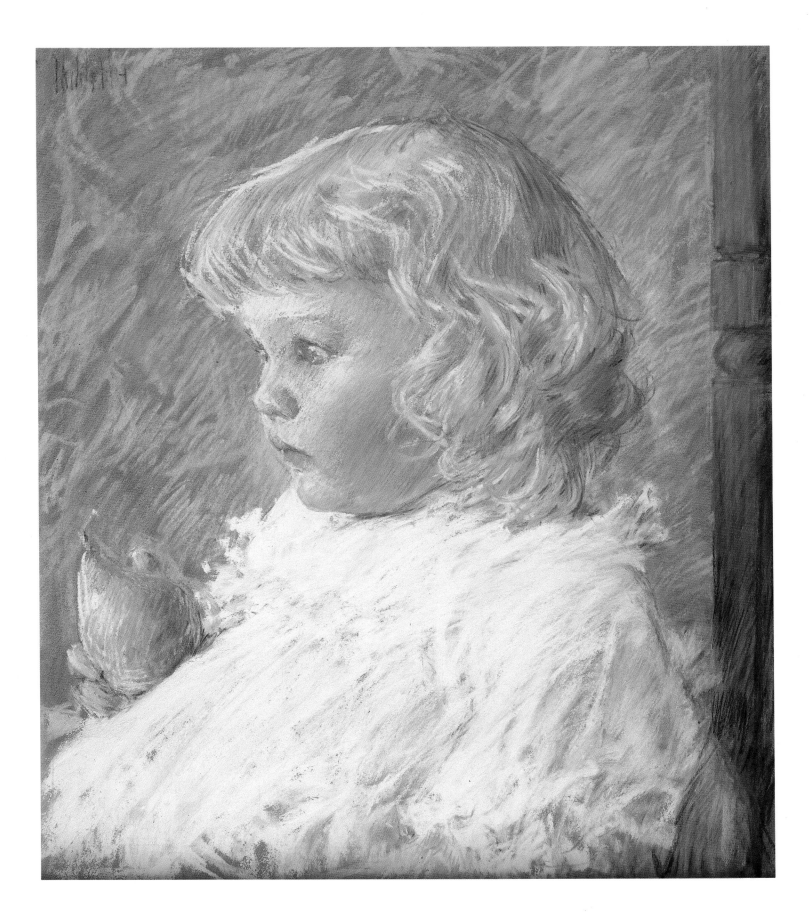

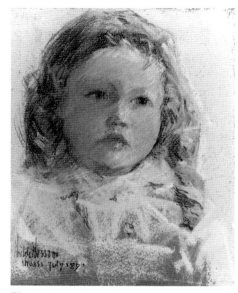

Fig. 22: Childe Hassam, **Portrait of Master Sterling Turner**, 1890. Pastel on paper, 9½ × 7¾ in. (24.1 × 19.7 cm). Collection of Mr. and Mrs. F. Alton Tybout.

Fig. 23: Childe Hassam, **At the Grand Prix in Paris**, 1887. Pastel and pencil on board, 15⅞ × 12½ in. (40.3 × 31.8 cm). The Corcoran Gallery of Art, Washington, D.C.; Bequest of James Parmelee.

racecourse (fig. 23). Nevertheless, *Little Girl with a Pear* is the only work extant today that begins to fit the above descriptions.[9]

It can also be argued that the Clark picture dates from the summer of either 1890 or 1893 on the basis of its similarities with the Sterling Turner and Katharine Thaxter portraits. All three pastels present intimate, bust-length views of their sitters. Kathleen Burnside, however, has found that a greater formality and completeness separate *Little Girl with a Pear* from the other two works.[10] The Turner and Thaxter portraits have very finished faces but only a suggestion of clothing and background. *Little Girl with a Pear*, on the other hand, with its more completed costume and decorative background, is a more formal work. Yet it retains a spontaneity not evident in Hassam's commissioned *Portrait of Elizabeth Wolcott Tuckerman*.

In November 1891 Hassam exhibited at Doll and Richards a pastel entitled *A Study of a Young Girl*.[11] This, too, could be *Little Girl with a Pear*.[12] Although the pastels from 1891 are mainly landscapes, they are executed with a sense of finish comparable to that in *Little Girl with a Pear*.

A writer for the *Boston Evening Transcript* wrote of Hassam's early pastels: "Mr. Hassam's pastels are delightful. His use of color is lavish, abundant, and intelligent; he makes it sing for him in all sorts of keys; and he is seldom wanting in those qualities that proclaim the instincts and temperament of a painter."[13] *Little Girl with a Pear*, which may have been included in the November 1891 Doll and Richards exhibition that was the occasion for this remark, displays the reasons for such positive press. Hassam suggested a wonderful variety of textures through the ordering of colored strokes. The carefully modeled, soft round face is set off by the blond wavy hair, frilly dress, and the decorative background of bright blues, greens, and yellow that complement the child's coloring. Although she is posed as if lost in thought, Hassam's vigorous use of pastel imparts an underlying vitality to her form.

1 For a concise discussion of the Society and pastel in America at the end of the nineteenth century, see Dianne Pilgrim, "The Revival of Pastels in 19th-Century America: The Society of Painters in Pastel," *American Art Journal*, 10 (November 1978), pp. 43–62.

2 Ibid., p. 43.

3 There is one indistinctly dated pastel that may be as early as 1883, but research has not been able to prove conclusively that Hassam was working in pastel before 1887. Many thanks are due to Kathleen M. Burnside, Hirschl & Adler Galleries, who is preparing with Stuart Feld the catalogue raisonné of Hassam's work. Ms. Burnside graciously shared with me her in-depth knowledge of Hassam's early pastels, and

the facts concerning them in this entry appear courtesy of her records.

4 That the work was a commission is reported by the descendants of the sitter.

5 *Catalogue of Oil Paintings, Water Colors and Pastels by Childe Hassam*, auction cat. (New York: American Art Association, 1896), no. 46.

6 Noted in "The Pastel Exhibition," *The Art Amateur*, 23 (June 1890), p. 4.

7 *Exhibition and Private Sale of Oil Paintings and Water Color and Pastel Drawings by Childe Hassam*, sales cat. (Boston: Doll and Richards Gallery, 1891), no. 45.

8 Kathleen Burnside informs me that racing subjects appear only in this early group of Hassam's works.

9 Kathleen Burnside has attached these references to *Little Girl with a Pear* as of October 1989.

10 Letter from Kathleen Burnside to the author, July 26, 1988, CAI curatorial files.

11 *Exhibition and Private Sale of Pastel and Watercolor Drawings by Childe Hassam*, sales cat. (Boston: Doll and Richards Gallery, 1891), no. 5.

12 It could also be the same work that had appeared at the Society of Painters in Pastel as early as June 1890; see n. 6 above. Title changes would not be unusual, so it is difficult to discern whether there are one, two, three, or four different works in question.

13 "The Fine Arts—Exhibition of Pastels and Watercolors by Mr. Childe Hassam," *Boston Evening Transcript*, November 16, 1891, p. 6.

Provenance: To (American Art Association, New York, "Sale of Oil Paintings, Water Colors and Pastels by Childe Hassam," February 6–7, 1896, no. 46); Mrs. Henry Healy, Cold Spring-on-Hudson, New York; to (M. Knoedler & Co., New York, June 30, 1941); to Robert Sterling Clark, September 1, 1941.

Exhibitions: Society of Painters in Pastel, New York, "4th Exhibition," June 1890 (as *At the Races*, possibly the same work); Doll and Richards Gallery, Boston, "Exhibition and Private Sale of Oil Paintings and Water Color and Pastel Drawings by Childe Hassam," February 1891, no. 45 (as *Head at the Races*, possibly the same work); Doll and Richards Gallery, Boston, "Exhibition and Private Sale of Pastel and Watercolor Drawings by Childe Hassam," November 1891, no. 5 (as *Study of a Young Girl*, possibly the same work); Sterling and Francine Clark Art Institute, Williamstown, Massachusetts, "The Ten: Works on Paper," July 18–August 24, 1980, no. 11 (as *A Child with a Pear*).

References: "The Pastel Exhibition," *The Art Amateur*, 23 (June 1890), p. 4 (possibly the same work); Katherine S. Parks, "Mr. Hassam's Work," *Daily Advertiser* (Boston), November 17, 1891, p. 3 (possibly the same work); CAI 1972, p. 54; *The Ten: Works on Paper*, exh. cat. (Williamstown, Massachusetts: Sterling and Francine Clark Art Institute, 1980), pp. 27, 44; CAI 1984, pp. 19, 107.

Born in Boston in 1836, Winslow Homer grew up in nearby Cambridge. His mother, Henrietta Maria Benson Homer (1808/9–1884), an accomplished watercolorist, encouraged his early interest in drawing. At nineteen he was apprenticed for two years to J.H. Bufford's lithographic firm in Boston, where he prepared illustrations for sheet-music covers and magazines. In 1857 he began to work as a free-lance illustrator, first in Boston, then, from the fall of 1859, in New York. He took drawing classes in Brooklyn, studied at night at the National Academy of Design, and received about a month of lessons from the landscape and genre painter Frederick Rondel (1826–1892).

During the Civil War, Homer served as an artist-correspondent for *Harper's*. Traveling to the southern battlefields, he recorded camp life and non-military activities. The Civil War also provided him with the subject matter for his earliest oils, begun around 1862. In 1863 he began to exhibit regularly at the National Academy of Design; the following year he was elected an academician. His Civil War paintings received favorable reviews, and his first international recognition came with the exhibition of *Prisoners from the Front* (1866; The Metropolitan Museum of Art, New York) at the 1867 Exposition Universelle in Paris.

Homer spent ten months in France, mostly in Paris, from late 1866 through the fall of 1867. Very little is known about his travels, but extant paintings confirm a trip to the countryside near Ecouen. On his return to America, he continued illustrating and painting. Gradually, he illustrated less and painted more. For financial reasons, he was not able to break away completely from illustration until 1875.

During the 1870s Homer concentrated on non-urban genre subjects, which reflected his summer trips to beaches in New Jersey and Gloucester, Massachusetts; the Catskill and Adirondack Mountains; and Virginia. The resulting pictures focused on the close observation of nature and life and presented a truthful and unsentimental view of society. Generally lacking polish and broadly painted, the majority of Homer's works from the 1870s received mixed reviews.

Homer spent most of 1881–82 at Cullercoats in England. Painting almost exclusively in watercolor, a medium with which he had been working successfully since 1872, he depicted the hard life of the English fisherfolk. Deeply touched by their binding relationship to the sea, he returned to New York in 1882 to work on a series of oils, watercolors, and etchings that explored man's heroism and frailty in the face of powerful oceanic forces.

By late 1883 Homer had become a year-round resident of Prout's Neck, Maine, where he produced the marine subjects that secured his place as a master of American art. In addition, his lifelong love of fishing often took him to the Adirondacks and Canada in the summers and to the warmer climates of Cuba, Nassau, and Florida in the winters. He died at Prout's Neck in 1910.

Bibliography: William Howe Downes, *The Life and Works of Winslow Homer* (Boston and New York: Houghton Mifflin Co., 1911); Lloyd Goodrich, *Winslow Homer* (New York: Macmillan Co., 1944); Alfred Ten Eyck Gardner, *Winslow Homer, American Artist: His World and His Work* (New York: Clarkson N. Potter, 1961); Gordon Hendricks, *The Life and Work of Winslow Homer* (New York: Harry N. Abrams, 1979).

Winslow Homer visited the White Mountains in New Hampshire during August 1868. A free-lance illustrator, he may have hoped that his pictorial reports of the summer resort life would help recoup finances depleted by his European sojourn the previous year. This White Mountain trip and another the following summer were the only two Homer made to the area, but they resulted in a number of drawings, illustrations, and paintings, including *The Bridle Path, White Mountains*.[1]

When the painting was first exhibited at the Brooklyn Art Association in March 1869, viewers saw an increasingly familiar scene from summer life: vacationers on horseback, here enjoying the Crawford Path in the Presidential Range of New Hampshire. Since the late 1850s, hotels, riding and hiking trails,

and roads had been established throughout the sparsely populated White Mountain region.[2] In the years following the Civil War, tourists could experience a comfortable if rustic stay in this yet untamed mountain range.[3]

Artists, for their part, had been exploring the White Mountains in search of unspoiled scenery since the late 1820s. A vision of a divinely inspired America unfolded in the landscape canvases of Thomas Cole (1801–1848), Asher B. Durand (1796–1886), and many others. In *The Bridle Path, White Mountains*, however, Homer portrayed the area from a different perspective. He chose to depict tourists, with the central focus here on a female rider on a mountain trail. This decision reflected his employment as an illustrator who was expected to produce scenes

The Bridle Path,
White Mountains, 1868
(The White Mountains)
Oil on canvas
24⅛ × 38 (61.3 × 96.5)
Signed and dated lower left: HOMER N.A./
—1868—
No. 2

Fig. 24: Winslow Homer, **The Bridle Path, White Mountains**, 1868. Pencil on paper, 6¾ × 9⁹⁄₁₆ in. (17.2 × 24.3 cm). The Cooper-Hewitt Museum, Smithsonian Institution, New York; Gift of Charles Savage Homer, 1912-12-221.

Fig. 25: Winslow Homer, **Two Riders**, 1868. Watercolor and pencil on paper, 8¾ × 12½ in. (22.2 × 31.8 cm). Location unknown.

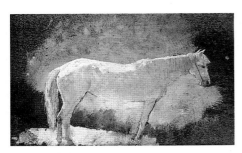

Fig. 26: Winslow Homer, **White Mare**, n.d. Oil on panel, 7⅞ × 12⅞ in. (20 × 32.7 cm). The Cleveland Museum of Art; Bequest of Leonard C. Hanna, Jr., 58.33.

of everyday life and also the growing interest of painters in genre subjects. At the same time it represented some significant changes in American life in the years immediately following the Civil War.

As northeastern cities became more industrialized after 1865, many Americans had increased leisure time and expendable income. They sought escape from urban life, particularly in the steamy summer months. A trip to the mountains or seashore provided needed relief from heat and urban congestion. *The Bridle Path, White Mountains* documents one type of popular summer outing. Other activities of the day included walking, carriage rides, picnicking, and swimming.

The centrality of the female rider illustrates the changing role of women in the late 1860s. The Civil War had opened women's lives to many previously unknown experiences. Caring for wounded, replacing men in businesses, and overseeing family finances led to a generally greater freedom. One manifestation of this new freedom in the postwar years was women's increased participation in leisure-time sports. Swimming, hiking, and riding, which had been predominantly male activities in the first half of the nineteenth century, became more accepted for both sexes by the late 1860s.

A drawing and a watercolor of a young woman riding a trail horse at the summit of Mt. Washington (figs. 24, 25) provided Homer with the initial concept for the Clark painting.[4] These sketches established the basic composition of the horse and young woman silhouetted against the landscape. Possibly at this same time Homer painted a small oil study of the horse (fig. 26). With these and perhaps other studies in hand, he returned to New York to work out carefully the final painting in his studio.

Typical of many of Homer's genre pictures, *The Bridle Path, White Mountains* gives a private glimpse of the subject with little anecdotal reference. The young woman, separated from her companions in the distance, stares down and away into space. The picture's cropped edges, the depiction of the horse in mid-step, and the handkerchief-waving figure at left give the appearance of a fleeting moment in a larger narrative.[5] Although the title indicates a specific locale, the panoramic view does not correspond to any landscape seen from Mt. Washington on the Crawford Path.[6]

Homer created *The Bridle Path, White Mountains* through the careful manipulation of space, light, and color. The horse and rider, tightly rendered and brightly lit from behind, are silhouetted against the sky and distant mountain view, and the high horizon line compresses the space between the foreground figures and background landscape.

This compositional scheme, together with a low viewpoint and shallow foreground, flattens the work's pictorial elements without sacrificing the quality of their illusion. By having the brightest light in the painting fall behind the main figure, Homer was able to define the outline of his forms and to dissolve the mountain range into a milky fog of blurred distances. The shadows that result from this mid-canvas light model the front of the woman's dress, the near side of the horse, and the foreground rocks, so that they appear closely observed even though they are quite broadly painted. The juxtaposition of grays, yellows, and greens, which are all accented sparingly with lighter or brighter colors, creates a dancing play of light and shade over the canvas surface even as the colors help to define the shapes.

Although Homer often denied the influence of other artists on his work,[7] *The Bridle Path, White Mountains*, executed when the artist had been painting only sporadically for six years, suggests a wide range of possible sources. The subject matter, carefully outlined figure and horse, and costume details may derive from the style of magazine illustrations, which stressed precisely delineated genre scenes. Homer's choice of an implied rather than an anecdotal narrative as well as the depiction of a single, anonymous female figure in a landscape may have been inspired by the British Pre-Raphaelite painters.[8] Furthermore, a variety of sources, including illustration, photography, and the military paintings of the popular French artist Jean-Louis-Ernest Meissonier (1815–1891), could have influenced the figure alignment across the front picture plane, the extended horizon, and the untheatrical pose.[9]

Homer's use of light in the painting also points to his knowledge of the work of American landscape painters of the 1860s, such as John F. Kensett (pp. 112–14) and Sanford Gifford (1823–1880), and also possibly that of the Frenchman Eugène Boudin (1824–1898). The palpable atmosphere that sharply defines forms and invokes stillness is like that found in many American landscape paintings of the early 1860s now categorized under the term Luminism. For example, Gifford's *Kauterskill Clove* (fig. 27), one version of which had been exhibited at the National Academy of Design in 1863, has a similar haziness.[10] Yet Boudin's sunlit scenes of recreation (fig. 28), which employed bright light and color as well as figures lined up across the front, may also have contributed to Homer's choice of light effects, composition, and subject.[11]

Whereas James Jackson Jarves counted Homer among the rising American artists who clearly looked to both English and French contemporary art,[12] most of the con-

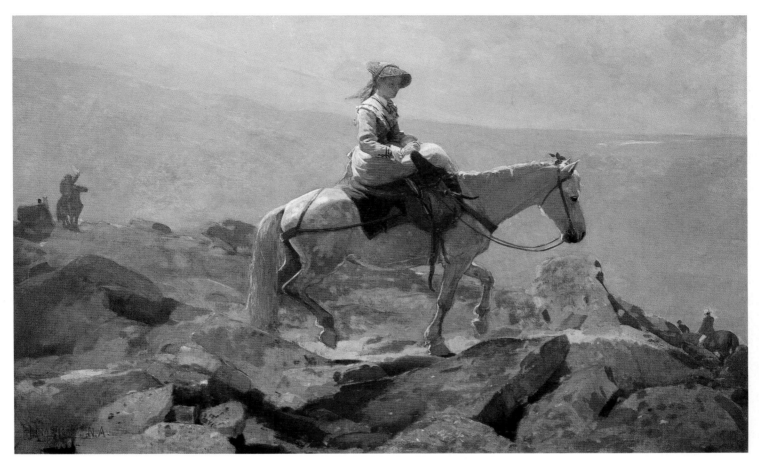

The Bridle Path, White Mountains

Fig. 27: *Sanford Robinson Gifford,* **Kauterskill Clove,** *1862. Oil on canvas, 48×39⅞ in. (121.9×101.3 cm). The Metropolitan Museum of Art, New York; Bequest of Maria De Witt Jesup, 1915.*

Fig. 28: *Eugène Boudin,* **The Beach at Trouville,** *1864. Oil on panel, 10¼×18½ in. (26×47 cm). Virginia Museum of Fine Arts, Richmond; Collection of Mr. and Mrs. Paul Mellon.*

temporaneous comments on *The Bridle Path, White Mountains* centered around the subject matter and technique. Eugene Benson, a painter and a friend of Homer, defined the criteria by which American art was judged at this time and precisely where Homer and this painting fit in: "As an artist, he has yet to reach the exquisite and beautiful; he is now in the good and true. He has invention, he is fresh and just in his observation, and he has but to attain the beautiful to become our master figure painter."[13] To an audience that still loved the detail of the Hudson River School artists, Homer's broad brushwork often generated less than praiseworthy remarks, but from the start *The Bridle Path, White Mountains* was rightly recognized for its wonderful freshness of observation.

1 Among the other paintings are: *Mount Washington* (1869; The Art Institute of Chicago) and *Artist in the Country* (1869; Portland Art Museum, Maine). At least four engravings appeared in 1869 and 1870 with White Mountain subjects. For a complete list, see Gordon Hendricks, *The Life and Work of Winslow Homer* (New York: Harry N. Abrams, 1979), pp. 327–28.

2 David Tatham, "Winslow Homer in the Mountains," *Appalachia,* 36 (June 15, 1966), p. 73.

3 Donald D. Keyes, "Perceptions of the White Mountains: A General Survey," in *The White Mountains: Place and Perceptions* (Hanover, New Hampshire: University Press of New England, 1980), p. 49.

4 Lauren Barth brought to my attention the watercolor reproduced in *Twelve Important Paintings by Monet from the Sutton Collection Together with Fine Examples of the Barbizon School and Works by Other Artists,* sales cat. (New York, American Art Association, October 26, 1933), lot 8, p. 3.

5 The following year Homer painted a similar scene, *Mount Washington* (1869; The Art Institute of Chicago), with a more readable narrative.

6 Verified by David Tatham, letter to the author, April 6, 1988.

7 J. Eastman Chase, "Some Recollections of Winslow Homer," *Harper's Weekly,* 54 (October 22, 1910), p. 13.

8 It was most likely through the Irish-born William Hennessey (1839–1917), Homer's friend and fellow illustrator in New York, or from firsthand experience of the work of Arthur Hughes (1832–1915), who clearly inspired Hennessey, that Homer would have known Pre-Raphaelite figure painting. For a full discussion of Pre-Raphaelite painting in America, see Linda Ferber and William H. Gerdts, *The New Path: Ruskin and the American Pre-Raphaelites,* exh. cat. (New York: The Brooklyn Museum, 1985), p. 268 and passim.

9 John Wilmerding has discussed the possible influence of photography, particularly that of the Civil War, in his *Winslow Homer* (New York: Praeger Publishers, 1972), pp. 42–43. For a concise explication of Homer's relationship to the works of Meissonier, see *Winslow Homer in*

the Clark Collection, exh. cat. (Williamstown, Massachusetts: Sterling and Francine Clark Art Institute, 1986), p. 10.

10 Natalie Spassky, *American Paintings in The Metropolitan Museum of Art* (New York: The Metropolitan Museum of Art, 1985), vol. 2, pp. 170–73.

11 Homer would have been able to see several works by Boudin in New York as early as 1866 in an exhibition sponsored by the Frenchman Cadart at the Fine Arts Gallery. There were also at least two Boudin paintings at the 1867 Paris Salon. For a concise discussion of French art in the United States in the mid-1860s, see Lois Marie Fink, "French Art in the United States, 1850–1870: Three Dealers and Collectors," *Gazette des Beaux-Arts,* 92 (September 1978), pp. 87–100.

12 James Jackson Jarves, *Art Thoughts* (New York: Hurd and Houghton, 1869), p. 297.

13 Eugene Benson, "The Annual Exhibition of the Academy," *Putnam's Magazine,* 5 (June 1870), p. 703.

Provenance: Martha Bennett Phelps; to William George Phelps, Binghamton, New York, by descent; to Esther Phelps Pumpelly, Oswego, New York, by descent; to (Macbeth Gallery, New York, 1937); to (Milch Gallery, New York); to (Macbeth Gallery, New York); to the Whitney Museum of American Art, 1938; to (M. Knoedler & Co., New York, 1950); to Robert Sterling Clark, May 1, 1950.

Related Works: The Bridle Path, White Mountains, August 24, 1868, graphite on paper, 9⁹⁄₁₆×6¾ (24.3×17.1), Cooper-Hewitt Museum, Smithsonian Institution, New York; Gift of Charles Savage Homer, 1912–12–221.

Two Riders, 1868, watercolor and pencil on paper, 8¾×12½ (22.2×31.8), whereabouts unknown.

White Mare, n.d., oil on panel, 7⅞×12⅞ (20×32.7), The Cleveland Museum of Art; Bequest of Leonard C. Hanna, Jr., 58.33.

Exhibitions: Brooklyn Art Association, New York, "Spring Exhibition," March 1869, no. 252; National Academy of Design, New York, "45th Annual Exhibition," April 15–early June 1870, no. 173 (as *The White Mountains*); Century Association, New York, "Fifty Years of American Art, 1870–1920," January 9–February 3, 1938, no. 18; Macbeth Gallery, New York, July 1938; Museum of Fine Arts, Boston, "Sport in American Art," October 10–December 10, 1944, no. 57; The Detroit Institute of Arts, "The World of the Romantic Artist," December 28, 1944–January 28, 1945, no. 93; Akron Art Institute, Akron, Ohio, "Forty American Painters," December 1945; Munson-Williams-Proctor Institute, Utica, New York, "Winslow Homer and Thomas Eakins," December 1, 1946–January 19, 1947, no. 11; Wildenstein and Co., New York, "Loan Exhibition of Winslow Homer," February 19–March 22, 1947, no. 9; Utah Centennial, Salt Lake City, "One Hundred Years of American Painting," July 1–29, 1947, no. 23; Sterling and Francine Clark Art Institute, Williamstown, Massachusetts, "Exhibit 4: The First Two Rooms," May 17, 1955, no. 2; Sterling and Francine Clark Art Institute, Williamstown, Massachusetts, "Exhibit 16: Winslow Homer," June 1961; Public Education

Association and Hirschl & Adler Galleries, New York, "The American Vision," October 8–November 2, 1968, no. 69; Whitney Museum of American Art, New York, "Winslow Homer," April 3–June 3, 1973, no. 11; Sterling and Francine Clark Art Institute, Williamstown, Massachusetts, "Winslow Homer in the Clark Collection," June 28–October 19, 1986, no. 10.

References: "The Art Exhibition," *Brooklyn Daily Eagle,* March 17, 1869, p. 2; "The Academy of Design," *New York Daily Tribune,* April 15, 1870, p. 4; "National Academy of Design," *The World* (New York), April 24, 1870, p. 3 (as *The White Mountains);* "National Academy of Design—1st Notice," *New York Evening Post,* April 27, 1870, p. 1; *Harper's Weekly,* May 14, 1870, p. 307; Eugene Benson, "The Annual Exhibition of the Academy," *Putnam's Magazine,* 5 (June 1870), pp. 703–4; *Fifty Years of American Art, 1870–1920,* exh. cat. (New York: Century Association, 1938); Forbes Watson, *Winslow Homer* (New York: Crown Publishers, 1942), p. 46; "The Whitney Merges with the Metropolitan," *Art News,* 41 (February 1–14, 1943), p. 12; Lloyd Goodrich, "Young Winslow Homer," *Magazine of Art,* 37 (February 1944), p. 63; Lloyd Goodrich, *Winslow Homer* (New York: Macmillan Co., 1944), pp. 41–42, pl. 8; E.P. Richardson, *American Romantic Painting* (New York: E. Weyhe, 1944), p. 36, pl. 213; *Sport in American Art,* exh. cat. (Boston: Museum of Fine Arts, 1944); *The World of the Romantic Artist,* exh. cat. (Detroit: The Detroit Institute of Arts, 1944); *Forty American Painters,* exh. cat. (Akron, Ohio: Akron Art Institute, 1945), n.p.; Frank Jewett Mather, Jr., "The Expanding Arena," *Magazine of Art,* 39 (November 1946), p. 298; *Winslow Homer and Thomas Eakins,* exh. cat. (Utica, New York: Munson-Williams-Proctor Institute, 1946); *A Loan Exhibition of Winslow Homer,* exh. cat. (New York: Wildenstein and Co., 1947), p. 15; *One Hundred Years of American Painting,* exh. cat. (Salt Lake City: Utah Centennial, 1947); Oliver W. Larkin, *Art and Life in America* (New York: Rinehart and Co., 1949), p. 223; Virgil Barker, *American Painting* (New York: Macmillan Co., 1951), p. 640; Isobel Gordon, "Winslow Homer, Painter of the American Scene," *Hobbies,* 57 (February 1952), pp. 32–33; Helen Comstock, "The Connoisseur in America," *Connoisseur,* 136 (December 1955), p. 305; CAI 1955, n.p., pl. 2; Diggory Venn, "Enigma in Williamstown," *New England Home,* 3 (January–February 1956), p. 16; CAI 1958a, n.p., pl. XXXV; R. Ammi Cutter, "Art—A Museum in the Mountains," *Appalachia,* 32 (December 1959), pp. 568–69; Lloyd Goodrich, *Winslow Homer* (New York: George Braziller, 1959), pp. 14, 114, pl. 9; François Daulte, "Des Renoirs et des chevaux," *Connaissance des Arts,* 103 (September 1960), p. 31; William H. Pierson and Martha Davidson, eds., *Arts of the U.S.: A Pictorial Survey* (New York: McGraw-Hill, 1960), p. 311; Eloise Spaeth, *American Art Museums and Galleries* (New York: Harper & Brothers, 1960), p. 25; *Exhibit 16:*

Winslow Homer, exh. cat. (Williamstown, Massachusetts: Sterling and Francine Clark Art Institute, 1961), n.p.; Alfred Ten Eyck Gardner, *Winslow Homer, American Artist: His World and His Work* (New York: Clarkson N. Potter, 1961), p. 20; Jean Gould, *Winslow Homer: A Portrait* (New York: Dodd, Mead and Co., 1962), p. 114; Elizabeth Ripley, *A Biography of Winslow Homer* (Philadelphia: J.B. Lippincott Co., 1963), p. 23; "Again Winslow Homer on Mount Washington," *Appalachia,* 34 (December 1963), p. 812; *The Chronicle of the Horse,* 27 (September 4, 1964), cover; David Tatham, "Winslow Homer in the Mountains," *Appalachia,* 36 (June 15, 1966), pp. 76–77, 89; *The American Vision,* exh. cat. (New York: Public Education Association and Hirschl & Adler Galleries, 1968); *The Graphic Art of Winslow Homer,* exh. cat. (New York: Museum of Graphic Art and Whitney Museum of American Art, 1968), p. 30; D. Bruce Locherbie, *Major American Authors* (New York: Holt, Rinehart and Winston, 1970), p. 2; CAI 1972, pp. 54, 55; John Wilmerding, *Winslow Homer* (New York: Praeger Publishers, 1972), pp. 49–50, 85–86, pl. 14; Russell E. Chappell, "Winslow Homer: 'Greatest Pictorial Poet of Outdoor Life' Is Back in Town," *New York Sunday News,* April 1, 1973, p. 29; *Winslow Homer,* exh. cat. (New York: Whitney Museum of American Art, 1973), pp. 58, 134; Charles W. Millard, "Winslow Homer," *The Hudson Review,* 26 (Winter 1973–74), p. 694; Richard J. Boyle, *American Impressionism* (Boston: New York Graphic Society, 1974), pp. 86–87, 124; Sophie Monneret, *L'Impressionisme et son époque* (Paris: Editions Denoël, 1978), vol. 1, p. 283; *The Chronicle of the Horse,* 42 (March 16, 1979), cover; Miriam Soffer, "A Taste for Freedom," *NAHO,* 12 (Spring 1979), pp. 10–14; Philip C. Beam, *The Magazine Engravings of Winslow Homer* (New York: Harper & Row, 1979), p. 244; Gordon Hendricks, *The Life and Work of Winslow Homer* (New York: Harry N. Abrams, 1979), pp. 78, 81, 298; Barbara Novak, *American Painting of the Nineteenth Century: Realism, Idealism, and the American Experience* (New York: Harper & Row, 1979), pp. 169–70, 172; CAI 1981, pp. 76–77; Kathleen A. Foster, "Makers of the American Watercolor Movement," Ph.D. dissertation, Yale University, New Haven, 1982, pp. 69–70; Sara Cornell, *Art: A History of Changing Style* (Oxford: Phaidon Press, 1983), no. 451, pp. 362–64; *Winslow Homer: Watercolors,* exh. cat. (Brunswick, Maine: Bowdoin College Museum of Art, 1983), pp. 18–19, 46; CAI 1984, pp. 19, 105; Natalie Spassky, *American Paintings in The Metropolitan Museum of Art* (New York: The Metropolitan Museum of Art, 1985), vol. 2, p. 454; *Winslow Homer in the Clark Collection,* exh. cat. (Williamstown, Massachusetts: Sterling and Francine Clark Art Institute, 1986), pp. 28, 29; David Tatham, "The *Two Guides:* Winslow Homer at Keene Valley, Adirondacks," *American Art Journal,* 20, no. 2 (1988), p. 25.

Farmyard Scene, c. 1874
(A Woman Feeding Chickens and Turkeys)
Oil on canvas
12³/₈ × 18⁷/₁₆ (31.4 × 46.8)
Signed and inscribed on stretcher: W. Homer
51 W 10th St. N.Y.
No. 772

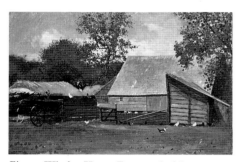

Fig. 29: Winslow Homer, **Farmyard with Duck and Chickens**, c. 1874. Oil on canvas, 15⁵/₁₆ × 22⁹/₁₆ in. (38.9 × 57.3 cm). The Cooper-Hewitt Museum, Smithsonian Institution, New York; Gift of Mrs. Charles Savage Homer, 1918-20-4.

Winslow Homer's primary subject during the 1870s was rural America. Although pastoral landscapes provided the backdrop, these paintings most often were centered around human activity, especially that including women and children. The artist's frequent trips to the countryside north of New York City made appropriate scenes and models readily available.

The theme of life in rural America was a popular one for many of Homer's genre-painting colleagues, among them Eastman Johnson (1824–1906), Enoch Wood Perry (1831–1915), and Thomas Waterman Wood (1823–1903). The attraction of this subject in the 1870s was due in large part to the growing nostalgia in postwar America for the simple agrarian way of life that was vanishing with increasing industrialization. While artists such as Wood or Perry depicted this life in anecdotal, sentimental scenes, Homer relied on close but impartial observation.[1]

Farmyard Scene simply portrays a woman feeding chickens. Many of Homer's early to mid-1870s works, including *The Dinner Horn* (1873; The Detroit Institute of Arts), *Gloucester Farm* (1874; Philadelphia Museum of Art), *Weaning the Calf* (1875; North Carolina Museum of Art, Raleigh), and *Milking Time* (1875; Delaware Art Museum, Wilmington), picture similar daily farm tasks. Although the Clark picture is undated, it is most likely the product of this same period. The *Evening Post* reported that among Homer's entries at the Century Club art exhibition in February 1875 was "a farmyard study with the figure of a girl feeding chickens. . . ."[2] It was often Homer's practice to show his smaller pictures and sketches at venues like the Century Club in the season following their execution. Thus, while *Farmyard Scene* could have been painted as early as 1872 when Homer visited Hurley, New York, it is more likely that the picture was created during the summer of 1874 at the Walden, New York, residence of Lawson Valentine, Homer's brother's business partner.

Homer remarked in 1880: "I prefer every time a picture composed and painted outside,"[3] and the rapid, sketchlike execution of *Farmyard Scene* does indicate that the work may have been painted outdoors. After Homer carefully drew the architectural elements on the canvas, the picture was rapidly painted in short, broad strokes. The speed of Homer's working method is also evident in the chickens, which are indicated in a shorthand of color notations. Moreover, the figure seems to have been painted over still wet landscape elements.[4] Whether or not

Homer first conceived the small canvas without a figure, as in *Farmyard with Duck and Chickens* (fig. 29), the wet-into-wet process is another sign of on-the-spot painting.

Farmyard Scene continued the study of outdoor light and color that Homer had begun in the mid-1860s (pp. 63–67). To this end, he chose a viewpoint at an angle to the buildings and a time of day—late afternoon—that enabled him to explore the patterning of light and shade over a variety of colored shapes. Alternating light and shadow and bright and subdued colors across horizontal, vertical, and angled surfaces, he could both define the variety of forms and create a decorative pattern.

Whereas *Farmyard Scene* was certainly dependent on what the artist saw, his presentation was no doubt influenced by other art. Rejecting the tightly painted, storytelling genre tradition of William Sidney Mount (1807–1868), Homer turned for inspiration, as did many American artists after the Civil War, to popular French painters of rural subjects such as the Barbizon painters Jean-Baptiste-Camille Corot (1796–1875) and Jean-François Millet (1814–1875) and the peasant painters Jules Bastien-Lepage (1848–1884) and Jules Breton (1827–1906), all of whose works he could have seen firsthand during his 1867 trip to Europe as well as in Boston and New York.[5] In the Barbizon style Homer would have found an unsentimental and non-narrative approach as well as a reliance on direct observation. From the French peasant painters, who accentuated the design qualities of their canvases, he learned about the manipulation of composition, light, and color. Lastly, the juxtaposition of colors in *Farmyard Scene,* particularly orange and blue and yellow and green, may have resulted from his reading of Michel-Eugène Chevreul's treatise on color theory.[6]

Homer's artistic sophistication in these pictures of rural life was noted by Henry James, even though James found Homer's choice of subject repulsive: "He is almost barbarously simple . . . but there is nevertheless something one likes about him. . . . We frankly confess that we detest his subjects. . . . He has chosen the least pictorial features of the least pictorial range of scenery and civilization; he has resolutely treated them as if they were *pictorial* . . . and, to reward his audacity, he has incontestably succeeded."[7] James recognized in these pictures of farm life exactly what Homer was pursuing in his art during the mid-1870s and indeed for much of his life: the depiction of ordinary life without false picturesqueness but with a

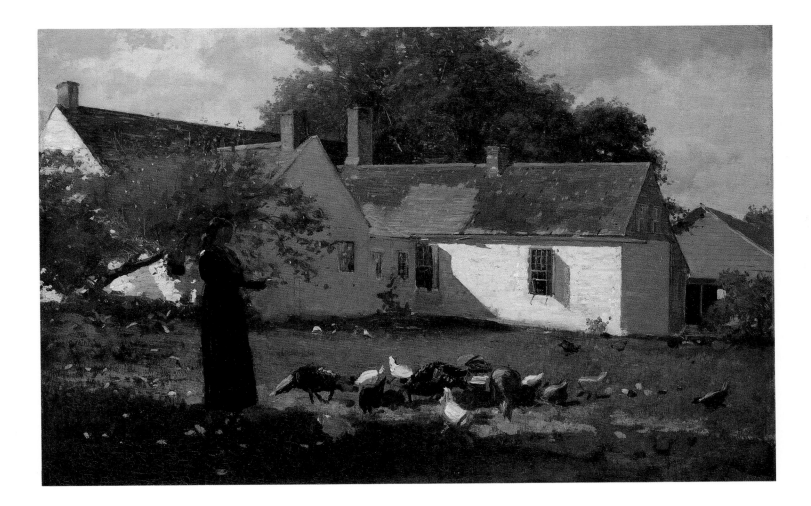

premeditated artistic perception. *Farmyard Scene* presents a woman feeding her stock in the warmth of a late afternoon sun. Homer's direct and truthful observations, joined with a sensitive arrangement of color and light, evoke a simple and harmonious life which was, by 1874, already associated with America's past.

1 For the different ways this nostalgia manifested itself in American painting, see Patricia Hills, *The Painter's America: Rural and Urban Life, 1810–1910*, exh. cat. (New York: Whitney Museum of American Art, 1974), pp. 74–83.

2 "City Intelligence. Art at the Century," *New York Evening Post*, February 8, 1875, p. 3.

3 Quoted in George Sheldon, "Sketches and Studies—II," *The Art Journal*, 6 (April 1880), p. 107.

4 Microscopic examination of the painting revealed that the landscape does exist underneath the woman's dress. The indistinctness of the layers suggests that the figure was painted shortly after the first layer had been applied.

5 See Michael Quick's excellent discussion of the international context of American depictions of farm life and Homer's place in it, "Homer in Virginia," *Los Angeles County Museum of Art Bulletin*, 24 (1978), pp. 61–81. From 1855 on, Barbizon pictures by Millet, Jules Dupré (1811–1889), and Charles-Émile Jacque (1813–1894) as well as the peasant works of Jules Breton were available in Boston and New York. The most thorough investigation of French art in the United States between 1850 and 1870 is Lois Marie Fink, "The Role of France in American Art," Ph.D. dissertation, University of Chicago, 1970.

6 Homer had owned an English translation of Chevreul's book, *The Laws of Contrast of Color* (1859) since 1860. Recently, Kristin Hoermann has studied the possible influence of Chevreul

on Homer's Civil War paintings in "A Hand Formed to Use the Brush," in *Winslow Homer: Paintings of the Civil War*, exh. cat. (San Francisco: The Fine Arts Museums of San Francisco, 1988), pp. 103–19. The connection of the orange-blue palette of *Farmyard Scene* to Chevreul is therefore tempting but demands further technical study.

7 Henry James, "On Some Pictures Lately Exhibited," *Galaxy*, 20 (July 1875), pp. 96–97.

Provenance: To Charles Savage Homer (the artist's brother); to Mrs. Charles Savage Homer (his widow); to (Wildenstein and Co., New York); to Robert Sterling Clark, October 6, 1944.

Exhibitions: The Century Club, New York, February 1875; Sterling and Francine Clark Art Institute, Williamstown, Massachusetts, "Exhibit 16: Winslow Homer," June 1961, no. 14 (as *A Woman Feeding Chickens and Turkeys*); Sterling and Francine Clark Art Institute, Williamstown, Massachusetts, "Winslow Homer in the Clark Collection," June 28–October 19, 1986, no. 16.

References: "City Intelligence. Art at the Century," *New York Evening Post*, February 8, 1875, p. 3; *Century Loan Exhibition as a Memorial to Winslow Homer by the Prout's Neck Association* (Prout's Neck, Maine: Prout's Neck Association, 1936), n.p., no. 56; Philip Beam, "Winslow Homer: A Biography," Ph.D. dissertation, Harvard University, 1944, pp. 46, 47; *Exhibit 16: Winslow Homer* (Williamstown, Massachusetts: Sterling and Francine Clark Art Institute, 1961), n.p.; CAI 1972, pp. 54, 55; Gordon Hendricks, *The Life and Work of Winslow Homer* (New York: Harry N. Abrams, 1979), p. 298; CAI 1984, pp. 19, 105; *Winslow Homer in the Clark Collection*, exh. cat. (Williamstown, Massachusetts: Sterling and Francine Clark Art Institute, 1986), p. 34.

Playing a Fish,

1875 and early 1890s
(*Guide Fishing*)
Oil on canvas
11 11/16 × 18 15/16 (29.7 × 48.1)
Signed lower left: HOMER
No. 773

Homer's love of fishing and the woods led to numerous visits to the Adirondack Mountains over a forty-year period. By 1850 the Adirondacks had been opened for recreational use, and in the late nineteenth century groups of affluent men often took camping expeditions into the mountains for outdoor sport, relaxation, and camaraderie.[1] Homer usually made such trips to the wilderness with his brother Charles or a group of friends and actively participated in the life of the holiday fisherman. Yet his paintings of the Adirondacks generally deny the tourism and clubbiness of his experience.[2] In fact, many of Homer's Adirondack images showed the other side of life in the mountains: the rugged men who depended on the woods for their food and livelihood (pp. 73–77).

In the early summer of 1874, Homer and Eliphalet Terry (1826–1896), a fellow painter with a passion for fishing, visited the Baker

Farm near Minerva in Essex County, New York. During June, Homer painted a portrait of Terry fishing (fig. 30). *Playing a Fish* is a later treatment of this image. Recent examination of the painting under infrared light revealed "Winslow Homer 1875" in the area above the present signature (fig. 31), but it is now covered by an added layer of paint. Lloyd Goodrich determined, however, that the painting was reworked in the early 1890s, even though most of it does date from 1875.[3] During the 1870s and 1890s the majority of Homer's Adirondack pictures were watercolors. *Playing a Fish*, then, provides an excellent example of the relationship between Homer's watercolors and his oils at two different points in his career. At the same time, such a comparison clarifies the assertion that the second working of the canvas took place in the early 1890s.

The 1874 portrait of Eliphalet Terry falls very early in Homer's career as a watercolor-

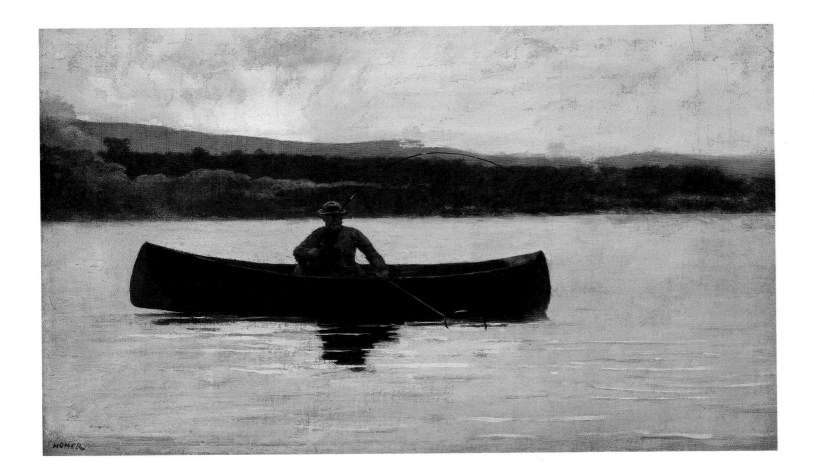

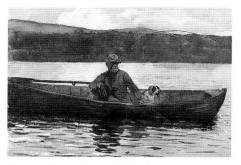

Fig. 30: Winslow Homer, **The Painter Eliphalet Terry Fishing from a Boat,** 1874. Watercolor on paper, 10½ × 13¼ in. (26.7 × 33.7 cm). The Century Association, New York.

Fig. 31: Infrared photograph of Winslow Homer, **Playing a Fish,** detail of date and signature. Sterling and Francine Clark Art Institute.

Fig. 32: Winslow Homer, **Sunrise, Fishing in the Adirondacks,** 1892. Watercolor on paper, 13½ × 20⁹⁄₁₆ in. (34.3 × 52.2 cm). The Fine Arts Museums of San Francisco, Achenbach Foundation for Graphic Arts; Purchase, Mildred Anna Williams Fund.

ist, which began seriously in 1873. As Helen Cooper has pointed out, Homer's early works in watercolor increased his interest in depicting filtered light and helped him reduce the illustrative aspect of his art.[4] For *Playing a Fish* in 1875, as in the Terry portrait, Homer used opposing forms to create a balanced image, but he further reduced the few incidentals of the watercolor. In both works Terry's reflection and that of the net on the surface of the water mirror those of the fisherman and the arc of his cast rod. In the oil, however, the figure is depersonalized since the fisherman and his boat (minus the dog) are pushed back in the water. This change makes the man's features indistinct and accentuates the layered horizontal bands of the composition. In the later repainting of the Clark picture, Homer turned what had been a rowboat into a canoe, thus strengthening this horizontal effect.

Between 1889 and 1894 Homer produced his largest number of watercolors. These works have a greater brilliance of color and light, primarily achieved through the use of a heavily loaded brush.[5] It is this technique, also found in the watercolors *Sunrise, Fishing in the Adirondacks* (fig. 32), *Adirondack Lake* (1892; Fogg Art Museum, Harvard University, Cambridge), and *Boy Fishing* (1892; private collection), that appears in the reworking of *Playing a Fish.* Homer painted over the sky and water with dry, thick brushstrokes, transforming three-quarters of the picture surface from a muted blue to the pink and ivory glow of sunrise and its reflection on a still lake.

In the final version of *Playing a Fish,* Homer presented a solitary gentleman angler, a man at peace in nature. In this sense the painting could just as easily have depicted Homer, who, with Terry, went to the mountains for moments like this one.

1 Helen A. Cooper, *Winslow Homer Watercolors,* exh. cat. (Washington, D.C.: National Gallery of Art, 1986), p. 162.

2 Ibid., p. 170.

3 Lloyd Goodrich to Wilbur Peat, March 26, 1943, Indianapolis Museum of Art.

4 Cooper, *Winslow Homer Watercolors,* p. 27.

5 Ibid., p. 166.

Provenance: Nicholls Collection, Boston; to (Schneider-Gabriel Galleries, New York); to James E. Roberts; to John Herron Art Institute, Indianapolis, 1943, bequest of James E. Roberts; to (Hirschl & Adler Galleries, New York, 1954); to (M. Knoedler & Co., New York, 1955); to Robert Sterling Clark, 1955.

Related Work: The Painter Eliphalet Terry Fishing from a Boat, 1874, watercolor on paper, 10½ × 13¼ (26.7 × 33.7), The Century Association, New York.

Exhibitions: Babcock Gallery, New York, "Works by Winslow Homer," December 8–30, 1941, no. 17; Sterling and Francine Clark Art Institute, Williamstown, Massachusetts, "Exhibit 16: Winslow Homer," June 1961, no. 28; Brockton Art Center–Fuller Memorial, Brockton, Massachusetts, "Selections: Three Centuries of New England Art from New England Museums," January 15–March 2, 1969, no. 51; Myers Fine Arts Gallery, State University of New York, College at Plattsburgh, "Adirondack Paintings," January 9–30, 1972, no. 41; Sterling and Francine Clark Art Institute, Williamstown, Massachusetts, "Winslow Homer in the Clark Collection," June 28–October 19, 1986, no. 48.

References: Works by Winslow Homer, exh. cat. (New York: Babcock Gallery, 1941); Henrik Mayer, "Guide Fishing by Winslow Homer," *John Herron Art Institute Bulletin,* 30 (June 1943), pp. 11, 12; *One Hundred Five Paintings in the John Herron Art Museum* (Indianapolis: John Herron Art Museum, 1951), no. 64; *Winslow Homer in the Adirondacks,* exh. cat. (Blue Mountain Lake, New York: Adirondack Museum, 1959), p. 22; *Exhibit 16: Winslow Homer,* exh. cat. (Williamstown, Massachusetts: Sterling and Francine Clark Art Institute, 1961), n.p.; *Selections: Three Centuries of New England Art from New England Museums,* exh. cat. (Brockton, Massachusetts: Brockton Art Center, 1969); CAI 1972, pp. 54, 55; *Adirondack Paintings* (Plattsburgh, New York: Myers Fine Arts Gallery, State University of New York, College at Plattsburgh, 1972), no. 41; Gordon Hendricks, *The Life and Work of Winslow Homer* (New York: Harry N. Abrams, 1979), p. 298; CAI 1984, pp. 20, 105; *Winslow Homer in the Clark Collection,* exh. cat. (Williamstown, Massachusetts: Sterling and Francine Clark Art Institute, 1986), p. 63; *Winslow Homer Watercolors,* exh. cat. (Washington, D.C.: National Gallery of Art, 1986), p. 48 n. 14.

Two Guides pictures a pair of Adirondack mountain residents who made their living leading expeditions for sportsmen and tourists. Homer presents them on a bright but cloudy day, engaged in routine scouting activities with some of the tools of their trade—axes, bucket, and pack basket. The men and the landscape relate directly to people and a place Homer knew well.[1] Orson "Old Man" Phelps (1816–1905) and Charles Monroe Holt (1845–1921), two well-known guides from Keene Valley, New York, served as the models. Phelps, on the right, was considered by many to be the best Adirondack guide of his day. He was, among other things, the first to reach the top of Mt. Marcy, the highest Adirondack peak, and can be credited with the dissemination and popularity of the woven pack basket (such as the one he wears in the painting), which today is still associated with the Adirondack region. Phelps achieved renown in 1878 with the publication of Charles Dudley Warner's *In the Wilderness,* which devoted a chapter to him. Homer's portrait of Phelps perfectly parallels Warner's description: "a true citizen of the wilderness. . . . His features were small and delicate, and set in the frame of a reddish beard. . . . His clothes seemed to have been put on him once and for all, like the bark of a tree, a long time ago. . . . This woodsman, this trapper, this hunter, this fisherman, this sitter on a log, and philosopher, was the real proprietor of the region over which he was willing to guide the stranger."[2] Charles Monroe Holt, known as Monroe, younger and not as famous as Phelps, was still well known for his strapping figure and bright red shirt.[3] A lifelong resident of Keene Valley, Holt later became a justice of the peace and Keene Valley town supervisor. Homer painted these two men as identifiable individuals, but in the larger context of the painting they exemplify the types of which they were supreme examples.

A view of Beaver Mountain provided Homer with the landscape setting for the painting. The mountain was not far from the Baker family farm near Minerva, New York, which Homer had visited in 1870 and to which he came twice in 1874. During the early 1870s, Baker's farm was more than a twenty-four-hour journey from New York City by boat, train, stage, and carriage.[4] The Bakers provided artists, sportsmen, and tourists with rustic hospitality in a remote setting.[5] Beaver Mountain had first appeared in Homer's work in an illustration for *Every Saturday,* December 24, 1870, captioned *Trappers in the Adirondacks.* The symmetrical cone shape of the mountain peak must have had a special

appeal to the artist, for it appears in at least two other works from his 1874 Minerva visits: *Camping Out in the Adirondack Mountains,* a *Harper's Weekly* illustration for November 7, 1874, and *Beaver Mountain, Adirondacks, Minerva, N.Y.* (fig. 33). The mountain can be seen in more than twenty of Homer's works between 1874 and 1902.

The last digit of the date inscribed in the lower left corner of *Two Guides* is obscured; it most closely resembles a five.[6] Since there is no evidence that Homer was in the Adirondacks in 1875, the picture was most likely painted during the winter after his 1874 fall trip. In October 1874 Homer was in Keene Valley with a group of fellow artists. Since it would have been unusual for Phelps and Holt to guide near Beaver Mountain, some thirty miles to the south of their headquarters at Keene Valley, the two guides, along with Homer and his friends, probably made a special trip to the Baker farm at that time. The autumnal palette of *Two Guides* suggests this, as does that of *Beaver Mountain, Adirondacks, Minerva, N.Y.,* which also includes Phelps in the background.[7]

By placing the two guides, one old, one young, in a clearing where old stumps, freshly cut trees, thinned scrub, and new growth freely mix, Homer presents the ordinary life cycle for man and nature. Reviewers of the painting in the 1890s specifically read the image as one where one generation was passing on knowledge to the next.[8] Homer often used a pair of figures in his works,[9] and here the pairing helps to distinguish the similarities and differences between the two men. In the words of a *New York Times* critic, "There is something free and audacious in his [the younger man's] pose beside the weather-beaten old guide with his grizzled beard and slouch hat; something finer and nobler than mere size and good health."[10]

The guides are at the center of a structural arrangement that also conveys their complicated relationship to the land. Axes in hand, they are pointedly shown to be among those who destroy natural environments. Concern for preserving the wilderness was already being voiced in America. In 1872 Yellowstone National Park was established and Arbor Day was dedicated to restoring trees. That the process of destruction was already underway in the Adirondacks in the mid-1870s is indicated in the painting by the juxtaposition of the older guide and weathered stumps with the younger figure and the more recently cut trees and scrub growth.[11] Nevertheless, though the guides' supremacy over their environment is alluded to by their commanding presence and axes, the extensive

Two Guides, c. 1875
(*The Guides*)
Oil on canvas
24¼ × 38¼ (61.6 × 97.2)
Signed and dated lower left: Winslow Homer/
187[?]
No. 3

Fig. 33: Winslow Homer, **Beaver Mountain, Adirondacks, Minerva, N.Y.,** *c. 1876. Oil on canvas, 13⅜ × 18⅜ in. (34 × 46.7 cm). The Newark Museum, New Jersey; Purchase, 1955.*

*Fig. 34: Winslow Homer, **Crossing the Pasture**, c. 1872. Oil on canvas, 26⅛ ×38⅛ in. (66.4×96.8 cm). Amon Carter Museum, Fort Worth.*

mountain view around and behind them implies their dependency on nature.

The composition of *Two Guides* attests to Homer's interest in design. The overlapping masses placed along diagonal planes and the low viewpoint flatten the surface of the picture, heightening our awareness of the painting as an arrangement of shapes over the canvas surface. Homer's use of light and rendering of atmosphere enhance the painting's design and the definition of the figures and landscape. The clouds that float across Beaver Mountain add a diagonal reinforcement to the banded design of the picture, while illustrating the misty conditions prevalent in the Adirondacks. In a similar way, the bright light that floods through the clouds and glitters sporadically across the canvas is faithful to the realities of an Adirondack day, but it also creates a patterning of bright colors across the foreground.

Although Homer's pictorial conception of *Two Guides* was his own, it depends on a variety of other art. His interest in flat patterns on a surface and his use of a figure set starkly against a background may have been derived from the combined influences of his illustration experience, Japanese prints, and the works of William Sidney Mount (1807–1868), Jules Breton (1827–1906), and Jean-François Millet (1814–1875).[12]

Two Guides exemplifies the main concern of Homer's art throughout the 1870s: the depiction of a contemporary subject through the meshing of objective realism and a desire to work out interesting compositions. The use of two monumentalized figures against a flattened background appears in other Homer works of the early to mid-1870s, such as *Crossing the Pasture* (fig. 34), *Boys in a Pasture* (1874; Museum of Fine Arts, Boston), *Gloucester Farm* (1874; Philadelphia Museum of Art), and *The Cotton Pickers* (1876; Los Angeles County Museum of Art). These works announced a new level of maturity for the artist, which was appreciated by critics during the 1880s and 1890s. In 1880 S.G.W. Benjamin recognized the growing sophistication in Homer's approach to subject: "The key-note of his art seems to be the realistic endeavor to place man and nature, landscape and *genre,* in harmonious juxtaposition; never alone, but both aiding each other, they are ever the themes of his brush."[13] An 1895 article surveying the first thirty years of Homer's career articulated the new technical merits achieved in a painting like *Two Guides:* "In the middle of the seventies Mr. Homer . . . discovered his métier and embraced a scheme of color which has been uniformly vigorous, vivid, in perfect accord with the virile brushing and strong draftsmanship."[14]

When *Two Guides* was first shown at the National Academy of Design in 1878, how-

ever, it received little recognition. Although its exhibition coincided with the publication of Warner's *In the Wilderness,* the lion's share of critical attention went to Homer's images of blacks. Moreover, at this stage in his career, Homer's technique was still often condemned for its lack of finish. The critic for *The Sun* called all of Homer's Academy entries for 1878 "sketchy and slovenly."[15] What the critic may have been alluding to in *Two Guides* was the thinness and lack of traditional modeling in the painting of the legs of the old man. In a general way, however, Homer was praised for his truthful themes and seriousness, and *Two Guides* was admitted to be better than its companions.[16]

It was during the 1890s that Homer, and specifically *Two Guides,* received the greatest praise. The use of the wilderness for recreation and the conservation movement that had begun in the 1870s had fully blossomed. Homer, a property owner in the Adirondacks since 1886, had a large number of watercolors of Adirondack subjects on the market. They were immensely popular and most likely bolstered the reception of *Two Guides.* Furthermore, by this time the Impressionist aesthetic had been accepted in American art, so that Homer's technique was no longer considered loose and unstructured. In 1898 a critic could refer to the picture as "a vigorous bit of realism."[17] Lastly, the popularity of this picture and Homer in general also must be attributed to the patronage of Thomas B. Clarke.[18] From the late 1870s on, Clarke had bought and exhibited many works by Homer, and he probably purchased *Two Guides* from the artist in 1890 or 1891.[19] By March 1892 Homer wrote Clarke: "I have never for a moment forgotten you in connection with what success I have had in Art."[20] In the eight years between 1891 and 1899, when Clarke sold his entire collection, *Two Guides* was exhibited no fewer than four times.

1 David Tatham kindly shared with me all of his information concerning Homer in the Adirondacks, which he has gathered during many years of research and excellently chronicled in "The *Two Guides:* Winslow Homer at Keene Valley, Adirondacks," *American Art Journal,* 20, no. 2 (1988), pp. 20–34. Unless otherwise indicated, all the facts in this entry are taken from Tatham's article.

2 Charles Dudley Warner, *In the Wilderness,* first published in installments in the *Atlantic Monthly,* 1878, reprinted in *The Complete Writings of Charles Dudley Warner* (Hartford, Connecticut: American Publishing Co., 1904), vol. 6, pp. 74–75.

3 Tatham, "The *Two Guides,*" p. 31, identified the shirt as that from a fire company. However, Mrs. Lapine, a current resident of Keene Valley, New York, who knew Holt when she was a child, remembers him being well known for wearing a red long-underwear shirt in all sea-

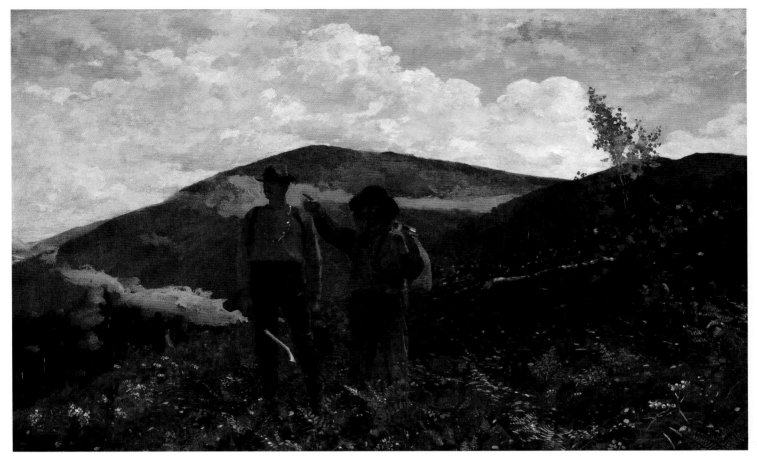

Two Guides

sons, and it seems possible that Homer embellished that piece of Holt's clothing. Mary Bell, Essex County Historical Society, gathered Mrs. Lapine's reminiscences for me in conversations, May 1989.

4 *Winslow Homer in the Adirondacks,* exh. cat. (Blue Mountain Lake, New York: Adirondack Museum, 1959), p. 14.

5 At this time the Adirondacks were considerably more remote than the White Mountains or the Lake George area; see David Tatham, "Winslow Homer in the Mountains," *Appalachia,* 36 (June 15, 1966), p. 85.

6 The number probably was always fuzzy, but paint loss and thinning due to restoration work have made it even less legible. The first notices of the painting that mention a date, such as the reviews of the 1898 Union League Club exhibition, consistently use 1876. It should be remembered, though, that due to the Centennial, 1876 was the year of the mid-decade that stuck in people's minds over time; see "Art at the Union League Club," *The New York Times,* March 11, 1898, p. 7, and also "The Art World: The Paintings of Two Americans, Notes," *The Commercial Advertiser* (New York), March 11, 1898, p. 4.

7 There is the possibility that both paintings conflate separate visits to Minerva and Keene Valley in 1874. *Two Guides,* measuring 38 inches in width, is no doubt a studio creation. *Beaver Mountain, Adirondacks, Minerva, N.Y.* is smaller in size and less finished, suggesting that it might have been worked at least in part outdoors. Unfortunately, the smaller work is undated, so the exact relationship between the two remains a mystery.

8 Tatham, "The *Two Guides,*" p. 19.

9 John Wilmerding has explored Homer's use of pairs in "Winslow Homer's *Right and Left,*" *Studies in the History of Art,* 9 (Spring 1980), pp. 59–85.

10 "Art at the Union League," *The New York Times,* February 14, 1890, p. 4.

11 Homer's use of tree stumps and their meaning has been most effectively treated in Nicolai Cikovsky, Jr., "The Ravages of the Axe," *The Art Bulletin,* 61 (December 1979), pp. 611–26.

12 The question of other influences, especially European, on Homer's art of the 1870s is a difficult one, with which scholars have only begun to grapple; see Wilmerding, "Winslow Homer's *Right and Left,*" and *Winslow Homer* (New York: Praeger Publishers, 1972), pp. 89–94, as well as Michael Quick, "Homer in Virginia," *Los Angeles County Museum of Art Bulletin,* 24 (1978), pp. 61–81.

13 S.G.W. Benjamin, *Art in America* (New York: Harper & Brothers, 1880), p. 117.

14 "Winslow Homer," *New-York Daily Tribune,* May 26, 1895, part 3, p. 25.

15 "The National Academy of Design, II," *The Sun* (New York), April 14, 1878, p. 3.

16 Among the reviews that included this kind of praise while still denouncing Homer's technique and style are: "The National Academy of Design (2nd Notice)," *Art Journal,* 2 (June 1878), pp. 189–90, and "American Painters—Winslow Homer and F.A. Bridgman," *Art Journal,* 4 (August 1878), p. 227.

17 "The Art World," p. 4.

18 See H. Barbara Weinberg, "Thomas B. Clarke: Foremost Patron of American Art from 1872–1899," *American Art Journal,* 8 (May 1976), pp. 60–75.

19 We know that Clarke definitely had the picture by October 1891, when it was exhibited as part of his collection at the Pennsylvania Academy of the Fine Arts, Philadelphia, but he may have purchased it out of the Reichard Gallery exhibition in March 1890.

20 Homer to Clarke, quoted in Weinberg, "Thomas B. Clarke," p. 59.

Provenance: To (Gustav Reichard Gallery, New York); Thomas B. Clarke, New York by October 1891; to (American Art Association, New York, sale of Clarke collection, February 15–18, 1899, no. 360); to Chauncey J. Blair, Chicago; to (Scott and Fowles, New York, 1916); to Robert Sterling Clark, November 3, 1916.

Related Work: Beaver Mountain, Adirondacks, Minerva, N.Y., c. 1876, oil on canvas, 13⅜ × 18⅜ (34 × 46.7), The Newark Museum, New Jersey; Purchase 1955.

Exhibitions: National Academy of Design, New York, "53rd Annual Exhibition," April 1–end of May 1878, no. 135; Union League Club, New York, "American Pictures by American Figure Painters," February 1890, no. 2 (as *The Guides*); Gustav Reichard Gallery, New York, March 1890; Pennsylvania Academy of the Fine Arts, Philadelphia, "Collection of Thomas B. Clarke," October 15–November 28, 1891, no. 84; National Academy of Design, New York, "Loan Exhibition: New York—Columbian Celebration," October 1892, no. 86; World's Columbian Exposition, Chicago, "Fine Arts Exhibition," May 1–October 31, 1893, no. 572; Union League Club, New York, "The Paintings of Two Americans—George Inness and Winslow Homer," March 10–12, 1898, no. 26; Carnegie Institute, Pittsburgh, "Loan Exhibition of Oil Paintings by Winslow Homer," May–June 1908, no. 158; Cleveland Museum of Art, "Inaugural Exhibition," June 6–September 20, 1916, no. 16; Sterling and Francine Clark Art Institute, Williamstown, Massachusetts, "Exhibit 4: The First Two Rooms," May 17, 1955, no. 3; Sterling and Francine Clark Art Institute, Williamstown, Massachusetts, "Exhibit 16: Winslow Homer," June 1961; Whitney Museum of American Art, New York, "Art of the United States, 1670–1960," September 27–November 27, 1966, no. 138; Whitney Museum of American Art, New York, "Winslow Homer," April 3–June 3, 1973, no. 36; Sterling and Francine Clark Art Institute, Williamstown, Massachusetts, "Winslow Homer in the Clark Collection," June 28–October 19, 1986, no. 24.

References: "The National Academy of Design, II," *The Sun* (New York), April 14, 1878, p. 3; *Catalogue of Pictures by American Figure Painters and Persian and Indian Works of Art,* exh. cat. (New York: Union League Club, 1890), n.p.; "The Monthly Exhibition of the Union League

Club," *The Studio* (New York), 5 (February 22, 1890), p. 116; "Art Notes," *The Art Interchange,* 24 (March 1, 1890), pp. 66, 68 (as *The Guides*); Montezuma, "My Note Book," *The Art Amateur,* 22 (March 1890), p. 72; *Fine Arts World's Columbian Exposition Official Catalogue* (Chicago: W.B. Conkey Co., 1893), p. 20; "Some Living American Painters: Critical Conversations by Howe and Torrey, Winslow Homer, N.A.," *Art Interchange,* 32 (May 1894), p. 137; Ripley Hitchcock, *The Art of the World, Illustrated in Paintings, Statuary, and Architecture of the World's Columbian Exposition* (New York: D. Appleton and Co., 1894), vol. 2, sect. 9, p. 150; "Winslow Homer," *New-York Daily Tribune,* May 26, 1895, part 3, p. 25; "Art at the Union League," *The New York Times,* March 11, 1898, p. 7; "Art Notes: Exhibition of Works by George Inness and Winslow Homer at the Union League Club," *The Sun* (New York), March 11, 1898, p. 6; "The Art World: The Paintings of Two Americans, Notes," *The Commercial Advertiser* (New York), March 11, 1898, p. 4; "The Fine Arts: Paintings by Inness and Homer," *The Critic,* March 19, 1898, p. 201; Samuel Swift, "Winslow Homer," *The Mail and Express* (New York), March 19, 1898, Saturday supplement, p. 11; "The Collector: Exhibitions," *The Art Amateur,* 38 (April 1898), p. 107; Christopher W. Knauff, "Certain Exemplars of Art in America—IV. Elliott Daingerfield and Winslow Homer," *The Churchman,* 78 (July 23, 1898), p. 128; "Winslow Homer," *The Art Amateur,* 39 (November 1898), p. 112; "Greatest Picture Sale," *The Sun* (New York), February 18, 1899, p. 2; Samuel Isham, *The History of American Painting* (New York: Macmillan Co., 1905), p. 355; "Correspondence: Shurtleff Recalls Homer," *Art News,* 9 (October 29, 1910), p. 4; William Howe Downes, *The Life and Works of Winslow Homer* (Boston and New York: Houghton Mifflin Co., 1911), pp. 82–83, 90, 162, 165, 178, 203, 232; Kenyon Cox, *Winslow Homer* (New York: Privately printed, 1914), pp. 24, 25, 28; Nathaniel Pousette-Dart, *Winslow Homer* (New York: Frederick A. Stokes, 1923), p. x; Theodore Bolton, "The Art of Winslow Homer: An Estimate in 1932," *The Fine Arts,* 18 (February 1932), p. 53; William Howe Downes, "American Painters of Mountains," *American Magazine of Art,* 25 (October 1932), p. 200; *Dictionary of American Biography* (New York: Charles Scribner's Sons, 1932), vol. 9, p. 189; *Century Loan Exhibition as a Memorial to Winslow Homer by the Prout's Neck Association* (Prout's Neck, Maine: Prout's Neck Association, 1936), n.p.; Lloyd Goodrich, *Winslow Homer* (New York: Macmillan Co., 1944), pp. 57–58, 117, 129, pl. 16; Helen Comstock, "The Connoisseur in America," *Connoisseur,* 136 (December 1955), p. 305; CAI 1955, n.p., pl. III; CAI 1958a, n.p., pl. XXXIX; Albert Ten Eyck Gardner, *Winslow Homer: A Retrospective Exhibition,* exh. cat. (Washington, D.C.: National Gallery of Art; New York: The Metropolitan Museum of Art, 1958), p. 71; Gorham Munson, "Maine's First Vacationist,"

Down East, 5 (January 1959), p. 26; Lloyd Goodrich, *Winslow Homer* (New York: George Braziller, 1959), pl. 39; *Winslow Homer in the Adirondacks,* exh. cat. (Blue Mountain Lake, New York: Adirondack Museum, 1959), pp. 14, 19, 22, 67; William H. Pierson and Martha Davidson, eds., *Arts of the U.S.: A Pictorial Survey* (New York: McGraw-Hill, 1960), p. 312; Albert Ten Eyck Gardner, *Winslow Homer, American Artist: His World and His Work* (New York: Clarkson N. Potter, 1961), pp. 200, 201, 202, 204–5; Jean Gould, *Winslow Homer: A Portrait* (New York: Dodd, Mead & Co., 1962), pp. 152, 239–40, 243; James Fosburgh, "Homer in the Adirondacks," *Art News Annual Portfolio* (Winter 1963), p. 73; Lloyd Goodrich, "Winslow Homer in New York State," *Art in America,* 52 (April 1964), pp. 78, 81; *Dictionary of American Biography,* rev. ed. (New York: Charles Scribner's Sons, 1964), vol. 5, pp. 186–91; Thomas C. Jones, *Shaping the Spirit of America* (Chicago: J.G. Ferguson Publishing Co., 1964), opp. p. 32; David Tatham, "Winslow Homer in the Mountains," *Appalachia,* 36 (June 15, 1966), pp. 83, 89; *Art of the United States, 1670–1960,* exh. cat. (New York: Whitney Museum of American Art, 1966), p. 150; Gorham Munson, "Winslow Homer of Prout's Neck, Maine," *The Dalhousie Review,* 47 (Summer 1967), p. 228; Matthew Baigell, *A History of American Painting* (New York: Praeger Publishers, 1971), pp. 161–63; John Wilmerding, *Winslow Homer* (New York: Praeger Publishers, 1972), pp. 93–94, 121, 171; CAI 1972, pp. 56, 57; *Art News,* 72 (May 1973), p. 70; *Winslow Homer,* exh. cat. (New York: Whitney Museum of American Art, 1973), pp. 33, 135; Charles W. Millard, "Winslow Homer," *The Hudson Review,* 26 (Winter 1973–74), pp. 695–96; H. Barbara Weinberg, "Thomas B. Clarke: Foremost Patron of American Art from 1872 to 1899," *American Art Journal,* 8 (May 1976), p. 76; Michael Quick, "Homer in Virginia," *Los Angeles County Museum of Art Bulletin,* 24 (1978), pp. 74, 76, 77; Gordon Hendricks, *The Life and Work of Winslow Homer* (New York: Harry N. Abrams, 1979), pp. 103, 107, 137, 214, 250, 266, 275, 300; John Wilmerding, "Winslow Homer's *Right and Left,*" *Studies in the History of Art,* 9 (Spring 1980), p. 63 n. 12; Edward S. Feldmann, "As Enduring as the Mountains," *The Conservationist,* 38 (November–December 1983), p. 8; CAI 1984, pp. 20, 106; "Adirondack Park: A Painterly Celebration of the First Wilderness Preserve in History," *Wilderness,* 48 (Summer 1985), p. 31; Mary Judge, *Winslow Homer* (New York: Crown Publishers, 1986), p. 27; *Winslow Homer in the Clark Collection,* exh. cat. (Williamstown, Massachusetts: Sterling and Francine Clark Art Institute, 1986), pp. 42–43; Edith Pilcher, *Up the Lake Road: The First Hundred Years of the Adirondack Mountain Reserve* (Keene Valley, New York: Adirondack Mountain Reserve, 1987), p. 11; David Tatham, "The *Two Guides:* Winslow Homer at Keene Valley, Adirondacks," *American Art Journal,* 20, no. 2 (1988), pp. 20–34.

Undertow, 1886

Oil on canvas

$29^{13}/_{16} \times 47^{5}/_{8}$ *(75.7 × 121)*

Signed and dated lower right: Winslow Homer/
1886

No. 4

Fig. 35: Winslow Homer, **Study for
"Undertow"** (no. 1481a), n.d. Pencil and
black chalk on paper, $7^{1}/_{8} \times 8^{5}/_{8}$ in. (18.1
×21.9 cm). Sterling and Francine Clark Art
Institute.

Fig. 36: Winslow Homer, **Study for
"Undertow"** (no. 1481b), n.d. Pencil on
paper, $5 \times 7^{13}/_{16}$ in. (12.7 × 19.8 cm). Sterling
and Francine Clark Art Institute.

At Prout's Neck between 1884 and 1886, Homer completed six major oils, of which *Undertow* was the last.[1] Thematically, they focus on man facing the power of nature and, in particular, of the sea. Whereas four center around the work of fishermen, *The Life Line* and *Undertow* represent imperiled women saved by men—unlike Homer's Cullercoats images, which ennobled stalwart females who worked as hard as their men.[2]

Exactly what is depicted in *Undertow* has been best described in the 1911 Metropolitan Museum of Art Homer memorial exhibition catalogue: "Two exhausted women, clinging to each other, are being drawn toward shore by two men. The man at right . . . lifts one of the women by her blue bathing suit; at the left a man . . . is struggling against the current, his right hand raised to shield his eyes from the glare and the left one dragging a rope, which is fastened about the waist of a woman whose face is upturned."[3] Women were still not regularly taught to swim before the turn of the century, and near or actual drownings were an all-too-common event.[4] In fact, although *Undertow*'s composition was a product of Homer's imagination, the painting is based on an actual incident. In the summer of 1883, Homer visited Atlantic City, New Jersey, to see a demonstration of a breeches buoy, an experience he drew upon for *The Life Line*. During his stay he also witnessed a rescue.[5]

It seems that the idea for the painting simmered in Homer's mind until 1886. An 1887 review of the picture noted: "Probably no one will ever know the amount of work which has entered into this picture; it is the result of a year's labor."[6] Seven drawings and two etchings, all at the Clark, directly relate to *Undertow* (figs. 35–43) and help reveal the artist's working process. They all focus on the presentation of the figures, drawn singly, in pairs, or in threes. It is difficult to discern the order of the drawings and their relationship to the etchings. Only one (fig. 37) is dated (April 25, 1886); another (fig. 38) is inscribed "No. 1," but it may refer to Homer's preference for the figural arrangement rather than an order of execution. Whatever their sequence, the drawings indicate that Homer experimented with at least one substantially different composition, for in one of them (fig. 35) the two women are standing. At one time he even X-ed out what seems to have become the final arrangement (fig. 40).

Once Homer decided on a general layout for the left-hand male and the two women, he labored over their relationship and individual forms. He considered showing the faces of both women (figs. 36, 37, and 41), but his greatest concern seems to have been for the flow of the figures' lines. In both figs. 36 and 37, the figures are tightly compacted, and the heavy outlines underscore the curving lines that dominate the final painting. Homer turned the face of the woman on the right aside but continued to be dissatisfied with the figure at the far left; it is scribbled over (fig. 38). Only by redrawing the man (fig. 39) and overlaying that drawing on the drawing marked "No. 1," did he come closest to the final work both in composition and indications of light and dark moving across the bodies (fig. 44). The two etchings (figs. 42, 43) concentrate on the women's figures, particularly the modeling of the forms. Infrared light reveals that for the final picture Homer gently shifted the positions of the women's bodies and the right-hand figure to balance the composition.

The friezelike presentation of the figures in *Undertow* had appeared in Homer's work as early as his 1866 *Prisoners from the Front* (The Metropolitan Museum of Art, New York), but in *Undertow* there is a much greater emphasis on line and modeled form. The result was more monumental, sculpturesque figures. To achieve this, Homer supposedly drenched his models so that he could study wet drapery over the female form.[7] He then added lines around the drawn figures and brightly highlighted different parts of the individual anatomies. This method not only yielded a greater sense of three-dimensionality but created a sinuous curve through the figure group to hold it together.

Along with Homer's other paintings of 1884–86, *Undertow* reflects the tremendous interest in figure painting that consumed American art in the 1880s.[8] Contemporaneous critics such as S.G.W. Benjamin found American painting in its healthiest state, due to "the increased study given to the human figure and the growing attention bestowed on subjects suggested by the great drama of human life."[9] John Wilmerding has suggested that Homer's exposure to antique sculpture at the British Museum during his 1881–82 English sojourn also may have encouraged the artist to seek both a greater definition of form and a dependence on line.[10] However, the emphasis on outline in *Undertow* should also be connected to Homer's excursions into etching, which began in 1884, and which he found to be useful in working out the two central figures of the painting.

The seascape in *Undertow* was no less carefully considered than the figures. Homer's

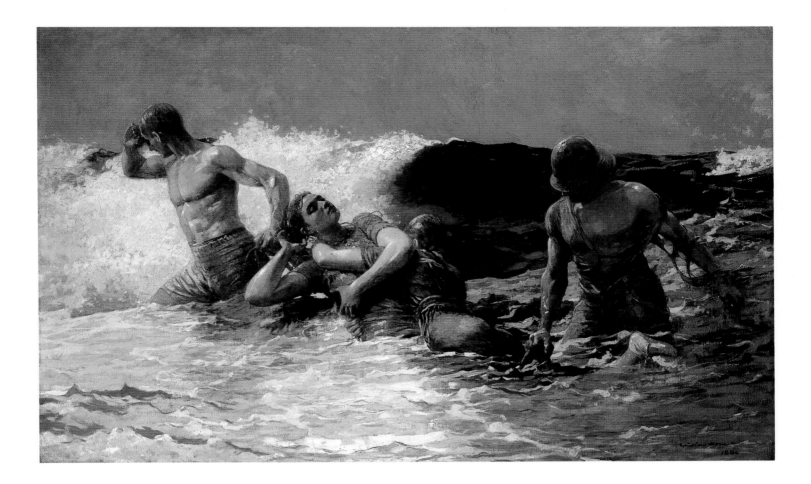

Fig. 37: Winslow Homer, **Study for "Undertow"** (no. 1481c), April 25, 1886. Pencil on paper, 5¾ × 7¼ in. (14.6 × 18.4 cm). Sterling and Francine Clark Art Institute.

Fig. 38: Winslow Homer, **Study for "Undertow"** (no. 1481d), n.d. Pencil and black chalk on paper, 5¾ × 8⅞ in. (14.6 × 22.5 cm). Sterling and Francine Clark Art Institute.

Fig. 39: Winslow Homer, **Study for "Undertow"** (no. 1481e), n.d. Pencil on paper, 5⁵⁄₁₆ × 3⁹⁄₁₆ in. (13.5 × 9.1 cm). Sterling and Francine Clark Art Institute.

continual study of the ocean in her various moods at Prout's Neck gave him objective knowledge, and he manipulated the paint in broad, thick strokes to create a convincing effect of the water's liquidity and action. The dark, blue-green curl of the wave was contrasted against the scumbled whites and lighter blues that constitute the foam. The foreground's rough surf is rendered in light and dark opaque slashes on top of a yellow-gray ground. This kind of treatment added texture to the surface of the canvas as it formed a rich surround for the figure group.

The wave in *Undertow* may owe its configuration and tactile texture not only to what Homer had seen in nature but also to the work of Gustave Courbet (1819–1877). In December 1883, less than six months after witnessing the rescue operation that sparked the idea for *Undertow*, Homer could have seen Courbet's *La Vague* of c. 1869 at the Pedestal Fund Art Loan exhibition in New York.[11] Courbet's inclusion in that exhibition was controversial, and some of his works were decried as ugly, but his realism and ability to impart texture were praised.[12] The biggest New York art event of the 1883–84 season, the exhibition surely would have come to Homer's attention, even though he was living in Prout's Neck. A comparison of *Undertow* and Courbet's *La Vague* (fig. 45) shows waves remarkably similar in structure and textural definition.[13]

Of Homer's 1884–86 paintings, *Undertow* is the only work depicted in full sunlight. It may be that the bright light of the artist's winter 1885–86 watercolors of the Caribbean spilled over onto this oil. But the brightness of *Undertow* is without warmth. Homer worked with a limited palette based in cool colors appropriate to the iciness of the setting. Yet by flooding the canvas with light, he was able to include a shimmering surface and add highlights to the four bodies, thereby accentuating pattern as well as form. The suggested glare also justified the gesture of the left-hand man shielding his eyes.

Despite one critic's description of *Undertow* as "a familiar incident from modern life,"[14] Homer's subject, disguised as an everyday event, was man's struggle against an indifferent nature. The frozen, monumental figure group raised a common occurrence to a loftier plane, and the lack of anecdote produced what Kenyon Cox called "the story of big and simple issues."[15] In the 1870s Homer had generally depicted a harmonious relationship between man and the elements or one in which man was the victor. His experience of life by the sea in the 1880s resulted in a more pessimistic view. In *Undertow*, men perform a heroic act, but it is not clear whether they are successful. The women still seem alive — how else could they hold on? — but their ultimate fate is uncertain. Although some

scholars have suggested a psychosexual reading of *Undertow*, connecting the painting to Homer's personal life, the subject reads most clearly as a statement about life and death, inspired by Homer's attitude toward nature, with a composition relating to his artistic concerns.[16]

Undertow had two inaugural showings after Homer completed it in December 1886. During January and February 1887, it was featured at Doll and Richards Gallery in Boston; more important, it represented Homer at the annual exhibition of the National Academy of Design in April and May. From its first public appearance *Undertow* was accorded masterpiece status. Most obvious in the reviews, which numbered nearly twenty in the first half of 1887, is unabashedly high praise for the painting as a whole. Typical is the review in the *New York Herald*, which began by describing *Undertow* as "the star painting of the exhibition."[17] Phrases such as "most striking," "outranks every picture," "deserves honor," and "beyond question or criticism" can frequently be found in the reviews.[18] Only Clarence Cook could find no redeeming features in the painting.[19]

The nineteenth-century critics, writing at a time when technique and style were the critical issues of American art, based their high opinions of the painting primarily on its technical merit. It was *how* Homer had painted *Undertow*, not *what* he had painted, that was considered a great success. The reviewer of the Academy show in *The Critic* summed up many of the points about the figures that were found so praiseworthy: "Winslow Homer's *Undertow* is a picture in which four figures . . . are made to assume magnificent combinations of line, and to present an heroic sculpturesque effect which endows them with the quality of the antique. . . . Mr. Homer's . . . thorough understanding of the human figure and his brilliant draughtsmanship were never better shown than in this powerful group."[20] Equally successful was the figures' presentation in the composition. John R. Tait noted that *Undertow*'s composition "rises to the height of tragedy. . . . The charm of the picture lies in its reserve. The story is vividly told while the horrors of the situation are subordinated, with true aesthetical insight, to a simple heroism. . . . The gracefulness of the presentation softens its realism, while the matter-of-fact, business-like bearing of . . . the rescuers takes away . . . the sense of danger."[21] To Tait and his fellow art writers, Homer's use of seemingly suspended motion, the truthful and honest portrayal of the figures that does not force the subject on the viewer, and the lack of exaggerated action or repulsive detail all contributed to *Undertow*'s grace, realism, and power.[22]

Despite all the positive press surrounding the 1887 exhibition of *Undertow,* the painting remained unsold for two years. Perhaps its disaster subject put off potential buyers. In any case, for the rest of the decade Homer concentrated on watercolors. When he returned to painting the sea in oil in the early 1890s, his theme was still the raw and relentless power of nature, but rarely again did figures play such a prominent role. The disappearance of figures from Homer's paintings coincided with the reassertion of landscape as an important subject in American art in the 1890s.[23] Homer concentrated on the depiction of the ocean near Prout's Neck for the rest of his career.

1 The other five are: *The Life Line* (1884; Philadelphia Museum of Art), *The Fog Warning* (1885; Museum of Fine Arts, Boston), *The Herring Net* (1885; The Art Institute of Chicago), *Lost on the Grand Banks* (1885; Los Angeles County Museum of Art), and *Eight Bells* (1886; Addison Gallery of American Art, Phillips Academy, Andover, Massachusetts).

2 Only twice before had Homer depicted drowned women: in 1863 in an illustration for M.E. Braddon's short tale of gothic horror, "The Cold Embrace," and in 1873 to accompany *Harper's* report of the wreck of the steamship "Atlantic"; see Phoebe Lloyd, "Death and American Painting: Charles Willson Peale to Albert Pinkham Ryder," Ph.D. dissertation, Graduate Center, City University of New York, 1980, pp. 225–31. For an excellent discussion of Homer's Cullercoats pictures, see William H. Gerdts, "Winslow Homer in Cullercoats," *Yale University Art Gallery Bulletin,* 36 (Spring 1977), pp. 18–35.

3 *Catalogue of a Loan Exhibition of Paintings by Winslow Homer,* exh. cat. (New York: The Metropolitan Museum of Art, 1911), p. 10.

4 Reviewers of *Undertow* remarked on the familiarity of the picture's theme. Comments on the frequency of such incidents can be found in Augustus Stonehouse, "Winslow Homer," *Art Review,* 1 (February 1887), p. 14, and "The National Academy Exhibition," *The Art Amateur,* 16 (May 1887), p. 125.

5 That *Undertow* was based on fact was initially mentioned in a newspaper review at the time of the picture's first exhibition at Doll and Richards in January 1887; see "Art Notes—American Pictures at Doll and Richards," unidentified newspaper clipping, Winslow Homer scrapbooks, Bowdoin College Museum of Art, Brunswick, Maine (Archives of American Art, roll 2932).

6 Ibid.

7 Kenyon Cox, "The Art of Winslow Homer," *Scribner's Magazine,* 56 (September 1914), p. 379.

8 For a general overview of this trend, see Richard N. Murray, "Painting and Sculpture," in *The American Renaissance 1876–1917,* exh. cat. (New York: The Brooklyn Museum, 1979), pp. 153–89.

9 S.G.W. Benjamin, "American Art since the Centennial," *New Princeton Review,* 4 (July, September, November 1887), p. 27.

10 John Wilmerding, *Winslow Homer* (New York: Praeger Publishers, 1972), pp. 133–34.

11 The exhibition was held to raise funds for the base of the Statue of Liberty; see Maureen C. O'Brien, *In Support of Liberty,* exh. cat. (Southampton, New York: Parrish Art Museum, 1986).

12 Ibid., pp. 140–42.

13 Homer's reversal of Courbet's composition suggests the possibility that he may have seen the Frenchman's work in engraved reproduction rather than in person.

14 "The National Academy Exhibition," p. 125.

15 Kenyon Cox, *Winslow Homer* (New York: Privately printed, 1914), p. 34.

16 For psychosexual interpretations of the picture, see Henry Adams, "Mortal Themes: Winslow Homer," *Art in America,* 71 (February 1983), pp. 112–26, and Jules D. Prown, "Winslow Homer in His Art," *Smithsonian Studies in American Art,* 1 (Spring 1987), pp. 31–45.

17 "National Academy of Design," *New York Herald,* April 2, 1887, p. 3.

18 See, for example, "The Academy Exhibition," *The World* (New York), April 2, 1887, p. 2; John R. Tait, "The Academy Exhibition," *The Mail and Express* (New York), April 11, 1887, p. 3; and "Fine Arts: The Academy Exhibition, I," *The Nation,* 44 (April 14, 1887), p. 327.

19 Clarence Cook, "The National Academy of Design: The 62nd Annual Exhibition," *The Studio* (New York), 2 (May 1887), p. 192.

20 "The Fine Arts: Good Work at the Academy," *The Critic,* 7 (April 9, 1887), p. 183. Similar praise can be found in Tait, "The Academy Exhibition," p. 3, and "The Academy of Design: A Well Chosen Exhibition," *The New York Times,* April 2, 1887, p. 5.

21 Tait, "The Academy Exhibition," p. 3.

22 See also "The Academy Exhibition," *The Evening Post* (New York), April 14, 1887, p. 4. The coloration of *Undertow* is the only aspect of the painting that provoked a less-than-favorable response on the part of reviewers. Nearly every one, and some more vehemently than others, found Homer's colors too bold and discordant; or, as the critic for *The Commercial Advertiser* (New York), April 16, 1887, p. 5, succinctly put it: "His pigments want juiciness."

23 For the return to landscape in American painting in the contexts of Tonalism and Impressionism, see Wanda Corn, *The Color of Mood: American Tonalism, 1880–1910,* exh. cat. (San Francisco: M.H. de Young Memorial Museum, 1972), and William H. Gerdts, *American Impressionism* (New York: Abbeville Press, 1984).

Provenance: To Edward D. Adams, 1889; to (M. Knoedler & Co., New York, 1924); to Robert Sterling Clark, April 30, 1924.

Related Works: All the works cited below are at the Sterling and Francine Clark Art Institute, Williamstown, Massachusetts.

Study for "Undertow" (no. 1481a), n.d., pencil and black chalk on paper, 7⅛ × 8⅝ (18.1 × 21.9).

Study for "Undertow" (no. 1481b), n.d., pencil on paper, 5 × 7¹³/₁₆ (12.7 × 19.8).

Fig. 40: Winslow Homer, **Study for "Undertow"** *(no. 1481f), n.d. Pencil on paper, 5¾ × 8⅞ in. (14.6 × 22.5 cm). Sterling and Francine Clark Art Institute.*

Fig. 41: Winslow Homer, **Study for "Undertow"** *(no. 1481d: verso), n.d. Pencil on paper, 5¾ × 8⅞ in. (14.6 × 22.5 cm). Sterling and Francine Clark Art Institute.*

Fig. 42: Winslow Homer, **Study for "Undertow,"** *n.d. Etching, sheet: 9¹¹/₁₆ × 13 in. (24.6 × 33 cm), plate: 6⅝ × 10 in. (16.8 × 25.4 cm). Sterling and Francine Clark Art Institute.*

Fig. 43: Winslow Homer, **Studies for "Undertow,"** n.d. Etching (restrike), sheet: 10 × 13¹¹/₁₆ in. (25.4 × 34.8 cm), plate: 6¹⁵/₁₆ × 9¹³/₁₆ in. (17.6 × 24.9 cm). Sterling and Francine Clark Art Institute.

Fig. 44: Winslow Homer, Overlay of **Study for "Undertow"** (1481d: recto) and **Study for "Undertow"** (1481e). Sterling and Francine Clark Art Institute.

Study for "Undertow" (no. 1481c), April 25, 1886, pencil on paper, 5¾ × 7¼ (14.6 × 18.4).

Study for "Undertow" (no. 1481d), n.d., pencil and black chalk on paper, 5¾ × 8⅞ (14.6 × 22.5).

Study for "Undertow" (no. 1481d verso).

Study for "Undertow" (no. 1481e), n.d., pencil on paper, 5⁵/₁₆ × 3⁹/₁₆ (13.5 × 9).

Study for "Undertow" (no. 1481f), n.d., pencil on paper, 5¾ × 8⅞ (14.6 × 22.5).

Study for "Undertow," n.d., etching, 9¹¹/₁₆ × 13 (24.6 × 33).

Study for "Undertow," n.d., etching (restrike), 10 × 13¹¹/₁₆ (25.4 × 34.8).

Exhibitions: Doll and Richards Gallery, Boston, January–February 1887; National Academy of Design, New York, "62nd Annual Exhibition," April 1–mid-May 1887, no. 393; Pennsylvania Academy of the Fine Arts, Philadelphia, "58th Annual Exhibition," February 16–March 29, 1888, no. 174; Carnegie Institute, Pittsburgh, "12th Annual Exhibition," May–June 1908 no. 152; Königliche Akademie der bildenden Künste, Berlin, "Ausstellung Amerikanischer Kunst," 1910; The Metropolitan Museum of Art, New York, "Loan Exhibition of Paintings by Winslow Homer," February 6–March 19, 1911, no. 7; Sterling and Francine Clark Art Institute, Williamstown, Massachusetts, "Exhibit 4: The First Two Rooms," May 17, 1955, no. 4; Sterling and Francine Clark Art Institute, Williamstown, Massachusetts, "Exhibit 16: Winslow Homer," June 1961; Wildenstein and Co., New York, "An Exhibition of Treasures from the Sterling and Francine Clark Institute," February 2–25, 1967, no. 18; Museum of Graphic Art and Whitney Museum of American Art, New York, "The Graphic Art of Winslow Homer," October 29–December 16, 1968, no. 94A; Whitney Museum of American Art, New York, "Winslow Homer," April 3–June 3, 1973, no. 50; Sterling and Francine Clark Art Institute, Williamstown, Massachusetts, "Winslow Homer in the Clark Collection," June 28–October 19, 1986, no. 40.

References: "The Fine Arts: Brisk Opening of the Exhibition Season for 1887—Events of the Week," *Boston Daily Advertiser,* January 24, 1887, p. 4; Augustus Stonehouse, "Winslow Homer," *Art Review,* 1 (February 1887), p. 14; "The Academy Exhibition," *The World* (New York), April 2, 1887, p. 2; "The Academy of Design: A Well Chosen Exhibition. Strong Work by Academicians—Portraits by Munkacsy—Homer's 'Undertow'—Battlepiece by Gau.," *The New York Times,* April 2, 1887, p. 5; "The National Academy of Design," *New York Herald,* April 2, 1887, p. 3; "The National Academy of Design: 62nd Annual Exhibition," *New York Daily Tribune,* April 2, 1887, p. 4; "The Fine Arts: Good Work at the Academy," *The Critic,* 7 (April 9, 1887), p. 183; John R. Tait, "The Academy Exhibition," *The Mail and Express* (New York), April 11, 1887, p. 3; "The Academy Exhibition," *The Evening Post* (New York) April 14, 1887, p. 4; "Fine Arts: The Academy Exhibition, I," *The Nation,* 44 (April 14, 1887), p. 327; Mariana van Rensselaer, "Fine Arts: The Academy Exhibition, I," *The Independent,* April 14, 1887, p. 459; "At the Academy," *The Commercial Advertiser* (New York), April 15, 1887, p. 5; "Art Notes," *The Art Interchange,* 18

(April 23, 1887), p. 129; Ripley Hitchcock, "Spring Exhibition, National Academy," *Art Review,* 1 (April 1887), p. 2; "The Spring Picture Exhibitions," *The Sun* (New York), May 8, 1887, p. 5; Clarence Cook, "The National Academy of Design: The 62nd Annual Exhibition," *The Studio* (New York), 2 (May 1887), pp. 188–95; "The National Academy Exhibition," *The Art Amateur,* 16 (May 1887), p. 125; Mariana van Rensselaer, *Six Portraits* (Boston and New York: Houghton Mifflin Co., 1889), pp. 261–64; W[illiam] H[owe] D[ownes], "What Pictures Should the American Section of the World's Fair Contain?" *Boston Evening Transcript,* August 22, 1892, sect. The Fine Arts, p. 5; "Some Living American Painters: Critical Conversations by Howe and Torrey, Winslow Homer, N.A.," *Art Interchange,* 32 (May 1894), p. 137; William Howe Downes, *Twelve Great Artists* (Boston: Little, Brown and Co., 1900), pp. 115–18; "The Collector," *The Art Amateur,* 44 (February 1901), p. 62; *National Cyclopedia of American Biography* (New York: J.T. White, 1901), vol. 11, p. 305; Frederick W. Morton, "Art of Winslow Homer," *Brush and Pencil,* 10 (April 1902), p. 53; Charles H. Caffin, *American Masters of Painting* (New York: Doubleday, Page & Co., 1902), p. 78; Charles H. Caffin, "American Painters of the Sea," *The Critic,* 44 (December 1903), p. 550; "Notes from the Art Museums," *Brush and Pencil,* 15 (January 1905), p. 63; Sir Caspar Purden Clarke, "Still the Hoi Polloi, Bon Ton, and Metropolitan are Daft on European Art," *Brush and Pencil,* 19 (March 1907), p. 100; Kenyon Cox, "Three Pictures by Winslow Homer in the Metropolitan Museum," *The Burlington Magazine,* 12 (November 1907), p. 124; Charles H. Caffin, *The Story of American Painting* (New York: Frederick A. Stokes, 1907), p. 234; *Moderne Kunst,* 24 (June 16, 1910), pl. LIX; Christian Brinton, "Winslow Homer," *Scribner's Magazine,* 49 (January 1911), p. 19; Bryson Burroughs, "The Winslow Homer Exhibition," *Bulletin of The Metropolitan Museum of Art,* 1 (January 1911), p. 2; Frank Jewett Mather, Jr., "The Art of Winslow Homer," *The Nation,* 92 (March 2, 1911), p. 226; A.E. Gallatin, "The Winslow Homer Memorial Exhibition," *Art and Progress,* 2 (April 1911), p. 168; *Catalogue of a Loan Exhibition of Paintings by Winslow Homer,* exh. cat. (New York: The Metropolitan Museum of Art, 1911), pp. 10–11; William Howe Downes, *The Life and Works of Winslow Homer* (Boston and New York: Houghton Mifflin Co., 1911), pp. 121, 137, 142–45, 150, 183, 231, 248, 258; Kenyon Cox, "The Art of Winslow Homer," *Scribner's Magazine,* 56 (September 1914), pp. 379–80, 384, 386; Kenyon Cox, *Winslow Homer* (New York: Privately printed, 1914), pp. 33–35; J. Walker McSpadden, *Famous Painters of America* (New York: Dodd, Mead and Co., 1916), p. 184; Frederick Fairchild Sherman, *American Painters of Yesterday and Today* (New York: Privately printed, 1919), p. 31; John C. Van Dyke, *American Painting and Its Tradition* (New York: Charles Scribner's Sons, 1919), pp. 91, 102–3; H.B.W., "Early Paintings by Winslow Homer," *Bulletin of The Metropolitan Museum of Art,* 18 (February 1923), p. 38; Nathaniel Pousette-Dart, *Winslow Homer* (New York: Frederick A. Stokes, 1923), n.p.; Lloyd Goodrich, "Winslow Homer," *The Arts,* 6 (October 1924), p. 201; William Starkweather,

"He Painted the Might of the Sea," *The Mentor*, 13 (July 1925), pp. 45, 49; Eugen Neuhaus, *The History and Ideals of American Art* (Stanford, California: Stanford University Press, 1931), p. 298; Theodore Bolton, "The Art of Winslow Homer: An Estimate in 1932," *The Fine Arts*, 18 (February 1932), pp. 52, 54; *Dictionary of American Biography* (New York: Charles Scribner's Sons, 1932), vol. 9, p. 189; Lloyd Goodrich, *Winslow Homer* (New York: Macmillan Co., 1944), pp. 94–96, 102, 118, 140, 153, 169, 228, pl. 29; Clement Greenberg, "Winslow Homer's Work," *The Nation*, 159 (October 28, 1944), pp. 539–41; Philip Beam, "Winslow Homer: A Biography," Ph.D. dissertation, Harvard University, Cambridge, Massachusetts, 1944, pp. 275–77, 377, 584; "Homer, Success Story," *Art News*, 46 (March 1947), p. 60; *A Loan Exhibition of Winslow Homer*, exh. cat. (New York: Wildenstein and Co., 1947), p. 23; Helen Comstock, "The Connoisseur in America," *Connoisseur*, 136 (December 1955), p. 305; CAI 1955, n.p., pl. IV; E.P. Richardson, *Painting in America* (New York: Thomas Y. Crowell Co., 1956), p. 316; CAI 1958a, n.p., pl. XL; Lloyd Goodrich, *Winslow Homer* (New York: George Braziller, 1959), p. 27; Albert Ten Eyck Gardner, *Winslow Homer, American Artist: His World and His Work* (New York: Clarkson N. Potter, 1961), pp. 127, 192–93; *Exhibit 16: Winslow Homer*, exh. cat. (Williamstown, Massachusetts: Sterling and Francine Clark Art Institute, 1961), n.p.; "The Love Affair of Winslow Homer," *Bulletin of The New York Public Library*, 66 (September 1962), p. 448; Jean Gould, *Winslow Homer: A Portrait* (New York: Dodd, Mead and Co.), 1962, pp. 203–5, 208, 232–34, 237, 240; *Yankee Painter: A Retrospective Exhibition of Oils, Watercolors, and Graphics by Winslow Homer*, exh. cat. (Tucson: University of Arizona Art Gallery, 1963), p. 37; John McCoubrey, *American Tradition in Painting* (New York: George Braziller, 1963), p. 40; Hunter Ingalls, "Elements in the Development of Winslow Homer," *Art Journal*, 24 (Fall 1964), p. 20; *Homer and the Sea*, exh. cat. (Richmond, Virginia: Mariner's Museum and Virginia Museum of Fine Arts, 1964), p. 8; Philip C. Beam, *Winslow Homer at Prout's Neck* (Boston: Little, Brown and Co., 1966), pp. 80, 108, 149, 256; James Thomas Flexner, *The World of Winslow Homer 1836–1910* (New York: Time Incorporated, 1966), p. 115; *Winslow Homer at Prout's Neck*, exh. cat. (Brunswick, Maine: Bowdoin College Museum of Art, 1966), n.p.; John Ashbery, "Williamstown-sur-Seine," *Art News*, 65 (February 1967), p. 47; Mahonri Sharp Young, "Letter from the U.S.A.: Infinite Variety," *Apollo*, 85 (May 1967), p. 382; *An Exhibition of Treasures from the Sterling and Francine Clark Art Institute*, exh. cat. (New York: Wildenstein and Co., 1967), n.p.; *The Graphic Art of Winslow Homer*, exh. cat. (New York: Museum of Graphic Art and Whitney Museum of American Art, 1968), pp. 14–15; Russell Lynes, *The Art-Makers of 19th-Century America* (New York: Atheneum, 1970), p. 356;

Anne Lattimore, "Winslow Homer," *American Chronicle*, 1 (January 1972), pp. 41–42; CAI 1972, pp. 56, 57; John Wilmerding, *Winslow Homer* (New York: Praeger Publishers, 1972), pp. 138, 150, 168, pl. 30; Gordon Hendricks, "The Flood Tide in the Winslow Homer Market," *Art News*, 72 (May 1973), p. 70; Mahonri Sharp Young, "Letter from the U.S.A.: The Boat and the Shark," *Apollo*, 98 (September 1973), p. 228; *Winslow Homer*, exh. cat. (New York: Whitney Museum of American Art, 1973), pp. 39, 94, 136; Charles W. Millard, "Winslow Homer," *The Hudson Review*, 26 (Winter 1973–74), pp. 696–97; William H. Gerdts, *The Great American Nude* (New York: Praeger Publishers, 1974), pp. 117, 118; Philip C. Beam, *Winslow Homer* (New York: McGraw-Hill, 1975), p. 18; *Seascape and the American Imagination*, exh. cat. (New York: Whitney Museum of American Art, 1975), p. 111; Theodore Stebbins, Jr., *American Master Drawings and Watercolors* (New York: Harper & Row, 1976), pp. 204, 205; Karen M. Adams, "Black Images in 19th-Century American Painting and Literature: An Iconological Study of Mount, Melville, Homer and Mark Twain," Ph.D. dissertation, Emory University, Atlanta, 1977, p. 140; Gordon Hendricks, *The Life and Work of Winslow Homer* (New York: Harry N. Abrams, 1979), p. 128, 187–92, 250, 300; Barbara Novak, *American Painting of the Nineteenth Century: Realism, Idealism, and the American Experience* (New York: Harper & Row, 1979), pp. 185, 187; John Wilmerding, "Winslow Homer's *Right and Left*," *Studies in the History of Art*, 9 (Spring 1980), pp. 63 n. 12, 72; Phoebe Lloyd, "Death and American Painting: Charles Willson Peale to Albert Pinkham Ryder," Ph.D. dissertation, Graduate Center, City University of New York, 1980, pp. 229–31, 239; Henry Adams, "Mortal Themes: Winslow Homer," *Art in America*, 71 (February 1983), cover, pp. 117, 119–21, 124–25; Henry Adams, "Winslow Homer's 'Shall I Tell Your Fortune?'" *Birmingham Museum of Art Bulletin* (1983), n.p.; *Winslow Homer in the 1880s*, exh. cat. (Syracuse, New York: Everson Museum of Art, 1983), pp. 20, 24 n. 9; *Winslow Homer: Watercolors*, exh. cat. (Brunswick, Maine: Bowdoin College Museum of Art, 1983), pp. 23, 47; Jo Durden-Smith and Diane Desimone, "Art Town U.S.A.," *Connoisseur*, 216 (July 1984), p. 89; CAI 1984, pp. 20, 106; Mary Judge, *Winslow Homer* (New York: Crown Publishers, 1986), pp. 42–43; *Winslow Homer in the Clark Collection*, exh. cat. (Williamstown, Massachusetts: Sterling and Francine Clark Art Institute, 1986), pp. 11, 16, 52–55; Jules D. Prown, "Winslow Homer in His Art," *Smithsonian Studies in American Art*, 1 (Spring 1987), pp. 42–43; Patrick McCaughey, "Native and Nomad: Winslow Homer and John S. Sargent," *Daedalus*, 116 (Winter 1987), p. 144; *Winslow Homer: All the Cullercoats Pictures*, exh. cat. (Sunderland, England: The Northern Centre for Contemporary Art, 1988), pp. 68, 73; Anne Hollander, *Moving Pictures* (New York: Alfred A. Knopf, 1989), pp. 366, 367.

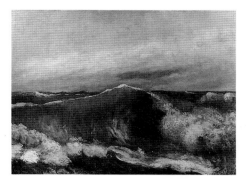

*Fig. 45: Gustave Courbet, **La Vague**, c. 1865–69. Oil on canvas, 25¾ × 34¾ in. (64.4 × 88.3 cm). The Brooklyn Museum, New York; Gift of Mrs. Horace Havemeyer, 41.1256.*

Sleigh Ride, c. 1890–95
(*Moonlight on the Snow; Sleigh Going Over a Hill — Winter Afternoon*)

Oil on canvas
$14^{1}/_{16} \times 20^{1}/_{16}$ (35.7 × 51)
Unsigned
No. 771

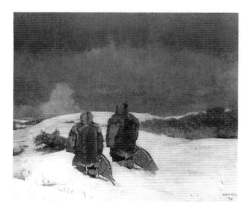

Fig. 46: *Winslow Homer,* **Below Zero**, *1894. Oil on canvas, 23^{13}/_{16} × 27^{15}/_{16} in. (60.5 ×71 cm). Yale University Art Gallery, New Haven; Bequest of George Roberts, B.A. 1905.*

Homer painted little if anything in oil between 1887 and 1889.[1] The fact that *Undertow* (pp. 78–83) did not sell immediately in 1887 seems to have discouraged him. As late as 1893, responding to a Chicago dealer who requested some work, he wrote: "At present and for some time past I see no reason why I should paint any pictures."[2]

After concentrating on watercolors for two years, Homer had returned to oil painting in 1890. The date coincides with the selling of *Undertow* in late 1889, a successful exhibition at the Gustav Reichard Gallery, New York, in March 1890, and the increased patronage of Thomas B. Clarke. At Reichard's, Homer showed mainly the 1887–89 watercolors. Only two oils, one of them *Two Guides,* were on view at Reichard's, and it seems that Clarke may have purchased *Two Guides* from the Reichard exhibition (pp. 74, 76 n. 19).

The works Homer painted immediately following the Reichard show were different from the monumental canvases of 1884–86.[3] Rather than focus on man's heroic spirit, he first looked to simpler subjects.[4] Figures, which had such an important place in works like *Life Line* and *Undertow,* were relegated to subordinate roles or eliminated, and the definite narrative implications of his eighties paintings were replaced with a viewpoint that Lloyd Goodrich has aptly characterized as "at once more realistic and more poetic."[5]

In the works of the early 1890s, Homer depicted both winter settings and the relaxed side of his life at Prout's Neck. *Sleigh Ride,* although undated, most likely was executed between 1890 and 1895. For this modest excursion in oil, Homer found a subject right outside his door. (*Summer Night,* 1890, Musée d'Orsay, Paris, represents a summertime equivalent of relaxation: girls dancing in the moonlight by the shore.) Other winter depictions of Prout's Neck painted between 1890 and 1895, of which *The Fox Hunt* (1893; Pennsylvania Academy of the Fine Arts, Philadelphia) and *Below Zero* (fig. 46) are the best known, depict the cold, frozen Maine landscape, at once beautiful and potentially life-threatening, to suggest the dynamic and paradoxical state of nature. *Sleigh Ride* lacks this undercurrent, but the human element becomes incidental; by placing the sleigh just going over a rise into the darkness, Homer was able to imply the smallness of man in nature.

Homer painted *Sleigh Ride* directly and swiftly on the canvas. No underpainting is apparent, and there were only minor adjustments.[6] The steep diagonal moving from upper left to lower right divides the canvas into a dark and a light sector, which, along with the low viewpoint, create an abstract quality. The few bold tracks leading from the bottom of the painting to the sleigh provide the only definition of movement into space. This economy of design is matched by a spareness of means. Homer used a monochromatic palette based in blue, applying the paint in broad, opaque strokes. The relatively smooth top half of the canvas is contrasted with the more vigorously painted bottom section. By showing the moon peeking out from behind dark clouds, Homer could illuminate subtle variations of color and texture. Only the brown sleigh, a stroke of red for the passenger's scarf, and the yellow-peach and black tracks depart from the light to dark blue coloration. Small as these accents are, they give a lyric syncopation to Homer's scheme.

A painting such as *Sleigh Ride* raises the question of Homer's relationship to Japonisme, Impressionism, and Post-Impressionism in the early 1890s. Scholars have credited his interest in decorative qualities, use of a diagonal, foreshortening, and off-center placement of the junction of vertical and horizontal axes to the influence of Japanese color woodblock prints.[7] Homer had been aware of these prints, called ukiyo-e, certainly by the early 1870s, and their influence had been evident in his work in varying degrees since that time.[8] In the 1890s Japonisme was very popular throughout the West,[9] and Homer, always conscious of what was in fashion in the art world, may have found it useful to accentuate these Eastern qualities in his compositions.

Homer's connection to Impressionism may be one of similar interests rather than influence. Both Homer and the Impressionists sought informal presentations of momentary incidents, looked to Japanese sources for design, and were concerned with the tactile qualities of paint. Although Homer had the opportunity to see a great deal of French Impressionism in the 1890s, the qualities and strategies his work shared with it had been evident much earlier (pp. 63–67). However, Impressionism was a favored style in America in the nineties, and it is not unlikely that Homer chose to stress its techniques in his own work. Yet his involvement in the perception of color had no connection to the Impressionists' scientific interest in optics.[10] By the 1890s, in a work such as *Sleigh Ride,* he conveyed a poetic lyricism that is antithetical to Impressionism.

In its intimate vision of the power of nature, *Sleigh Ride* takes an attitude toward art that has been associated with Post-Impressionism.[11] During the 1890s the

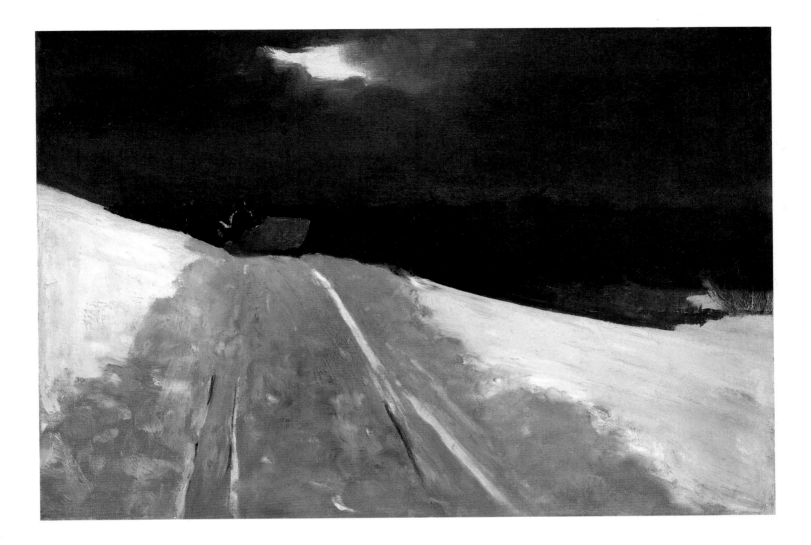

emphasis in much American and European art moved from the depiction of fact to the suggestion of feeling. *Sleigh Ride,* though small and quickly executed, is among Homer's most evocative images. By pushing strategies already part of his style to a greater simplicity and abstraction, he let us glimpse his response to the wonders of nature.

1 No dated oils exist for these years; see Lloyd Goodrich, *Winslow Homer* (New York: Macmillan Co., 1944), p. 118.

2 Ibid., p. 133.

3 For a discussion of these works, see the entry on *Undertow,* pp. 78–83.

4 Goodrich, *Winslow Homer,* pp. 118–19.

5 Ibid., p. 119.

6 The only noticeable adjustment is on the right side of the painting, where Homer lowered the sky a little in order to accentuate the diagonal.

7 Albert Ten Eyck Gardner, *Winslow Homer, American Artist: His World and His Work* (New York: Clarkson N. Potter, 1961), pp. 89–118, was the first to insist on Homer's reliance on Japanese art. Although later scholars have modified Gardner's thesis, the correlation between Homer and Japanese prints has generally been accepted. See, for example, John Wilmerding, *Winslow Homer* (New York: Praeger Publishers, 1972), passim.

8 Homer most likely became familiar with Japanese prints through his friend John La Farge (pp. 115–19). It is difficult to document exactly when the two artists met, but by 1872 they both had studios in the Tenth Street Studio Building.

9 Clay Lancaster, *The Japanese Influence in America* (New York: Abbeville Press, 1983).

10 Homer's interest in color theory has just begun to be investigated; see Kristin Hoermann, "A Hand Formed to Use the Brush," in *Winslow Homer: Paintings of the Civil War,* exh. cat. (San Francisco: The Fine Arts Museums of San Francisco, 1988), pp. 103–19.

11 Homer in general and *Sleigh Ride* in particular were briefly studied in this context in *Post-Impressionism: Cross-Currents in European and American Painting, 1880–1906,* exh. cat. (Washington, D.C.: National Gallery of Art, 1980), pp. 219–21.

Provenance: Estate of Winslow Homer; to Charles Savage Homer (the artist's brother); to Dr. George Woodward, Chestnut Hill, Pennsylvania; to (Wildenstein and Co., New York, 1944); to Robert Sterling Clark, July 7, 1944.

Exhibitions: Royal Academy of Fine Arts, Stockholm, "Utställning av Amerikansk Konst," March 15–April 7, 1930, no. 52 (as *Moonlight on the Snow*); Williamstown, Massachusetts, Sterling and Francine Clark Art Institute, "Exhibit 16: Winslow Homer," June 1961, no. 18 (as *Sleigh Going Over a Hill — Winter Afternoon*); William A. Farnsworth Library and Art Museum, Rockland, Maine, "Winslow Homer, 1836–1910," July 10–September 7, 1970, no. 15; National Gallery of Art, Washington, D.C., "Post-Impressionism: Cross-Currents in European and American Painting, 1880–1906," May 25–September 1, 1980, no. 257; Hood Museum of Art, Dartmouth College, Hanover, New Hampshire, "Winter," February 1–March 16, 1986, no. 34; Museum of Fine Arts, Boston, "The Bostonians: Painters of an Elegant Age, 1870–1930," June 11–September 14, 1986, no. 28 (shown only at the Denver Art Museum and Terra Museum of American Art, Chicago); Sterling and Francine Clark Art Institute, Williamstown, Massachusetts, "Winslow Homer in the Clark Collection," June 28–October 12, 1986, no. 49.

References: Exhibit 16: Winslow Homer, exh. cat. (Williamstown, Massachusetts: Sterling and Francine Clark Art Institute, 1961), n.p.; *Winslow Homer, 1836–1910,* exh. cat. (Rockland, Maine: William A. Farnsworth Library and Art Museum, 1970); CAI 1972, p. 56; Gordon Hendricks, *The Life and Work of Winslow Homer* (New York: Harry N. Abrams, 1979), pl. 51; *Post-Impressionism: Cross-Currents in European and American Painting, 1880–1906,* exh. cat. (Washington, D.C.: National Gallery of Art, 1980), pp. 151, 226; S. Lane Faison, Jr., *The Art Museums of New England: Massachusetts* (Boston: David R. Godine, Publisher, 1982), p. 259; S. Lane Faison, Jr., *The New England Eye: Master American Paintings from New England School, College and University Collections,* exh. cat. (Williamstown, Massachusetts: Williams College Museum of Art, 1983), pp. 33–34; CAI 1984, pp. 20, 106; *The Bostonians: Painters of an Elegant Age, 1870–1930,* exh. cat. (Boston: Museum of Fine Arts, 1986), pp. 55, 119; *Winslow Homer in the Clark Collection,* exh. cat. (Williamstown, Massachusetts: Sterling and Francine Clark Art Institute, 1986), pp. 6, 7, 54; *Winter,* exh. cat. (Hanover, New Hampshire: Hood Museum of Art, Dartmouth College, 1986), p. 82.

Prout's Neck, a spit of land on the Maine coast south of Portland, juts out into Saco Bay on the west and the Atlantic Ocean on the east. Homer made his home here for the last twenty-seven years of his life, and the coast and sea off Prout's Neck were repeatedly the subject of his work. These later paintings, including *Saco Bay, Eastern Point, West Point, Prout's Neck,* and *Summer Squall* (pp. 90–100), were the result of Homer's dedicated observation of this area. In them he endeavored to know the sea in all her various moods, and this study gave him unlimited opportunities to work out his artistic concerns. As a Boston critic noted, Homer was "both the historian and poet of the sea."[1]

When *Saco Bay* was presented with *Lookout—All's Well* (1896; Museum of Fine Arts, Boston) and *Maine Coast* (1896; The Metropolitan Museum of Art, New York) at the 1897 Society of American Artists annual exhibition, it marked Homer's return to exhibiting with New York art organizations after a nine-year hiatus.[2] *Saco Bay,* with its beautiful sunset, is a visual counterpart to what Homer expressed in a letter to his brother Charles on February 21, 1895: "The life that I have chosen gives me my full hours of enjoyment for the balance of my life— The Sun will not rise, or set, without my notice, and thanks."[3] In its peaceful beauty the painting differs from many of Homer's later seascapes, which more often concentrated on the raw power of the ocean (pp. 90–93 and 98–100).

Saco Bay was painted at Checkley Point on the southwest corner of Prout's Neck overlooking the bay.[4] Homer used Maude Googins Libby and Cora Sanborn, who had also appeared in his 1890 *Summer Night* (Musée d'Orsay, Paris), as models for the figures. But they are not the subject of the picture in the way that figures had been for Homer until about 1890; rather they simply represent human meditation on natural surroundings. As a reporter noted, the theme is "a sunset effect with the sea reflecting the color of the sky."[5] Within a year after painting *Saco Bay,* Homer would end his depictions of women altogether and, with few exceptions, would fill his canvases with pure seascapes.[6]

Like most of Homer's later works, *Saco Bay* results from his direct study of nature. Because Homer was after an atmospheric effect that lasted only a short while on certain days, he worked on this painting for a long time. When he wrote about *Saco Bay* to Thomas B. Clarke in November 1896, he admitted: "I have had it [the painting] on

hand and observed and studied this point and picture for the past ten years."[7] In his investigation of the spot Homer made at least one smaller related study on academy board (fig. 47), in which he quickly tried to capture the view over Saco Bay as the sun dipped below the horizon. It was not easy to arrest the fleeting moment, and he continued to work on the picture until three days before he sent it to the Pennsylvania Academy of the Fine Arts, Philadelphia, in December 1896.[8]

Using a low viewpoint and shallow foreground, Homer placed his audience right on the edge of Saco Bay, accentuating the immediacy and visual sensation of the sunset glow. This close-up viewpoint was one that he used repeatedly; in the Clark collection alone, it is also represented in *Eastern Point, West Point, Prout's Neck,* and *Summer Squall.* He rendered the sunset effect with broad brushstrokes and a variety of colors, working in wide, horizontal bands accented with bright, electric hues. Salmon-colored strips and slashes of light blue, yellow, and white create the illusion of water shimmering underneath the sky. In contrast, the dark rocks, silhouetted figures, sailboat, and far spit of land are painted in shadow. As Homer labored on the picture, he simplified each of these forms.[9]

Saco Bay was among Homer's favorite pictures, but he knew it would attract criticism. "It will not sell," he wrote to Clarke, "but I have some others that will pay me, and make it possible for me to show a work of this merit, which I now call your attention to. P.S. This above, would seem that W Homer has a great opinion of himself but it is *the picture* I am talking about."[10] When the painting was exhibited, the criticism focused on the strong pink tones in the sky and elicited such comments as "cold and hard" and "unnatural strawberry."[11] Whereas many critics found Homer a great painter, *Saco Bay* was considered "one of his slips."[12] Nonetheless, the Lotos Club purchased the painting out of the Society of American Artists exhibition with funds set aside for buying contemporary art.

The unfavorable comments that *Saco Bay* drew are not surprising considering the climate of American art during the mid-1890s. Homer's work did not fall within any of the three popular and interrelated major trends of the day: figure painting of lovely ladies, American Impressionism, and Tonalism. Unlike the Impressionists, Homer was never solely after a simple description of nature. Although he shared with the Tonalists a concern for personal interpretation of landscape, his insistence on depicting what he knew to be true in nature and his vigorous paint

Saco Bay, 1896
(*Saco Bay—Coming Storm; Sunset, Saco Bay*)
Oil on canvas
$23^{13}/_{16} \times 37^{15}/_{16}$ (60.5 × 96.4)
Signed and dated lower right: HOMER 1896
No. 5

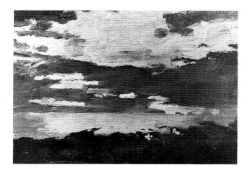

Fig. 47: Winslow Homer, **Sunset, Saco Bay,** *c. 1896. Oil on academy board, 13×20 in. (33×50.8 cm). Collection IBM Corporation, Armonk, New York.*

application separated him from his more inward-turning, smoother-painting colleagues. Furthermore, *Saco Bay*'s raw, nearly acidic, color and loose paint handling did not fit anywhere within the accepted norms of American art of this time.

1 "Art Notes," *Boston Evening Transcript,* December 6, 1883, p. 6.

2 During these years Homer did have individual pictures on view occasionally with his New York dealer, Gustav Reichard. Between 1887 and 1896, his largest showing of oil paintings was at the 1893 Chicago World's Columbian Exposition; see Lloyd Goodrich, *Winslow Homer* (New York: Macmillan Co., 1944), pp. 122, 144.

3 Homer to "Dear Charlie" (Charles S. Homer), February 21, 1895, CUNY/Goodrich/ Whitney Record of the Works of Winslow Homer, Graduate Center, City University of New York.

4 Philip C. Beam, *Winslow Homer at Prout's Neck* (Boston: Little, Brown and Co., 1966), p. 142.

5 William A. Coffin, "Society of American Artists: Pictures at the 19th Annual Exhibition," *The Sun* (New York), March 31, 1897, p. 7.

6 *Light on the Sea* (1897; The Corcoran Gallery of Art, Washington, D.C.) was Homer's last oil to include a female figure.

7 Quoted in Goodrich, *Winslow Homer,* p. 145.

8 Ibid.

9 Under infrared light, one can see that Homer started with a greater definition in the forms of the rocks and the women's dresses. Similarly, the far shore originally had more of an architectural skyline, which he then smoothed out.

10 Quoted in Goodrich, *Winslow Homer,* p. 145.

11 "The Society of American Artists: Its 19th Annual Exhibition — Clever Work by Younger American Artists," *The New York Times, Saturday Review of Books and Art,* March 27, 1897, p. 15. The picture was also criticized for similar reasons in "The Society Exhibition: A Conservative Collection with Portraiture in the Van," *New York Daily Tribune,* March 28, 1897, sect. I, p. 7, and in Coffin, "Society of American Artists," p. 7.

12 Coffin, "Society of American Artists," p. 7.

Provenance: To (Gustav Reichard Gallery, New York); returned to the artist; to The Lotos Club, New York, 1897; to (M. Knoedler & Co., New York, 1923); to Robert Sterling Clark, November 27, 1923.

Related Work: Sunset, Saco Bay, c. 1896, oil on academy board, 13×20 (33×50.8), IBM Corporation, Armonk, New York.

Exhibitions: Pennsylvania Academy of the Fine Arts, Philadelphia, "66th Annual Exhibition," December 21, 1896–February 22, 1897, no. 153; Society of American Artists, New York, "19th Annual Exhibition," March 28–May 1, 1897, no. 272; Carnegie Institute, Pittsburgh, "12th Annual Exhibition," April 30–June 30, 1908, no. 149; National Academy of Design, New York, "Winter Exhibition," December 10, 1910–

January 8, 1911, no. 214; The Metropolitan Museum of Art, New York, "Winslow Homer Memorial Exhibition," February 6–March 19, 1911, no. 18 (as *Saco Bay — Coming Storm*); Buffalo Fine Arts Academy, New York, "6th Annual Exhibition of American Paintings," May 12–August 28, 1911, no. 65 (as *Saco Bay — Coming Storm*); Panama-Pacific International Exposition, San Francisco, "Department of Fine Arts Panama-Pacific International Exposition," 1915, no. 2514; Sterling and Francine Clark Art Institute, Williamstown, Massachusetts, "Exhibit 4: The First Two Rooms," May 17, 1955, no. 5 (as *Sunset, Saco Bay*); Sterling and Francine Clark Art Institute, Williamstown, Massachusetts, "Exhibit 16: Winslow Homer," June 1961 (as *Sunset, Saco Bay*); Wildenstein and Co., New York, "An Exhibition of Treasures from the Sterling and Francine Clark Art Institute," February 2–25, 1967, no. 19; Sterling and Francine Clark Art Institute, Williamstown, Massachusetts, "Winslow Homer in the Clark Collection," June 28–October 19, 1986, no. 51.

References: "Many Good Pictures at the Academy's 66th Annual Exhibition," *Public Ledger* (Philadelphia), December 21, 1896, p. 9; Sophia Antoinette Walker, "Fine Arts: The Pennsylvania Academy, II," *Independent,* 49 (January 28, 1897), p. 7; B.V. King, "Art Notes," *The Washington Post,* February 14, 1897, p. 11; "The Society of American Artists: Its 19th Annual Exhibition — Clever Work by Younger American Artists," *The New York Times, Saturday Review of Books and Art,* March 27, 1897, p. 15; "Clever Pictures — Seen at the Exhibition of the Society of American Artists," *New York Herald,* March 28, 1897, p. 5; "The Society Exhibition: A Conservative Collection with Portraiture in the Van," *New York Daily Tribune,* March 28, 1897, sect. I, p. 7; William A. Coffin, "Society of American Artists: Pictures at the 19th Annual Exhibition," *The Sun* (New York), March 31, 1897, p. 7; John N. Fort, "Two Exhibitions," *Philadelphia Evening Item,* April 3, 1897, p. 1; "The Observer," *Art Interchange,* 38 (June 1897), p. 146; Charles Henry Dorr, "420 Pictures in Winter Display of the Academy," *The World* (New York), December 11, 1910, p. 3; "Roosevelt's Portrait Is Commanding Attention," *Buffalo Evening News,* May 13, 1911, Albright-Knox Art Gallery scrapbook; "Gallery and Studio Chat," *Buffalo Express,* May 16, 1911, Albright-Knox Art Gallery scrapbook; *Buffalo Evening News,* July 22, 1911, Albright-Knox Art Gallery scrapbook; William Howe Downes, *The Life and Works of Winslow Homer* (Boston and New York: Houghton Mifflin Co., 1911), pp. 181–82, 191–92, 231, 258; Christian Brinton, "American Painting at the Panama-Pacific Exposition," *International Studio,* 56 (August 1915), p. xxx; J. Nilsen Laurvik, "Evolution of American Painting," *The Century,* 90 (September 1915), pp. 772, 785; *Catalogue Deluxe of the Department of Fine Arts Panama-Pacific International Exposition,* exh. cat. (San Francisco: Paul Elder and Co., 1915), vol. 1, p. 197; Christian Brinton, *Impressions of the Art at the Panama-Pacific Exposition* (New York: John Lane Co., 1916), p. 91; Lorinda Munson Bryant, *American Pictures and Their Painters* (New York: John Lane Co., 1917), pp. 69, 70; Nathaniel Pousette-Dart, *Winslow Homer* (New York: Frederick

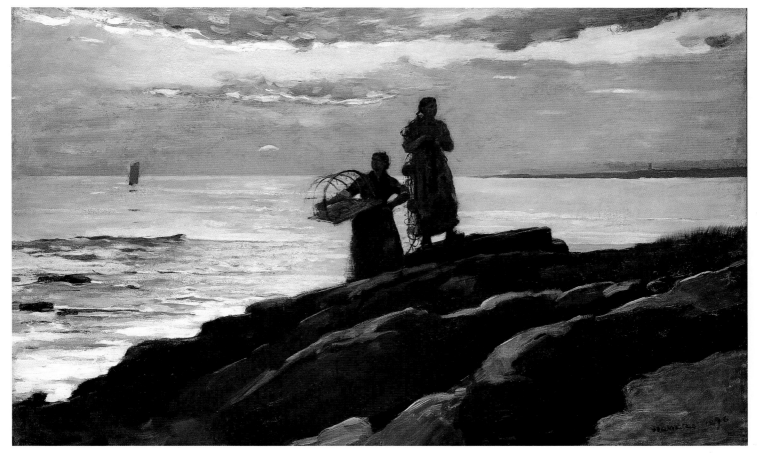

Saco Bay

A. Stokes, 1923), n.p.; Theodore Bolton, "The Art of Winslow Homer: An Estimate in 1932," *The Fine Arts*, 18 (February 1932), p. 55; Philip C. Beam, "Winslow Homer: A Biography," Ph.D. dissertation, Harvard University, Cambridge, Massachusetts, 1944, p. 358; Lloyd Goodrich, *Winslow Homer* (New York: Macmillan Co., 1944), pp. 144–45, 233; CAI 1955, n.p., pl. V (as *Sunset, Saco Bay*); CAI 1958a, n.p., pl. XXXVIII (as *Sunset, Saco Bay*); Albert Ten Eyck Gardner, *Winslow Homer, American Artist: His World and His Work* (New York: Clarkson N. Potter, 1961), pp. 241, 243; *Exhibit 16: Winslow Homer*, exh. cat. (Williamstown, Massachusetts: Sterling and Francine Clark Art Institute, 1961), n.p.; Hunter Ingalls, "Elements in the Development of Winslow Homer," *Art Journal*, 24 (Fall 1964), p. 20; *Dictionary of American Biography*, rev. ed. (New York: Charles Scribner's Sons, 1964), vol. 5, p. 190; Philip C. Beam, *Winslow Homer at Prout's Neck* (Boston: Little, Brown and Co., 1966), pp. 121, 142–43, 153; *An Exhibition of Treasures from the Sterling and Francine Clark Art Institute*, exh. cat. (New York: Wildenstein and Co., 1967), n.p.; CAI 1972, p. 56 (as *Sunset, Saco Bay*); Philip C. Beam, *Winslow Homer* (New York: McGraw-Hill, 1975), pp. 23–26, 43–44; N.G. Heller and J. Williams, "Winslow Homer: The Great American Coast," *American Artist*, 40 (January 1976), p. 37; G. Fairburn, "Winslow Homer at Prout's Neck," *Horizon*, 22 (April 1979), p. 59; Philip C. Beam, *The Magazine Engravings of Winslow Homer* (New York: Harper & Row, 1979), p. 5; Gordon Hendricks, *The Life and Work of Winslow Homer* (New York: Harry N. Abrams, 1979), pp. 165, 214, 225, 229–31, 300; *Winslow Homer: Watercolors*, exh. cat. (Brunswick, Maine: Bowdoin College Museum of Art, 1983), p. 25; CAI 1984, pp. 20, 106 (as *Sunset, Saco Bay*); *Winslow Homer in the Clark Collection*, exh. cat. (Williamstown, Massachusetts: Sterling and Francine Clark Art Institute, 1986), pp. 62–56; Patrick McCaughey, "Native and Nomad: Winslow Homer and John S. Sargent," *Daedalus*, 116 (Winter 1987), p. 143.

Eastern Point, 1900

(*Weatherbeaten; Eastern Point, Prout's Neck*)

Oil on canvas

30¼ × 48½ (76.8 × 123.2)

Signed and dated lower right: Winslow Homer/ Oct. 14 1900

No. 6

During the last decade of the nineteenth century, marine painting, which had been overshadowed by figurative works since 1870, made a significant comeback.[1] Seashore subjects were prevalent among the outdoor painters who practiced the American brand of Impressionism and those painters who found the poetic or mysterious in the sea. Foremost among all American seascapists is Winslow Homer. Unlike artists of the Hudson River School, who subordinated the evidence of the brush in favor of still and silent depictions, he exploited the tactile qualities of paint in his images of the weatherbeaten coast.

When Homer painted *Eastern Point* in 1900, he had been continually studying and painting the ocean at Prout's Neck, Maine, for nearly twenty years. As one critic noted in a review of *Eastern Point:* "He has lived with the ocean so long, grown in communion with it and paid unconscious homage to it, that the spirit of the ocean has entered into him and his utterance of what he feels is spontaneous."[2] This longtime relationship enabled Homer to paint the sea directly, boldly, and very quickly. On September 13, 1900, he wrote to John W. Beatty, director of the Carnegie Institute, Pittsburgh: "I have nothing new at present I have just commenced painting."[3] Just one month later, on October 14, he signed and dated *Eastern Point*. By the end of December 1900 he had finished a second picture, *West Point, Prout's Neck* (pp. 93–97).

Within a span of no more than thirty-two days, Homer created a powerful image of the view off the eastern end of Prout's Neck. This painting presents the ocean in a tumultuous mood and perhaps was inspired by one of the frequent autumn storms that hit the Maine coast. A leaden sky, painted opaquely and smoothly, pushes down from above as the sea churns, pounding the rocky shore and sending up billowing clouds of spray. The cropped edges and shallow foreground draw the viewer into the picture. As a writer for the New York *Evening Post* noted, *Eastern Point* was "quite the next thing to a brisk tramp along shore on a stormy day."[4]

A sense of action and power emanates from Homer's vigorous brushwork, which was aptly described in a 1901 review as "full-charged pure color, sweeping the canvas here, elsewhere blunt or curved, but with assurance in every movement."[5] The white caps and foam are described by zigzag strokes of opaque white on top of or slightly mixed with the deep green ocean. Against the agitated sea, Homer formed solid, worn rocks with broad, decisive strokes of gray and brown. Near the lower edge of the canvas, he used ocher, rust, and deep brown paint in thick impastos to delineate a bit of pebbly beach strewn with kelp and seaweed. The rich colors and diverse brushwork create an energetic surface that suggests the vitality of a stormy sea.

Homer's swift execution of *Eastern Point* did not prevent careful consideration of the painting's design. He divided the canvas into thirds both left to right and top to bottom. The clouds of spray set a pulsing rhythm of green and white from side to side, and the impenetrable sky is balanced against the bulky rock. Within this framework, the open-ended composition evokes the vastness of the ocean. This harmonious arrangement

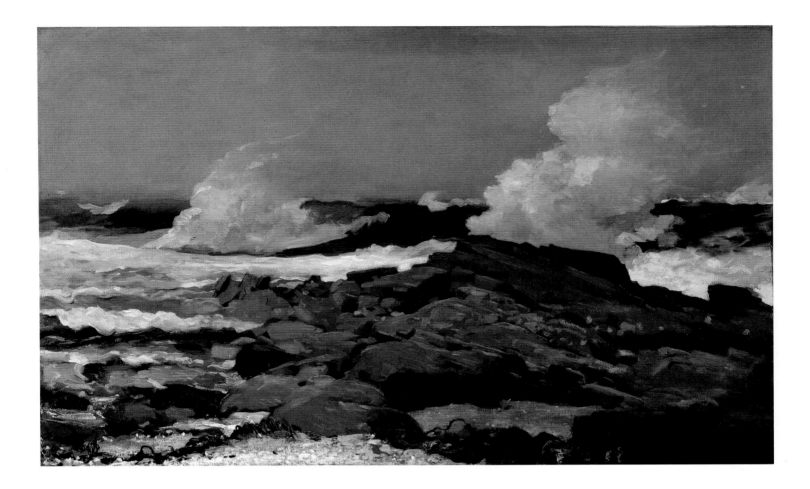

of equal parts, which also appears in *Northeaster* and *Cannon Rock* (both 1895; The Metropolitan Museum of Art, New York) among others, generates a sense of the awe-inspiring instead of the threatening. *Eastern Point* is at once humbling and marvelous.

Homer considered *Eastern Point* one of his finest paintings and wrote to M. Knoedler & Co. in 1901 that it was "too good not to be sold."[6] Although the picture was not sold until Knoedler's bought it in January 1903, the critics who saw it at the Union League Club and Society of American Artists in 1901 agreed with Homer that it was an exceptional painting. Universally praised in this picture, as well as in Homer's work in general, was his direct and truthful reflection of the power and force of the ocean. Charles H. Caffin, a major spokesman for American art at the turn of the century, explained: "Stated in words the scene seems but a repetition of previous pictures, and in a sense it is, but with that freshness of impulse and phenomenon such as the same piece of ocean will continually present."[7] *Eastern Point*, in which Homer combined a sensitively balanced composition with some of his most authoritative painting, remains a supreme example of his Prout's Neck seascapes.

1 John Wilmerding, *A History of American Marine Painting*, 2nd ed. (New York: Harry N. Abrams, 1987), is the most comprehensive survey of this aspect of American art.

2 "23rd Annual Exhibition of the Society of American Artists," *The Artist*, 30 (May 190), supplement, p. xx.

3 Homer to Beatty, September 13, 1900, CUNY/Goodrich/Whitney Record of the Works of Winslow Homer, Graduate Center, City University of New York.

4 "Pictures at the Union League Club," *The Evening Post* (New York), January 11, 1901, p. 4.

5 "Society of American Artists—1st Notice," *The Sun* (New York), April 5, 1901, p. 6.

6 Homer to M. Knoedler & Co., April 29, 1901, CUNY/Goodrich/Whitney Record.

7 Charles H. Caffin, "Exhibition of the Pennsylvania Academy," *International Studio*, 19 (March 1903), p. cxvii.

Provenance: To (M. Knoedler & Co., New York, January 9, 1903); to Lyman G. Bloomingdale, New York, March 1903; to (M. Knoedler & Co., New York, December 1923); to Robert Sterling Clark, December 1923; to (Macbeth Gallery, New York); to Thomas Cochrane; to Addison Gallery of American Art, Phillips Academy, Andover, Massachusetts 1929; to (M. Knoedler & Co., New York, August 1954); to Robert Sterling Clark, November 6, 1954.

Exhibitions: Union League Club, New York, "Loan Exhibition of American Paintings," January 10–12, 1901, no. 1; Society of American Artists, New York, "23rd Annual Exhibition," March 30–May 4, 1901, no. 272; Pennsylvania Academy of the Fine Arts, Philadelphia, "72nd Annual Exhibition," January 19–February 28, 1903, no. 49; Macbeth Gallery, New York, "American Masters Loaned for Exhibition," October 13–26, 1925, no. 11 (as *Weatherbeaten*); Macbeth Gallery, New York, "Thirty Paintings by Thirty Artists," February 19–March 4, 1929, no. 14; Milch Gallery, New York, "From Homer On," February 8–March 1, 1932; The Century Association, New York, "Special Exhibition of American Paintings," March 12–29, 1932; Whitney Museum of American Art, New York, "Loan Exhibition of 19th Century American Painting from the Addison Gallery," March 28–April 27, 1933; William Rockhill Nelson Gallery, Kansas City, Missouri, "Loan Exhibition of American Paintings since 1900," November 21, 1933–February 23, 1934; Lyman Allyn Museum, New London, Connecticut, February 28–April 24, 1934; The Cleveland Museum of Art, "American Paintings from 1860 until Today," June 23–October 4, 1937, no. 86; The Detroit Institute of Arts, "Five Centuries of Marine Painting," March 6–April 5, 1942, no. 115; Whitney Museum of American Art, New York, "Oils and Watercolors by Winslow Homer," October 3–November 2, 1944; Munson-Williams-Proctor Institute, Utica, New York, "Paintings by Winslow Homer and Thomas Eakins," December 1, 1946–January 19, 1947, no. 15; Birmingham Museum of Art, Alabama, "Opening Exhibition," April 8–June 3, 1951; The Western Canada Art Circuit, September 16, 1953–June 20, 1954; Sterling and Francine Clark Art Institute, Williamstown, Massachusetts, "Exhibit 4: The First Two Rooms," May 17, 1955, no. 6 (as *Eastern Point, Prout's Neck*); Sterling and Francine Clark Art Institute, Williamstown, Massachusetts, "Exhibit 16: Winslow Homer," June 1961 (as *Eastern Point, Prout's Neck*); Wildenstein and Co., New York, "An Exhibition of Treasures from the Sterling and Francine Clark Art Institute," February 2–25, 1967, no. 20; Sterling and Francine Clark Art Institute, Williamstown, Massachusetts, "Winslow Homer in the Clark Collection," June 28–October 19, 1986, no. 54.

References: "Pictures at the Union League Club," *The Evening Post* (New York), January 11, 1901, p. 4; "Art Notes: Union League Club's January Exhibition of American Paintings—Coming Sales," *The Sun* (New York), January 14, 1901, p. 6; "American Arts Show Fine, General Average of Exhibition High, with Some Masterpieces," *The World* (New York), March 30, 1901, p. 6; "Art Exhibitions—The Society of American Artists," *New York Daily Tribune*, March 30, 1901, p. 6; "Art Notes," *The Mail and Express* (New York), March 30, 1901, p. 2; "Good Pictures by American Artists: 23rd Annual Exhibition Opens To-Day in the Fine Arts Building," *New York Herald*, March 30, 1901, p. 11; "Fine Arts: Society of American Artists," *The Brooklyn Daily Eagle*, March 31, 1901, sec. 2, p. 13; "Pictures from the 23rd Annual Exhibition of the Society of American Artists," *New York Daily Tribune*, March 31, 1901, supplement, p. 9; "Pictures and Sculptures: Annual Exhibition of the Society of American Artists . . . 1st Notice," *The Evening Post* (New York), April 3, 1901, p. 7; "Society of American Artists—1st Notice," *The Sun* (New York), April 5, 1901, p. 6; Sophia A. Walker, "Society of American Artists," *Independent*, 53 (May 9, 1901), p. 1078;

"Exhibition of the Society of American Artists," *The Art Interchange,* 46 (May 1901), p. 105; "23rd Annual Exhibition of the Society of American Artists," *The Artist,* 30 (May 1901), supplement, p. xx; "Brilliant Display of High Class Art," *The Philadelphia Inquirer,* January 18, 1903, pp. 1–2; Arthur Z. Bateman, "The Fine Art Display at Philadelphia," *Brush and Pencil,* 11 (February 1903), p. 384; Charles H. Caffin, "Exhibition of the Pennsylvania Academy," *International Studio,* 19 (March 1903), p. cxvii; Charles H. Caffin, "American Painters of the Sea," *The Critic,* 46 (December 1903), p. 551; "The Fine Arts," unidentified newspaper clipping, 1903, Pennsylvania Academy of the Fine Arts, Philadelphia, scrapbook; Florence Finch Kelly, "Painters of the Sea and Shore," *Broadway Magazine,* 18 (August 1907), p. 583; William Howe Downes, *The Life and Works of Winslow Homer* (Boston and New York: Houghton Mifflin Co., 1911), pp. 207–8; "Thirty Paintings by Thirty Artists, Macbeth Galleries," *Art News,* 29 (February 23, 1929), pp. 8, 9; D[orothy] L[efferts] M[oore], "Exhibitions in New York," *The Arts,* 15 (March 1929), p. 186; *Thirty Paintings by Thirty Artists,* exh. cat. (New York: Macbeth Gallery, 1929), frontispiece; *Catalogue of the Permanent Collection* (Andover, Massachusetts: Addison Gallery of American Art, Phillips Academy, 1931), n.p.; "Now on View at Milch Galleries," *Art News,* 30 (February 6, 1932), p. 7; Theodore Bolton, "The Art of Winslow Homer: An Estimate in 1932," *The Fine Arts,* 18 (February 1932), p. 55; Margaretta M. Salinger, "Three Show [sic] and the American Tradition," *Parnassus,* 4 (February 1932), p. 21; Cedric Caldwell, Jr., "Around the Galleries," *Creative Art,* 10 (March 1932), pp. 227, 228; "Homer Centenary," *The Art Digest,* 10 (January 15, 1936), p. 14; *American Paintings from 1860 until Today,* exh. cat. (Cleveland: The Cleveland Museum of Art, 1937), p. 86, pl. VI; *Handbook of Paintings, Sculptures, Prints and Drawings in the Permanent Collection of the Addison Gallery of American Art* (Andover, Massachusetts: Addison Gallery of American Art, Phillips Academy, 1939), p. 33; *Five Centuries of Marine Painting* (Detroit: The Detroit Institute of Arts, 1942), p. 15; Forbes Watson, *Winslow Homer* (New York: Crown Publishers, 1942), p. 64; Philip C. Beam, "Winslow Homer: A Biography," Ph.D. dissertation, Harvard University, Cambridge, Massachusetts, 1944, pp. 510–11, 514; Lloyd Goodrich, *Winslow Homer* (New York: Macmillan Co., 1944), pp. 163–66; *Opening Exhibition,* exh. cat. (Birmingham, Alabama: Birmingham Museum of Art, 1951), p. 41; Alfred Frankfurter, "Dark Horse in Williamstown," *Art News,* 54 (Summer 1955), p. 31; CAI 1955, n.p., pl. VI; E.P. Richardson, *Painting in America* (New York: Thomas Y. Crowell Co., 1956), p. 317; CAI 1958a, n.p., pl. XXXVI (as *Eastern Point, Prout's Neck*); *Exhibit 16: Winslow Homer,* exh. cat. (Williamstown, Massachusetts: Sterling and Francine Clark Art Institute, 1961), n.p.; Albert Ten Eyck Gardner, *Winslow Homer, American Artist: His World and His Work* (New York: Clarkson N. Potter, 1961), p. 242; Jean Gould, *Winslow Homer: A Portrait* (New York: Dodd, Mead and Co., 1962), pp. 226, 248, 250, 276; Philip C. Beam, *Winslow Homer at Prout's Neck* (Boston: Little, Brown and Co., 1966), pp. 158, 213, 214; *An Exhibition of Treasures from the Sterling and Francine Clark Art Institute,* exh. cat. (New York: Wildenstein and Co., 1967), n.p.; CAI 1972, pp. 54, 55 (as *Eastern Point, Prout's Neck*); John Wilmerding, *Winslow Homer* (New York: Praeger Publishers, 1972), p. 204, pl. 48; Patti Hannaway, *Winslow Homer in the Tropics* (Richmond, Virginia: Westover Publishing Co., 1973), p. 106; Linda Hyman, *Winslow Homer: America's Old Master* (New York: Doubleday & Co., 1973), p. 65; Philip C. Beam, *The Magazine Engravings of Winslow Homer* (New York: Harper & Row, 1979), p. 245; Gordon Hendricks, *The Life and Work of Winslow Homer* (New York: Harry N. Abrams, 1979), pp. 245, 246–48, 250, 299; *A New World: Masterpieces of American Painting 1760–1910,* exh. cat. (Boston: Museum of Fine Arts, 1983), p. 338; A. Berman, "Historic Houses: Winslow Homer at Prout's Neck," *Architectural Digest,* 41 (July 1984), p. 139; CAI 1984, pp. 19, 107 (as *Eastern Point, Prout's Neck*); *Winslow Homer in the Clark Collection,* exh. cat. (Williamstown, Massachusetts: Sterling and Francine Clark Art Institute, 1986), pp. 70, 71.

F or *West Point, Prout's Neck,* Homer chose the view looking southwest over Saco Bay toward Old Orchard Beach.[1] Although the painting represents a certain locality, Homer's primary interest lay in depicting a specific time of day. The artist wrote to his dealer, M. Knoedler & Co., in New York: "The picture is painted *fifteen minutes* after sunset — not one minute before — as up to that minute the clouds over the sun would have their edges lighted a brilliant glow of color — but now (in this picture) the sun has got beyond their immediate range and *they are in shadow.*"[2]

The painting began with a drawing Homer made in late November 1899 on the outside of a cardboard shirt box (fig. 48).[3] In black and white chalk, he roughly sketched a few figures looking out at a choppy sea punctuated by a curving column of spray at the left. In the painting the view was distilled to its key elements of rock, water, and sky. The human presence remains only by implication. Dominating both the drawing and the painting is the cloudlike form of the flying spray. *West Point, Prout's Neck* was completed by December 23, 1900, and it was sent to Knoedler's with *Eastern Point* on January 4, 1901.[4]

The light effects found fifteen minutes after sunset permeate the entire canvas. Painted thickly and smoothly, the sky radiates with glowing light, the result of the bands of different colors Homer worked up and down

West Point, Prout's Neck, 1900
Oil on canvas
30¹/₁₆ × 48¹/₈ (76.4 × 122.2)
Signed and dated lower right: HOMER 1900
No. 7

Fig. 48: Winslow Homer, **Rough Sea Breaking upon Shore**, c. 1899–1900. Charcoal and white chalk on cardboard, 12½ × 21⅝ in. (31.8 × 54.9 cm). The Cooper-Hewitt Museum, Smithsonian Institution, New York; Gift of Charles Savage Homer, 1912-12-273.

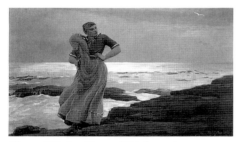

Fig. 49: Winslow Homer, **A Light on the Sea**, 1897. Oil on canvas, 28 × 48 in. (71.1 × 121.9 cm). The Corcoran Gallery of Art, Washington, D.C.; Museum purchase.

into the adjacent areas with a fairly dry brush. The whitest and reddest accents, which heighten the appearance of the sunset burning through the atmosphere, were added last. The water of the middle distance, reflecting the light of the sky, appears to be, as one critic noted, "a metallic mirror"[5] and is contrasted with the pounding surf on the rocks, painted in lyrical, vigorous strokes.

West Point, Prout's Neck, like its companion picture Eastern Point, displays Homer's affinity with mid-nineteenth-century American landscape painting (pp. 90–93), and its intense red coloration may be directly related to the work of Frederic Edwin Church (1826–1900).[6] The summer before Homer began the painting, he could have seen a memorial exhibition of Church's work at the Metropolitan Museum of Art. Although he had certainly explored sunset themes earlier (for example, Saco Bay, pp. 87–90), the blood-red sunset of West Point, Prout's Neck, depicted with such raw truthfulness, evokes Church's famous sunset scenes, some of which were on view, including Twilight in the Wilderness (1860; The Cleveland Museum of Art).

Homer's interest in recording a specific light, time, and atmospheric condition connects him to the Hudson River School, but it has also been cited as evidence of his connection to the French and American Impressionists.[7] Yet West Point, Prout's Neck, although concerned with a specific moment of weather and water, is the result of great labor. It does not reflect the quick recording of optical sensation that most Americans associated with Impressionism in the nineteenth century. Homer, in fact, wrote to Knoedler's about the extent of his study for this picture: "You can see that it took many days of careful observation to get this."[8]

Closely observing the sea over a long period of time, Homer came to understand the dialogue between the transitory and the permanent, which appears in most of his seascapes, though with different emphasis. Whereas Eastern Point focused on the continual action of the sea, West Point, Prout's Neck, presenting a fleeting moment at sunset, emphasizes the ephemeral.

The rising column of water in West Point, Prout's Neck, at once intruding and diaphanous, aided Homer in picturing the evanescent. He had used images of swirling ocean spray a number of times in his work after 1890. Sunlight on the Coast (1890; Toledo Museum of Art), Northeaster (1895; The Metropolitan Museum of Art, New York), and On the Lee Shore (1900; Museum of Art, Rhode Island School of Design, Providence) all have columnar funnels of water, but it is only in West Point, Prout's Neck that the

shape is so intrusive. Carol Troyen has suggested that Homer used the shaped spray as a "stand-in for humanity," and she sees its antecedent not so much in other pure seascapes but in Homer's last depiction of a woman, in A Light on the Sea (fig. 49).[9] She thus reads the painting as symbolizing human mortality in the face of enduring nature.[10] However, since Homer chose a form directly associated with ocean phenomena—water spraying upward after hitting rocks—his intention must remain ambiguous. Whether conceived simply as a dissolving spurt of ocean spray or as the veiled image of a person, Homer's column nonetheless contributes to the painting's focus on the concept of temporality in the universe.

In addition to its symbolic function, the anthropomorphic S-curve of the spray served an important design function for Homer. Both the woman in A Light on the Sea and the water spray in West Point, Prout's Neck create important vertical axes in predominantly horizontal compositions. In West Point, Prout's Neck, the bisection of the canvas works with the low viewpoint to assert an artistic patterning of shapes on the surface. A greater design consciousness permeates Homer's later works,[11] and this is borne out in the careful balance Homer strikes in West Point, Prout's Neck. The disintegrating but emphasized vertical column is played against the solid, horizontal seascape to form the basic components of Homer's composition.

Homer considered West Point, Prout's Neck and Eastern Point "the best that I have painted."[12] Prior to sending them to New York for exhibition at the Union League Club in January 1901, he sent his patron and the show's organizer, Thomas B. Clarke, a sketch indicating his preferred installation of the paintings.[13] West Point, Prout's Neck was to hang on the left and Eastern Point on the right, separated by Cannon Rock (1895; The Metropolitan Museum of Art, New York). Northeaster was substituted for Cannon Rock at the last minute, but Homer's request that his two different but complementary views be separated by another seascape was met at the inaugural showing.[14]

When shown at the Union League Club and the Society of American Artists in early 1901, West Point, Prout's Neck was not received with the enthusiasm that greeted Eastern Point. Homer was criticized both for the crimson that colored the sunset effect and for the prominence of the shooting spray. Complaints that the picture was "smacking a little of the spectacular" and questions whether the "isolated spurt . . . has any part in . . . the phenomena which arrested his attention at Prout's Neck" abounded.[15] Although today it is precisely the color and

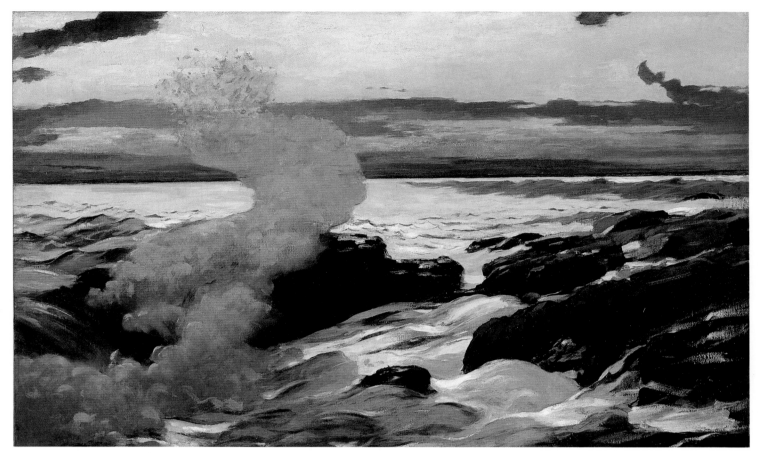

West Point, Prout's Neck

striking composition that are most appealing, *West Point, Prout's Neck* proved too potent to the public of 1901.

1 Homer identified this as the location of the picture in a letter to Thomas B. Clarke, January 4, 1901, Archives of American Art, Winslow Homer, Miscellaneous manuscripts, roll 2814, frame 652.

2 Homer to M. Knoedler & Co., April 16, 1901, CUNY/Goodrich/Whitney Record of the Works of Winslow Homer, Graduate Center, City University of New York.

3 The drawing is on a box sent to Homer from Brooks Brothers clothiers in New York. On the Brooks Brothers label is written "Winslow Homer/Scarboro"; in the upper right corner is "11/23/99" and in the upper left "pd." The date probably indicates when Homer received the box, which provides a *terminus post quem* for the drawing. I am grateful to Gail S. Davidson of the Cooper-Hewitt Museum for her help in figuring out the inscriptions on the label.

4 Homer to M. Knoedler & Co., January 4, 1901, CUNY/Goodrich/Whitney Record. Although *West Point, Prout's Neck* is inscribed only with "1900," Lloyd Goodrich noted in a letter dated December 6, 1941, M. Knoedler & Co. archives, "that when I first examined it, the following was written on the back of the upper stretcher: Winslow Homer. Dec 23rd — 1900. This was in Homer's hand."

5 "Art Notes: Union League Club's January Exhibition of American Paintings—Coming Sales," *The Sun* (New York), January 14, 1901, p. 6.

6 Carol Troyen suggests this connection in her entry on this painting in *A New World: Masterpieces of American Painting 1760–1910*, exh. cat. (Boston: Museum of Fine Arts, 1983), p. 339.

7 For instance, Kenyon Cox, *Winslow Homer* (New York: Privately printed, 1914), p. 45, compared Homer to Monet. The modern association of Homer with Impressionism began with Lloyd Goodrich, *Winslow Homer* (New York: Macmillan Co., 1944), p. 165.

8 Homer to M. Knoedler & Co., April 16, 1901, CUNY/Goodrich/Whitney Record.

9 Troyen, in *A New World*, p. 339. Jules D. Prown, "Winslow Homer in His Art," *Smithsonian Studies in American Art*, 1 (Spring 1987), pp. 43–44, has also recently argued for the column as representative of a woman.

10 Troyen, in *A New World*, p. 339.

11 For an exploration of this idea, see John Wilmerding, "Winslow Homer's *Right and Left*," *Studies in the History of Art*, 9 (Spring 1980), pp. 59–85.

12 Homer to Thomas B. Clarke, January 4, 1901, CUNY/Goodrich/Whitney Record.

13 Homer to Thomas B. Clarke, December 11, 1900, CUNY/Goodrich/Whitney Record.

14 The sale of *Cannon Rock* prevented it from appearing at the Union League Club; see Homer to Thomas B. Clarke, December 31, 1900, CUNY/Goodrich/Whitney Record.

15 "23rd Annual Exhibition of the Society of American Artists," *The Artist*, 30 (May 1901),
p. xx; "Art Notes: Union League Club's January Exhibition of American Paintings," *The Sun*, January 14, 1901. *West Point, Prout's Neck* was found superior only in "Good Pictures by American Artists: 23rd Annual Exhibition Opens To-Day in the Fine Arts Building," *New York Herald*, March 30, 1901, p. 11.

Provenance: To (M. Knoedler & Co., New York, January 10–31, 1901); to Hugh H. Harrison, New York, January 31, 1901; George W. Young, New Rochelle, New York; to (I.A. Rose, New York); to Dr. George G. Heye, c. 1902; to (Mr. Gatterdam); to (Babcock Galleries, New York, 1941); to (M. Knoedler & Co., New York, November 7, 1941); to Robert Sterling Clark, December 1, 1941.

Related Work: Rough Sea Breaking upon Shore, c. 1899–1900, charcoal and chalk on cardboard, $21^{5}/_{8} \times 12^{1}/_{2}$ (54.9 × 31.8), Cooper-Hewitt Museum, Smithsonian Institution, New York.

Exhibitions: Union League Club, New York, "Loan Exhibition of American Paintings," January 10–12, 1901, no. 3; Society of American Artists, New York, "23rd Annual Exhibition," March 30–May 4, 1901, no. 263; Whitney Museum of American Art, New York, "Oils and Watercolors by Winslow Homer," October 3–November 2, 1944; Sterling and Francine Clark Art Institute, Williamstown, Massachusetts, "Exhibit 4: The First Two Rooms," May 17, 1955, no. 7; Sterling and Francine Clark Art Institute, Williamstown, Massachusetts, "Exhibit 16: Winslow Homer," June 1961; Whitney Museum of American Art, New York, "Art of the United States, 1670–1960," September 27–November 27, 1966, no. 140; The Baltimore Museum of Art, "From El Greco to Pollock: Early and Late Works by European and American Artists," October 22–December 8, 1968, no. 70; Whitney Museum of American Art, New York, "Winslow Homer," April 3–June 3, 1973; Currier Gallery of Art, Manchester, New Hampshire, "Masterworks by Artists of New England," April 3–May 16, 1982; Museum of Fine Arts, Boston, "A New World: Masterpieces of American Painting 1760–1910," September 7–November 13, 1983, no. 109; Sterling and Francine Clark Art Institute, Williamstown, Massachusetts, "Winslow Homer in the Clark Collection," June 28–October 19, 1986, no. 55.

References: "Pictures at the Union League Club," *The Evening Post* (New York), January 11, 1901, p. 4; "Art Exhibitions: American Paintings at the Union League Club," *New York Daily Tribune*, January 12, 1901, p. 8; "Art Notes: Union League Club's January Exhibition of American Paintings—Coming Sales," *The Sun* (New York), January 14, 1901, p. 6; "American Arts Show Fine, General Average of Exhibition High, with Some Masterpieces," *The World* (New York), March 30, 1901, p. 6; "Art Exhibitions—The Society of American Artists," *New York Daily Tribune*, March 30, 1901, p. 6; "Art Notes," *The Mail and Express* (New York), March 30, 1901, p. 2; "Good Pictures by American Artists: 23rd Annual Exhibition Opens To-Day in the Fine Arts Building," *New York Herald*, March 30, 1901, p. 11; "Fine Arts: Society of American Artists," *The Brooklyn Daily Eagle*, March 31, 1901, sect. 2, p. 13; "Pictures

and Sculptures: Annual Exhibition of the Society of American Artists . . . 1st Notice," *The Evening Post* (New York), April 3, 1901, p. 7; "Society of American Artists—1st Notice," *The Sun* (New York), April 5, 1901, p. 6; Charles H. Caffin, "The Society of American Artists," *Harper's Weekly*, 45 (April 20, 1901), pp. 404, 417; Sophia A. Walker, "Society of American Artists," *Independent*, 53 (May 9, 1901), p. 1078; "23rd Annual Exhibition of the Society of American Artists," *The Artist*, 30 (May 1901), supplement, p. xx; William Howe Downes, *The Life and Works of Winslow Homer* (Boston and New York: Houghton Mifflin Co., 1911), p. 283; Theodore Bolton, "Homer Revisited at the Whitney," *Art News*, 43 (October 15–31, 1944), p. 18; Philip C. Beam, "Winslow Homer: A Biography," Ph.D. dissertation, Harvard University, Cambridge, Massachusetts, 1944, p. 510; Lloyd Goodrich, *Winslow Homer* (New York: Macmillan Co., 1944), pp. 163–66, pl. 55; "Art Institute Unveils Treasures," *Williams College Alumni Review*, 47 (July 1955), p. 20; CAI 1955, n.p., pl. VII; Lloyd Goodrich, "Winslow Homer: Pictorial Poet of the Sea and Forest," *Perspectives (USA)*, 14 (Winter 1956), pp. 48, 49, 50–51; Lloyd Goodrich, *The Metropolitan Museum of Art Miniatures: Winslow Homer, 1836–1910* (New York: The Metropolitan Museum of Art, 1956), p. 13; CAI 1958a, n.p., pl. XLI; Lloyd Goodrich, *Winslow Homer* (New York: George Braziller, 1959), p. 25, pl. 94; William H. Pierson, Jr., and Martha Davidson, *Arts of the United States: A Pictorial Survey* (New York: McGraw-Hill, 1960), p. 312; *Exhibit 16: Winslow Homer*, exh. cat. (Williamstown, Massachusetts: Sterling and Francine Clark Art Institute, 1961), n.p.; Albert Ten Eyck Gardner, *Winslow Homer, American Artist: His World and His Work* (New York: Clarkson N. Potter, 1961), p. 242; Jean Gould, *Winslow Homer: A Portrait* (New York: Dodd, Mead and Co., 1962), p. 276; Gertrude A. Mellon and Elizabeth F. Wilder, eds., *Maine and Its Role in American Art, 1740–1963* (New York: The Viking Press, 1963), p. 103; Lloyd Goodrich, "American Art and the Whitney Museum," *Antiques*, 40 (November 1966), p. 661; *Art of the United States, 1670–1960*, exh. cat. (New York: Whitney Museum of American Art, 1966), p. 150; Philip C. Beam, *Winslow Homer at Prout's Neck* (Boston: Little, Brown and Co., 1966), pp. 212–13; James Thomas Flexner, *The World of Winslow Homer 1836–1910* (New York: Time Incorporated, 1966), p. 164; Gorham Munson, "Winslow Homer of Prout's Neck, Maine," *The Dalhousie Review*, 47 (Summer 1967), p. 231; Abraham Davidson, "Early and Late Works at the Baltimore Museum of Art," *Arts Magazine*, 43 (November 1968), p. 55; *From El Greco to Pollock: Early and Late Works by European and American Artists*, exh. cat. (Baltimore: The Baltimore Museum of Art, 1968), pp. 90–91; Richard McLanathan, *The American Tradition in the Arts* (New York: Harcourt, Brace and World, 1968), p. 338; John Wilmerding, "Winslow Homer: Impressive and Solemn Landscapes," *Antiques*, 102 (September 1972), pp. 102, 420–21; CAI 1972, pp. 56, 57; John Wilmerding, *Winslow Homer* (New York: Praeger Publishers, 1972), pp. 177, 203; *Winslow Homer*, exh. cat. (New York: Whitney Museum of American Art, 1973), cover, pp. 42, 124, 137; Ann Hill, ed., *A Visual Dictionary of Art* (Greenwich, Connecticut: New York Graphic Society, 1974), p. 301; Philip C. Beam, *Winslow Homer* (New York: McGraw-Hill, 1975), p. 23; Jean Lipman and Helen M. Franc, *Bright Stars: American Painting and Sculpture since 1776* (New York: E.P. Dutton and Co., 1976), pp. 12–13; Gordon Fairburn, "The World of Winslow Homer: Letter from Prout's Neck," *Art World*, 2 (September–October 1977), p. 4; Karen M. Adams, "Black Images in 19th-Century American Painting and Literature: An Iconological Study of Mount, Melville, Homer and Mark Twain," Ph.D. dissertation, Emory University, Atlanta, 1977, p. 152; Gordon Fairburn, "Winslow Homer at Prout's Neck," *Horizon*, 22 (April 1979), p. 62; Philip C. Beam, *The Magazine Engravings of Winslow Homer* (New York: Harper & Row, 1979), pp. 1, 245; Gordon Hendricks, *The Life and Work of Winslow Homer* (New York: Harry N. Abrams, 1979), pp. 223, 246–48, 250, 300; Barbara Novak, *American Painting of the Nineteenth Century: Realism, Idealism, and the American Experience* (New York: Harper & Row, 1979), p. 190; CAI 1981, pp. 82, 83; Abraham A. Davidson, *Early American Modernist Painting: 1910–1935* (New York: Harper & Row, 1981), p. 2; Ernest Goldstein, *Winslow Homer: The Gulf Stream* (Champaign, Illinois: Garrard Publishing Co., 1982), pp. 34, 35; *Masterworks by Artists of New England*, exh. cat. (Manchester, New Hampshire: Currier Gallery of Art, 1982), p. 19; *A New World: Masterpieces of American Painting 1760–1910*, exh. cat. (Boston: Museum of Fine Arts, 1983), pp. 175, 190, 338–39; CAI 1984, pp. 20, 107; Mary Judge, *Winslow Homer* (New York: Crown Publishers, 1986), p. 75; *Winslow Homer in the Clark Collection*, exh. cat. (Williamstown, Massachusetts: Sterling and Francine Clark Art Institute, 1986), pp. 12, 70–71; *Winslow Homer Watercolors*, exh. cat. (Washington, D.C.: National Gallery of Art, 1986), pp. 225, 226; Jules D. Prown, "Winslow Homer in His Art," *Smithsonian Studies in American Art*, 1 (Spring 1987), pp. 43–44; Susan E. Strickler, ed., *American Traditions in Watercolor: The Worcester Art Museum Collection* (New York: Abbeville Press, 1987), p. 100; John Arthur, *Spirit of Place: Contemporary Landscape Painting and the American Tradition* (Boston: Bullfinch Press, 1989), pp. 20–21; Anne Hollander, *Moving Pictures* (New York: Alfred A. Knopf, 1989), pp. 360, 361.

Summer Squall, 1904

Oil on canvas
24¼ × 30¼ (61.6 × 76.8)
Signed and dated lower left: Homer 1904
No. 8

*Fig. 50: Winslow Homer, **Blown Away**, c. 1888. Watercolor over pencil on paper, 10⅛ × 19¹/₁₆ in. (25.7 × 48.4 cm). The Brooklyn Museum, New York; Museum Collection Fund and Special Subscription, 11.543.*

After 1900 Homer's production of oil painting dropped substantially. Several factors may have contributed to this development. Watercolor, in part due to its portability, was Homer's preferred medium when he traveled, which he did frequently in these years. During the last decade of his life, he spent winters in the southern United States or in the Caribbean and at least part of the summer in the Adirondacks or eastern Canadian wilderness. Moreover, his financial situation was good, and he no longer needed to sell paintings. By the mid-1890s the demand for his works, especially watercolors, had provided him with a comfortable living. Negative criticism also may have pushed Homer away from his easel. In June 1903 he wrote to his friend John Beatty that he had "retired from business for good. . . . As the last picture I painted—only met with abuse and no one understood it."[1]

Homer spent the winter of 1903–4 in Florida. He returned to Prout's Neck in late March and began to paint in oil for the first time in a year and a half.[2] On May 5, 1904, when the paint had just finished drying, he sent *Summer Squall* to Knoedler's.[3] The painting depicts a large flat rock (from which Homer is known to have often fished)[4] sitting prominently in the foreground of a stormy sea. In the right middle distance a small sailboat rises out of the trough of a wave. Philip Beam has connected the initial painting of the picture to an incident Homer may have witnessed in the summer of 1896,[5] but no physical evidence on the canvas confirms or denies an eight-year period of work. The only extant picture related to *Summer Squall* is the watercolor *Blown Away* (fig. 50), whose boat with two figures nearly duplicates that in the oil. Unfortunately, the watercolor is undated.[6]

Homer's later seascapes display the majesty of oceanic forces rather than the weakness of man in confrontation with nature. *Summer Squall* does present an endangered sailboat, but compared to earlier, more predominantly figurative works such as *The Fog Warning* (1895; Museum of Fine Arts, Boston), human helplessness is minimized.

In 1903 Frank Fowler had characterized Homer's work as a blending of "the rude reportorial with organized thought."[7] *Summer Squall* is the product of keen observation and conscious design strategies that evoke through paint application the essence of the water's movement. The general palette for *Summer Squall* is grayish blue-green. The bottom half of the canvas is marked by vigorous brushstrokes built up at midsection to thick white impasto, suggesting the break-

ing wave; the background is painted more smoothly. With paint texture and blending of color Homer was able to capture the different characteristics of the sea in a storm. The foreground is anchored by the massive rock placed slightly off center, and the canvas is bisected by the breaking wave that separates the churning surf from the swells farther out. The enclosed, almost claustrophobic feel of the foreground is relieved only in the far distance, slightly left of center, where the gray storm clouds break for a view toward the horizon. Sky merges with sea except in that small, open passageway where Homer navigates his viewers through the stormy sea. The tunnel to the light gives both a sense of considerable distance and possible hope for the stranded sailors.

Homer countered the illusion of movement back into space through a low viewpoint and a nearly square canvas. His use of this format began when he worked on square ceramic tiles as a member of the Tile Club in the late 1870s, though it did not become common in his paintings until the mid-1890s, when equal-sided canvases were favored by many artists.[8] In *Summer Squall* the tension produced by the illusion of three-dimensional reality in a format and composition that reinforce the two-dimensional canvas matches the paradox of magnificence and destructive force that Homer found in nature.

Homer considered *Summer Squall* one of his more modest efforts and told Knoedler's that it only need bring him seven hundred dollars.[9] The painting was sold within six months to a New York collector.[10] During November and December 1904, it was exhibited at the Carnegie Institute in Pittsburgh. Although reviewers noted that the painting was smaller than Homer's earlier marines, they nonetheless found it characteristic of the larger works for which he was famous.[11]

1 Homer to Beatty, received by Beatty June 15, 1903, CUNY/Goodrich/Whitney Record of the Works of Winslow Homer, Graduate Center, City University of New York.

2 Lloyd Goodrich, *Winslow Homer* (New York: Macmillan Co., 1944), p. 181.

3 Homer to M. Knoedler & Co., May 5, 1904, CUNY/Goodrich/Whitney Record: "I regret the long delay in sending the painting to fill that frame. It has been so cold and wet here that paint would not dry—. . . . I now send you by American Express the painting 'Summer Squall.'"

4 Philip Beam, *Winslow Homer at Prout's Neck* (Boston: Little, Brown and Co., 1966), p. 143.

5 Ibid. Homer's nephew told Beam that the picture records a summer storm that caught a man with children out in a sailboat. Rather than risk sailing through the turbulence near shore,

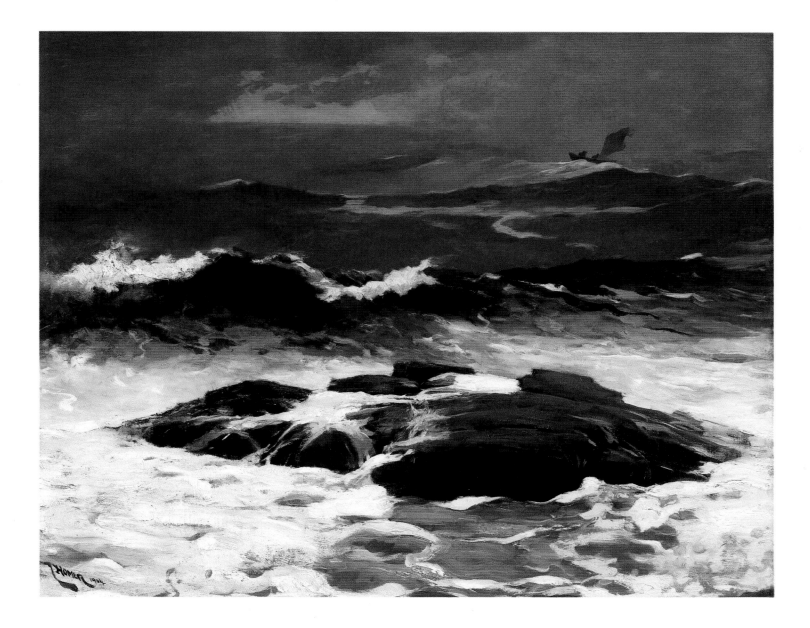

the man took the boat farther out to sea to wait for improved weather.

6 The Brooklyn Museum, owner of *Blown Away,* dates the watercolor c. 1888 on the basis of a letter from Charles S. Homer, the artist' brother, that gives 1888 as a "probable date." Barbara Dayer Gallati, associate curator of American painting, the Brooklyn Museum, kindly traced the history of the watercolor Beam, *Winslow Homer at Prout's Neck,* p. 143, in relating the story about the painting of the oil, dates the watercolor 1896.

7 Frank Fowler, "The Field of Art," *Scribner's Magazine,* 33 (May 1903), p. 640.

8 William H. Gerdts, "The Square Format and Proto-Modernism in American Painting," *Arts Magazine,* 50 (June 1976), p. 72.

9 Homer to M. Knoedler & Co., May 5, 1904, CUNY/Goodrich/Whitney Record. In comparison, Homer wanted $2,000 and $2,400 for *Eastern Point* and *West Point, Prout's Neck,* respectively.

10 *Summer Squall* arrived at Knoedler's in May 1904 and was owned by Morris J. Hirsch by October; M. Knoedler & Co. archives.

11 See, for example, "Art Exhibition Is an Especially Fine One," *The Times* (Pittsburgh), November 3, 1904, p. 6.

Provenance: To (M. Knoedler & Co., New York, May–October 1904); to Morris J. Hirsch, New York, by October 1904; to (M. Knoedler & Co., New York, 1914?); to (John Levy Gallery, New York); to Harold Somers, Brooklyn, New York, 1916; to (M. Knoedler & Co., New York); to Robert Sterling Clark, June 16, 1923.

Related Work: Blown Away, c. 1888, watercolor over pencil on paper, 10⅛ × 19¹⁄₁₆ (25.7 × 48.4), The Brooklyn Museum, New York; Museum Collection Fund and Special Subscription. 11.543.

Exhibitions: Carnegie Institute, Pittsburgh, "9th Annual Exhibition," November 3, 1904– January 1, 1905, no. 138; M. Knoedler & Co., New York, "7th Annual Exhibition of Paintings by American Artists," July 1914, no. 20; Sterling and Francine Clark Art Institute, Williamstown, Massachusetts, "Exhibit 4: The First Two Rooms," May 17, 1955, no. 8; Sterling and Francine Clark Art Institute, Williamstown, Massachusetts, "Exhibit 16: Winslow Homer," June 1961; Wildenstein and Co., New York, "An Exhibition of Treasures from the Sterling and Francine Clark Art Institute," February 2– 25, 1967, no. 21; Sterling and Francine Clark Art Institute, Williamstown, Massachusetts, "Winslow Homer in the Clark Collection," June 28–October 19, 1986, no. 57; Sterling and Francine Clark Art Institute, Williamstown, Massachusetts, "Safe Harbor, Smooth Sands, Rough Crossing," March 5–April 17, 1988 (no catalogue).

References: "Art Exhibition Is an Especially Fine One," *The Times* (Pittsburgh), November 3, 1904, p. 6; "Tribute Is Paid to Art Workers," *Gazette* (Pittsburgh), November 3, 1904, p. 2; "Works of Famous Artists Are on View," *Dispatch* (Pittsburgh), November 3, 1904, p. 2; "Paintings at Carnegie Galleries (No. 7): 'A Summer Squall' by Winslow Homer," *Gazette* (Pittsburgh), December 6, 1904, p. 6; C.E. Harcourt, "The Fine Arts in Pittsburgh," *Brush and Pencil,* 14 (December 1904), p. 374; William Howe Downes, *The Life and Works of Winslow Homer* (Boston and New York: Houghton Mifflin Co., 1911), p. 158; "Exhibits at the Galleries," *Arts and Decoration,* 4 (July 1914), p. 355; George Senseney, "The Effect of This War on American Art," *Arts and Decoration* 5 (March 1915), p. 176; Nathaniel Pousette-Dart, *Winslow Homer* (New York: Frederick A. Stokes, 1923), n.p.; Philip C. Beam, "Winslow Homer: A Biography," Ph.D. dissertation, Harvard University, Cambridge, Massachusetts, 1944, pp. 359, 361, 511; Lloyd Goodrich, *Winslow Homer* (New York: Macmillan Co., 1944), p. 181; CAI 1955, n.p., pl. VIII; "New England Museum, Williamstown: Sterling and Francine Clark Art Institute," *Arts Digest,* 29 (July 1, 1955), p. 15. Alexander Eliot, *Three Hundred Years of American Painting* (New York: Time Incorporated, 1957), pp. 137, 138; CAI 1958a, n.p., pl. XXXVII; Lloyd Goodrich, *Winslow Homer* (New York: George Braziller, 1959), no. 81; *Exhibit 16: Winslow Homer,* exh. cat. (Williamstown, Massachusetts: Sterling and Francine Clark Art Institute, 1961), n.p.; *Grolier Encyclopedia* (New York: Grolier, 1961), vol. 15, pp. 184, 194; Alfred Frankenstein, "American Art and American Moods," *Art in America,* 54 (March–April 1966), p. 80; Philip C. Beam, *Winslow Homer at Prout's Neck* (Boston: Little, Brown and Co., 1966), pp. 143, 144, 145; James Thomas Flexner, *The World of Winslow Homer 1836–1910* (New York: Time Incorporated, 1966), pp. 164, 176–77; *An Exhibition of Treasures from the Sterling and Francine Clark Art Institute* exh. cat. (New York: Wildenstein and Co., 1967), n.p.; Richard McLanathan, *The American Tradition in the Arts* (New York: Harcourt, Brace and World, 1968), p. 338; Donelson F. Hoopes, *Winslow Homer Watercolors* (New York: Watson-Guptill Publications, 1969), p. 34; CAI 1972, p. 56; Philip C. Beam, *Winslow Homer* (New York: McGraw-Hill, 1975), pp. 22, 24; Philip C. Beam, *The Magazine Engravings of Winslow Homer* (New York: Harper & Row, 1979), pp. 12, 245; Gordon Hendricks, *The Life and Work of Winslow Homer* (New York: Harry N. Abrams, 1979), pp. 197, 246, 260, 262, 267, 300; CAI 1981, pp. 80, 81; *Winslow Homer: Watercolors,* exh. cat. (Brunswick, Maine: Bowdoin College Museum of Art, 1983), pp. 28, 29; CAI 1984, pp. 20, 107; *Winslow Homer in the Clark Collection,* exh. cat. (Williamstown, Massachusetts: Sterling and Francine Clark Art Institute, 1986), pp. 12, 73.

George Inness
1825–1894

B orn in Newburgh, New York, George Inness spent his youth in Newark, New Jersey. His art studies began with Jesse Barker (active 1815–56), an itinerant painter, and an engraving apprenticeship with Sherman and Smith in New York. Inness's first important training took place around 1843 under the French émigré artist, Régis Gignoux (1816–1882). As a result, Inness's early work, although of American scenery, employed an artistic structure that indicated his familiarity with European Old Master painting.

Inness made two trips to Europe during the early 1850s. In 1851–52, shortly after his marriage, he spent fifteen months in Italy; in 1853 he visited France and became acquainted with the Barbizon painting of Théodore Rousseau (1812–1867) and Jean-Baptiste-Camille Corot (1796–1875), among others. The Barbizon experience taught Inness to work with more informal compositions, direct observation, and greater simplicity.

In 1860, suffering from poor health, unfavorable criticism, and lack of patronage, Inness moved to Medfield, Massachusetts. Three years later he moved to Eagleswood near Perth Amboy, New Jersey. At Eagleswood he was introduced to Swedenborgianism and began an important friendship with the painter William Page (1811–1885). Throughout the 1860s Inness's paintings continued to reflect the influence of the Barbizon artists' light and color. In 1868, as the American art world began to welcome the softer, more personal style of French Barbizon painting, Inness was elected to the National Academy of Design.

The 1870s was a decade of change for Inness. During 1870–75 he lived in Rome and visited Paris. He returned to Medfield in 1875, relocated to New York City in 1877, and settled in Montclair, New Jersey, the following year. He concentrated on the formal refinement of his art, focusing on the arrangement of pictorial shapes, the use of color, and more brushy paint application.

Greater prosperity and acceptance filled the last fifteen years of Inness's life, especially after an 1884 exhibition of his work in New York. He continued to live in Montclair but also traveled to Connecticut, Florida, Virginia, Massachusetts, and California. Inness's last paintings reflect his greater involvement with Swedenborgianism and a consequent desire to depict a metaphysical order in the painting of nature's various moods.

In 1894 Inness died in Scotland while on a tour of Europe. After his death, his reputation soared; his work influenced a generation of poetic landscape painters, and he stands today as one of America's most revered artists.

Bibliography: George Inness, Jr., *Life, Art and Letters of George Inness* (New York: The Century Co., 1917); LeRoy Ireland, *The Works of George Inness: An Illustrated Catalogue Raisonné* (Austin: University of Texas Press, 1965); *George Inness,* exh. cat. (Los Angeles: Los Angeles County Museum of Art, 1985).

T he subject and process of George Inness's art remained constant during his fifty-year career. Since the artist believed that reproducing man's mark in nature was most worthy of expression, he chose to depict civilized landscape rather than the wilderness chosen by many of his peers.[1] And instead of minute fidelity to the facts of nature, he focused on the emotions the landscape evoked through the use of indefinite forms and suggestive color.

The primary source of influence for Inness's subject matter and aesthetic was French Barbizon painting, which he encountered during an 1853 trip to France. After the Civil War, the work of Jean-Baptiste-Camille Corot (1796–1875), Jean-François Millet (1814–1875), and Théodore Rousseau (1812–1867) became very popular in the United States and was readily accessible to Inness in New York. Inness adopted especially Corot's ordinary, unspectacular landscape views, rendered with a sense of intimacy through informal compositions, subtle coloration, and hazy atmospheric conditions. Avoiding the strictly factual, the Barbizon artists blended naturalism with lyricism to create images of nature at once real and poetic.

As Inness matured, his Barbizon-inspired landscapes came to symbolize a higher power he saw reflected in the world around him through his growing commitment to the teachings of Swedish philosopher Emanuel Swedenborg.[2] Elliot Daingerfield (1859–1932), an Inness protégé and champion, characterized his mentor's conjunction of artistic and theoretical interests: "There was never a time when he let go of the great principle which guided him, that an artist's business is to paint what he feels . . . mindful, however, that he must ever lay up knowledge by study, since by its use, only can he express the qualities of unity which are qualities of Beauty."[3] By the 1890s, Inness had moved beyond simply capturing the material world to the expression of the spiritual.[4]

Wood Gatherers: An Autumn Afternoon is a prime example of Inness's later, more metaphysically inspired work. He used specific

Wood Gatherers: An Autumn Afternoon, 1891
Oil on canvas
30 × 45⅛ (76.2 × 114.6)
Signed and dated lower right: G. Inness 1891
No. 9

seasons and times of day to evoke certain sentiments throughout his career, and it was in the last decade of his life that he concentrated on painting autumn.[5] While the commonplace activity of a woman and child gathering wood is the ostensible subject of this painting, the autumnal afternoon setting charges the image with a mood of peace and serenity.

The year 1891 was particularly rich in autumn scenes, perhaps because Inness was in California for February through June and only resettled in Montclair, New Jersey, at the very end of the summer. In California, Inness spent a considerable amount of time with William Keith (1839–1911), a fellow landscape artist and Swedenborgian.[6] It is likely, then, that when Inness began to conceive his four major autumn pieces of 1891 — the Clark painting, *Early Autumn, Montclair* (Delaware Art Museum, Wilmington), *Sunset in the Woods* (The Corcoran Gallery of Art, Washington, D.C.), and *Spirit of Autumn* (private collection) — his thought rested on Swedenborgian ideas. Fundamental to Swedenborgianism is the doctrine of correspondences. Alfred Trumble defined this central principle as: "God alone lives. . . . Our apparent life, the life of the earth itself, is but the divine presence, which exists in individuals and in objects in different degrees."[7] For Swedenborgians, the understanding of the correspondences between God and the physical world revealed the spiritual world, which in turn revealed the natural world in a new way.[8] In *Wood Gatherers: An Autumn Afternoon* and the other 1891 autumn paintings, the mood Inness evoked may be no less than representations of spirit.

If Inness's subjects gave him the forum in which to suggest a higher reality, his method of painting contributed significantly to his program.[9] As a Swedenborgian, Inness believed that higher truths could only be suggested and not definitely depicted,[10] which led him to carry to an extreme a set of artistic strategies he had been working with for many years. Among those found specifically in *Wood Gatherers: An Autumn Afternoon* are the use of a balanced composition cropped on both sides; indistinct forms; a smooth, but painterly style; and a narrow range of colors that envelops the whole canvas.[11] Inness's compositional theory, evident in *Wood Gatherers: An Autumn Afternoon,* was very specific: "From the horizon (not the skyline) to the nearest point — the bottom of the canvas — there shall be three great planes; the first two shall be foreground, the third, or last, shall contain the distance. The subject matter must not be within the first plane, but behind it. . . . A figure, wherever placed, must not reach above the horizon, else it becomes subject matter and therefore a figure picture. . . . If followed logically [the system]

gives beautifully balanced results."[12] Within this formula, Inness worked out an ordered, balanced two-dimensional design which suggested the perfect unseen that he believed nature represented. In *Wood Gatherers: An Autumn Afternoon,* he spaced the vertical accents — the trees — at regular intervals across the canvas. With dense woods on each side framing a central open space, he created a balanced movement of the tree forms traversing the surface of the painting. He also truncated the tree tops, implying their extension beyond the picture plane, which may be a symbol for the extension of the natural world beyond materiality.[13]

These devices present a unity of composition enhanced by the yellow-green atmosphere that envelops the entire painting. The tonal range from cream to brown through the shifting greens evokes the qualities of air and light found at the end of a fall day. Instead of factual landscape description, Inness used a loose painting technique that suggests the different textures of tall grass, brush, and leaves on the brink of turning. Inness's forms — the figures, the buildings, and the trees — are rendered only as soft shapes of color that blend harmoniously into the overall scheme. Thus composition, color, and technique together present a consciously ordered and calm image corresponding to the physical world and therefore intelligible, but also evocative of a greater perfection.

It was with paintings such as *Wood Gatherers: An Autumn Afternoon* that Inness received great praise in the last decade of his life and almost heroic status after his death in 1894. One reason for this remarkable success was the patronage of Thomas B. Clarke; another was a shift in the American art climate that better accommodated Inness's subject matter and style. Thomas B. Clarke, possibly American art's most important nineteenth-century patron, began to collect Inness's work in the early 1870s.[14] Between 1872 and the sale of his collection in 1899, Clarke owned no fewer than sixty-four Inness works. Clarke was particularly fond of Inness's later paintings, and he bought at least seven works dated 1891, including *Wood Gatherers: An Autumn Afternoon.* In addition to purchasing pictures, Clarke acted as an agent for Inness and helped to arrange exhibitions of his work. In 1898 Clarke secured the artist's posthumous reputation by sponsoring an exhibition of his Inness and Homer pictures at the Union League Club, New York. With Inness's death relatively fresh in the critics' minds, the praise for his works was effusive. *Wood Gatherers: An Autumn Afternoon* was among the paintings that were particularly noted,[15] and it continued to make headlines into the twentieth century when, at the George A. Hearn sale in 1918, it brought a record price for the artist's work.[16]

Wood Gatherers: An Autumn Afternoon

Along with Clarke's patronage, the character of the art world in the artist's later years played a significant role in his success. As Michael Quick has noted, American art finally caught up to George Inness around 1890.[17] What caused him to be heralded as a pioneer at the time of his death were the features of his art that became the hallmarks of American Tonalist landscape painting from about 1890 to 1910. As a late extension of American Barbizon style, Tonalism offered personal and intimate reactions to nature through light and color.[18] Inness was clearly an example to younger artists, including J. Francis Murphy (1853–1921), Dwight Tryon (1849–1925), and his own son, George Inness, Jr. (1853–1926), who focused on the inward, poetic, and meditative through muted palettes, balanced compositions, cropping, and the use of a single atmospheric tone.

What separated Inness from other painters in the 1890s, however, was the religious impetus behind his work and the extent to which he depended on formal means to express it. *Wood Gatherers: An Autumn Afternoon* exemplifies his synthesis of a believable natural landscape with the suggestion of higher power through a conscious sense of design. Inness's special expression of metaphysical thought led George Lathrop to call him a "modern among moderns."[19]

1 Inness was quoted in 1878: "I love it [civilized landscape] more and think it more worthy of reproduction than that which is savage and untamed. It is more significant. Every act of man, everything of labor, effort, suffering, want, anxiety, necessity, love, marks itself wherever it had been"; "A Painter on Painting," *Harper's New Monthly Magazine*, 56 (February 1878), p. 461.

2 The most convincing discussion of Inness's work as a symbol of the divine can be found in Nicolai Cikovsky, Jr., *The Life and Work of George Inness* (New York: Garland Publishing, 1977), passim. From 1864 to 1867 Inness's friendship with the artist William Page particularly influenced his understanding of how art and Swedenborgian thought could be reconciled; ibid., pp. 202–5.

3 Elliot Daingerfield, *George Inness: The Man and His Art* (New York: Frederic Fairchild Sherman, 1911), p. 44.

4 Nicolai Cikovsky, Jr., and Michael Quick, *George Inness*, exh. cat. (Los Angeles: Los Angeles County Museum of Art, 1985), pp. 55, 180.

5 Autumn scenes appear in his work as early as 1869 and are found intermittently in pictures of the 1870s. Earlier autumn scenes include *Autumn Oaks* (1875; The Metropolitan Museum of Art, New York) and *Autumn Meadows* of 1869 (now lost; see LeRoy Ireland, *The Works of George Inness: An Illustrated Catalogue Raisonné* [Austin: University of Texas Press, 1965], no. 475).

6 "A California Chronology," in *George Inness Landscapes: His Signature Years 1884–1894*, exh. cat. (Oakland, California: The Oakland Museum, 1978), p. 33.

7 Alfred Trumble, "Inness," *Masters in Art*, 9, part 102 (June 1908), p. 27.

8 Cikovsky, *The Life and Work of George Inness*, p. 321.

9 Ibid., pp. 334–35.

10 Ibid., p. 299.

11 Bruce Weber, "In Nature's Ways: American Landscape Painting of the Late Nineteenth Century," in *In Nature's Ways*, exh. cat. (West Palm Beach, Florida: Norton Gallery of Art, 1987), p. 17.

12 Quoted in Daingerfield, *George Inness*, pp. 25–26.

13 Weber, "In Nature's Ways," p. 17.

14 This and all other information about Clarke has been gleaned from H. Barbara Weinberg's excellent article "Thomas B. Clarke: Foremost Patron of American Art from 1872 to 1899," *American Art Journal*, 8 (May 1976), pp. 60–83.

15 See, for example, "Art at the Union League," *The New York Times*, March 11, 1898, pp. 6–7.

16 "The Great Inness Sold," *American Art News*, 16 (March 23, 1918), p. 1.

17 Quick, "The Late Style in Context," in *George Inness*, p. 45.

18 The two most important studies of Tonalism are Wanda Corn, *The Color of Mood: American Tonalism, 1880–1910*, exh. cat. (San Francisco: M.H. de Young Memorial Museum, 1972), and William H. Gerdts, *Tonalism: An American Experience*, exh. cat. (New York: Grand Central Art Galleries Art Education Association, 1982).

19 George P. Lathrop, "The Progress of Art in New York," *Harper's Monthly Magazine*, 86 (1893), p. 86, quoted in Cikovsky "The Civilized Landscape," in *George Inness*, 1985, p. 41.

Provenance: To Thomas B. Clarke; to (American Art Association, New York, sale of Clarke collection, February 15–18, 1899, no. 169); to George A. Hearn, 1899; to (American Art Association, New York, sale of Hearn collection, February 26, 1918, no. 125); to (Scott and Fowles, New York); to Harold Somers; to (Parke-Bernet Galleries, New York, sale of Somers collection, May 26, 1943, no. 48); to (Scott and Fowles, New York); to (Parke-Bernet Galleries, New York, March 28, 1946, no. 60); to (M. Knoedler & Co., New York); to Robert Sterling Clark, April 1, 1946.

Exhibitions: Union League Club, New York, "George Inness and Winslow Homer," March 1898, no. 7; Union League Club, New York, December 11–13, 1902, no. 3; Macbeth Gallery, New York, "George Inness Centennial Exhibition," January 20–February 9, 1925, no. 9; Sterling and Francine Clark Art Institute, Williamstown, Massachusetts, "Exhibit 4: The First Two Rooms," May 17, 1955, no. 9; The Oakland Museum, California, "George Inness Landscapes: His Signature Years 1884–1894," November 28, 1978–January 28, 1979.

References: John C. Van Dyke, "George Inness as a Painter," *Outlook*, 73 (March 7, 1903), p. 541; "Art at the Union League," *The New York Times*, March 11, 1898, pp. 6–7; "Art Notes: Works by George Inness and Winslow Homer at the Union League Club," *The Sun* (New York), March 11, 1898, p. 6; Alfred Trumble, "Inness," *Masters in Art*, 9, part 102 (June 1908),

p. 41; Elliot Daingerfield, *George Inness: The Man and His Art* (New York: Frederic Fairchild Sherman, 1911), p. 45, opp. p. 48; "The Great Inness Sold," *American Art News*, 16 (March 23, 1918), p. 1; C.L. Buchanan, "Inness and Winslow Homer," *Bookman*, 47 (July 1918), p. 488; John C. Van Dyke, *American Painting and Its Tradition* (New York: Charles Scribner's Sons, 1919), p. 41; "George Inness," *Literary Digest*, 84 (March 21, 1925), p. 30; "A Century of George Inness: Master Painter of American Landscape," *Mentor*, 13 (June 1925), p. 44; "Coming Auctions: XIX Century Painters and Old Masters," *Art News*, 42 (May 15, 1943), p. 27; "Scott and Fowles Collection Comes to Auction," *The Art Digest*, 20 (March 15, 1946), p. 26; Elizabeth McCausland, "Some Inness Pieces," *Magazine of Art*, 39 (March 1946),

p. 103; CAI 1955, n.p., pl. IX; CAI 1958a, n.p., pl. XLIII; LeRoy Ireland, "George Inness: Painter of Landscapes," *Antiques*, 88 (December 1965), p. 823; LeRoy Ireland, *The Works of George Inness: An Illustrated Catalogue Raisonné* (Austin: University of Texas Press, 1965), pp. 351–52; Nicolai Cikovsky, Jr., *George Inness* (New York: Praeger Publishers, 1971), no. 83; CAI 1972, pp. 56, 57; H. Barbara Weinberg, "Thomas B. Clarke: Foremost Patron of American Art from 1872 to 1899," *American Art Journal*, 8 (May 1976), p. 77; Nicolai Cikovsky, Jr., *The Life and Work of George Inness* (New York: Garland Publishing, 1977), p. x; *George Inness Landscapes: His Signature Years 1884–1894*, exh. cat. (Oakland, California: The Oakland Museum, 1978), pp. 27, 58; CAI 1984, pp. 20, 104.

While autumnal scenes primarily occupied Inness in the last few years of his life (pp. 101–5), he painted at least one winter landscape in 1892, *Home at Montclair*. The artist had settled permanently in Montclair, New Jersey, in 1878, and, according to his son, the painting depicts the area right behind the Inness house.[1] Although winter was never a frequent setting in Inness's oeuvre, he had explored the subject as early as the mid-1860s — *Winter, Close of Day* (1866; The Cleveland Museum of Art) and *Christmas Eve* (1866; Montclair Art Museum) were his first two winter paintings — and he retained a mild interest in it throughout his active career.

For *Home at Montclair*, Inness chose the quietude at the end of a winter's day. Unlike other American painters who were attracted to the bright light of snow scenes, he painted his subject with a leaden atmosphere typical of the season. However damp and cold the air Inness depicts, the picture is neither depressing nor devoid of a sense of life. In the distance a figure trudges toward the house. The smoke rising from the domicile promises warmth and possibly companionship. Although the landscape is barren, the snow cover softens its harshness and birds dip into the foreground, suggesting that nature's life cycle continues throughout the year.

Painted within a year after *Wood Gatherers: An Autumn Afternoon* (pp. 101–5), *Home at Montclair* also expresses Swedenborgian beliefs through similar artistic strategies. Although Inness's method of painting depended on the study of nature, he rarely painted directly from nature, preferring to work from small sketches and drawings.[2] Even when a painting was based on a real locale, as here, he quickly moved away from it to seek eternal qualities through carefully constructed compositions, color, and paint application.

The techniques Inness employed for *Home at Montclair* are diverse. The background paint is thinly applied, with the trees and buildings, appearing as if drawn with soft charcoal, merely hinted at. The foreground is painted more freely, with touches of gray, blue, and browns on white impasto creating the image of a landscape seen far enough away to be blurred but with some distinctions intact. Because Inness believed that the physical world revealed the presence of the divine, he always preserved a certain amount of factual description, texture, and coloration. This kind of naturalism often led to the comparison of his art with Impressionist painting, but it was a comparison he detested.[3] "Impressionism," Inness remarked, "is the sloth enwrapped in its own eternal dullness."[4] In fact the genesis of Inness's work was quite the opposite from that of Impressionism. Rather than capture the momentary and transient effects of nature by replicating optical sensations, he wanted to present an eternal order of reality. Unlike many of the Impressionists, who broke each object into a variety of colors, he used a dominant tone, orange-gray in the case of *Home at Montclair*, that unified the whole composition while removing the landscape setting from strict descriptiveness. In this practice, Inness's approach resembled that of James McNeill Whistler (1834–1903).

Composition provided Inness with another means to unify his canvases and thereby suggest eternal perfection. Particularly in his late paintings and quite evidently in *Home at Montclair*, he used an almost mathematical precision in the structuring of the designs. A diagonal line from right foreground to left background anchors the composition, balancing the open foreground against the more closed background. Similarly, the naked tree at right front is offset by the bushy evergreen in the left rear, and the dusky darker sky

Home at Montclair, 1892
Oil on canvas
30⅛ × 45 (76.5 × 114.3)
Signed and dated lower left: G. Inness 1892
No. 10

plays against the lighter snow even as orange-gray pervades the entire canvas. As Inness moved from the general to the specific throughout this work, every element is softened to suggest the ethereal. The unusual balance and orderliness Inness imposed on the physical world correspond to Swedenborgian ideality.[5]

Soon after its completion, *Home at Montclair* entered the collection of James W. Ellsworth of Chicago. Like his friend Thomas B. Clarke, Ellsworth collected contemporary American painting and especially the work of George Inness. By 1892 Ellsworth owned sixteen Inness paintings, ranging in date from 1868 to 1892.[6]

1 George Inness, Jr., *Life, Art and Letters of George Inness* (New York: The Century Co., 1917), p. 245.

2 Nicolai Cikovsky, Jr., *The Life and Work of George Inness* (New York: Garland Publishing, 1977), pp. 304–6.

3 Nicolai Cikovsky, Jr., in *George Inness,* exh. cat. (Los Angeles: Los Angeles County Museum of Art, 1985), p. 180.

4 Quoted in *A New World: Masterpieces of American Painting 1760–1910,* exh. cat. (Boston: Museum of Fine Arts, 1983), p. 306.

5 Cikovsky, *The Life and Work of George Inness,* pp. 332–34.

6 C.M. Kurtz, "A Notable Chicago Gallery, I. — Mr. James W. Ellsworth's Paintings," *The Art Amateur,* 26 (March 1892), pp. 110–11.

Provenance: James W. Ellsworth, Chicago; to Mrs. Bernon S. Prentice (née Ellsworth), by descent; to (Parke-Bernet, New York, sale of the Prentice collection, April 19, 1952, no. 659); to (M. Knoedler & Co., New York, 1952); to Robert Sterling Clark, January 14, 1955.

Exhibitions: M. Knoedler & Co., New York, "A Half Century of Landscape Paintings by George Inness," November 16–28, 1953, no. 24; Sterling and Francine Clark Art Institute, Williamstown, Massachusetts, "Exhibit 4: The First Two Rooms," May 17, 1955, no. 10; M.H. de Young Memorial Museum, San Francisco, "The Color of Mood: American Tonalism, 1880–1910," January 15–April 2, 1972, no. 20; Museum of Fine Arts, Boston, "A New World: Masterpieces of American Painting 1760–1910," September 7–November 13, 1983, no. 86.

References: George Inness, Jr., *Life, Art and Letters of George Inness* (New York: The Century Co., 1917), pp. 245–46, opp. p. 186; CAI 1955, n.p., pl. X; CAI 1958a, n.p., pl. XLII; LeRoy Ireland, *The Works of George Inness: An Illustrated Catalogue Raisonné* (Austin: University of Texas Press, 1965), p. 366; CAI 1972, pp. 56, 57; *The Color of Mood: American Tonalism, 1880–1910,* exh. cat. (San Francisco: M.H. de Young Memorial Museum, 1972), p. 29; Alfred Werner, *Inness Landscapes* (New York: Watson-Guptill Publications, 1973), pp. 80–81; *A New World: Masterpieces of American Painting 1760–1910,* exh. cat. (Boston: Museum of Fine Arts, 1983), pp. 145, 157, 306; CAI 1984, pp. 20, 104; *George Inness,* exh. cat. (Los Angeles: Los Angeles County Museum of Art, 1985), pp. 59, 62; Robert M. Jolly, "George Inness's Swedenborgian Dimension," *Southeastern College Art Conference Review,* 11 (Spring 1986), pp. 20–21.

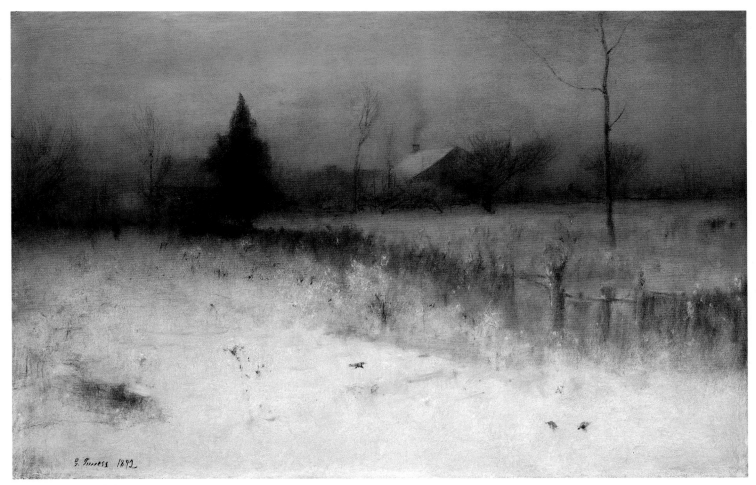

Home at Montclair

John Beaufain Irving
1826–1877

John Beaufain Irving was born in 1826 into a wealthy Charleston, South Carolina, family. Nothing is known about his early art training, but he was sufficiently skilled by 1849 to win the award for best painting at the first South Carolina Institute Fair. In 1851 he traveled to Europe to make the popular Grand Tour, which evolved into a nearly seven-year stay in Düsseldorf, where he studied under Emanuel Leutze (1816–1868). Irving returned to Charleston in 1858 and made his reputation there as a portrait painter.

Shortly after the end of the Civil War, Irving moved to New York City. Genre subjects soon replaced portraits as the mainstay of his work, and he quickly rose to fame. Beginning in 1866 he kept a studio in the Tenth Street Studio Building. He regularly exhibited at the Brooklyn Art Association and the National Academy of Design, where he was elected an associate in 1869 and an academician in 1872. Among Irving's distinguished patrons were John Jacob Astor, Leland Stanford, and August Belmont. Belmont exhibited his important collection to benefit Irving's family after the artist's sudden death in 1877.

Bibliography: "Art in the South," *Cosmopolitan Art Journal*, 4 (June 1860), p. 132; "Notes," *Art Journal*, 3 (June 1877), p. 191; "Beaufain Irving," *The Art Critic*, 1 (July 1879), pp. 34–35; Sallie Doscher, "Art Exhibitions in 19th-Century Charleston," *Art in the Lives of South Carolinians: 19th-Century Chapters* (Charleston, South Carolina: Carolina Art Association, 1979), pp. SD1–SD20.

An Amused Reader, 1876
(The Good Book)
Oil on panel
10 × 7⁷/₈ (25.4 × 20)
Signed and dated lower right: J Beaufain Irving
NA/76
No. 776

Irving's fame, during his short but very successful career, rested on paintings such as *An Amused Reader*—carefully rendered depictions of real or imagined sixteenth- and seventeenth-century European nobility. Some of Irving's works described actual historical or literary events. Others, such as the Clark painting, were constructed around the contemporary definition of genre painting: "on canvas what the novel, the story, the sketch is supposed to be on paper—a representation of some phase of human life, and hence the reason it appeals so forcibly to human feeling."[1]

In *An Amused Reader* the costume, chair, and Turkish carpet on the table speak of earlier centuries, while the lamp fixture and picture frames are typical of Irving's own time.[2] The subject, a gentleman's enjoyment of a favorite pastime, was one to which Irving's potential patrons could relate. His choice of style and subject was the product of several influences. Study in Düsseldorf in the 1850s had led him to historical themes and to a tightly painted and detail-oriented technique. He was also aware of the new class of American collectors interested in French genre painting by the late 1860s and seems to have been particularly inspired by the works of Jean-Louis-Ernest Meissonier (1815–1891).[3]

From 1840 on Meissonier had repeatedly explored the theme of the gentleman reader, or bibliophile, and he often arranged his composition around a table jutting out at an angle.[4] Irving absorbed Meissonier's painstakingly exact painting style, not only in *An Amused Reader* but also in *The Readers* (1873) and *The Book Worm* (1874).[5] Such a close affinity to the French painter's oeuvre prompted critics to dub Irving "the American Meissonier,"[6] an appellation intended as praise for the anecdotal character of his compositions, their exquisite detail, and jewel-like finish.[7]

Irving painted *An Amused Reader* in 1876, possibly during a sojourn in London.[8] One of his last works, it represents the height of his mature style.

1 A. Saule, "Genre Pictures," *The Aldine*, 9 (1878), p. 20.

2 I am grateful to Beth Carver Wees, curator of decorative arts, Sterling and Francine Clark Art Institute, for assisting in separating out the nineteenth-century elements in the painting.

3 The editor of *North American Review* described the tastes of America's new rich after the Civil War: "Purchasers longed to see their walls hung with subjects that would recall to them the Reignaults [*sic*], the Meissoniers and Gérômes of Transatlantic fame"; "The Progress of Painting in America," *North American Review*, 124 (May 1877), p. 459.

4 Constance Hungerford, "The Art of Jean-Louis-Ernest Meissonier," Ph.D. dissertation, University of California at Berkeley, 1977, pp. 128, 132.

5 The whereabouts of both pictures are unknown. *The Readers* was described in "New Pictures at the Schaus Gallery," *Evening Post* (New York), November 10, 1873, p. 2; mention of *The Book Worm* appeared in "Notes," *Art Journal*, 3 (June 1877), p. 191.

6 See, for example, Delta, "Music and Pictures in New York," *Boston Evening Transcript*, April 25, 1877, p. 2.

7 "The Progress of Painting in America," p. 462, and "Notes," p. 191.

8 The painting is on panel with a Windsor and Newton, London, label. Robert Sterling Clark bought the work in London in 1935. These two facts strongly suggest that Irving visited London in 1876.

Provenance: (N. Mitchell, London); to Robert Sterling Clark, March 18, 1935.

References: CAI 1972, pp. 130, 131; CAI 1984, pp. 20, 101.

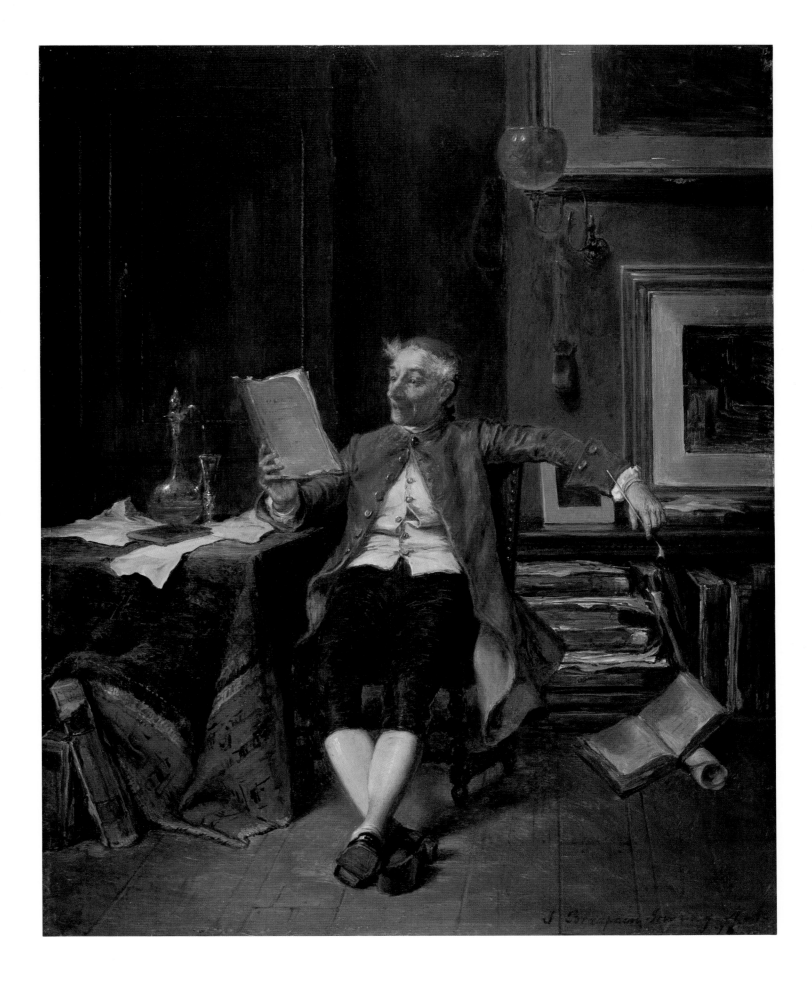

Clarence Johnson
1894–1981

Born in Maxtown, Ohio, Clarence Johnson came to Philadelphia in 1913 to attend the Pennsylvania Academy of the Fine Arts. He began in illustration classes, but by 1916 he had moved into life drawing. His teachers included Cecilia Beaux (1855–1942) and Daniel Garber (1880–1958). During World War I, Johnson served in France. In 1920 he resided there on a Cresson Traveling Scholarship granted before the war by the Pennsylvania Academy. Presumably he studied painting in Paris, but, like so many other young American artists, he also ventured to Giverny to paint the French countryside made famous by Claude Monet (1840–1926).

On his return to the United States, Johnson made his home in Lumberville, Pennsylvania, near New Hope. Between 1920 and 1930, he exhibited frequently at the Pennsylvania Academy. *Lumberville Lock* became his best-known work with its showing at the Cincinnati Art Museum, the Carnegie Institute, the National Academy of Design, and the Art Institute of Chicago during 1923–26. In 1924 he had his first one-man exhibition in New York City at the Dudensing Galleries. In the mid-1930s he put aside his brushes permanently to become an antiques dealer. He lived in the New Hope area until 1958 and then moved first to Doylestown, Pennsylvania, and finally to North Carolina.

Bibliography: Pennsylvania Academy of the Fine Arts student records; *Clarence Johnson* (Philadelphia: Janet Fleisher Gallery, 1982).

At the Hill's Top — Lumberville,

c. 1920–23
Oil on canvas
15⅛ × 18⅛ (38.4 × 46)
Signed lower right: C. Johnson
No. 1030

By the early 1920s Lumberville, Pennsylvania, five miles north of New Hope, was a small rural town past its heyday as a logging center. Around 1900 artists had begun to settle in this stretch of eastern Pennsylvania on the Delaware River, and in 1920, when Clarence Johnson moved there, an active group of painters headed by Daniel Garber (1880–1958) resided in the area.

At the Hill's Top — Lumberville is undated, but it was included in Johnson's one-man exhibition in January 1924 at Dudensing Galleries, New York. The picture's brown and purple coloration suggests a late autumnal setting, and it could have been executed in any of the first four autumns Johnson spent in Lumberville.

Johnson's style in this depiction of a Lumberville farmhouse and environs reflects his great admiration for his friend and teacher, Daniel Garber. Like Garber, Johnson used very dry paint that created a matte, almost chalky effect and blended his naturalism with stylistic features of Impressionism, Tonalism, and Symbolism.[1] He employed the broad, short brushstrokes of Impressionist painters as well as the more elongated ones of the Symbolists. The consequent ordering of strokes with a varied palette not only suggests the texture of the Pennsylvania landscape but also creates a decorative effect similar to that found in much art of the Post-Impressionist era. Yet the predominance of two colors, purple and brown, hints at the artist's probable familiarity with Tonalism.

Johnson's work, including *At the Hill's Top — Lumberville*, was well received at the 1924 Dudensing exhibition. The pictures were praised for both their sincere point of view and their able painting.[2] Robert Sterling Clark was also taken by the promise Johnson showed, and he bought this painting "to encourage the young man."[3]

1 For a discussion of how different American artists combined these various strains, see William H. Gerdts, "Post-Impressionist Landscape Painting in America," *Art and Antiques,* 6 (July–August 1983), pp. 60–67.

2 "Clarence Johnson — Dudensing Galleries." *Art News,* 25 (February 26, 1927), p. 9.

3 Robert Sterling Clark, diary, January 26, 1924, CAI archives.

Provenance: (Dudensing Galleries, New York, 1924); to Robert Sterling Clark, February 1, 1924.

Exhibition: Dudensing Galleries, New York, "Clarence Johnson," January 1924.

Reference: CAI 1984, pp. 24, 111.

John Frederick Kensett
1816–1872

Born in Cheshire, Connecticut, in 1816, John Frederick Kensett was initially trained as an engraver by his father and uncle. During the 1830s he worked in that profession in New York City, Albany, and New Haven, but his goal was to become a landscape painter. He went to Europe in 1840; for the next seven years he lived in England and Paris and also toured the Rhine Valley, Switzerland, and Italy. When he returned to New York in 1847, he quickly established himself as a painter. He was elected an associate of the National Academy of Design in 1848 and an academician the next year. Kensett exhibited regularly at the Academy and the Brooklyn Art Association, among other places. He also held key positions in many art organizations including, at the time of his death, the presidency of the Artists' Fund Society. He was also a founding trustee of the Metropolitan Museum of Art.

From the late 1840s on, Kensett's work pattern was unvaried. He spent summers sketching throughout New England and New York, making only occasional excursions away from the East Coast. In wintertime he used his sketches to create picturesque landscape views in his New York studio. During the 1850s his fame rested mainly on woodland scenes, but by the next decade he was focusing on light and atmosphere.

Bibliography: John Frederick Kensett: An American Master, exh. cat. (Worcester, Massachusetts: Worcester Art Museum, 1985)

Seascape, 1862
(Seascape with Schooner; Seascape with Schooner — Narragansett Bay)
Oil on canvas
10⅛ × 18 (25.7 × 45.7)
Signed and dated at lower right on rock:
JFK 62.
No. 1971.50

During the 1850s Kensett slowly shifted his subject matter from New England woodland scenery to coastal views, particularly those around Newport, Rhode Island. As early as 1789 Jedediah Morse had called Rhode Island "the Eden of America," and by the 1850s the environs of Newport were attracting artists.[1] The landscape offered fine views and exceptional light and was a relatively easy boat trip from New York; it was frequented by prominent New Yorkers and Bostonians and therefore had appropriate accommodations and social activities.[2]

Seascape, dated 1862, most likely depicts the southern coastline of Aquidneck Island, the largest in Narragansett Bay and the one on which Newport is located.[3] Kensett represented the same general area—identifiable by the small sandy beaches between rocky outcroppings that project into the ocean to create inlets—in the 1861 *Narragansett Bay* (fig. 51) and *The Rocks at Newport, Rhode Island* of 1862 (fig. 52).[4] The beaches around Newport were particular favorites of Kensett between 1862 and 1865, and he exhibited at least ten paintings, studies, and sketches of Newport and Narragansett Bay at the Brooklyn Art Association and Artists' Fund Society during these three years. Unfortunately, it has been impossible to determine if *Seascape* was among those shown.[5]

Fig. 51

Fig. 52

*Fig. 51: John Kensett, **Narragansett Bay**, 1861. Oil on canvas, 14 × 24 in. (35.6 × 61 cm). Private collection.*

*Fig. 52: John Kensett, **The Rocks at Newport, Rhode Island**, 1862. Oil on canvas, 10⅝ × 18⅝ in. (27 × 47.3 cm). Herbert F. Johnson Museum of Art, Cornell University, Ithaca, New York; Gift of Mr. and Mrs. Quinto Maganini, 54.5.*

The formal strategies evident in *Seascape* appeared regularly in Kensett's sea paintings from about 1855 to 1865.[6] His lateral compositions were open panoramas where vast expanses of sea and sky were balanced, horizontally and vertically, by massive rock formations. To heighten the illusion of distance, Kensett often placed boats and rocks at the horizon line.[7] Within these fixed settings, he concentrated on depicting a variety of light and air effects. Natural perfection and tranquility, the keystones of Kensett's art, were expressed through smooth brushwork and the subtle modulation of tone.

Seascape also exemplifies Kensett's method of painting during the early 1860s. On his travels he often sketched—in pencil and in oil—*en plein air,* and *Seascape,* which seems to have been painted in two stages, may have been started out of doors.[8] After drawing a horizon line in graphite below the middle of the canvas, he painted the sky and sea over the entire surface. The large rocks, the beach with small figures and boats on its far side, and the ships and rocks near the horizon were then painted over the sky and sea. Each of the boulders and the two schooners at right were enlarged after their initial painting, suggesting that *Seascape* may have begun as an outdoor study but later was worked to greater completion in the studio.

Kensett's Newport seascapes received much critical acclaim. They prompted James Jackson Jarves to call Kensett "the Bryant of our painters" and a writer for *The Aldine* to remark that nature had "no more conscientious student and no more devoted lover than John Frederick Kensett."[9] *Seascape,* though modest in size and scope, demonstrates Kensett's ability to combine pictorial poetry with close observation, which placed

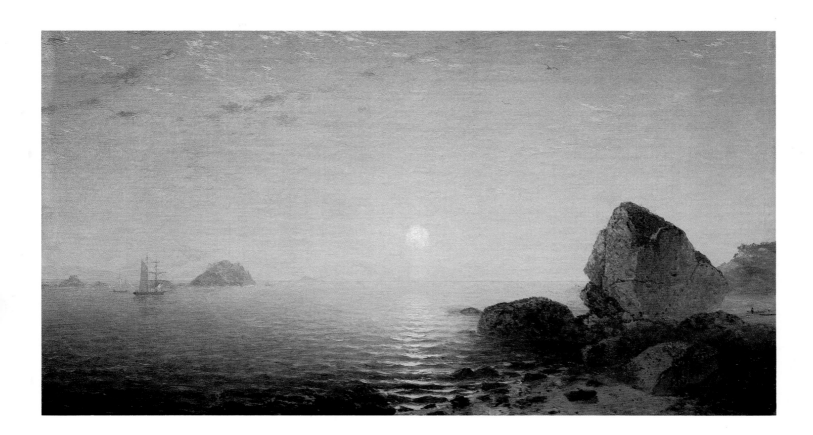

him among the most favored at a time when "truth to nature" was requisite for artistic success.

1 Robert G. Workman, *The Eden of America: Rhode Island Landscapes, 1820–1920,* exh. cat. (Providence: Museum of Art, Rhode Island School of Design, 1986), p. 15.

2 In the 1850s, prior to the residence of the great robber barons, Newport and its surrounding beach remained only moderately populated; see Carol Troyen in *American Paradise: The World of the Hudson River School,* exh. cat. (New York: The Metropolitan Museum of Art, 1987), p. 158. Newport was often praised by writers, including George Curtis in *The Lotus-Eaters* and Henry James in his 1870 essay on Newport, in which he favorably compared the light to that of Venice; see Mark W. Sullivan, "John F. Kensett," Ph.D. dissertation, Bryn Mawr College, Bryn Mawr, Pennsylvania, 1981, p. 134.

3 The painting's ownership can only be traced back to 1964, when it was assigned the title *Seascape with Schooner* by the dealers who had it in stock. At the time the painting came to the Clark, it was simply assumed to be a Narragansett view; Rudolph Wunderlich, Kennedy Galleries, to Frank Kelly, Clark Art Institute, February 14, 1979, CAI curatorial files.

4 Workman, *The Eden of America,* p. 29. New scholarship, however, has begun to reconsider some scenes heretofore identified with Rhode Island as depictions of similar topography found in Beverly, Massachusetts; see Kathleen Bennewitz, "A New Title," *Amon Carter Museum Bimonthly Calendar* (September–October 1988), n.p. To date, the Clark painting seems more closely allied to the Newport scenery, but it is difficult in many cases to differentiate the nearly identical Rhode Island and Massachusetts coasts.

5 I am grateful to David Dearinger for surveying the Artists' Fund Society catalogues at the New York Public Library and Kensett's sale ledger, Archives of American Art, roll N68–85. No sizes or descriptions of coast paintings in these records exactly match the Clark painting.

6 John Paul Driscoll, "From Burin to Brush: The Development of a Painter," in *John Frederick Kensett: An American Master,* exh. cat. (Worcester, Massachusetts: Worcester Art Museum, 1985), pp. 66–70.

7 Carol Troyen, in *American Paradise,* p. 159.

8 Dianne Dwyer, "John F. Kensett's Painting Technique," in *John Frederick Kensett,* p. 166. Since the Clark painting is lined and the tacking edges were removed, it cannot be determined if there were tack holes where the artist may have attached the unstretched canvas to a board.

9 James Jackson Jarves, *Art Idea* (Boston: Hurd and Houghton, 1864), p. 192, and "John Frederick Kensett," *The Aldine,* 6 (February 1873), p. 48.

Provenance: (Mitchell Work); to (Kennedy Galleries, New York, March 18, 1964); to William Ittman, March 1967; to Sterling and Francine Clark Art Institute, by exchange, 1971.

Exhibition: The Society of the Four Arts, Palm Beach, Florida, "Ships and Seas: A Loan Exhibition," January 8–30, 1966, no. 39 (as *Seascape with Schooner*).

References: Ships and Seas: A Loan Exhibition, exh. cat. (Palm Beach, Florida: The Society of the Four Arts, 1966), n.p.; CAI 1980, p. 39; CAI 1984, pp. 21, 101.

John La Farge was born in New York City on March 31, 1835. His grandfather gave him his earliest art instruction, but his formal training began in 1845 with art classes at the Columbia Grammar School. The pursuit of a classical education and law studies did not stifle his interest in art. In 1856 he visited relatives in France, and through them he entered the important artistic and literary circles of the day. He also copied at the Louvre, studied briefly with Thomas Couture (1815–1879), and traveled around the French countryside. On his return to New York in 1857, he briefly practiced law before setting up a studio at the Tenth Street Studio building. In the spring of 1859, committed to a career as a painter, he moved to Newport, Rhode Island, to study with William Morris Hunt (1824–1879).

During the first half of the 1860s, La Farge divided his time between New York and Newport, but from 1865 to 1871 he lived mainly in Rhode Island. Landscape and still life were his primary subjects and an interest in color theory guided all his work. He had become interested in mural painting and stained glass while in Europe; in 1876 he was chosen to decorate the interior of Trinity Church, Boston. With this commission, he began more than a decade of almost-full-time work as a muralist and decorator. In both sacred and secular interiors, he became a pioneer in stained-glass and mural techniques. It was during these years as well that watercolor became his preferred medium for smaller works and designs.

La Farge traveled to Japan in 1886 and the South Seas in 1890–91. For the first time in many years he was able to paint without interruption, and he created a large group of beautiful watercolors. At his death in 1910, he was recognized as an important figure in both the fine and the decorative arts.

Bibliography: John La Farge, exh. cat. (Pittsburgh: The Carnegie Museum of Art; Washington, D.C.: National Museum of American Art, Smithsonian Institution, 1987); Henry La Farge, Mary La Farge, and James Yarnall, *John La Farge: Catalogue Raisonné* (New Haven: Yale University Press, forthcoming).

A portion of John La Farge's early work was devoted to classical themes, no doubt inspired by his traditional education, exposure to French academic painting while in France in 1856–57, and the instruction he received from William Morris Hunt (1824–1879) beginning in 1859.[1] La Farge also attended the lectures on art anatomy given by physician-artist William Rimmer (1816–1879) in Boston between 1862 and 1864, which not only encouraged his fascination with the classical but also helped him master figure painting.[2]

Classical themes appeared in both La Farge's still-life and figure paintings. During the early 1860s he concentrated on still life, as in his beautiful wreath paintings—*Agathon to Erosanthe, Votive Wreath* (1861; private collection), and *Wreath of Flowers (Greek Love Token)* (1866; National Museum of American Art, Washington, D.C.). Around the same time he also painted a group of classically based figures, including *Portrait of Margaret Perry* (fig. 53), *Woman Bathing* (n.d.; Worcester Art Museum), *Venus Anadyomene* (1862; whereabouts unknown), and *Andromeda.*

Identifying the model and date of *Andromeda* has created some controversy among La Farge scholars.[3] L. Bancel La Farge and Henry La Farge, the artist's grandsons and authorities on his work, disagreed as to whether *Andromeda* features Margaret Perry La Farge, the artist's wife, and therefore could be associated with an early group of classical figures for which she is known to have been the model. A comparison of *Andromeda* with the 1859 *Portrait of Margaret Perry* shows a significant resemblance between the two women. This and the fact that *Andromeda* was owned by Margaret Perry La Farge's mother by 1878 makes a strong case for identifying Mrs. La Farge as the model for the Clark picture. Yet both La Farge grandsons preferred an early 1870s dating, based in part on the fact that La Farge first exhibited the picture in 1875. Furthermore, Henry La Farge strongly believed that *Andromeda* was the result of the artist's response to the discovery of classical sculptures at Tanagra in 1870. James Yarnall, however, has suggested that *Andromeda* dates from the early 1860s, and that the title was most likely La Farge's last-minute designation before the work's inclusion in the 1875 Century Association exhibition.[4] It does seem that the close relation of pose and figure type between *Andromeda* and the 1859 *Portrait of Margaret Perry* cannot be ignored, even if the free and confident paint handling of *Andromeda* suggests a later date. La Farge's decision to exhibit *Andromeda* first only in 1875 may simply reflect the renewed interest in the classical that came with the discoveries at Tanagra.

Complicating the complete acceptance of an early 1860s date is the fact that La Farge did paint portrait studies from photographs

Andromeda, by 1875
(Woman in a White Dress Walking)
Oil on academy board
$9\frac{1}{4} \times 6\frac{1}{16}$ (23.5 × 15.4)
Unsigned
Gift of L. Bancel La Farge
No. 1966.9

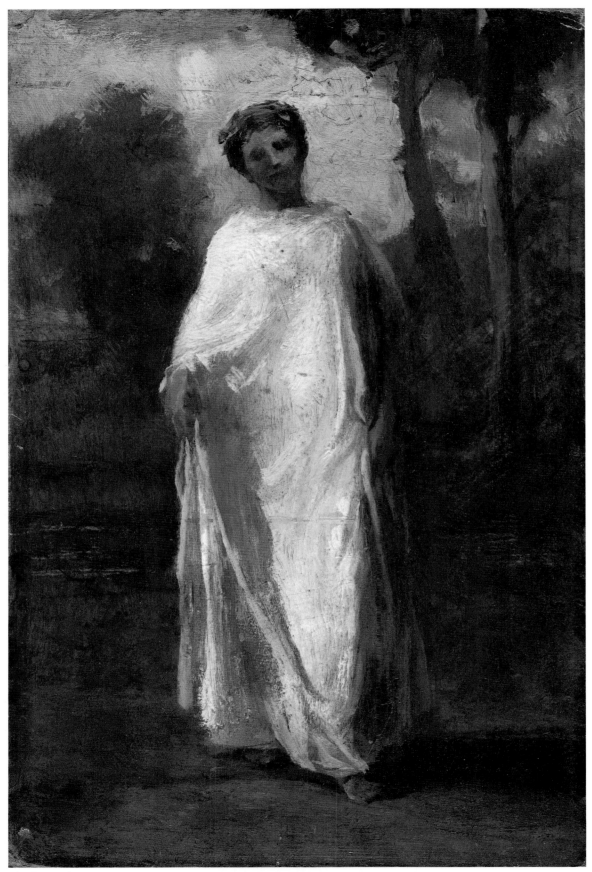

Andromeda

in the early 1870s.[5] His own interest in Tanagra figures in the early seventies could have prompted his return to classical themes after a hiatus of several years. The lack of other similar pictures firmly dated in the 1870s, however, makes this course of events seem less probable.

Regardless of its date, *Andromeda* displays La Farge's lifetime passion for merging the real and the ideal. Throughout his career he used a realistic interpretation of nature to express ideal themes.[6] In *Andromeda* the careful painting of the drapery over the form of a striding figure makes a definite connection to the physical world. Yet the wet-drapery effect intimates classical Greek sculpture, while the white-robed and crowned figure and the non-specific and loosely painted landscape background extend an otherworldly aura. Through this dichotomy, *Andromeda* suggests both a portrait of the artist's wife and an ideal image of womanhood.

1 H. Barbara Weinberg, *The Decorative Work of John La Farge* (New York: Garland Publishing, 1977), p. 51.

2 Exactly when La Farge heard Rimmer's lectures is unknown. The anatomical studies that would apparently relate to Rimmer's talks are mostly dated 1863; see James Yarnall, "The Role of Landscape in the Art of John La Farge," Ph.D. dissertation, University of Chicago, 1982, p. 142 n. 1; Weinberg, *The Decorative Work of John La Farge*, pp. 52–53.

3 James Yarnall generously shared with me the material on *Andromeda* to be included in the forthcoming catalogue raisonné, including the opinions of Henry and L. Bancel La Farge. The 1859 *Portrait of Margaret Perry* is no. P1859.13 in the catalogue.

4 James Yarnall to the author, October 12, 1987.

5 James Yarnall, "John La Farge's *Portrait of the Painter* and the Use of Photography in His Work," *American Art Journal*, 18 (Winter 1986), pp. 5–20.

6 Barbara Weinberg, "John La Farge—The Relation of His Illustrations to His Ideal Art," *American Art Journal*, 5 (May 1973), p. 71.

Provenance: To Mrs. Christopher Grant Perry (the artist's mother-in-law), Philadelphia, by 1875; to Bancel La Farge (the artist's son), Mount Carmel, Connecticut, 1903; to Mabel Hooper La Farge (his wife), 1938; to L. Bancel La Farge (their son), New York, 1942; gift to Sterling and Francine Clark Art Institute, June 1966.

Related Work: Portrait of Margaret Perry, c. 1859, oil on panel, size and whereabouts unknown.

Exhibitions: Century Association, New York, "Monthly Exhibition," January 1875, no. 19; Philadelphia, "Centennial Loan Exhibition," 1875, no. 16; National Academy of Design, New York, "53rd Annual Exhibition," mid-April–June 1, 1878, no. 617 (as *Androma* [sic]—*Study*); Graham Gallery, New York, "John La Farge," May–June 1966, no. 25 (as *Woman in a White Dress Walking*).

References: M[ariana] G[riswold] v[an] R[ennselaer], "National Academy of Design, New York: 53rd Annual Exhibition," *The American Art and Building News*, 3 (April 27, 1878), p. 149; "National Academy of Design: Final Notice," *The Nation*, 26 (May 30, 1878), p. 363; CAI 1972, pp. 58, 59; CAI 1980, p. 35; CAI 1984, pp. 22, 102; Henry La Farge, Mary La Farge, and James Yarnall, *John La Farge: Catalogue Raisonné* (New Haven: Yale University Press, forthcoming).

*Fig. 53: John La Farge, **Portrait of Margaret Perry**, c. 1859. Oil on panel, dimensions unknown. Location unknown.*

Still life, specifically floral themes, occupied John La Farge at two different times during his career: from 1859 to around 1866 and again beginning in 1876.[1] The latter excursion lasted about six years and coincided with the artist's growing interest in watercolor.

Flowers—Decorative Study, a floral still life in encaustic, may date from the early 1880s but was not exhibited until La Farge's first one-man show at the Gustav Reichard Gallery, New York, in 1890.[2] By 1881 La Farge was engrossed in commissions to decorate the Union League Club and the home of Cornelius Vanderbilt II, both in New York. *Flowers—Decorative Study* and another similar but circular encaustic still life (fig. 54) probably served as preliminary studies for these kinds of interior commissions,[3] which were done mainly in encaustic, La Farge's preferred method for both sacred and secular

wall decorations since the late 1860s. They are the only wax pictures in La Farge's oeuvre listed as "Flowers—Decorative Study."[4]

The Clark work underwent significant changes after its initial execution. La Farge cut down at least three sides of the canvas and repainted the background entirely.[5] When first executed, the background had a low-toned but bold geometric pattern, which was almost completely obliterated in the repainting. (The picture was restretched before La Farge worked on it the second time, and the original pattern background is visible on the present tacking edges.) La Farge seems to have left the flowers untouched. Painted much more thinly than the rest of the picture, they have retained their fresh color.

The evidence strongly suggests that La Farge cut down and repainted *Flowers—Decorative Study* during the last eight months of his life. Unfortunately, no record exists

Flowers—Decorative Study,
by 1890 and 1910
(Decorative Panel of Flowers; Flower Study; Roses)
Encaustic on canvas
$9^{3}/_{8} \times 16^{15}/_{16}$ (23.8 × 43)
Unsigned
Gift of L. Bancel La Farge
No. 1966.10

Fig. 54: John La Farge, **Flowers— Decorative Study,** *c. 1880–90. Encaustic on canvas, 15 in. (38.1 cm) diameter. Private collection.*

of the picture's size before 1910, although it seems likely that the picture was taller than it is now. When it was sold through Anderson Art Galleries on March 9, 1910, it was listed as "Height, 14½ in.; width 14½ in."[6] This may indicate a typographical error in the width and/or that the painting was put in a square mat within a larger frame, obscuring one or both of its dimensions. (There is no evidence that anything has been added to the canvas to form the present width of 16¹⁵⁄₁₆ inches.) Failing to sell at Anderson's, it was returned to the artist. After La Farge's death in November 1910, it remained with his estate until it was acquired by Vose Galleries, Boston, on April 17, 1912. It was then recorded as 9⅜ × 16⅜ inches, a fraction off its present size.[7] All this suggests that the picture was altered when it was returned to La Farge after the March 1910 sale. Since the edges of the picture confirm that it was repainted and re-stretched at the same time, it is possible to date La Farge's alterations to some time between March and November 1910.

Why La Farge chose to rework the background remains a mystery. The last year of his life was fraught with financial difficulties and illness.[8] In the summer of 1910, perhaps realizing that death was imminent, he finished and signed a number of older works.[9] Always interested in experimentation, he may have tried to rethink earlier ideas. The changes in *Flowers—Decorative Study* indicate that he wished to turn the image of flowers floating on a patterned background to a still-life arrangement resting on a table. Unfortunately, the properties of the wax medium did not allow him to succeed.

1 Kathleen A. Foster, "The Still Life Painting of John La Farge," *American Art Journal*, 11 (Summer 1979), p. 6.

2 James Yarnall, director of the La Farge catalogue raisonné project, made available to me all his provenance and exhibition information for this picture.

3 Between 1880 and 1885, La Farge was primarily involved with the Union League Club and Vanderbilt jobs. While 1886 was spent in the South Seas, on his return in 1887 he began work on the Whitelaw Reid house; see *John La Farge,* exh. cat. (Washington, D.C.: National Museum of American Art, Smithsonian Institution, 1987), p. 243.

4 *Catalogue of Drawings, Water Colors and Paintings by Mr. John La Farge, N.A.,* exh. cat. (New York: Gustav Reichard Gallery, 1890), no. 14 or 15. Subsequent catalogues show these two works always exhibited together until c. 1900, when the circular painting was taken to England.

5 Although the bottom edge, too, appears to be cut, paint loss and the remains of two painted stripes that seem to mark a bottom edge make it difficult to draw precise conclusions.

6 *Illustrated Catalogue of Important Paintings by Distinguished Modern Artists from Private Collections,* auction cat. (New York: Anderson Art Galleries, March 8–9, 1910), no. 99. It is not known if this was an actual, sight, or framed size.

7 Vose Galleries records and John Nutting, "In the Art Galleries," *Boston Daily Advertiser,* November 20, 1911, p. 5, indicate that the picture was in the gallery in November 1911 for a La Farge exhibition. The gallery records, however, do not reflect their acquisition of the picture until April 17, 1912 (stock card #3174). I am grateful to the Vose Galleries, especially Robert Vose, Sr., for assisting me in this matter.

8 *John La Farge,* p. 245.

9 James Yarnall, conversation with the author, January 21, 1988.

Provenance: To (Macbeth Gallery, New York, 1907); to the artist; to (Anderson Art Galleries, New York, March 9, 1910, no. 99); to August Jaccaci for the artist; to estate of John La Farge, 1910; to (Vose Galleries, Boston, April 17, 1912); to Henry Lee Higginson, Boston, April 21, 1914; to Mr. and Mrs. Bancel La Farge, Mount Carmel, Connecticut, by 1919; to L. Bancel La Farge, New York, 1938; gift to Sterling and Francine Clark Art Institute, June 1966.

Related Work: Flowers—Decorative Study, c. 1880–90, encaustic on canvas, 15 (38.1) diameter, private collection.

Exhibitions: Doll and Richards, Boston, "Drawings, Watercolors, and Paintings by Mr. John La Farge on Exhibition and Sale," January 25–February 6, 1890, no. 39 or 40; Gustav Reichard Gallery, New York, "Drawings, Water Colors and Paintings by Mr. John La Farge, N.A.," April 15–May 1, 1890, no. 14 or 15 (no. 14, *Flowers. Decorative Study. Wax Painting;* no. 15, *Same*); St. Louis Exposition, "7th Annual Exhibition," September 3–October 18, 1890, no. 194 or 195; Doll and Richards, Boston, "Exhibition and Private Sale of Paintings in Water Color and Oil Chiefly from South Sea Islands," February 14–26, 1896, no. 28 or 29; Doll and Richards, Boston, "Works by John La Farge," February 21–March 5, 1907, no. 134 (as *Decorative Panel of Flowers [Wax.]*); Macbeth Gallery, New York, "Exhibition of Pictures by John La Farge," November 27–December 12, 1907, no. 22 (as *Decorative Panel of Flowers. [Oil.]*); Poland Spring Art Gallery, South Poland, Maine, "13th Annual Exhibition of Paintings by Prominent Artists," 1907, no. 52; Seattle Fine Arts Association, "Exhibition of Paintings and Drawings by John La Farge, N.A.," January 4–16, 1909, no. 25; M. Knoedler & Co., New York, "Exhibition of Glass, Oil and Water Color Paintings and Sketches by John La Farge, N.A.," February 15–31, 1909, no. 86; Anderson Art Galleries, New York, "Important Paintings by Distinguished Modern Artists from Private Collections," March 8–9, 1910, no. 99; Vose Galleries, Boston, "Exhibition of Paintings, Water Colors and Drawings by the late John La Farge," November 13–25, 1911, no. 69 (as *Flower Study—Wax*).

References: "Paintings, Sketches, and Studies by John La Farge," *The Studio* (New York), 5 (April 26, 1890), p. 206; "The La Farge Exhibition," *The Art Amateur,* 23 (June 1890), p. 4; "Art Exhibitions: A Collection of Pictures by Mr.

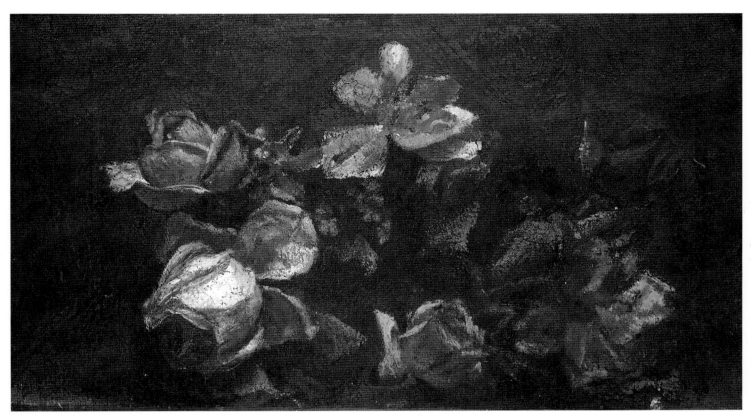

Flowers—Decorative Study

John La Farge," *New-York Daily Tribune,* December 4, 1907, p. 7; "John La Farge to Exhibit Here," *The Seattle Post-Intelligencer,* January 1, 1909, p. 1; "La Farge's Art Studies an Interesting Exhibit," *Boston Daily Advertiser,* March 20, 1909, p. 5; "Paintings at Auction," *American Art Annual,* 8 (1911), p. 373; John Nutting, "In the Art Galleries," *Boston Daily Advertiser,* November 20, 1911, p. 5; CAI 1972, pp. 58, 59 (as *Roses*); CAI 1980, p. 35 (as *Roses*); CAI 1984, pp. 22, 102 (as *Roses*); Henry La Farge, Mary La Farge, and James Yarnall, *John La Farge: Catalogue Raisonné* (New Haven: Yale University Press, forthcoming).

Nicholas Winfield Scott Leighton 1847–1898

The artist, known throughout his life as Scott Leighton, grew up in Grey, Maine. Drawing was an early passion, but at fourteen he joined his father in the horse-trading business. In 1864 Leighton moved to Portland, Maine, determined to be a painter. Unsuccessful at making a living painting portraits of horses, he soon moved to Providence, Rhode Island, to work as a furniture painter. He returned to Portland in 1867 and studied with the landscapist Harrison B. Brown (1831–1915). By about 1870 Leighton was sufficiently accomplished to give lessons to D.D. Coombs (1850–1938).

From the mid-1870s, Leighton divided his time between Boston and Portland. He painted horse portraits almost exclusively until about 1883, when he began to include other animals and landscape in his work. Horses, however, remained the focus of his art. Throughout the 1880s, his pictures were lithographed by various firms, including Currier and Ives. He exhibited regularly at the Boston Art Club, the Paint and Clay Club, and occasionally at the National Academy of Design. By 1888 he was renowned enough to be included in Frank Robinson's *Living New England Artists.*

Leighton experienced a considerable decline in the 1890s. Late in 1897 he suffered a nervous breakdown. He died early the following year, leaving his estate in debt. It was settled in April 1898, when 350 of his paintings were sold at auction.

Bibliography: "Scott Leighton," *Lewiston Journal* (Maine), May 26, 1934, p. A12; Frank Torrey Robinson, *Living New England Artists* (Boston: S.E. Cassino, 1888), pp. 127–31; Sherwood E. Bain, "N.W. Scott Leighton," *The Magazine Antiques,* 115 (March 1979), pp. 544–51.

Two Horses and Riders, after 1883

Oil on canvas
$10^{1}/_{16} \times 11^{15}/_{16}$ (25.6 × 30.3)
Signed at lower left: Scott Leighton
No. 786

Fig. 55: *Nicholas Winfield Scott Leighton,* **First on the Ground,** 1890. Oil on canvas, 18 × 24 in. (45.7 × 61 cm). Location unknown.

From 1868 to 1883 Scott Leighton painted only horse portraits. After 1883, however, he "determined to work for art and art's sake."[1] Although horses still figured prominently in his work, Leighton set his subjects within landscape settings and often implied a narrative theme. *Two Horses and Riders,* though undated, was likely executed during this second half of the artist's career.

Very little is known about Leighton's working methods, but a comparison of *Two Horses and Riders* with his 1890 *First on the Ground* (fig. 55) provides us with some clues.[2] The pair of horses and men placed prominently in the foreground of a landscape in the Clark picture was repeated in the larger *First on the Ground.* The same two horses, with subtle changes, appear elsewhere in *First on the Ground,* and the model for the standing figure in *Two Horses and Riders* was used for the figure on the dark horse at center left in *First on the Ground.* Despite noticeable differences between the works, *Two Horses and Riders* and perhaps other pictures seem to have provided a model for the 1890 picture. This sequence is suggested by the small size of *Two Horses and Riders,* its direct painting technique with no drawing, and hasty brushwork for the landscape, all of which speak for an early step in the creation of the larger and more complicated canvas.

As in all Leighton's pictures, the animals in *Two Horses and Riders* were tightly painted and carefully colored. Even in this small-scale oil, the truth of what Frank Robinson wrote of Leighton's ability to paint horses is apparent: "His horses are always technically good in drawing, showing unerring knowledge, the result of arduous study and a happy sense of seeing and feeling for the noble traits of these creatures."[3] By comparison, the figures are crudely painted, but they provide the necessary human element that shifts the picture's subject from horse portraiture to genre. The landscape, painted thinly and freely, serves simply as a stage set. Its soft focus suggests Leighton's familiarity with Barbizon pastoral scenes and creates a fitting environment for the depiction of two gentlemen meeting in the field.

As America headed toward the twentieth century, art collectors took a greater interest in feeling than in fact. At the same time the advent of photography must have affected artists such as Scott Leighton who portrayed animals for their owners. Leighton may have found that his patrons demanded fewer horse portraits and more bucolic scenes of genteel living that included the animals they loved. *Two Horses and Riders* documents the artist at work toward that end.

1 Frank Torrey Robinson, *Living New England Artists* (Boston: S.E. Cassino, 1888), p. 128.

2 Vose Galleries, Boston, kindly shared their Leighton files and photographs with me.

3 Robinson, *Living New England Artists,* p. 130.

Provenance: (Wildenstein and Co., New York); to Robert Sterling Clark, November 1, 1944.

Related Work: First on the Ground, 1890, oil on canvas, 18 × 24 (45.7 × 61), whereabouts unknown.

References: CAI 1972, pp. 60, 61; Sherwood E. Bain, "N.W. Scott Leighton," *The Magazine Antiques,* 115 (March 1979), pp. 544–51; CAI 1984, pp. 22, 100.

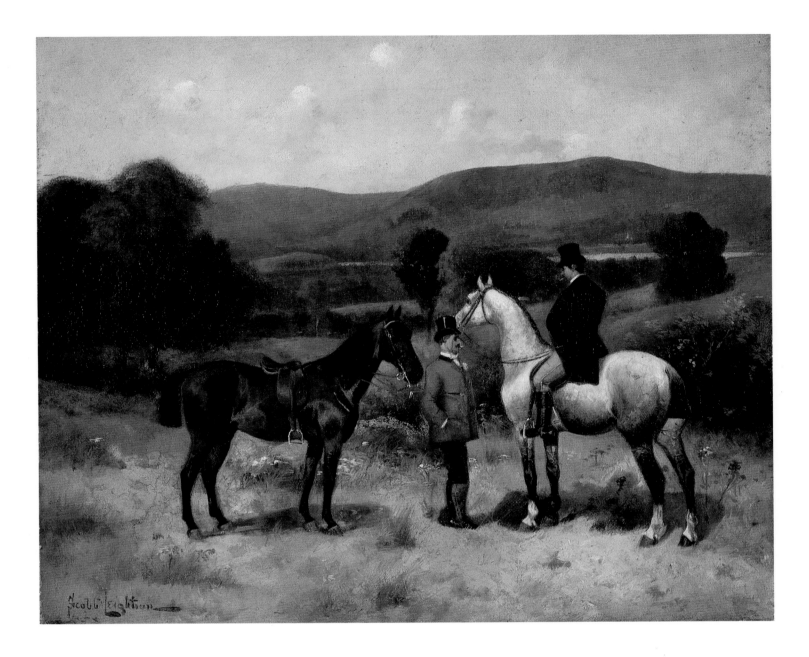

Walter McEwen
1860–1943

A Chicago native, Walter McEwen attended Northwestern University in 1875–76 before enrolling in the Munich Royal Academy in May 1877. His rise to success there was swift, and in 1880 he won a silver medal for his accomplishments. Six years later he left Munich for Paris, where he kept a studio for more than fifty years. He studied with both Fernand Cormon (1845–1924) and Tony Robert-Fleury (1837–1912) in his early Parisian days. From 1883 to the beginning of World War II, McEwen maintained a summer residence in Holland.

Although he chose to live abroad after 1877, McEwen's genre paintings, mostly of Dutch life, were appreciated in the United States as well as in Europe. Among the many awards and honors bestowed on him were a silver medal at the 1889 Paris Exposition, honors at the 1893 World's Columbian Exposition in Chicago, a gold medal at the 1897 Munich International Exhibition, and a gold medal at the 1904 Louisiana Purchase Exposition in St. Louis. In 1896 the French named McEwen a chevalier of the Legion of Honor.

In 1920 arthritis forced McEwen to stop painting and he turned to etching. He was on a visit to America when war broke out in Europe, and he remained in this country until his death in 1943.

Bibliography: Artists' files, Ryerson Library The Art Institute of Chicago; "Walter M'Ewen, Artist, Dies at 85," *The New York Times,* March 21, 1943, p. 26; *American Expatriate Painters,* exh. cat. (Dayton, Ohio: Dayton Art Institute, 1976), pp. 108–10; *The Hague School and Its Legacy,* exh. cat. (Washington, D.C.: Federal Reserve Gallery, 1982), p. 14.

A Girl Looking in a Mirror,
after 1890

(The Little Blue Coat Vanity)
Oil on canvas
11 1/2 × 9 1/8 (29.2 × 23.2)
Signed at left: M'Ewen
No. 806

A *Girl Looking in a Mirror* shows the expatriate McEwen's preference for Dutch themes, often involving genteel, beautiful women. A partially disrobed woman gazes dreamily into a mirror. Her blue, fur-trimmed coat gives her a distinctly old-fashioned Netherlandish appearance, but her casual pose seems thoroughly contemporary.

Figure painting was a principal concern for artists in the last quarter of the nineteenth century, and McEwen was among those praised by George Sheldon in his *Recent Ideals of American Art* for pursuing the figure and the beautiful.[1] McEwen's rendering of the figure in a tight, carefully constructed method had been influenced primarily by his French academic training. As in the works of so many of his Paris-trained colleagues, McEwen's use of a vague narrative and a foreign, historical costume veiled his fundamental interest in painting the figure. The Dutch, historicized subject also reflects the influence of the Hague School during the 1870s and 1880s, although McEwen's figures are more refined than the rough peasants painted by many of his peers.[2] His pictures also differ from the more serious-minded Dutch works of his fellow expatriates Gari Melchers (1860–1932) and George Hitchcock (1850–1913) in their penchant for the anecdotal and sentimental.[3]

Other aspects of *A Girl Looking in a Mirror* closely ally McEwen with the wide variety of Dutch painting he was exposed to during his many summers in Holland.[4] The intimate viewpoint, small scale, and the variety of textures depicted on the woman's garments reflect traditional Dutch art, particularly the work of the Dutch Little Masters such as Pieter de Hooch (1629–1684) and Gerard Terborch (1617–1681). The composition of *A Girl Looking in a Mirror,* centered on a single female illuminated by an outside source through a window, was one frequently used throughout the history of Dutch painting — both by seventeenth-century Netherlanders such as Jan Vermeer (1632–1675) and the Hague School figure painters with whom McEwen was associated.[5]

Although undated, *A Girl Looking in a Mirror* may have been executed in the early 1890s soon after McEwen shifted his subject matter from rustic to more refined scenes.[6] In 1894 he exhibited a painting entitled *The Mirror* at the Art Institute of Chicago. It was described by a reviewer as "a warm little canvas of a girl studying herself in 'The Mirror.'"[7] Although this brief description matches the Clark painting, McEwen may have returned to the theme more than once in his long career. With the exception of a small number of Empire costume pictures he made late in life, he varied his themes and style very little after 1890.

A writer for the *Chicago Tribune* in 1890 remarked that "Mr. McEwen leaves to the reformers the misery of life; he feels that the artist must pursue beauty in her haunts and reveal her for the world's delight."[8] In *A Girl Looking in a Mirror,* richly textured painting in harmonious tones of blue and yellow speaks for McEwen's pursuit of the beautiful.

1 George Sheldon, *Recent Ideals of American Art* (New York: D. Appleton and Co., 1888–90), p. 66.

2 Mary Ann Goley, *The Hague School and Its Legacy,* exh. cat. (Washington, D.C.: Federal Reserve Gallery, 1982), p. 2.

3 Michael Quick, *American Expatriate Painters,* exh. cat. (Dayton, Ohio: Dayton Art Institute, 1976), p. 108.

4 For the range of Netherlandish influence on American painters, see Annette Stott, "American Painters Who Worked in the

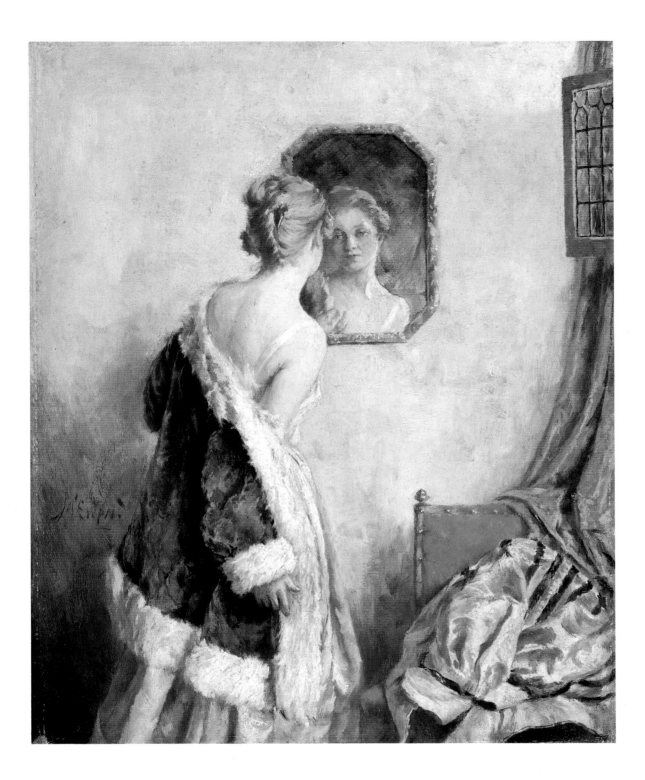

Netherlands," Ph.D. dissertation, Boston University, 1986.

5 Goley, *The Hague School and Its Legacy*, p. 24.

6 Joseph G. Dreiss, *Gari Melchers: His Works in the Belmont Collection* (Charlottesville, Virginia: University of Virginia Press, 1984), p. 12.

7 "American Art at Chicago," *The Art Amateur*, 32 (December 1894), p. 4.

8 "Three Fine Collections," *Chicago Tribune*, February 22, 1890, Ryerson Library scrapbook, The Art Institute of Chicago.

Provenance: To (M. Knoedler & Co., Paris, as *The Little Blue Coat Vanity*); to Robert Sterling Clark, January 7, 1938.

Exhibition: The Art Institute of Chicago, Chicago, "7th Annual Exhibition of Paintings by American Artists," October 29–December 17, 1894, no. 207 (as *The Mirror*, possibly the same work).

References: "American Art at Chicago," *The Art Amateur*, 32 (December 1894), p. 4 (possibly the same work); CAI 1972, pp. 132, 133; CAI 1984, pp. 23, 111.

Frederick MacMonnies
1863–1937

Born in Brooklyn, New York, MacMonnies began a four-year apprenticeship in 1880 with America's premier sculptor, Augustus Saint-Gaudens (1848–1907). After two years Saint-Gaudens promoted MacMonnies to assistant. During this time MacMonnies attended night drawing classes at the National Academy of Design and at the Cooper Union. In 1884 he went to Paris. Letters of introduction from Saint-Gaudens gave the young sculptor immediate access to the art community there. He first enrolled in drawing classes at the Académie Colarossi and at the Ecole des Beaux-Arts. His preparation for the Ecole entrance examination was interrupted by a five-month stay in Munich and a summer visit to New York in 1885 to assist Saint-Gaudens.

Back in Paris in 1886, MacMonnies began a two-year course at the Ecole des Beaux-Arts under the sculptor Jean-Alexandre Falguière (1831–1900). He also took private instruction from Antonin Mercié (1845–1916). In both 1887 and 1888 he won the most prestigious prize for foreign students, the Prix d'Atelier. The next year he opened his own studio and entered his first work in the Salon; *Diana* won an honorable mention. That same year he also received his first American commission: a fountain for the 1893 World's Columbian Exposition in Chicago, which secured his success in America and initiated

more than a decade of fame and fortune. An astute businessman, he made his pieces available in both full and reduced sizes.

Through the 1890s MacMonnies continued to live in Paris while summering in Giverny and began to work actively as a painter. Although he moved to Giverny in 1898, he continued to teach in Paris as well as travel to seek and oversee commissions. Tired of the restrictions of commissions, he increasingly turned to painting after 1900. In 1915 he went back to New York, but his academically based figurative sculpture was no longer in vogue. He occasionally executed large commissions, until 1922, when the perceived sexual implications of his *Civic Virtue* (Queens, New York) caused an uproar; he never again did commissioned work. For the rest of his career he produced portrait busts and reliefs. After the stock-market crash of 1929 his resources dwindled, and at his death in 1937 he was impoverished and nearly forgotten.

Bibliography: Joseph Walker McSpadden, *Famous Sculptors of America* (New York: Thomas Y. Crowell Co., 1924), pp. 73–112; Edward J Foote, "An Interview with Frederick MacMonnies," *New-York Historical Society Quarterly,* 61 (July–October 1977), pp. 102–23; *American Figurative Sculpture in the Museum of Fine Arts, Boston* (Boston: Museum of Fine Arts, 1986), pp. 293–95.

Bacchante et Enfant, 1894
(Bacchante and Infant Faun;
La Bacchante)
Bronze
34½ × 10 × 10 (87.6 × 25.4 × 25.4)
Incised in base: F. MacMonnies 1890; *stamped in base:* E. Gruet Jeune Fondeur/44 bis Avenue de Chatillon Paris
No. 17

As a writer for the *Boston Transcript* aptly put it, MacMonnies's *Bacchante et Enfant* "is in vigorous and joyous motion poised on the toes of her left foot, her springy weight falling altogether on her left leg, her right uplifted and her bended knee thrust forward, as, half-dancing, she pursues her way. In her left hand she raises a bunch of grapes high above her head. With her right arm bent about him as though to make a seat of her elbow, she carries a naked child, that . . . gazes with wide-eyed and open-mouthed eagerness at the quivering grapes."[1] MacMonnies had been contemplating the subject for some time before he executed it in 1893.[2] "I had made this design long before, but I never found the model for it. . . . Then a woman came in and I said, 'there is my Bacchante!'"[3] That woman was Eugénie Pasque, who first modeled for MacMonnies's *Barge of State,* the sculptor's contribution to the 1893 World's Columbian Exposition in Chicago.[4]

A life-size cast of *Bacchante et Enfant* was MacMonnies's entry in the 1894 Paris Salon. Subsequently, it was purchased by the French government. As the first piece of American

sculpture bought by the French, it honored not only MacMonnies but also the progress of American art. Within the next two years, however, the sculpture became the center of the biggest art scandal of the decade. In 1896 Charles F. McKim proposed to donate the original life-size bronze to the Boston Public Library, but public outcry forced him to withdraw his offer.[5] What conservative Bostonians found so distasteful was the combination of the sculpture's apparent celebration of inebriety and its naturalistic modeling of a female figure, which suggested a nude individual more than a character out of mythology.

Bacchantes were mythological women devoted to the wine god Bacchus. While their duties included helping to educate the god in his boyhood, they are best known as symbols of intemperance and physical abandonment.[6] They were frequently depicted by the sculptors associated with the Ecole des Beaux-Arts, where MacMonnies had studied.[7] Nude figures had always been acceptable when connected to literary, historical, or allegorical themes. In the last quarter of the nineteenth century, however, artists began to

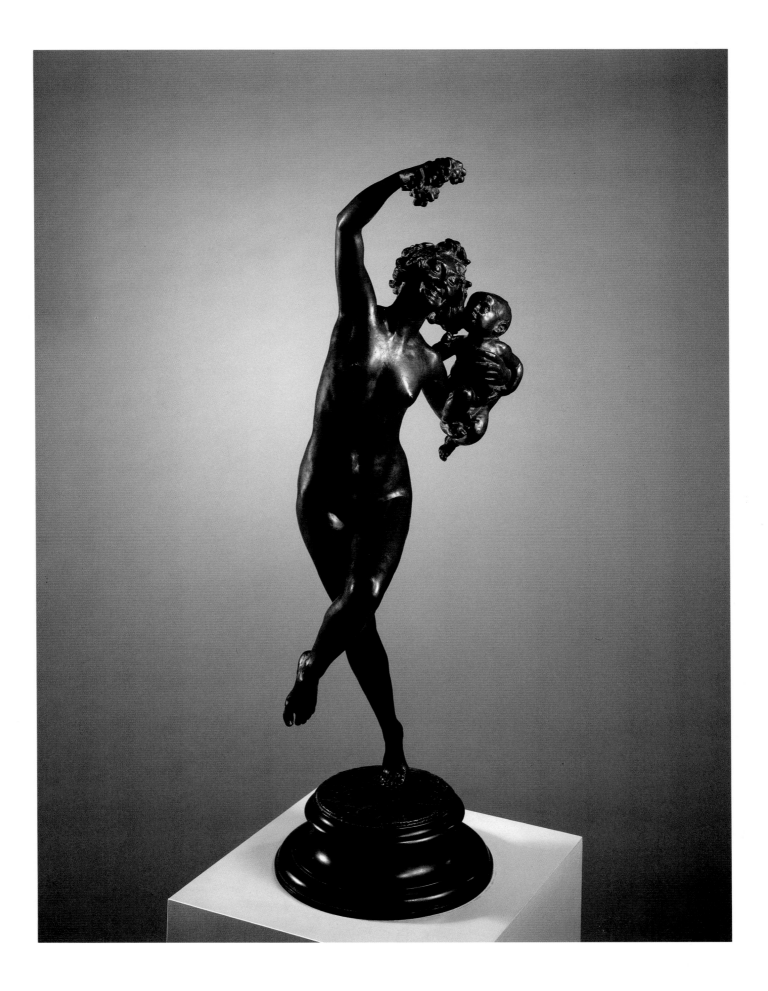

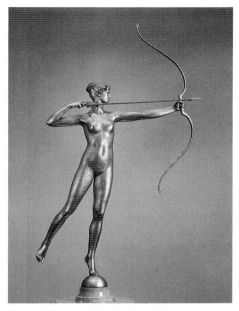

Fig. 56: Augustus Saint-Gaudens, **Diana**, after 1882. Bronze, gilded, 112 in. (284.5 cm) high. The Metropolitan Museum of Art, New York; Purchase, 1927, Rogers Fund.

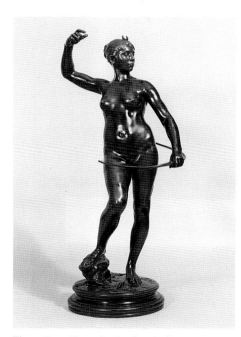

Fig. 57: Jean-Alexandre-Joseph Falguière, **Diana**, after 1882. Bronze, 28 × 14½ × 11⅜ in. (71.1 × 36.8 × 28.9 cm). Michael Hall Fine Arts, New York.

move away from classical references, especially in the depiction of the female nude, and to strive for more realistic renderings.[8] At the same time connections with specific narratives became more tenuous.

Although the grapes and infant child in *Bacchante et Enfant* confirm MacMonnies's intent to portray a mythological subject, the modeling of the nude and the challenge of artistically rendering movement were his primary concerns. His special brand of naturalism clearly delineated the features of the model's face and articulated the muscles of her back and legs. The bronze is incised to suggest strands of hair as they swing away from her tilted head. Yet her pose creates a continual spiral that turns a description of human action into a more abstract concept of motion. The end result is a graphic realism tempered by idealism and augmented by lively surface modeling. It creates an animated play of light over the surface that suggests the beauty both of the bronze medium and of living flesh.

MacMonnies's teachers gave him excellent examples for his approach to subject and craft. In New York, Augustus Saint-Gaudens (1848–1907) had brought a new sense of reality to American sculpture. His *Diana* (fig. 56) presented a female nude with only her accessories — a bow and arrow — to affirm her mythological ties, as MacMonnies used the bunch of grapes in *Bacchante et Enfant*. In Paris, Jean-Alexandre Falguière (1831–1900) created a series of life-size female nudes throughout the 1880s and 1890s, many of them the femmes fatales of mythology.[9] Falguière's works were very popular, although many felt that they verged on the pornographic. He was noted particularly for the realistic anatomy and faces of his figures and the suggestiveness of their poses. For *Bacchante et Enfant*, MacMonnies seems to have borrowed the arm pose of Falguière's *Diana* (fig. 57) almost directly. He also used a tiptoe stance similar to that in the French sculptor's *Hunting Nymph*, first exhibited in 1884. MacMonnies's figure, however, lacks the almost licentious character of Falguière's work.

The Clark cast of *Bacchante et Enfant* is one of the twelve known half-life-size bronzes MacMonnies authorized beginning in 1894.[10] Versions this size and a smaller reduction fifteen inches high were sold by Durand-Ruel in Paris and New York, Theodore Starr Jewelers, New York, and possibly Tiffany and Company.[11] The Clark's sculpture was cast at E. Gruet, Jeune, in Paris and was dated 1890. Since the inscription is most likely the work of foundry personnel and not from MacMonnies's hand, the date appears simply to be an error.[12] The three other thirty-four-inch casts from Gruet are inscribed correctly with 1894.

Despite the scandal that the life-size *Bacchante et Enfant* caused in Boston, the sculpture remained one of Frederick MacMonnies's most popular pieces. For fifty years its subject and scandal were remembered in songs, poems, fiction, and drama. It was the inspiration for at least one dance — the Bacchante Step — and in the 1950s Havana cigars called Bacchante Longfellows appeared.[13] What initially bothered the public about *Bacchante et Enfant* is perhaps what most pleases its viewers a century later. As a writer for *The Critic* noted in 1895, "this ancient motive is treated in a thoroughly modern spirit, without much reference to any rules derived from the antique. It is a fresh and original conception, carried out in the most masterly manner."[14]

1 H.T. Parker in the *Boston Evening Transcript*, May 23, 1895, quoted in Walter Muir Whitehall, "The Vicissitudes of Bacchante in Boston," *New England Quarterly*, 27 (December 1954), pp. 437–38.

2 Although in the twentieth century this sculpture has often been called *Bacchante and Infant Faun*, MacMonnies entered the piece in its first exhibition, the 1894 Salon, as *Bacchante et Enfant*; see *Explication des ouvrages de peinture, sculpture, architecture, gravure et lithographie des artistes vivantes*, exh. cat. (Paris: 1894), p. 295, no. 3334.

3 DeWitt Lockman interview with Frederick MacMonnies, 1927, quoted in Hildegard Cummings, "Chasing a Bronze Bacchante," *William Benton Museum of Art Bulletin*, 12 (1984), p. 6.

4 For a long time MacMonnies was very coy about the identity of his model. In 1935, however, he wrote on a print of Charles Dana Gibson's drawing *A Café Artist*, "This is how Charles Dana Gibson saw me in 1895" over the man's head, and over the woman's, "Eugénie the model for the Bacchante"; Archives of American Art, roll N61, frame 805.

5 For the complete story concerning this controversy, see Cummings, "Chasing a Bronze Bacchante," pp. 3–5.

6 James Hall, *Dictionary of Subjects and Symbols in Art* (New York: Harper & Row, 1979), pp. 38, 197.

7 A random sampling of French sculptors who depicted bacchantes, kindly supplied by Jennifer Gordon Lovett, assistant curator, Clark Art Institute, includes Jean-Baptiste Carpeaux (1827–1875), Jean-Baptiste Clésinger (1814–1883), Augustin Moreau-Vauthier (1831–1893), Jules Dalou (1838–1902), and Carrier-Belleuse (1824–1887).

8 Kathryn Greenthal, "Beaux-Arts Sculpture, the Issue of Nudity, and the Public Response," in *The Sublime and the Beautiful: Images of Women in American Sculpture, 1840–1930*, exh. cat. (Boston: Museum of Fine Arts, 1979), pp. 11–14.

9 For a good overview of this aspect of Falguière's work, see Peter Fusco, "Falguière, the Female Nude, and 'La Résistance,'" *Los Angeles County Museum of Art Bulletin*, 23 (1977), pp. 36–46.

10 As confirmed for me by Hildegard Cummings and Paula Kozol, casting records for this piece are incomplete, and it is unclear exactly how many *Bacchante et Enfant* pieces were made. In all, at least four foundries cast the *Bacchante et Enfant* in three different sizes, and two marbles were cut. They are listed in *American Figurative Sculpture in the Museum of Fine Arts, Boston* (Boston: Museum of Fine Arts, 1986), p. 295.

11 Cummings, "Chasing a Bronze Bacchante," p. 14.

12 E. Gruet, Jeune, was casting many of MacMonnies's pieces in the mid-1890s and each seems to be inscribed with the date of the first cast. That dates were confused by a foundry worker seems likely. Donna Hassler, assistant curator, the Metropolitan Museum of Art, informs me that other misdated pieces are known.

13 Cummings, "Chasing a Bronze Bacchante," pp. 3, 17.

14 "New Works by MacMonnies," *The Critic,* 26 (February 16, 1895), p. 129.

Provenance: James Henry Smith; to (American Art Association, sale of the Smith mansion and collection, January 18–22, 1910, no. 215); to H. Payne Whitney, Esq., New York; to Gertrude Vanderbilt Whitney (his widow); to the Whitney Museum of American Art, November 17, 1931; to (M. Knoedler & Co., New York); to Robert Sterling Clark, May 1, 1950.

Exhibitions: Sterling and Francine Clark Art Institute, Williamstown, Massachusetts, "Exhibit 4: The First Two Rooms," May 17, 1955, no. 17 (as *La Bacchante*); Sterling and Francine Clark Art Institute, Williamstown, Massachusetts, "Pop the Cork!" September 9–October 23, 1983 (no catalogue); Sterling and Francine Clark Art Institute, Williamstown, Massachusetts, "Cast in the Shadow," October 12, 1985–January 5, 1986, no. 19; Williams College Museum of Art, Williamstown, Massachusetts, "The Field Room in Context," September 1–December 31, 1988.

References: Catalogue of the Collection (New York: Whitney Museum of American Art, 1931), p. 94; *Catalogue of the Collection* (New York: Whitney Museum of American Art, 1937), p. 15; CAI 1955, n.p., pl. XVII; CAI 1958a, n.p., pl. XLVIII (as *Bacchante*); Hildegard Cummings, "Chasing a Bronze Bacchante," *William Benton Museum of Art Bulletin,* 12 (1984), p. 19 nn. 41, 45; *Cast in the Shadow,* exh. cat. (Williamstown, Massachusetts: Sterling and Francine Clark Art Institute, 1985), pp. 50–52; *American Figurative Sculpture in the Museum of Fine Arts, Boston* (Boston: Museum of Fine Arts, 1986), p. 295.

Elie Nadelman
1882–1946

Elie Nadelman was born in 1882 in Warsaw. After serving in the Russian Imperial Army from 1900 to 1901, he studied for about a year at the Warsaw Art Academy. In 1904 he spent close to six months in Munich before moving to Paris, where he stayed until 1914.

In Paris Nadelman was part of the avant-garde art and literary circle associated with Gertrude and Leo Stein. In 1909 he had his first solo show at the Galerie Druet. Featuring sculptures inspired by classical statuary, Auguste Rodin (1840–1917), and the new abstraction, it was very successful. Nadelman's writings on art at this time also added to his advancement in the art world.

On October 31, 1914, Nadelman arrived in New York City. Helena Rubenstein had assisted his immigration, and she continued to be an important friend in his early days in the United States. Over the next few years Nadelman's reputation was made in America with stylized sculpture of figures and animals. An exhibition at Alfred Stieglitz's gallery and an article in *International Studio,* both in 1915, as well as considerable support from Martin Birnbaum of Scott and Fowles buoyed Nadelman's career. By 1920, however, his sculpture was receiving less attention, but his marriage to a wealthy widow that year

allowed him to work without constraints. Soon the Nadelmans purchased a town house on East 93rd Street and "Alderbrook," an estate in Riverdale, New York. In the twenties they also formed an important collection of American folk art, which helped shift Nadelman's own sculpture toward whimsy and toylike forms.

The 1929 stock-market crash took a severe toll on the Nadelmans' fortune, and the artist became increasingly reclusive. Two architectural commissions during 1929–33 put him back in the public eye. From 1930 to 1935 he also received portrait commissions, but the bulk of his work was for his own pleasure. He experimented with ceramics and made small plaster and terra-cotta figures similar to ancient Tanagras.

In 1930 Nadelman had his last one-man show. Few pieces were sold, and he never exhibited again. At this time he also began to dispose of his folk-art collection. He lived his last years in seclusion and died, nearly forgotten, in 1946.

Bibliography: Lincoln Kirstein, *Elie Nadelman* (New York: The Eakins Press, 1973); *The Sculptures and Drawings of Elie Nadelman,* exh. cat. (New York: Whitney Museum of American Art, 1975).

Mrs. Clark, 1933

Marble
14¼ × 8½ × 10½ (36.2 × 21.6 × 26.7)
excluding base
Signed on back of neck: E. Nadelman
No. 975

Francine Clark was born in France on April 28, 1876. Little is known about her early life. The Clarks were married in 1919. In his memoir of the Clarks, Charles Durand-Ruel described Mrs. Clark as "a distinguished, refined and elegant cosmopolitan woman."[1]

This portrait of Mrs. Clark is one of a group of heads Elie Nadelman made of wealthy friends and acquaintances to offset his financial losses during the Depression. The style of these works belies the sculptor's earlier avant-garde achievements, but it was perfectly suited to his clients' upper-class taste. The 1933 marble portrait of Mrs. Clark captures her mature sophistication. As in most of Nadelman's portrait heads from the late 1920s and early 1930s, he combined a realistic portrayal of his sitter with the purity of form and curved lines he found in ancient, particularly Hellenistic, sculpture.[2] It was through curves that he sought to convey the life of the form he explored.[3] In depicting Mrs. Clark, Nadelman used the contours of her face—the curve of her chin, cheekbones, nose, and hair—to delineate her personality as well as her physiognomy. With smooth, milk-white marble, he created a classic portrait that acknowledged Francine Clark's dignity and strength.

Robert Sterling Clark was greatly pleased by both this portrait and the two of himself (pp. 130–31). With one of his payments to Nadelman he wrote: "They are great; the best I have seen."[4] Subsequently he ordered a terra-cotta of Mrs. Clark, which seems never to have left the artist's hands.[5]

1 Charles Durand-Ruel, typescript, CAI archives.

2 *The Sculptures and Drawings of Elie Nadelman,* exh. cat. (New York: Whitney Museum of American Art, 1975), p. 10.

3 Ibid., p. 7, quoting from Nadelman's stated ideas in *Camera Work,* 1910.

4 Robert Sterling Clark to Nadelman, May 19, 1933 (copy), CAI archives.

5 Letters in the CAI archives between Clark and Nadelman discuss a delay in the production of a terra-cotta head of Mrs. Clark. The last mention of it is in a letter from Clark dated May 19, 1934. Lincoln Kirstein, *Elie Nadelman* (New York: The Eakins Press, 1973), pp. 303–4, recorded the terra-cotta as being in the Nadelman estate in 1973.

Provenance: To Robert Sterling Clark, May 19, 1933.

Related Work: Mrs. Clark, terra-cotta, see n. 5 above.

Reference: Lincoln Kirstein, *Elie Nadelman* (New York: The Eakins Press, 1973), pp. 303–4.

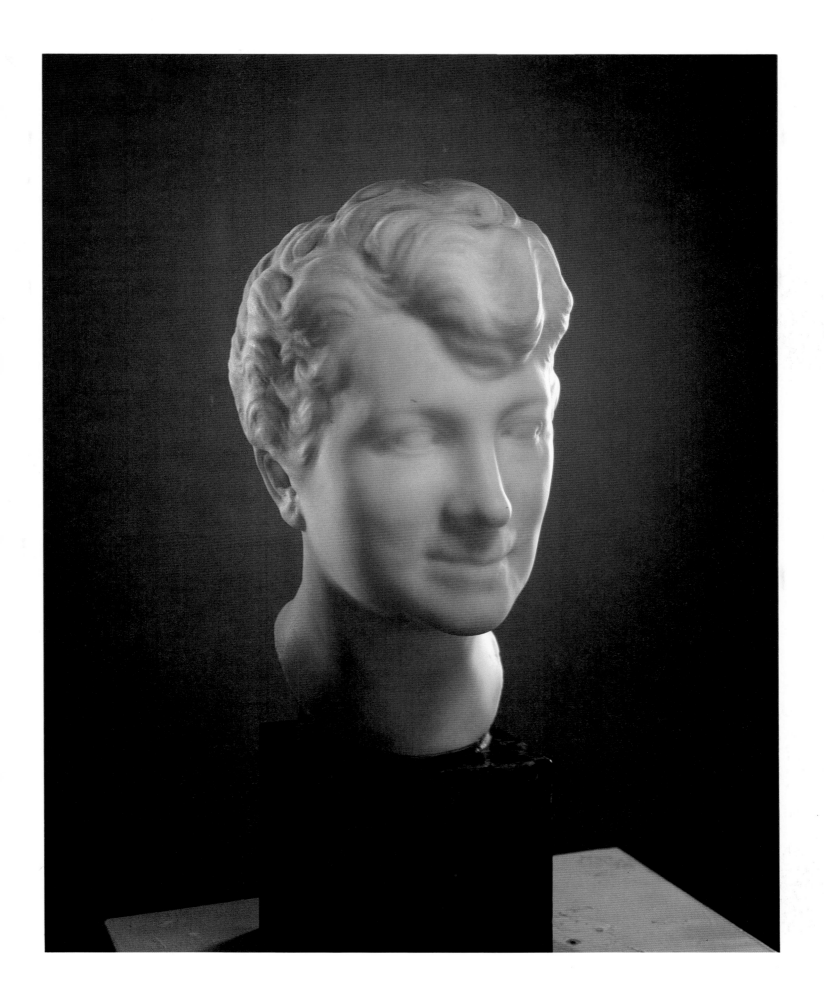

Mr. Clark, 1933

Marble
16 × 8½ × 10 (40.6 × 21.6 × 25.4) excluding base
Signed on back of neck: E. Nadelman
No. 1011

After a brief career in the United States Army, Robert Sterling Clark (1877–1956) settled in Paris in 1912. That year he bought his first painting, and for the rest of his life collecting art and books was at the center of his world. Clark rarely bought the art of his own day. However, in 1929 he had seen a portrait of Mrs. Stevenson Scott by Elie Nadelman that he thought particularly fine and by 1933 had commissioned Nadelman to carve marble portraits of both Mrs. Clark (p. 128) and himself and to cast a bronze of himself as well.[1]

Working first in clay and then in marble, Nadelman blended a truthful delineation of Mr. Clark with an obvious homage to antique sculpture. The marble portrait of Mr. Clark, more reductive than that of his wife, recalls Nadelman's earlier classically inspired heads, modeled according to the planes of the face, though the 1933 head is softer and the features more blurred.[2] The artist's debt to ancient art appears even in the details: for Clark's hair he used a stylized swirl in the Hellenistic manner.

Lincoln Kirstein described Nadelman's heads as "imperial, impersonal, authoritative, achieved."[3] Robert Sterling Clark, a wealthy gentleman who always retained the military air of his early career, was intensely private

and proud of his accomplishments as a collector. He was thus a perfect client for Elie Nadelman.

1 Mrs. Scott was the wife of one of the principals in the art firm Scott and Fowles, which supported Nadelman's work; Robert Sterling Clark, diary, February 18, 1929, CAI archives. Exactly when Clark contacted Nadelman is unclear, as is when Nadelman began working on the pieces and the order in which he executed them. Letters in the CAI archives between Clark and Nadelman all concern the completion of the project.

2 For an excellent article on Nadelman's early heads, see Athena Spear, "Elie Nadelman's Early Heads (1905–1911)," *Allen Memorial Art Museum Bulletin*, 28 (Spring 1971), pp. 201–22.

3 Lincoln Kirstein, *Elie Nadelman* (New York: The Eakins Press, 1973), p. 204.

Provenance: To Robert Sterling Clark, May 23, 1933.

Related Works: Head (Robert Sterling Clark), 1933, plaster, 16½ × 11 × 8¼ (41.9 × 27.9 × 21), The Metropolitan Museum of Art, New York; Gift of Lincoln Kirstein, 1970.127.1.

Mr. Clark, 1933, bronze, 15 × 8½ × 10 (38.1 × 21.6 × 25.4), Sterling and Francine Clark Art Institute.

Reference: Lincoln Kirstein, *Elie Nadelman* (New York: The Eakins Press, 1973), p. 303.

Mr. Clark, 1933

Bronze
15 × 8½ × 10 (38.1 × 21.6 × 25.4)
Signed on base of neck: Elie Nadelman
No. 1008

At the same time Robert Sterling Clark commissioned Elie Nadelman to carve a marble portrait head, he also seems to have requested that this bronze version be made.[1] To create these two works, Nadelman probably made a clay model from life,[2] which he could use as a guide for the marble and to make the plaster cast (fig. 58) necessary for the bronze process.

It is unclear why Clark wanted two versions of his portrait. Since he had several residences (Paris, New York City, and Upperville, Virginia), he may have wanted to display the portrait in more than one place. Perhaps, too, he wished to see his likeness in both materials. Whereas the marble suggests an otherworldly ideality, the bronze projects a more patrician solidity. Both works pleased Robert Sterling Clark very much.

1 The conditions of these commissions are not known, but letters in the CAI archives between

Clark and Nadelman show that the two pieces were being worked on simultaneously. One letter, dated May 23, 1933, is from Nadelman and indicates that Clark had paid for the marble and that Nadelman was finishing up the bronze.

2 Nadelman generally made clay models for his portraits, and we know from the letter cited above that both Clarks sat for the sculptor.

Provenance: To Robert Sterling Clark, June 1, 1933.

Related Works: Head (Robert Sterling Clark), 1933, plaster, 16½ × 11 × 8¼ (41.9 × 27.9 × 21), The Metropolitan Museum of Art, New York; Gift of Lincoln Kirstein, 1970.127.1.

Mr. Clark, 1933, marble, 16 × 8½ × 10 (40.6 × 21.6 × 25.4), Sterling and Francine Clark Art Institute.

Exhibition: Whitney Museum of American Art, New York, "The Sculptures and Drawings of Elie Nadelman," September 23–November 30, 1975, no. 82.

References: Lincoln Kirstein, *Elie Nadelman* (New York: The Eakins Press, 1973), p. 303; *The Sculptures and Drawings of Elie Nadelman*, exh. cat. (New York: Whitney Museum of American Art, 1975), pp. 84–85.

*Fig. 58: Elie Nadelman, **Head (Robert Sterling Clark)**, 1933. Plaster, 16½ × 11 × 8¼ in. (41.9 × 27.9 × 21 cm). The Metropolitan Museum of Art, New York; Gift of Lincoln Kirstein, 1970.127.1.*

Charles Adams Platt
1861–1933

Charles Adams Platt was born in 1861 to a wealthy New York family. He decided on a career in art at an early age, and by fifteen he was painting. Between 1878 and 1881 he studied at the National Academy of Design and the Art Students League. During this period he also met Stephen Parrish (1846–1938), who became a lifelong friend and from whom he learned etching.

Platt spent most of the years 1882 to 1887 in Europe. Beginning in 1884, he studied in Paris at the Académie Julian with Gustave Boulanger (1824–1884) and Jules-Joseph Lefebvre (1836–1911). In both 1884 and 1885 he exhibited at the annual Paris Salon. During his sojourn abroad he concentrated on painting but made etchings to support himself. He also sent paintings home to New York for exhibition and sale.

In 1887 Platt's wife of less than a year, Annie Hoe, died. Devastated, the artist returned to New York and gradually became active in the American art world. In 1889 he made his first visit to the artist colony at Cornish, New Hampshire, at the invitation of Henry O. Walker. For the rest of his life, he spent at least part of each year there. At this same time Platt began to shift from painting and etching to landscape design and architecture. By the mid-1890s he had made his reputation as an architect. Platt's commissions, primarily in a style reflecting his love of the Italian Renaissance, included the Freer Art Gallery, Washington, D.C., several buildings for the Astor family in New York, and the majority of the buildings on the campuses at the University of Illinois, Urbana, and Phillips Academy, Andover, Massachusetts. On the basis of his architectural successes, he was elected an academician at the National Academy of Design in 1911 and served as president of the Academy of Arts and Letters.

Bibliography: Keith Morgan, *Charles A. Platt: The Artist as Architect* (Cambridge, Massachusetts: The MIT Press, 1986).

The Quay, Larmor, 1884–85
(The Inlet; Harbor Scene)
Oil on canvas
10⁵/₁₆ × 14¹/₂ (26.2 × 36.8)
Signed lower right: . C. A. Platt .
No. 829

Foreign training and travel formed the core of many young American artists' early experiences in the 1880s. First-rate instruction, contemporary art, fine camaraderie, and inexpensive living were easily obtained in Europe, particularly in Paris. In addition, the nearby countryside provided suitable subjects for both the landscape and figure painter.

Like many of his French and American colleagues, Platt found the provinces of Brittany and Normandy in northwest France full of inviting scenery. From May to September of 1884, in the company of Dennis Miller Bunker (1861–1890) and Kenneth Cranford (dates unknown), Platt visited Larmor, a small town on the Breton coast well known for its pearly gray light and colorful fisherfolk.[1] *The Quay, Larmor* is the oil version of a view of the local pier that the artist also depicted in watercolor (fig. 59) and etching (fig. 60).[2] Although the painting is undated, its inclusion in the National Academy of Design Annual Exhibition of 1885 indicates that it was done sometime between Platt's arrival in Larmor and March 1885, when he would have had to ship it to New York for the April 6 opening of the exhibition.

As Keith Morgan has observed, by 1884 Platt had a specific idea as to what constituted proper subject matter and method in a painting. In a letter to his family, he derided the narrative thrust of contemporary German and English art: "An artist should interest one's sense of the beautiful and make that his great object. He must have a subject, of course, but he should *use* the subject to make his picture and not use the picture to render his subject."[3] Simultaneously, Platt became increasingly committed to painting in oil outdoors, and he wrote to his family after a month in Larmor: "I feel convinced that the best work I do is done directly from nature. Therefore in the future I expect to leave less for the studio."[4] In the summer of 1884, he wanted to "try to keep the freshness and breezy look that a sketch has and yet have the picture very carefully finished."[5]

The Quay, Larmor reflects Platt's frequent practice of painting outdoors and his desire to use subject as a vehicle for conveying his idea of the beautiful. He seems to have worked directly in oil from the start, and the modifications he made in progress are easily observed. The biggest change was the shift in the color of the foreground rocks and pier from a thickly painted palette of predominant greens to a gray-brown one that blended more harmoniously with the coloration of the sky and sea.[6] This unifying tone, along with the high viewpoint, makes the boats and their reflections appear as shapes flattened against a background. Yet at the same time the cropping of the image at right and along the bottom reinforces the illusion of a particular moment at this seaside pier. Through these means, *The Quay, Larmor* signals both Platt's direct response to the Brittany coast and his search for the beautiful.

Platt's artistic concerns and their manifestation in *The Quay, Larmor* were shared by

*Fig. 59: Drawing reproduced in **The Art Amateur**, 18 (March 1888), p. 84, after a watercolor by Charles Adams Platt, **Return of Sardine Boats from Morning's Catch**, c. 1884.*

*Fig. 60: Charles Adams Platt, **Pier at Larmor**, 1885. Etching, 8½ × 14⅛ in. (21.6 × 35 cm). Print Collection, Miriam & Ira D. Wallach Division of Art, Prints and Photographs; The New York Public Library; Astor, Lenox and Tilden Foundations.*

many American artists resident in France in the 1880s.[7] Absorbing a mixture of influences that included Barbizon pleinairism, the work of the Dutch landscapists Anton Mauve (1838–1888) and Jacob Maris (1837–1899), that of James McNeill Whistler (1834–1903), and Japanese prints, this group of American painters often depicted inhabited landscapes at quiet times of day enveloped in a single-toned atmosphere to suggest the poetic and beautiful within everyday life. In *The Quay, Larmor,* Platt also strove to retain a freshness and sense of immediacy.

1 Correspondence from Platt to his family dated May through September 1884 records his stay in Larmor. Keith N. Morgan of Boston University kindly provided me with transcriptions of these letters. Arthur Hoeber, "A Summer in Brittany," *The Monthly Illustrator,* 4, no. 2 (1895), p. 78, wrote about "that Brittany grey, like of which is seen nowhere else in the world,—a soft, pearly, luminous color, giving qualities of opalescent light to the landscape and enveloping everything in a tender tone of sentiment and poetry, a joy to look at and an inspiration to the painter."

2 The watercolor (whereabouts unknown) was illustrated in *The Art Amateur,* 18 (March 1888), p. 84. In 1885 Platt printed an etching called *Pier at Larmor.* It is not known in what sequence these works were executed.

3 Platt to his family, April 19, 1884; quoted in Keith Morgan, *Charles A. Platt: The Artist as Architect* (Cambridge, Massachusetts: The MIT Press, 1986), p. 18.

4 Platt to "My Dear Famb," dated Larmor, June 15, 1884, private collection, transcription courtesy Keith N. Morgan.

5 Platt to "My Dear Fambly," dated Larmor, July 31, 1884, private collection, transcription courtesy Keith N. Morgan.

6 This shift in color could have been reinforced by the change of seasons from summer into fall if Platt worked on the picture over several months.

7 For artists in Brittany in the 1880s, see *Americans in Brittany and Normandy, 1860–1910* exh. cat. (Phoenix: Phoenix Art Museum, 1982), pp. 38–65.

Provenance: J.W. Ellsworth by 1923; to (M. Knoedler & Co., New York, March 10, 1923); to Robert Sterling Clark, March 1, 1924 (as *The Inlet*).

Related Works: Return of Sardine Boats from Morning's Catch, c. 1884, watercolor, whereabouts unknown, drawing after the watercolor reproduced in *The Art Amateur,* 18 (March 1888), p. 84.

Pier at Larmor, 1885, etching, 8½ × 14⅛ (21.6 × 35.9), Miriam & Ira D. Wallach Division of Art, Prints and Photographs, The New York Public Library, Astor, Lenox and Tilden Foundations.

Exhibitions: National Academy of Design, New York, "60th Annual Exhibition," April 6–May 15, 1885, no. 614; M. Knoedler & Co., New York, "Exhibition of Paintings and Prints of Every Description on the Occasion of Knoedler One Hundred Years, 1846–1946," April 1–27, 1946, no. 77 (as *Harbor Scene*).

References: CAI 1958, n.p. (as *Harbor Scene*); CAI 1972, pp. 136, 137 (as *Harbor Scene*); CAI 1984, pp. 28, 102 (as *Harbor Scene*).

Marine painting has had an active and continuous history in American art.[1] Winslow Homer (pp. 63–100), the most prominent sea painter in the 1890s, carried the mantle of the seascape tradition into the twentieth century. Homer's realism and vigorous style of painting were continued after his death in 1910 by many artists, including George Bellows (1882–1925) and John Sloan (1871–1951). In general, these artists adopted Homer's truthful and powerful image of the sea. American marine painting continued to reflect these aspects of Homer's influence to 1945.

Pontiac, too, must have been aware of the vivacity and strength of Homer's painting style. In the cliff-edged coastline scene depicted in *Seascape,* the rocks, sea, and sky are all created with broad, forceful brush-strokes. Purple, blue, green, and pink are mixed in a variety of combinations to suggest the different qualities of earth, air, and water. *Seascape,* to judge by its style, probably was executed after 1920.

No records exist concerning Robert Sterling Clark's acquisition of this painting. The artist, date, and locale of the picture remain unidentified. From about 1920 until his death, Clark occasionally bought or accepted as gifts contemporary works of art.

1 See John Wilmerding, *A History of American Marine Painting,* 2nd ed. (New York: Harry N. Abrams, 1987), for an overview of this subject.

Provenance: Robert Sterling Clark.

Reference: CAI 1984, pp. 29, 111.

Pontiac
No information has been found on this artist.

Seascape, n.d.
Oil on canvas
20 × 24 (50.8 × 61)
Signed lower left: Pontiac
No. 831

Arthur Quartley
1839–1886

Arthur Quartley was born in Paris on May 24, 1839, and moved to Peekskill, New York, as an adolescent. The son of an English engraver for book illustrations, he was encouraged to draw from a young age. In 1856 or 1857 he was apprenticed to a sign painter in New York City. Within a few years, Quartley moved to Baltimore as a partner in the decorative and ornamental firm of Emmart and Quartley. In Baltimore he began to paint in his spare time. Around 1873, perhaps inspired by summer visits to the Isles of Shoals off New Hampshire, he made seascapes his principal subject. In 1876 he moved back to New York and set up a studio as an oil painter. He specialized in marine painting for the rest of his short life.

Once settled in New York, Quartley quickly rose to prominence. In 1877 he was one of the founding members of the Tile Club, a group of forward-thinking and fun-loving young artists that included William Merritt Chase (p. 37), Winslow Homer (p. 63), and Edwin Austin Abbey (1852–1911), among others. Quartley exhibited frequently and was represented at the 1878 Paris International Exposition. In 1879 he was elected an associate academician to the National Academy of Design. He also held membership in the Society of American Artists, the American Watercolor Society, and the Artists' Fund Society. In 1884 Quartley and F. Hopkinson Smith (1838–1915) auctioned a sizable portion of their works to finance an extended trip to Europe. They embarked the following year, but illness forced Quartley to return to New York, where he died on May 19, 1886.

Bibliography: S.G.W. Benjamin, *Our American Artists, 2nd Series* (Boston: D. Lothrop & Company, 1881), pp. 12–16; *American Landscape and Genre Painters in The New-York Historical Society* (New York: The New-York Historical Society, 1982), vol. 3, p. 80.

Marine, 1881
(Shore Scene)
Oil on canvas
13 3/8 × 21 7/16 (34 × 54.5)
Signed and dated lower right: *Quartley* 1881
No. 914

The members of the Tile Club, Arthur Quartley among them, formed the leading edge of American art in the late 1870s and early 1880s. At the Tile Club weekly meetings the participants painted on ceramic tiles according to their host's choice of subject. Extended summer journeys as a group allowed them the opportunity for sketching in the company of like-minded colleagues. In general the Tile Club members' attitudes were cosmopolitan rather than nationalistic; they were interested in a variety of media and subjects; and their art often emphasized visual and formal qualities rather than content.[1] Serious as they were about their art, the Tilers fully enjoyed their weekly meetings and summer outings, where plenty of food and drink accompanied drawing and painting.

The first Tile Club trip, during the summer of 1878, was to Long Island.[2] The following year they chartered a boat on the Erie Canal. In 1880 they again ventured to Long Island, including Cold Spring Harbor and East Hampton. Arthur Quartley's *Marine,* dated 1881, most likely was a result of the summer 1880 excursion, which brought several memorable experiences for the Tilers. After a bout with mosquitoes on a sandy beach, Quartley, aptly nicknamed "the Marine" (all the Tilers had appropriate nicknames), suggested that they move to a "tiley town," a nice ship-building community not far away where picturesque views and decent lodging were available.[3] Long Island in 1880 was composed mainly of fishing and farming communities and was not yet a fashionable resort area. Thus the Tilers "felt 1,000 miles away" from New York, although only fifty miles from the bustling city.[4]

Quartley found working conditions and scenery much to his liking in the small Long Island town. The chroniclers of the Tile Club adventures wrote that he worked even in inclement weather: "a great jovial sea-dog . . . hoisted sail and went off to sea with the Marine, and brought him home in great spirits in the midst of a gale wind and a storm of rain."[5] After many weeks of working at sea and on land, Quartley then returned to his Union Square studio to work through the winter on paintings derived from his summer observations.

In these paintings Quartley strove above all for a balanced whole. The artist remarked in an interview: "The most difficult thing in a marine is to make the whole picture hang together. To get the sky alone is not hard; to get the water alone is not hard; but the water partakes so much of the effect of the sky that, unless a hearty sympathy is preserved between them, the result is worse than a failure."[6] In *Marine,* Quartley painted the view as moonlight broke through a cloudy sky. The open and stormy sea and sky are balanced against the mass of the headland with its small townscape. Solid buildings counter the swaying, less substantial fishing boats on the water. Within this framework, Quartley concentrated on the "hanging together" of the sky and water and their atmospheric effects. The dissemination of grays and blues and moonlight above is complemented below by the browns, greens,

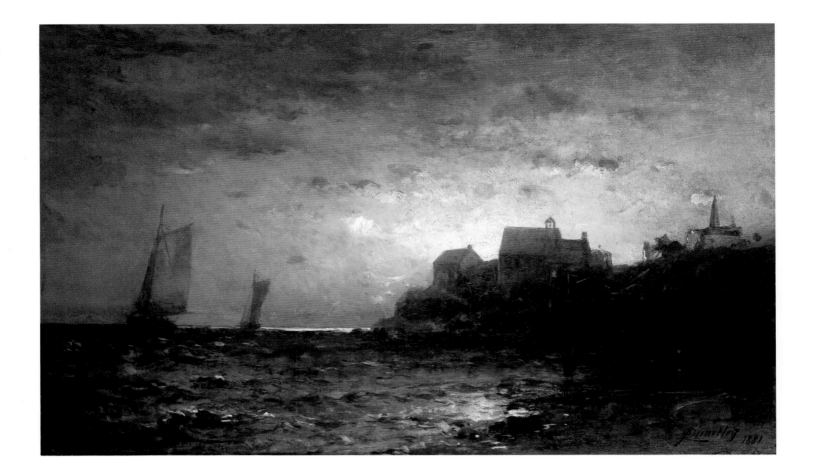

and yellows of water and reflected light, yielding the shimmering effect for which Quartley was often praised.[7]

Quartley labored to perfect *Marine*. He made many changes in the course of painting, and the fact that his signature lies under the top layer of paint suggests that he made significant changes after initially completing the picture. Contemporary reviews indicate that this kind of extensive reworking was not unusual for the artist. Edward Strahan commented in 1880 that Quartley's *Trinity from the River* (whereabouts unknown) "has been seen in New York, but never to such advantage, for it is worked up again."[8]

In *Marine,* Quartley lowered the horizon about three-quarters of an inch and totally repainted the sky to represent calmer weather. He also toned down the surf accordingly. Moreover, the small settlement that appears at right was originally a rocky headland without any sign of inhabitants. Among Quartley's last changes was that in the middle building, which was given a greater prominence through the addition of a higher roof and a small bell tower. At some point Quartley also cut down the left edge of the canvas. This revision made the darker left half nearly equal in size to the lighter right side. All of these changes were designed to create a harmonious composition.

The formal arrangement of pictures was of paramount interest to artists in the 1880s. Its importance was underscored regularly by critics, who often cited Quartley's work as among the best examples of pictorial design.[9] Nonetheless, the artist was taken to task in 1880 for his lack of truth in detail and tendency to over-activate his canvases.[10] Sensitive to the critical remarks, Quartley seems to have worked to solve these problems in *Marine*. Realizing that "the illusion of the eye is the main purpose [of detail]" and that he only had to give it "but a helping hand,"[11] he developed a painterly shorthand for the description of the different facets of the buildings and boats. With this adjustment, he went on to excel in the representation of inhabited landscapes. In 1884 a reviewer could remark in an exhibition notice: "Mr. Quartley is too well known to call for mention. He is always good."[12] *Marine*, too, was recognized for its success as an image of the moonlit coast; by the mid-1890s it had become part of the celebrated collection of Catholina Lambert of Paterson, New Jersey.[13]

1 For a complete discussion of the Tile Club and its relationship to art concerns in the last quarter of the nineteenth century, see Doreen Bolger Burke, "Painters and Sculptors in a Decorative Age," in *In Pursuit of Beauty: Americans and the Aesthetic Movement*, exh. cat. (New York: The Metropolitan Museum of Art, 1986), pp. 295–99.

2 The activities of the Tile Club were documented in a series of articles: "The Tile Club at Work," *Scribner's Monthly,* 17 (January 1879), pp. 401–9; "The Tile Club at Play," *Scribner's Monthly,* 17 (February 1879), pp. 457–78; "The Tile Club Afloat," *Scribner's Monthly,* 19 (March 1880), pp. 641–71; and "The Tile Club Ashore," *Century Illustrated Magazine,* 23 (February 1882), pp. 481–98.

3 It is not known today exactly to which town Quartley directed the Tilers; "The Tile Club Ashore," p. 495.

4 Ibid., p. 496.

5 Ibid., p. 498.

6 Quoted in "American Painters—William H. Beard and Arthur Quartley," *The Art Journal,* 4 (November 1878), p. 324.

7 At some point *Marine* sustained severe damage, including two significant tears through the brightest moonlit area and the main group of buildings. Although restoration has made these damages almost invisible, the picture in its original state may have had a more translucent sky. For Quartley's light effects, see "Fifty Years of American Art, III," *Harper's New Monthly Magazine,* 59 (October 1879), p. 680; S.G.W. Benjamin, *Our American Artists, 2nd Series* (Boston: D. Lothrop & Company, 1881), p. 15; and Edward Strahan, "Exhibition of the Academy of Design," *The Art Amateur,* 1 (May 1880), p. 112.

8 Edward Strahan, "Exhibition of the Philadelphia Society of Artists," *The Art Amateur,* 4 (December 1880), p. 5.

9 See, for example, Strahan, "Exhibition of the Academy of Design," p. 112, and Benjamin, *Our American Artists,* p. 15.

10 S.G.W. Benjamin, "The Exhibitions," *American Art Review,* 1 (1880), p. 350, and Strahan, "Exhibition of the Academy of Design," p. 112.

11 Quoted in "The Tile Club Ashore," p. 485.

12 "The Clarke Exhibition—2nd Notice," *The Studio* (New York), 3 (January 5, 1884), p. 4.

13 A photograph datable to sometime between 1892 and 1896 of Lambert's collection in his home, Lambert Castle, includes the Quartley; it is in the possession of the Passaic County Historical Society; see Flavia Alaya, *Silk and Sandstone: The Story of Catholina Lambert and His Castle* (Paterson, New Jersey: Passaic County Historical Society, 1984), p. 18.

Provenance: Catholina Lambert, Paterson, New Jersey, by 1896; to (American Art Association, New York, sale of the Lambert collection, February 21–24, 1916, no. 24); to J.E. Barbour (through agent Mr. Lorenz), 1916; to (Parke-Bernet Galleries, New York, December 3, 1942, no. 49); to Robert Sterling Clark, December 3, 1942.

Exhibition: Sterling and Francine Clark Art Institute, Williamstown, Massachusetts, "Not Normally on View," January 27–March 11, 1979 (no catalogue).

References: James B. Townsend, "Catholina Lambert Collection," *American Art News,* 14 (February 12, 1916), p. 2; "Renoir Sold for $3500," *The New York Times,* February 22, 1916, p. 11; "Catholina Lambert Sale," *American Art News,* 14 (February 26, 1916), p. 3; CAI 1984, pp. 29, 102.

Frederic Remington almost singlehandedly created the accepted view of the American West in the last quarter of the nineteenth century. Born in Canton, New York, on October 1, 1861, he moved with his family in 1872 to nearby Ogdensburg. After spending his high-school years in a military academy, young Remington entered Yale University. Although successful at Yale as a football player, he was also interested in art and studied at the Yale School of Fine Arts under John Ferguson Weir (1841–1926) and J.H. Niemeyer (1839–1932). He remained at Yale for only a year and a half due to his father's ill health and subsequent death. Back in Ogdensburg and then in Albany under an uncle's guardianship, he worked at a variety of jobs.

Remington's first excursion to the West was a short trip in 1881. In 1885 he spent nearly a year in New Mexico and Arizona before moving to New York to begin his long career as a chronicler of the West for many publications. From 1885 until his death, Remington's illustrations appeared in many magazines, including *Harper's, Century Illustrated Magazine,* and *Outing.* He also contributed stories to these periodicals.

Beginning in 1889, Remington made his home in New Rochelle, New York. By this time his illustrations were in great demand. He was determined, however, to make a reputation as a painter as well as an illustrator, and he worked specifically on non-commissioned oils of the western subjects with which he was already identified. His style in these early paintings was at first linear and hard-edged like his illustrations, but as the decade wore on he became more interested in the possibilities of color and paint

application. In 1895 he completed his first sculpture, thus initiating an enthusiastic involvement with the bronze medium that would last the rest of his life.

In 1898 Remington bought a small island in the St. Lawrence River. His seasonal retreats to Inglenuk, as he called the island, signaled his growing dissatisfaction with the world at large and the recognition that the frontier days of the West had passed. As a result, his later paintings were more contemplative and nostalgic in subject. His style alternated between the broken brushwork and brighter palette associated with Impressionism and the smooth, poetic images of Tonalism. Although M. Knoedler & Co. became his agent in 1905 and his exhibitions were popular with the public, reviewers often criticized the coloration of his pictures, though they praised his subjects for their nobility and Americanness. It was his sculpture, however, that brought him great acclaim.

In May 1909 Remington moved to more rural Ridgefield, Connecticut, where larger work spaces permitted more ambitious sculpture projects. He died in December of that year, so that little work was executed in the new studio.

Bibliography: Harold McCracken, *Frederic Remington: Artist of the Old West* (Philadelphia: J.B. Lippincott Co., 1947); Harold McCracken, *A Catalogue of the Frederic Remington Memorial Collection* (New York: M. Knoedler & Co. for the Remington Art Memorial, Ogdensburg, New York, 1954); Peggy and Harold Samuels, *Frederic Remington: A Biography* (Garden City, New York: Doubleday and Co., 1982); *Frederic Remington: The Masterworks,* exh. cat. (St. Louis: The Saint Louis Art Museum, 1988).

Frederic Remington
1861–1909

Frederic Remington once wrote to a friend: "I stand for the proposition of 'subjects'—painting something worthwhile as against painting *nothing* well—merely paint."[1] Throughout his career, subject matter guided his approach to art in an era when many artists used subject mainly as an armature for aesthetic interests. Remington's selection of the American West as his lifelong theme coincided with a call from critical circles for national subjects and with a growing public fascination with the western United States.

In the late 1880s the critics Clarence Cook and George W. Sheldon, although supporters of European training and cosmopolitanism, urged the introduction of indigenous subjects into American painting.[2] At this same time there was a renewed general interest in Indian

affairs and in the image of the West as part of the American national identity.[3] Between 1885 and 1890 Geronimo became a household word; the last of the Indian Wars was fought; and the 1890 census declared the closing of the frontier.[4] These nearly simultaneous occurrences sparked not only increased political and economic activity in the West, but helped to create the beginning of a myth of the West that expanded as the frontier truly closed.

Although it was not his only subject, Remington devoted a significant portion of his first decade of painting to battle scenes. The United States Cavalry figured prominently in both his illustrations and paintings, for these soldiers represented to Remington a heroic ideal that included manliness, white supremacy, and American strength.

Dismounted: The Fourth Trooper Moving the Led Horses, 1890
(Moving the Fourth Trooper; United States Cavalry Defending a Position; Dismounted: 4th Troopers Moving)
Oil on canvas
$34^1/_{16} \times 48^{15}/_{16}$ (86.5 × 124.3)
Signed and dated lower left: FREDERIC REMINGTON./1890
No. 11

Fig. 61: Frederic Remington, *A Dash for the Timber*, 1889. Oil on canvas, 48¼ × 84⅛ in. (122.6 × 213.7 cm). Amon Carter Museum, Fort Worth.

Dismounted: The Fourth Trooper Moving the Led Horses is one of a number of works dated 1889–91 that depict head-on, action-packed assaults by cavalry or cowboys. In 1889 Remington completed *A Dash for the Timber* (fig. 61), followed the next year by the Clark painting and in 1891 by *Right Front into Line —Come On* (destroyed) and *Captain Dodge's Colored Troops to the Rescue* (Flint Art Institute, Michigan). In *Dismounted*, Remington described a cavalry tactic in which one trooper (the fourth), having taken hold of three horses whose riders had dismounted in order to fire at the enemy, leads the animals away.[5] Remington subsequently returned to the "led horses" theme in 1909 with *Among the Led Horses* (private collection), which shows the horses waiting for their men.

In the early 1890s Remington, though still at the beginning of his painting career, was well established as an illustrator. He first exhibited *Dismounted* at the National Academy of Design in late 1890, but the image was also used as an illustration for E.S. Godfrey's article "Custer's Last Battle," published in *Century Illustrated Magazine* in January 1892. As Peter Hassrick has pointed out, the artist was so occupied with his illustration career in these years that he had little opportunity to paint solely for exhibition or sale. Instead, Remington developed a pattern of painting simultaneously for illustration, sale, and exhibition.[6] It is not known exactly when Remington was commissioned for the article in which *Dismounted* appeared, but the story was in process at *Century Illustrated Magazine* beginning in July 1888.[7] Thus he either knew of its possible publication well in advance of being commissioned for illustrations or the commission may have suggested the basic idea for the canvas.

Although *Dismounted* describes a specific maneuver, it is generic in setting and participants and was easily slipped into Godfrey's eyewitness account of Custer's Last Stand. The account does not relate the removal of the led horses, but it does mention their appearance during the heated fight. On the page preceding the illustration Godfrey wrote: "I dismounted my men to fight on foot, deploying as rapidly as possible without waiting for the formation laid down in tactics. . . . The led horses were sent to the main command."[8] Another set of led horses is also referred to in passing later in the article.[9]

Remington gathered a considerable amount of raw material to provide a flavor of authenticity in his work. On a number of trips to different parts of the West, he rode with the cavalry, sketched continually, took photographs, and collected regional costumes and objects.[10] Although he always remained only a visitor to the troops, he was credited with an ability to ride hard and was recognized for his keen observations of what the cavalry saw and did.[11] Yet his paintings, including *Dismounted*, were studio productions and often complete fabrications. He employed a practice he may have first learned at Yale under John F. Weir (1841–1926) — the use of sketches, photos, accumulated props, and knowledge of other art to create elaborately composed works.[12]

Remington's artistic devices developed out of his interest in naturalism and his desire to depict the character of the West through action. He accomplished this in *Dismounted* in large part through the sense of immediacy generated by the eye-level viewpoint and shallow foreground, which place the legs of the galloping horses directly in front of the viewer. The fact that none of the hooves touches the ground and all are somewhat obscured by kicked-up dust further suggests fast-moving animals. Remington painted the first four horses with the single rider with great clarity and in bright light, giving them a sense of individuality. As the foreground recedes, detail decreases substantially and similar forms — including the exact replication of one cavalryman's face — are repeated. The effect is one of incredible speed. In the far distance at left, the firing troopers are delineated only by patches of blue, but we imagine their identities from the more detailed fourth trooper. Remington used similar devices in many of his battle paintings, especially those painted during 1889–92, including *A Dash for the Timber* and *Right Front into Line—Come On*.

Remington's methods were the product of several influences. Foremost of course was his firsthand knowledge of the far West and his belief that it represented the true American identity. His experience as an illustrator, moreover, sharpened his sense of narrative and its depiction through line and detail. The frozen-action quality and low viewpoint probably stem from Remington's own work with a camera, which began around 1887, even though he recognized photography's limitations.[13] His depiction of galloping horses depended to a certain extent on the horse movement photographs of Eadweard Muybridge (1830–1904), well known as early as 1882, although he denied any such reliance.[14]

Nor was Remington ignorant of English and Continental painting, though he had eschewed European training. *Dismounted* represents an actual maneuver used by the United States Cavalry,[15] but his presentation was probably also inspired by the French military paintings of Jean-Louis-Ernest Meissonier (1815–1891) and Jean-Baptiste-Edouard Detaille (1848–1912), whose works were very popular among American collec-

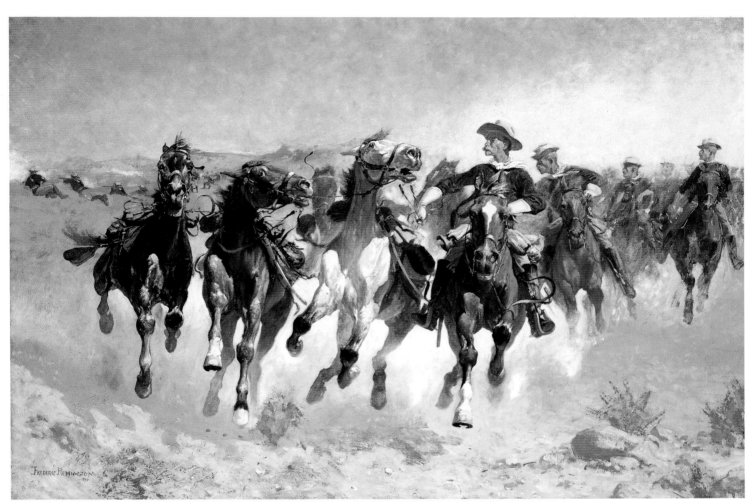

Dismounted: The Fourth Trooper Moving the Led Horses

Fig. 62: Jean-Louis-Ernest Meissonier, *Friedland, 1807*, 1875. Oil on canvas, 53½ × 95½ in. (135.9 × 242.6 cm). The Metropolitan Museum of Art, New York; Gift of Henry Hilton, 87.20.1.

tors during the 1880s. Remington appropriated the rushing charge composition in uch works as Meissonier's *Friedland, 1807* (fig. 62), which was given to the Metropolitan Museum of Art in 1887. The French artists' clarity of form and color may also have suggested an approach to painting that Remington was already familiar with from his black-and-white illustrations.

Viewers of *Dismounted* perceived it as an authentic rendering of an event, a misapprehension attributable to the public's ignorance of the West, a campaign by Harper Brothers in 1890 to present Remington as a "rough and tumble Westerner," and Remington's own interest in convincingly relating good stories. Although *Dismounted* was ultimately a confection, Remington must have been pleased when a critic for *The New York Times* described the painting as "a rattling, fly-away scene from a campaign against the Indians of the West, by Frederic Remington. The troopers leading off the horses sit their saddles with magnificent ease and have a delightfully devil-may-care, swashbuckler cast of countenance."[16] Using strategies derived from illustration, photography, and other art, Frederic Remington invented his American West, and the image, in many ways, remains alive today.

1 Remington to Al Brolley, undated, quoted in Doreen Bolger Burke, "In the Context of His Artistic Generation," in *Frederic Remington: The Masterworks,* exh. cat. (St. Louis: The Saint Louis Art Museum, 1988), p. 47.

2 Clarence Cook, "National Academy of Design," *The Studio* (New York), 3 (June 1888), p. 112; George William Sheldon, *Recent Ideals in American Art* (New York: D. Appleton and Co., 1888–90), p. 37.

3 Peggy and Harold Samuels, *Frederic Remington: A Biography* (Garden City, New York: Doubleday and Co., 1982), p. 60.

4 Judith MacBain Alter, "The Western Myth in American Literature and Painting of the Late 19th and Early 20th Centuries," Ph.D. dissertation, Texas Christian University, Fort Worth, 1970, p. 4.

5 Samuels and Samuels, *Frederic Remington,* p. 140.

6 Peter H. Hassrick, "The Painter," in *Frederic Remington: The Masterworks,* pp. 104, 113.

7 In July 1888 there began a three-year correspondence between Godfrey and the publishers of *Century Illustrated Magazine* concerning this story. By February 19, 1891, Godfrey was still revising his manuscript but also was gathering photographs for reproduction. The correspondence is in the Century Magazine Collection, Division of Manuscripts, The New York Public Library.

8 E.S. Godfrey, "Custer's Last Battle," *Century Illustrated Magazine,* 43 (January 1892), p. 375.

9 Ibid., p. 380.

10 In May 1888, for example, he traveled to Arizona for *Century Illustrated Magazine* and

rode with the cavalry under his friend Powhatan Clarke; see Samuels and Samuels, *Frederic Remington,* p. 107.

11 David McCullough, "The Man," in *Frederic Remington: The Masterworks,* p. 22.

12 Burke, "In the Context of His Artistic Generation," p. 43.

13 Remington remarked in 1892: "Kodacs [*sic* have no brains — no discrimination"; Hassrick, "The Painter," p. 97.

14 Ibid.

15 Michael McAfee, curator of military history at the West Point Museum of the United States Military Academy, confirmed that the moving away of led horses would have been executed in the manner Remington depicted, though the artist may have exaggerated the extremely fast pace.

16 "The Autumn Academy," *The New York Times,* November 21, 1890, p. 4.

Provenance: Mrs. William H. Sage, New York; to (M. Knoedler & Co., New York, February 24, 1944); to Lincoln Ellsworth, New York, March 7, 1944; to (M. Knoedler & Co., New York, February, 7, 1945); to Robert Sterling Clark, May 1, 1945.

Exhibitions: National Academy of Design, New York, "9th Autumn Exhibition," November 24–December 20, 1890, no. 255 (as *Moving the Fourth Trooper*); Sterling and Francine Clark Art Institute, Williamstown, Massachusetts, "Exhibit 4: The First Two Rooms," May 17, 1955, no. 11 (as *Dismounted: 4th Troopers Moving*); Amon Carter Museum of Western Art, Fort Worth, "Custer's Last," January–March 1968 (no catalogue); Amon Carter Museum of Western Art, Fort Worth, "Frederic Remington," January–March 1973, no. 28; West Point Museum, United States Military Academy, West Point, New York, "Frederic Remington: The Soldier Artist," May–June 1979, no. 55; The Denver Art Museum, "Frederic Remington The Late Years," July–August 1981; Sterling and Francine Clark Art Institute, Williamstown, Massachusetts, "Mainly off the Battlefield," December 1981–January 24, 1982 (no catalogue).

References: "The Autumn Academy," *The New York Times,* November 21, 1890, p. 4; "The Academy of Design," *The Art Amateur,* 24 (January 1891), p. 31; "Custer's Last Battle," *Century Illustrated Magazine,* 43 (January 1892), pp. 358–84; Harold McCracken, *A Catalogue of the Frederic Remington Memorial Collection* (New York: M. Knoedler & Co. for the Remington Art Memorial, Ogdensburg, New York, 1954), p. 34 (as *United States Cavalry Defending a Position*); CAI 1955, n.p., pl. XI; CAI 1958a, n.p., pl. L (as *Dismounted: 4th Troopers Moving*); Thomas C. Jones, *Shaping the Spirit of America* (Chicago: J.G. Ferguson Publishing Co., 1964), frontispiece; Samuel M. Green, *American Art: A Historical Survey* (New York: Ronald Press, 1966), p. 378, pl. 5:37; *Custer's Last,* exh. cat. (Fort Worth: Amon Carter Museum of Western Art, 1968), p. 40; Don Russell, *Custer's Last: A Checklist of Pictures Relating to the Battle of the Little Big Horn* (Fort Worth: Amon Carter Museum of Western Art, 1968), p. 36, no. 560; *Winning the West 1700–1900* (San Francisco: Field Educational Publications, 1971),

p. 119, pl. 17; CAI 1972, pp. 82, 83; *Frederic Remington,* exh. cat. (Fort Worth: Amon Carter Museum of Western Art, 1973), p. 21; Shirley Glubok, *Art of America in the Gilded Age* (New York: Macmillan Co., 1974), p. 21; Matthew Baigell, *The Western Art of Frederic Remington* (New York: Ballantine Books, 1976), pl. 9; *The Chronicle of the Horse,* 41 (August 18, 1978), back cover; *Frederic Remington: The Soldier Artist,* exh. cat. (West Point, New York: West Point Museum, United States Military Academy, 1979); CAI 1981, pp. 90–91; *Frederic Remington:*

The Late Years, exh. cat. (Denver: The Denver Art Museum, 1981), p. 28; Peggy and Harold Samuels, *Frederic Remington: A Biography* (Garden City, New York: Doubleday and Co., 1982), p. 140; CAI 1984, pp. 29, 105; *Frederic Remington: The Masterworks,* exh. cat. (St. Louis: The Saint Louis Art Museum, 1988), p. 108; James K. Ballinger, *Frederic Remington* (New York: Harry N. Abrams, 1989), pp. 50–51; Sophia Craze, *Frederic Remington* (New York: Crescent Books, 1989), pp. 26–27.

Frederic Remington's initial contact with sculpture probably took place in 1878 through the drawing classes of J.H. Niemeyer (1839–1932) at the Yale School of Fine Arts.[1] Niemeyer, who was an admirer and eventual practitioner of sculpture, may have imparted his enthusiasm for three-dimensional form as Remington and his classmates drew from plaster casts of antique sculpture. However, it was not until the fall of 1894 that Remington began to sculpt, and his initial attempts in clay were directly inspired and encouraged by the sculptor Frederic Wellington Ruckstuhl (1853–1942), his neighbor in New Rochelle.[2]

"I am to endure in bronze," Remington wrote in January 1895, when he had been modeling only a few months.[3] Around October 1895 when his first piece, *Bronco Buster,* was completed, he declared: "All other forms of art are trivialities—mud—or its sequence 'bronze' is a thing to think of when you are doing it—and afterwards, too. It dont [sic] decay. The moth dont [sic] break through and steal—the rust and the idiot cannot harm it. . . ."[4] These statements testify to Remington's lifelong concern for his reputation, but they also suggest the seriousness and reverence with which he approached the bronze medium.

Remington's themes for sculpture followed those he had pursued in illustration and painting: images of the far West, particularly the life of the cavalry, the cowboy, and the Indian during the last quarter of the nineteenth century. *The Wounded Bunkie,* Remington's second sculpture, was copyrighted July 9, 1896. It depicts two mounted cavalrymen at a gallop. One has just been shot in the back by a bullet and is beginning to fall. The other, supporting his injured fellow rider and bunkmate, or "bunkie," looks to the unseen battle, where the shot originated.

Like much of Remington's varied oeuvre, the sculpture focuses on the drama and danger of life in the West. Remington had explored the artistic possibilities of this particular kind of incident as early as 1889. In his first major painting, *A Dash for the Timber*

(fig. 61), a wounded cowboy is helped in the same fashion. In *The Wounded Bunkie,* Remington isolated and thereby intensified the subject. To leave no doubt that he was depicting a matter of life and death, an animal skull, symbolic of death in the western desert, rests at the rear of the base. *The Wounded Bunkie* also attests to the brotherly bond among the rough men of the cavalry. In concentrating on one man aiding another in the face of grave danger, Remington presented two sides of the cavalryman's psyche—his heroism and his regard for his fellow man.

The Wounded Bunkie was cast in a bronze edition of fourteen by the Henry Bonnard Bronze Company of New York. The casts were given letters for identification rather than the usual numbers. The Clark work is one of two with the letter D.[5] For his first four sculptures, including *The Wounded Bunkie,* Remington had his original clay models transformed into bronze through the sand-casting method, the popular system for casting bronze until the turn of the twentieth century. Sand casting employs a two-sided mold of baked sand made from a plaster cast of the clay original. A smaller core of sand with a metal armature is placed inside the mold and molten bronze is poured through a pipe to fill the space between the core and the mold. After the bronze cools, the mold and sand core are removed and the exposed pipe is cut off. The bronze sculpture with a metal armature inside it remains, and its exterior is filed, chased, and given a patina for color and finish and to prevent metal corrosion.[6] This method leaves very smooth, regular forms with simple linear patterns to create detail. In the case of *The Wounded Bunkie,* sand casting abetted Remington's desire to depict smooth-skinned, well-muscled horses with manes and tails flying. The smaller objects, including the canteens, reins, saber, rifle, stirrup, bedroll, and skull, were cast separately and pinned onto the main forms and base.[7] Remington suggested fast-paced action by placing the horses' and the riders' heads in sequence and overlapping them. In addition, the horses' legs are

The Wounded Bunkie, 1896

Bronze

$20\frac{1}{4} \times 13\frac{1}{8} \times 34\frac{5}{8}$ (51.4 × 33.3 × 87.9)

Inscribed on base: Frederic Remington/copyright by Frederic Remington 1896/D/Cast by the Henry Bonnard Bronze Company NY 1896

No. 13

depicted at a rushing gallop and they touch the base in only two places.

Remington's lack of reliance on extraneous supports for his main figure group was a radical concept for American sculpture in the mid-1890s. As Charles Mason Fairbanks noted in *Harper's Weekly:* "The technical and mechanical problems that have been solved in the execution of his work [*The Wounded Bunkie*] are novel and intricate. . . . The action of the horses is superb . . . and this sense of free action . . . is greatly heightened by the skillful manner in which both animals are made to appear as if in the air, barely touching the earth. The nigh hind leg of one horse and the nigh fore leg of the other are contrived so as to support and balance the whole group in the most natural manner possible."[8] Although Remington had been depicting galloping horses since the early days of his career (pp. 139–43), the tremendous success of the horses in *The Wounded Bunkie* fostered exact replications in the later sculptures *Coming Through the Rye* (1902), *The Stampede* (1909), and *Trooper of the Plains* (1909).[9]

Remington was also credited with depicting the characters of *The Wounded Bunkie* naturally and truthfully. His excellent knowledge of horse anatomy was praised; his treatment of the troopers was considered faithful; and his inclusion of the trappings of the cavalrymen was viewed as "a study of detailed completeness."[10] For these reasons *The Wounded Bunkie* was accepted as an authentic depiction of life in the far West. Whereas sculptors such as J.Q.A. Ward (1830–1910) occasionally had depicted western themes in works like *Indian Hunter* (1860), Remington released an energy and authority in his version of the western experience.[11]

As original as Remington was in his use of bronze and his approach to his subjects, his sculpture did have roots in earlier work. The casts of Hellenistic sculpture he first saw at Yale may have influenced the exaggerated gestures and poses he used as well as familiarized him with heroic and tragic figures.[12] In addition, by the early 1890s Remington would have had the opportunity to see the works of Antoine-Louis Barye (1796–1875), who specialized in animal sculpture.[13] He appropriated not only the French artist's preferred twenty-four- or thirty-six-inch format, but also the use of a linear realism that capitalized on the beautiful forms of the animals within the depiction of struggling forces.[14]

Remington absorbed these artistic modes of expression to present his personal vision of the West where the cavalrymen were tough and heroic, yet also compassionate. Through its compelling depiction of action, horseflesh, and military men and equipment, *The Wounded Bunkie* relates the heroism and camaraderie of the men who fought in the last Indian Wars around 1890. Almost fifty years after the completion of *The Wounded Bunkie,* Robert Sterling Clark, a career military man and horse-breeder, was struck by Remington's bronzes at the Metropolitan Museum of Art. On September 19, 1942, he wrote in his diary, "I would buy them [Remington bronzes] at a good price any time,"[15] but it was four years before a cast of *The Wounded Bunkie* could be added to his collection.

1 Michael Edward Shapiro, "The Sculptor," in *Frederic Remington: The Masterworks,* exh. cat. (St. Louis: The Saint Louis Art Museum, 1988), p. 171.

2 Michael Edward Shapiro, *Cast and Recast: The Sculpture of Frederic Remington,* exh. cat. (Washington, D.C.: National Museum of American Art, Smithsonian Institution, 1981), p. 37.

3 Remington to Owen Wister, quoted in Shapiro, *Cast and Recast,* p. 40.

4 Ibid.

5 Ibid., p. 117, for a complete listing of *The Wounded Bunkie* casts.

6 Ibid., pp. 13–19, for a detailed description of the sand-cast method.

7 After vandalism in 1970, the rifle of the injured bunkie was replaced with a modern cast.

8 Charles Mason Fairbanks, "The Wounded Bunkie," *Harper's Weekly,* 40 (November 28, 1896), p. 1174.

9 Shapiro, "The Sculptor," p. 221, has suggested that this reuse of particular figures or poses indicated a serial notion within Remington's own thought.

10 Fairbanks, "The Wounded Bunkie," p. 1177.

11 Doreen Bolger Burke, "In the Context of His Artistic Generation," in *Frederic Remington: The Masterworks,* p. 65.

12 Shapiro, "The Sculptor," p. 171.

13 Shapiro, *Cast and Recast,* p. 43.

14 Burke, "In the Context of His Artistic Generation," p. 65.

15 Robert Sterling Clark, diary, September 19, 1942, CAI archives.

Provenance: Arthur Curtis James, New York; to (Parke-Bernet Galleries, New York, sale of the James collection, November 13–15, 1941, no. 134); to (Milch Gallery, New York); to (M. Knoedler & Co., New York, September 30, 1946); to Robert Sterling Clark, October 21, 1946.

Exhibition: Sterling and Francine Clark Art Institute, Williamstown, Massachusetts, "Exhibit 4: The First Two Rooms," May 17, 1955, no. 13.

References: CAI 1955, n.p., pl. XIII; CAI 1958, n.p., pl. LII; *Cast and Recast: The Sculpture of Frederic Remington,* exh. cat. (Washington, D.C.: National Museum of American Art, Smithsonian Institution, 1981), p. 117.

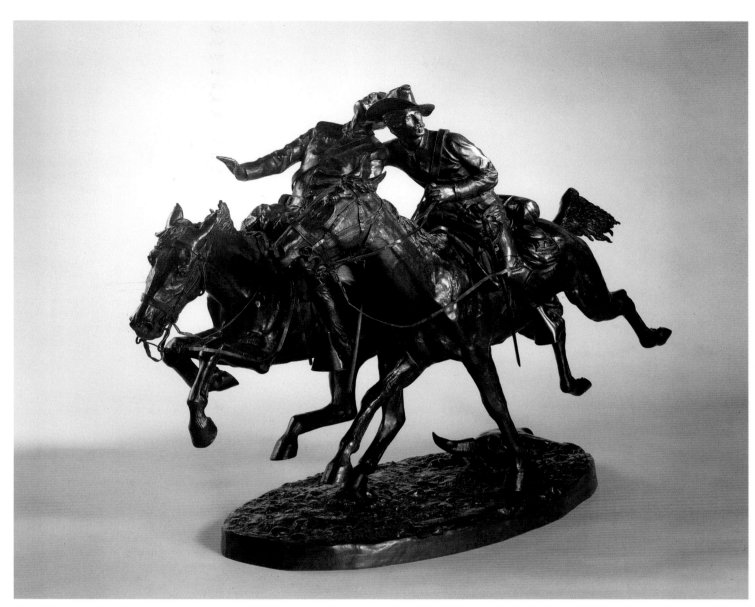

The Wounded Bunkie

The Scout: Friends or Foes,

c. 1900—1905

*(Friend or Enemy; Friends or Foes;
The Scout: Friends or Enemies?)*

Oil on canvas

27×40 (68.6×101.6)

Signed lower right: Frederic Remington

No. 12

Fig. 63: Frederic Remington, **Return of the
Blackfoot War Party,** 1888 (before repaint-
ing), from George William Sheldon, **Recent
Ideals of American Art** (New York: D.
Appleton, 1890), p. 105.

Throughout the nineteenth century, the
life and customs of Native Americans
received steady, if not frequent, treatment by
American artists.[1] Prior to 1840 Indians were
depicted as exotic aborigines and were placed
in romantic settings often derived from litera-
ture. After this period, when realism took
a stronger hold on all American art, accurate
depictions of many different tribes appeared
with greater regularity, often precipitated
by anthropological or ethnographic interests.
From mid-century on, both romantic and
realistic images occur. In the 1850s the demise
of the Indian was often depicted as a mixed
blessing, a sign of America's progress as well
as the destruction of her pure state. However,
as the West was settled with an increasingly
large white population, Native Americans
assumed near mythic status. By the end of the
century, Indians, frequently portrayed in
escape or pursuit, were depicted with nostal-
gia for a lost era.

The American Indian was among
Remington's principal subjects from the start
of his career in the mid-1880s. The Blackfeet
were one of several tribes he studied directly.
In the spring of 1887 and again in the summer
of 1890, he visited the Blackfeet reservation
south of the Bow River in Alberta as part of
his work for Harper Brothers. His drawings
of the Blackfeet then accompanied a short
article in *Harper's Weekly* in 1887, and he
exhibited *Return of the Blackfoot War Party*
(fig. 63) the following year. On scruffy but
hearty ponies, the somewhat ragged warriors
raise their arms in victory and defiance as
they endure the wintry elements on their way
to their home camp, viewed in the distant
left. Prior to their containment, the Blackfeet
Indians were considered one of the strongest,
most feared tribes. Their ability to survive
reservation life in arduous winters with less
than sufficient hunting grounds and govern-
ment support assured continued respect.[2]
Although Remington always distrusted
Indians and considered them inferior, he,
too, respected the strength of their character.

By 1890, when the last of the Indian Wars
had been fought, the United States govern-
ment stated: "It has become the settled policy
. . . to destroy tribal relations . . . incorporate
them [Indians] into the national life. . . .
The American Indian is to become the
Indian American."[3] The ramifications of such
policies slowly caused Remington's attitudes
toward the Indian to change. The artist's
mixed feelings of contempt and esteem for
Indians like those in *Return of the Blackfoot
War Party* gave way over the years to compas-
sion. Around 1900 Remington finally con-

ceded that "his" West — the West of a superior
cavalry conquering proud warriors — was
no longer.[4] Thus, after a decade of depicting
Native Americans, he came to rely less on
narrative and detail and more on a sympa-
thetic mood created with the effects of light
and color.[5]

The Scout: Friends or Foes is an excellent
example of the artist's altered viewpoint and
his more contemplative approach. The paint-
ing shows a single Blackfoot Indian on horse-
back surveying a distant encampment across a
high open plain on a starry winter night.
The quiet evening setting is contrasted
against a tense human moment. There is no
action; rather, the figure's stance and the
blurred distant forms imply a narrative. The
pervading blue tonality and the stark compo-
sition with minimal detail assist in conveying
the situation. Nonetheless, Remington
remained faithful to Blackfoot physiognomi-
cal characteristics and costume, which he
had carefully examined in 1887. He was also
able to suggest both the Blackfoot's former
power and present impotence. The figure's
alert pose astride his horse in the snowy
landscape signals the stamina for which the
Blackfeet were revered and their successful
surveillance methods. The balance of the fig-
ure against the vast terrain also suggests a
harmonious relationship between the man
and the desolate land, a spiritual bond com-
monly attributed to American Indians.
Nonetheless, the figure appears tense in con-
trast to his mount. The image of the lone
scout hints at the state of the Indian popula-
tion: alone, seemingly without support, out-
numbered, and potentially deprived of a
traditional way of life.

The Scout: Friends or Foes is undated. A date
of c. 1890 has usually been ascribed to it,
but facts about the painting's size, signature,
and history of ownership as well as the sub-
ject's presentation and the painting style
indicate that it was more likely executed
c. 1900—1905.[6] First, *The Scout: Friends or Foes*
never appeared as an illustration. Nearly
all Remington's early paintings from 1887 to
1893 were used as illustrations. In fact, illus-
tration formed the core of Remington's work
until a lucrative agreement with *Collier's
Magazine* in 1900 freed him from the need to
accept other illustration commissions.[7]
Second, the work is of a size (27×40 inches)
that Remington clearly preferred only after
1900.[8] Third, the artist's signature exhibits
the more flowing hand of his later writing.[9] A
comparison of the signature in *Dismounted*
of 1890 (fig. 64) and *The Scout* clearly illus-
trates the changes in the artist's hand. *The*

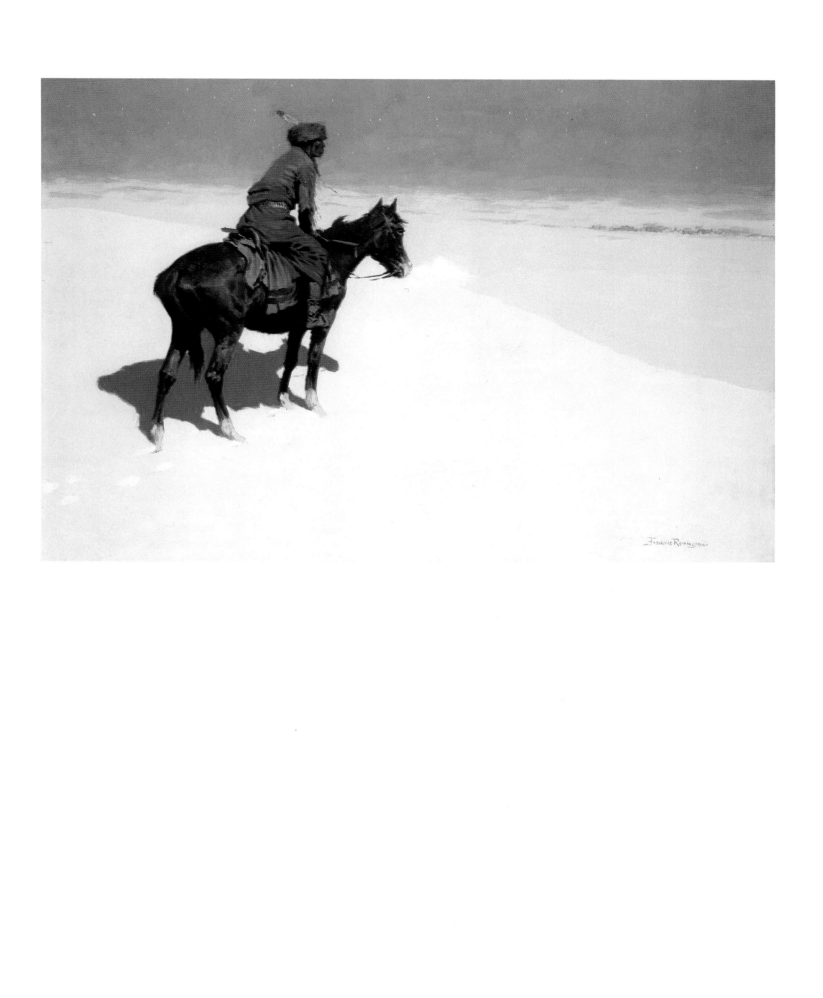

Fig. 64: Frederic Remington, **Dismounted: The Fourth Trooper Moving the Led Horses** (detail of signature). Sterling and Francine Clark Art Institute.

Fig. 65: Frederic Remington, **The Scout: Friends or Foes** (detail of signature). Sterling and Francine Clark Art Institute.

Fig. 66: Frederic Remington, **His First Lesson**, 1903 (detail of signature). Amon Carter Museum, Fort Worth.

Fig. 67: Frederic Remington, **The Luckless Hunter**, 1909. Oil on canvas, 26⅞ × 28⅞ in. (68.3 × 73.3 cm). Sid Richardson Collection of Western Art, Fort Worth, Texas.

Scout signature (fig. 65) compares much more favorably with those of many post-1900 works, including *His First Lesson* (fig. 66). Although it is possible that Remington signed the painting years after he created it, this was not his usual practice. Finally, the first known exhibition of *The Scout* was in March 1905 at the Albany Institute and Historical and Art Society.[10] It was lent by J. Townsend Lansing, an Institute trustee, who seems to have acquired it after 1900,[11] although it is uncertain whether Mr. Lansing was its first owner. Remington may have first sold the painting to Ledyard Cogswell, Sr., a prominent banker and another Albany Institute trustee.[12] Remington had long-standing connections with Albany through his family. He lived there on and off during 1880–82, but then had little association with the city until around 1897, when he began offering works of art for sale through Annesley's art store.[13] The known history of *The Scout*'s ownership and of Remington's renewed activity in Albany only from 1897 further suggest that the painting was probably not on the market much before 1900.

The subject, presentation, and style of *The Scout* corroborate a date in the first few years of the twentieth century. Although Blackfeet Indians mainly appear in Remington's earlier work, it was not uncommon for him to return to older themes as his attitudes changed and he explored new artistic strategies.[14] More than any other single painting, *The Scout: Friends or Foes* parallels Remington's last major piece of writing, *The Way of the Indian*. The book, which was begun in 1900 and was serialized in *Collier's Magazine* in 1905–6, has been recognized for its sympathetic, though novelized, study of an Indian chief unable to cope with the encroachments of the white man.[15] Although *The Scout* does not directly relate to *The Way of the Indian*, it reflects a similar compassion, which was absent from Remington's earlier works in all media. Among Remington's later paintings, *The Luckless Hunter* (fig. 67) and *The Outlier* (fig. 68) also express like sentiments despite their different painting techniques.

As Remington's view of the West altered, he applied a new set of artistic strategies to convey his empathy with the Indian. Most noticeably, night or dusk often replaced daytime as a setting and quietude replaced action. Nocturnes, which were relatively rare in the artist's pre-1900 work, account for nearly half of his images after 1900. The nocturnal and contemplative presentation of *The Scout* is remarkably similar to other post-1900 works, including *Evening on a Canadian Lake* (fig. 69). These two paintings, among others dated after 1900, also use a single tone, large reflective surfaces, and a silhouetted

figure. Peter Hassrick has identified these devices as directly related to Remington's response to the work of California artist Charles Rollo Peters (1862–1928).[16] Remington could have seen Peters's work in New York at his one-man exhibition at the Union League Club in 1899. During the next five years, the Californian was included in several other New York exhibitions. The star-dotted night sky in *The Scout* and the silhouetting of the forms against the sky and snow both reflect what Remington could particularly appreciate in a work like Peters's *Nocturnal Landscape, Monterey* (fig. 70).[17]

The art of Remington and Peters belonged to a larger movement in American painting at the turn of the century. The style, today called Tonalism, was one "of intimacy and expressiveness . . . in limited color scale and employing delicate effects of light to create vague suggestive moods."[18] Both nocturnes and winter scenes were popular Tonalist themes, most likely due to their overtly poetic nature and suitability for use with a restricted palette. Tonalist painters also frequently employed spare, abstracted designs. The work of James McNeill Whistler (1834–1903) was the ultimate source of inspiration for most late nineteenth-century blue-toned nocturnes. The popularity of this approach was noted by American art critic Charles Caffin in 1902: "To look for poetic quality in a landscape picture has become with many an axiom of standard, and they find its expression chiefly in the manner of tone."[19]

In *The Scout*, Remington combined the features of winter and nightfall with a cold, blue light enveloping a pared-down composition to assert the poetic quality that Caffin had noticed. Remington's success to this end was appreciated when his first group of nocturnes was shown at the Clausen Gallery in 1901. A writer for *The Commercial Advertiser* found these pictures much to his liking and commented that the artist "depicting the night . . . secures considerable sentiment with his paint."[20] Remington's work, however, did not attain the sense of reverie that often appeared in the Tonalist figure painting of the day, such as Thomas Dewing's *Recitation* (1891; The Detroit Institute of Arts).

For Remington, keeping his image of the West alive demanded that a certain amount of narrative and connection to reality be maintained. His highly detailed earlier works had created a truthful depiction of the American West; those of mid-career had presented a mythologized West that was fast disappearing. *The Scout* conveys a true but melancholic image of the West now gone. In this late work fact blends with emotional response to render the artist's special concept of the West.

1 For a concise yet thorough study of the subject, see Ellwood L. Parry, *The Image of the Indian and the Black Man in American Art* (New York: George Braziller, 1974).

2 "The Blackfeet Indians," *Harper's Weekly,* 31 (July 23, 1887), p. 523.

3 From the report of the Commissioner of Indian Affairs, T.J. Morgan, September 5, 1890, p. iii, quoted in W.E. Washburn, *The American Indian and the United States* (Westport, Connecticut: Greenwood Press, 1979), p. 435.

4 Melissa Webster, "Frederic Remington: His Art and His Nocturnes," M.A. thesis, University of California at Davis, 1986, p. 42.

5 Doreen Bolger Burke, "In the Context of His Artistic Generation," in *Frederic Remington: The Masterworks,* exh. cat. (St. Louis: The Saint Louis Art Museum, 1988), pp. 53, 60.

6 The only variant on the early dating in published literature appears in Harold McCracken, *A Catalogue of the Frederic Remington Memorial Collection* (New York: M. Knoedler & Co. for the Remington Art Memorial, Ogdensburg, New York, 1954), where the work was dated c. 1908. In subsequent writings McCracken did not attach a date to the picture. I am grateful to Peter Hassrick, director, and Melissa Webster, assistant curator, Buffalo Bill Historical Center, Cody, Wyoming, and Mark van Benschoten, Remington Museum, Ogdensburg, New York, for their assistance in this matter.

7 Peggy and Harold Samuels, *Frederic Remington: A Biography* (Garden City, New York: Doubleday and Co., 1982), pp. 293–94, and David McCullough, "The Man," in *Frederic Remington: The Masterworks,* p. 34.

8 Only two canvases dated prior to 1896 are known in this size; there are a small number between 1896 and 1900. Between 1900 and 1906, the 27×40–inch format is the one Remington used for the majority of his paintings; Melissa Webster to the author, February 21, 1989.

9 Peter Hassrick's expertise on the changes in Remington's signature, offered at the Remington Symposium, the Saint Louis Art Museum, March 26, 1988, contributed to this analysis.

10 Albany Institute and Historical and Art Society, *Catalogue of Paintings: Spring Exhibit,* March 1–14, 1905, no. 105. A caption under the listing stated: "Remington at his best. Effective composition. The horse and rider contrasting with the broad, empty spaces, giving a sense of endless plains."

11 In 1900 Lansing's collection was exhibited at the Albany Institute; *The Scout: Friends or Foes* was not included. According to Tammis Groft, curator, Albany Institute of History and Art, this exhibition is believed to have been a comprehensive showing of Lansing's holdings at that time.

12 A 1950 bill of sale from M. Knoedler & Co., New York, to Robert Sterling Clark provided a provenance that recorded the picture as bought from the artist by Mr. Ledyard Cogswell of Albany prior to its sale to Lansing. Cogswell did own a Remington painting around 1900, but his descendants do not remember *The Scout* as one of the pieces in this fairly well-known small collection. Arnold Cogswell, Ledyard Cogswell's

grandson, has suggested that his grandfather, who knew both Remington and Lansing, might have served as an agent for the artist, and thus may have held the picture as "owner" for a short time before Mr. Lansing purchased it.

13 Remington seems to have had works on consignment with Annesley's from 1897 until his death. In 1899 he sent nine pieces on consignment; he again consigned works there in 1900 and 1907. Mrs. Remington continued to sell some pictures through this same store for a short time after her husband's death. Unfortunately, the archive of Annesley papers is incomplete; Annesley and Co. Collection, McKinney Library, Albany Institute of History and Art.

14 Peter H. Hassrick, "The Painter," in *Frederic Remington: The Masterworks,* p. 126. This was true, for instance, in the case of the subject of *Dismounted: The Fourth Trooper Moving the Led Horses;* see pp. 139–43.

15 Peggy and Harold Samuels, eds., *The Collected Writings of Frederic Remington* (Garden City, New York: Doubleday and Co., 1979), p. 626.

16 Hassrick, "The Painter," p. 127.

17 Peter Hassrick, conversations with the author, March 25–26, 1988, now agrees that *The Scout* is of a later date and displays Remington's absorption of Peters's style.

18 Wanda Corn in *The Color of Mood: American Tonalism, 1880–1910,* exh. cat. (San Francisco: M.H. de Young Memorial Museum, 1972), p. 4.

19 Charles H. Caffin, *American Masters of Painting* (New York: Doubleday, Page & Co., 1902), p. 116, quoted in Wanda Corn in *The Color of Mood,* p. 8.

20 "The Art World," *The Commercial Advertiser* (New York), December 10, 1901, quoted in Hassrick, "The Painter," p. 127.

Provenance: To Ledyard Cogswell, Sr., Albany(?), New York; to J. Townsend Lansing, Albany, New York; estate of J. Townsend Lansing; to Albany Institute of History and Art, 1920; to (John Levy Galleries, New York, and M. Knoedler & Co., New York, 1950); to Robert Sterling Clark, January 23, 1951.

Exhibitions: Albany Institute and Historical and Art Society, New York, "Spring Exhibition," March 1–14, 1905, no. 105 (as *Friends or Foes*); Museum of Fine Arts, Dallas, "Texas Centennial Exposition," June 6–November 29, 1936 (as *Friends or Foes*); M. Knoedler & Co., New York, "Portrait of the Old West," October 20–November 1, 1952; Sterling and Francine Clark Art Institute, Williamstown, Massachusetts, "Exhibit 4: The First Two Rooms," May 17, 1955, no. 12 (as *The Scout: Friends or Enemies?*); Paine Art Center and Arboretum, Oshkosh, Wisconsin, "Frederic Remington: A Retrospective Exhibition of Painting and Sculpture," August 1–September 24, 1967, no. 63; Wildenstein and Co., New York, "How the West Was Won," May 22–June 22, 1968, no. 5; The Saint Louis Art Museum, "Frederic Remington: The Masterworks," March 11–May 22, 1988 (as *The Scout: Friends or Enemies?*).

*Fig. 68: Frederic Remington, **The Outlier,** 1909. Oil on canvas, 40⅛ × 27¼ in. (101.9 × 69.2 cm). The Brooklyn Museum, New York; Bequest of Miss Charlotte R. Stillman, 55.43.*

*Fig. 69: Frederic Remington, **Evening on a Canadian Lake,** 1905. Oil on canvas, 27¼ × 40 in. (69.2 × 101.6 cm). Private collection.*

*Fig. 70: Charles Rollo Peters, **Nocturnal Landscape, Monterey,** n.d. Oil on canvas, 16 × 24½ in. (40.6 × 62.2 cm). Collection of Charles R. Brown.*

References: Harold McCracken, *Portrait of the Old West* (New York: McGraw-Hill, 1952), p. 204; Harold McCracken, *A Catalogue of the Frederic Remington Memorial Collection* (New York: M. Knoedler & Co., for the Remington Art Memorial, Ogdensburg, New York, 1954), p. 42; CAI 1955, n.p., pl. XII; Alexander Eliot, *Three Hundred Years of American Painting* (New York: Time Incorporated, 1957), p. 97; CAI 1958a, n.p., pl. LI (as *The Scout: Friends or Enemies?*); Edmund Fuller and B.J. Kinnick, *Adventures in American Literature* (New York: Harcourt, Brace and World, 1958), p. 87; Thomas C. Jones, ed., *Shaping the Spirit of America* (Chicago: J.G. Ferguson Publishing Co., 1964), opp. p. 128; Harold McCracken, *The Frederic Remington Book: A Pictorial History of the West* (Garden City, New York: Doubleday and Co., 1966), pp. 170, 281; R.N. Gregg, "Art of Frederic Remington," *Connoisseur,* 165 (August 1967), pp. 269–73; William Greenleaf and Richard B. Morris, *U.S.A.: The History of a Nation* (Chicago: Rand McNally & Co., 1959), following p. 266; Shirley Glubok, *The Art of the Old West* (New York: Macmillan Co., 1971), p. 29; CAI 1972, pp. 82, 83 (as *The Scout: Friends or Enemies?*); Frank Getlein, *The Lure of the Great West* (Waukesha, Wisconsin: Country Beautiful, 1973), pp. 228–29; *Montana: The Magazine of Western History,* 24 (January 1974), cover; Matthew Baigell, *The Western Art of Frederic Remington* (New York: Ballantine Books, 1976), p. 53; *The Chronicle of the Horse,* 41 (August 18, 1978), back cover; Louis Chapin, *Great Masterpieces by Frederic Remington* (New York: Crown Publishers, 1979), pp. 18, 19; Sushil Mukherjee, "Treasures of the Clark Museum," *Berkshire Magazine,* 1 (Winter 1982), p. 41; Edward Buscombe, "Painting the Legend: Frederic Remington and the Western," *Cinema Journal,* 23 (Summer 1984), pp. 12–27; CAI 1984, pp. 30, 105 (as *The Scout: Friends or Enemies?*); *Frederic Remington: The Masterworks,* exh. cat. (St. Louis: The Saint Louis Art Museum, 1988), pp. 20, 82, 127; John Russell "Remington's War and Old West," *The New York Times,* February 10, 1989, p. C1; James K. Ballinger, *Frederic Remington* (New York: Harry N. Abrams, 1989), pp. 55, 112; Sophia Craze, *Frederic Remington* (New York: Crescent Books, 1989), pp. 78–79.

Little is known about Raisa Robbins. She was born in the Ukraine and immigrated to the United States in 1922. During her first decade in America, she turned from teaching piano to studying art and design in Philadelphia. Around 1933 she began painting scenes of the peasant life of her native country.

Between 1940 and 1950, Robbins's work was presented in several group and solo shows in Philadelphia and New York. She was also included in annual exhibitions of the Carnegie Institute from 1946 to 1948. Robbins spent time in Woodstock, New York, and was a member of the Woodstock Artists Association in the late 1940s. Her life after 1951 remains undocumented.

Bibliography: Exhibition of Paintings by Raisa Robbins, exh. cat. (New York: Durand-Ruel Galleries, 1945); "Reviews and Previews," *Art News,* 46 (May 1947), p. 44.

Raisa Robbins
Dates unknown

Although Raisa Robbins occasionally painted landscapes or contemporary urban scenes, the majority of her work was based on memories of her Russian childhood.[1] Trained as a pianist in her youth, she may have frequented musical events of all types. *Oriental Dance* perhaps recalls performances of Eastern dance and song that the artist attended in her native Ukraine.

Robbins's painting technique was characterized in 1945 as "consciously naive."[2] Turning away from her art-school instruction, she drew on the heritage of Russian folk painting for her personal style. This tradition, which often used simple drawing, non-naturalistic spatial conceptions, and bright coloration, is easily identified in *Oriental Dance.* The dancing figures, flatly painted with generalized forms and features, appear pasted onto the stage set. Rather than present the rows of chorus members as moving back into space, Robbins stacks them vertically. The green accents on the dancers' costumes and the variety of high-keyed colors dotting the women's dresses add a cheeriness, typical of Russian folk art, to this otherwise stilted scene.

Mr. Clark purchased *Oriental Dance* from Durand-Ruel's New York gallery. Although his diaries give no clues as to why he bought this work, which has little in common with the rest of his collection, it may have been to

Oriental Dance, 1944
(Oriental Dancer)
Oil on canvas
$24^{5}/_{16} \times 30^{1}/_{8}$ *(61.8 × 76.5)*
Signed and dated lower left: RAiSA/1944
No. 835

support one of his favorite galleries and a relatively unknown artist at the end of World War II.[3]

1 "Reviews and Previews," *Art News*, 46 (May 1947), p. 44.

2 "The Passing Shows," *Art News*, 44 (December 15, 1945), p. 23.

3 Clark bought his Clarence Johnson painting (p. 110) simply to encourage the young artist. Perhaps, finding Robbins's work charming, he did the same.

Provenance: To (Durand-Ruel Galleries, New York, 1945); to Robert Sterling Clark, January 2, 1946.

Exhibition: Durand-Ruel Galleries, New York, "Exhibition of Paintings by Raisa Robbins," December 3–28, 1945, no. 13.

References: Margaret Breuning, "Nostalgic Primitive," *The Art Digest*, 20 (December 15, 1945), p. 17; CAI 1972, pp. 136, 137 (as *Oriental Dancer*); CAI 1984, pp. 32, 111.

Russian Country Fair, 1944

Oil on canvas
$22^{1}/_{16} \times 28^{1}/_{4}$ (56 × 71.8)
Signed and dated lower left: RAiSA/1944
No. 836

Having seen Robbins's works, including *Russian Country Fair*, at a Durand-Ruel exhibition in 1945, a writer for *Art News* commented: "Raisa Robbins has a Russian accent and knows it."[1] That Robbins relied heavily on her Russian heritage both for her subject matter and style is apparent in this painting and *Oriental Dance* (pp. 151–52). *Russian Country Fair*, too, probably is derived from a scene the artist would have been familiar with as a child in Russia in the early twentieth century.

Like her fellow countrymen Marc Chagall (1889–1985) and Nikolay Rimsky-Korsakov (1844–1908), Robbins was inspired by the Russian folk tradition. Her use of a wide variety of bright colors was compared more than once with Russian peasant embroidery.[2] Robbins's unsophisticated definition of space, simplified forms, and patterned arrangements of figures created a decorative effect that has its roots in *lubok*, Russian folk prints.[3]

With this kind of approach, Robbins could recreate in 1944 the ambiance of her native land and life in the early years of the century.

1 "The Passing Shows," *Art News*, 44 (December 15, 1945), p. 23.

2 Howard Devree, "A Reviewer's Notebook," *The New York Times*, December 15, 1940, sect. 10, p. 12, and "Artists One By One," *The New York Times*, April 28, 1947, sect. 2, p. 10.

3 See *The Lubok: Russian Folk Pictures* (Leningrad: Aurora Art Publishers, 1984).

Provenance: To (Durand-Ruel Galleries, New York, 1945); to Robert Sterling Clark, January 2, 1946.

Exhibition: Durand-Ruel Galleries, New York, "Exhibition of Paintings by Raisa Robbins," December 3–28, 1945, no. 10.

References: Margaret Breuning, "Nostalgic Primitive," *The Art Digest*, 20 (December 15 1945), p. 17; CAI 1972, pp. 136, 137; CAI 1984, pp. 32, 112.

John Singer Sargent
1856–1925

John Singer Sargent, son of Mary and Fitzwilliam Sargent of Philadelphia, was born in Florence on January 12, 1856. His interest in drawing began in boyhood, and he received his earliest formal training in Rome in 1869 and in Florence at the Accademia di Belle Arti in 1873–74. In May 1874 the Sargent family moved to Paris so that the young artist could receive better art instruction. He was quickly accepted into the studio of Carolus-Duran (1838–1917). Sargent supplemented his four years of study with Carolus by attending the Ecole des Beaux-Arts and traveling abroad to Spain and Holland. In 1876 he made the first of many trips to the United States.

By the end of the 1870s, Sargent had developed the facile style, based on direct observation and economical paint handling, that would serve him throughout his career. Between 1877, when he first exhibited at the Paris Salon, and 1884, when the exhibition of *Madame X* created controversy, he had notable success in Paris. By 1886 friends and commissions in London and the problematic reception of *Madame X* led him to settle in England. For the remainder of his long career, Sargent was the preeminent portrait painter of both the English and American upper classes. He also exhibited widely and was elected an academician of the National Academy and Royal Academy as well as a chevalier of the French Legion of Honor.

In 1890 Sargent began work on murals for the Boston Public Library. This and other decorative commissions at the Museum of Fine Arts and Harvard University kept him closely tied to Boston for the next twenty-five years. Around 1909, however, he tired of the demands of commissions; his paintings became increasingly private and were executed mainly in watercolor.

Bibliography: William Howe Downes, *John S. Sargent: His Life and Work* (London: Thornton & Butterworth, 1926); Evan Charteris, *John Sargent* (London: William Heineman, 1927); Richard Ormond, *John Singer Sargent: Paintings, Drawings, Watercolors* (London: Phaidon Press, 1970); Carter Ratcliff, *John Singer Sargent* (New York: Abbeville Press, 1982); Robert Getscher and Paul Marks, *James McNeill Whistler and John Singer Sargent: Two Annotated Bibliographies* (New York: Garland Publishing, 1986); Stanley Olson, *John Singer Sargent: His Portrait* (London: Macmillan London, 1986).

Resting, c. 1875
Oil on canvas
8½ × 10⁹/₁₆ (21.6 × 26.8)
Signed upper right: John S. Sargent
No. 579

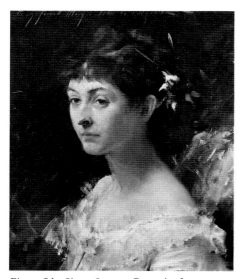

Fig. 71: John Singer Sargent, **Portrait of Mary Austin**, 1878. Oil on canvas, 18 × 15 in. (45.7 × 38.1 cm). The Christopher Whittle Collection.

In *Resting*, Sargent blended the two subjects that held his attention throughout his career: portraiture and landscape. This small oil study shows a young woman napping in the shade of a haystack. Using a high viewpoint and oblique angle, the artist quickly recorded an intimate, unceremonious moment. Sargent, who would become the master of the formal portrait, generally reserved this kind of informal approach for the depiction of family and friends, often painting such pictures as tokens of affection. His sister Violet (1870–1955), the writer Violet Paget (Vernon Lee, 1856–1935), and artist-friends Paul Helleu (1859–1927) and Ralph Curtis (1854–1922) were among those pictured in these private works.

Although the identity of the woman in *Resting* is not definitively known, Mary Austin, the artist's cousin, has been suggested as the most likely sitter.[1] In the summer of 1875 Sargent joined his family on the Brittany coast near Dinard. Mary Austin was a guest at the Sargent home that summer and *Resting* may be a record of that visit. However, Sargent's and Mary Austin's paths crossed many times during their young adult years; the artist also painted a more formal portrait of his cousin in 1878 (fig. 71), which shows a similar physiognomy. The chronology of the meetings between Sargent and Mary Austin suggests that *Resting* is likely a product of the mid- to late 1870s.[2] That the painting is signed with the more rounded style that characterized Sargent's handwriting before 1880 also supports this dating.[3] The high and angled point of view is also a feature of other works of this period, including two ascribed to 1875: *Violet Sargent* (Ormond Family Collection) and *Two Wine Glasses* (private collection).[4]

Resting displays, in part, what Sargent had quickly learned after entering the atelier of Carolus-Duran (1838–1917) in May 1874. Having adopted his teacher's preference for painting rather than drawing sketches, Sargent broadly defined his sitter's face and hands and modeled her features economically. He used half-circles of black for the eyes and a simple stroke of red for the lips. Broad strokes of blue and black with a few highlights of white are the only demarcations of the young woman's clothing. A golden hue dominates the picture, and within this scheme Sargent played brightness against shadow to define his subject. The brim of the hat is bathed in bright light and contrasted against the face it shades. The light also picks out the edges of the woman's costume, suggesting a three-dimensional form in even so slight a sketch and highlighting stray pieces of hay to give a contrapuntal effect in the background.

Resting previews Sargent's mature style. The use of an arrested pose to suggest the momentary, a loose, brushy paint application,

and light as a controlling factor for figural presentations appear repeatedly in his finest paintings (pp. 166–72). *Resting*, with its sense of outdoor light and the fleeting instant, also demonstrates how early in his career Sargent was attracted to certain aspects of the Impressionist aesthetic that he explored in depth in the late 1880s.[5]

1 Richard Ormond, *John Singer Sargent: Paintings, Drawings, Watercolors* (London: Phaidon Press, 1970), p. 235, and Stanley Olson, *John Singer Sargent: His Portrait* (London: Macmillan London, 1986), p. 69.

2 With the exception of Evan Charteris (*John Sargent* [London: William Heineman, 1927]), who dated it "1912?," the work has always been published as c. 1875.

3 Odile Duff, director of research, Coe Kerr Gallery, New York, who is currently working on the Sargent catalogue raisonné, made this observation to the author.

4 Olson, *John Singer Sargent*, p. 54; Ormond, *John Singer Sargent*, p. 235.

5 For an excellent study of Sargent's Impressionist works, see William H. Gerdts, "The Arch-Apostle of the Dab-and-Spot School: John Singer Sargent as an Impressionist," in *John Singer Sargent*, exh. cat. (New York: Whitney Museum of American Art, 1986), pp. 111–46.

Provenance: Miss Elizabeth E. Bourne, New York; to (M. Knoedler & Co., New York); to Stephen C. Clark, 1919; to (M. Knoedler & Co., New York, September 23, 1931); to Robert Sterling Clark, February 13, 1934.

Exhibitions: Sterling and Francine Clark Art Institute, Williamstown, Massachusetts, "Exhibit 7: The Regency and Louis XVI Rooms," May 18, 1957, no. 310; Huntsville Museum of Art, Alabama, "American Impressionist Painters," December 3, 1978–January 14, 1979, no. 1.

References: William Howe Downes, *John S. Sargent: His Life and Work* (London: Thornton & Butterworth, 1926), p. 261; Evan Charteris, *John Sargent* (London: William Heineman, 1927), p. 292; Charles Merrill Mount, *John Singer Sargent: A Biography* (New York: W.W. Norton & Co., 1955), p. 442, no. K753; CAI 1957, pl. XI; CAI 1958a, n.p., pl. LXIII; Dorothy Adlow, "Resting," *The Christian Science Monitor*, January 21, 1964, p. 8; Richard Ormond, *John Singer Sargent: Paintings, Drawings, Watercolors* (London: Phaidon Press, 1970), p. 235; CAI 1972, pp. 98, 99; Carter Ratcliff, *John Singer Sargent* (New York: Abbeville Press, 1982), p. 10; CAI 1984, pp. 34, 103; *Sargent at Broadway: The Impressionist Years*, exh. cat. (New York: Coe Kerr Gallery, 1986), p. 28; Stanley Olson, *John Singer Sargent: His Portrait* (London: Macmillan London, 1986), p. 69.

Blonde Model, c. 1877
(Head of a Woman [Bare Shoulders]; Head of a Female Model)
Oil on canvas
17¹⁵/₁₆ × 14¹⁵/₁₆ (45.6 × 37.9)
Signed and inscribed upper left: à mon ami Lacombe/John S. Sargent
No. 574

Fig. 72: Carolus-Duran, **Gloria Mariae Medicis**, 1878. Oil on canvas, dimensions unknown. Musée du Louvre, Paris.

John Singer Sargent was Carolus-Duran's (1838–1917) star pupil during the 1870s. The young artist quickly appropriated his teacher's method and closely adhered to it during the early years of his career. At the heart of Carolus's approach to painting was his belief that nature was composed of masses made up of planes and that light systematized their arrangement.[1] Thus Carolus-Duran defined his subjects as pared-down planar surfaces of reflected lights.

Blonde Model displays Sargent's mastery of his teacher's technique, and the construction of the painting closely parallels a description of how Carolus-Duran instructed his students to paint figure studies in planar arrangements. John Collier (dates unknown), another Carolus-Duran pupil, wrote: "The figure was drawn in charcoal, then we were allowed to . . . strengthen the outline with some dark color. . . . We . . . put in the figure or face in big touches like a coarse wooden head hewn with a hatchet; in fact, in a big mosaic . . . to get the right amount of light and the proper color. . . . The hair, etc. . . . just pasted on in the right tone like a coarse wig; then other touches were placed on the junctions of the big mosaic touches, to model them and make the flesh more supple."[2] Although Sargent simply left the hair in *Blonde Model* "pasted on in the right tone like

a coarse wig," he took the woman's features to a greater degree of completion. This was not achieved, however, by the tight delineation of eyes, nose, or mouth, but rather by the depiction of light playing over the surfaces of the face.[3] The alternation of light and dark—for instance, across the cheekbones or down the length of the nose and around the nostrils—shapes the facial characteristics without losing the texture of the broad brushstrokes.

Although undated, *Blonde Model* was probably painted in 1877 during the months that Sargent assisted Carolus-Duran with *Gloria Mariae Medicis* (fig. 72).[4] It is difficult to determine exactly what role Sargent and J. Carroll Beckwith (1852–1917), his Paris studio-mate and fellow Carolus student, played in the execution of this ceiling decoration for the Palais du Luxembourg, but their portraits appear in the painting along with their master's. As David McKibbin has pointed out, the low point of view and down-turned posture of *Blonde Model* conform to those found in ceiling painting and specifically in the Carolus-Duran decoration.[5] Even though *Gloria Mariae Medicis* has no figure that precisely matches *Blonde Model*, Sargent's painting, the pose of which is uncommon in his oeuvre, may have been a preliminary study for Carolus's scheme.

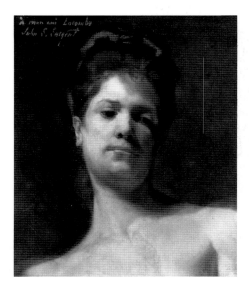

Fig. 73: John Singer Sargent, **Blonde Model**. Infrared photograph. Sterling and Francine Clark Art Institute.

Today *Blonde Model* shows significant alterations by a restorer. Originally, and still clearly visible under infrared light, the model's left hand reached across the center of her chest toward her throat (fig. 73). At some point the hand was scraped and painted over with an opaque pigment and false age cracks were incised in the new paint to match those already there.[6] Knowing that the hand was originally there clarifies the reasoning behind the foreshortened and turned-in left shoulder, which appears somewhat awkward in the picture's present state. Despite the overpainted hand, the work exhibits Sargent's clear understanding of his teacher's painting method and his ability to emulate it.

Blonde Model, inscribed "à mon ami Lacombe," was a gift from Sargent to Georges Lacombe (1869–1916), a painter and sculptor associated with the Nabis at Pont Aven. The particulars of Sargent's friendship with Lacombe are not known, but Alfred P. Roll (1846–1919), Lacombe's teacher at the Académie Julian and the probable owner of Sargent's *Gitana* (c. 1876; The Metropolitan Museum of Art, New York) in the 1890s, may have provided the link between the two men.[7]

1 Stanley Olson, *John Singer Sargent: His Portrait* (London: Macmillan London, 1986), p. 38.

2 John Collier, "Carolus Duran's Mode of Teaching," *The Art Amateur,* 16 (April 1887), p. 108.

3 Patricia Hills, "The Formation of a Style and Sensibility," in *John Singer Sargent,* exh. cat. (New York: Whitney Museum of American Art, 1986), p. 28.

4 With the exception of Evan Charteris, who left the picture undated, Charles Mount, David McKibbin, Richard Ormond, Stanley Olson, and the Coe Kerr Gallery all associate *Blonde*

Model with this point in Sargent's career. David McKibbin and Charles Mount expressed their opinions in letters to the Clark Art Institute on April 17, 1967, and January 28, 1973, respectively. Odile Duff, director of research, Coe Kerr Gallery, New York, shared the gallery opinion that will appear in the upcoming catalogue raisonné. For Ormond and Olson, see the bibliographic references to this entry.

5 David McKibbin to George Heard Hamilton, April 17, 1967, CAI curatorial files.

6 Michael Heslip, Williamstown Regional Art Conservation Laboratory, first recognized that the "cracks" in the center of the chest were lines etched into the paint. This suggests that the painting was of some age before the restoration occurred. Although Robert Sterling Clark was known to authorize significant changes to his pictures (see p. 22), no reference to such a request for *Blonde Model* has been found in his existing papers. Clark usually noted such requests in his diary.

7 David McKibbin discovered a photograph published in 1896 where the *Gitana* was hanging in Roll's studio; see Doreen Bolger Burke, *American Paintings in The Metropolitan Museum of Art* (New York: The Metropolitan Museum of Art, 1984), vol. 3, p. 221.

Provenance: To Georges Lacombe; (Scott and Fowles, New York); to Robert Sterling Clark, January 6, 1927.

Exhibition: Sterling and Francine Clark Art Institute, Williamstown, Massachusetts, "Exhibit 7: The Regency and Louis XVI Rooms," May 18, 1957, no. 312.

References: Hamilton Minchin, "Some Early Recollections of Sargent," *The Contemporary Review,* 127 (June 1925), p. 736 (possibly the same work); CAI 1957, n.p., pl. XIII; Evan Charteris, *John Sargent* (London: William Heineman, 1927), p. 295 (as *Head of a Woman [Bare Shoulders]*); CAI 1958a, n.p., pl. LVI; Richard Ormond, *John Singer Sargent: Paintings, Drawings, Watercolors* (London: Phaidon Press, 1970), pp. 16, 236 (as *Head of a Female Model*); CAI 1972, pp. 96, 97; Carter Ratcliff, *John Singer Sargent* (New York: Abbeville Press, 1982), p. 39, no. 50 (as *Head of a Female Model*); CAI 1984, pp. 34, 103; *John Singer Sargent,* exh. cat. (New York: Whitney Museum of American Art, 1986), pp. 28–29.

Staircase, c. 1878

Oil on canvas
21⅞ × 16⅛ (55.6 × 41)
Unsigned
No. 582

Each summer usually brought a change of scenery for John Singer Sargent. When he was a child, his family sought out the mountains or seashore for their health and comfort. As a young artist in the 1870s, Sargent joined the growing numbers of Paris-based artists who chose to work outside the city after the closing in May of the Ecole des Beaux-Arts, the various ateliers, and the Salon. Thus Sargent was not alone in his travels to Brittany, Capri, Spain, and North Africa between 1877 and 1880. Many painters,

American and European, visited sun-drenched locations where they could study natural light and a variety of subjects not accessible in their studios. On these seasonal excursions, Sargent's lifelong interest in light was carried from the studio to other environments, and for a brief period he became particularly interested in the play of light over architectural forms.

At the end of July 1878, Sargent arrived in Capri after a week's stay in Naples. Shortly thereafter, he met the English artist Frank

*Fig. 74: John Singer Sargent, **Staircase** (before folding), original dimensions 21¾ × 18⅛ in. (55.3 × 46.1 cm).*

Hyde (fl. 1872–85), with whom he soon shared studio space in the abandoned monastery of Santa Teresa.[1] *Staircase* depicts an interior stairwell of an Italian monastery,[2] and the rich, bright green landscape seen from the window indicates the full bloom of summer. The stairway image appears in Sargent's oeuvre only one other time, in the 1878 *Staircase at Capri* (private collection), which focuses on a narrow exterior set of stairs. The Clark painting, although undated, can be associated with this late summer spent on Capri, and the building featured may well be the one in which Sargent and Hyde worked. In the winter of 1879–80, on a trip to Spain and Morocco, Sargent painted a group of small oil-on-panel studies of building exteriors in bright light that further developed the thoughts begun in Capri, and which culminated in *Fumée d'Ambre Gris* (pp. 172–77).

In *Staircase,* Sargent worked out how exterior light acts on a variety of interior surfaces. By positioning himself on a landing in a narrow stairwell, he could focus on how the indirect light from the hidden upper window filtered down the wall to the next level and how that light should be handled in relation to the bright, direct light that flowed in from the window at lower right. For the graduated light across the flat surface of the wall, Sargent used Carolus-Duran's method for the painting of faces (pp. 156–58). He began with a middle tone and worked toward the darkest darks and highest lights.[3] Thus in the areas of the brightest light, at the top and bottom of the stairs, the architectural details are thrown into high relief. Together, the play of darks and lights shapes the space.

In *Staircase*'s original state, both the left and right sides of the painting remained at the blocking-in stage (fig. 74). Clearly a study, *Staircase* stayed with the artist until his death. Sometime after the Sargent estate sale in July 1925 and before Robert Sterling Clark purchased the painting from M. Knoedler & Co. in February 1939, two inches of the canvas on the left edge were folded around the stretcher to give the painting a more "completed" appearance.

1 Not much is known about Frank Hyde, who was active as a portrait and genre painter between about 1872 and 1885; see Christopher Wood, *Dictionary of Victorian Painters* (Woodbridge, England: Antique Collectors' Club, 1978), p. 246. Sargent seems to have remained in Capri until November or early December 1878; see Richard Ormond, *John Singer Sargent: Paintings, Drawings, Watercolors* (London: Phaidon Press, 1970), p. 237.

2 Professor Samuel Y. Edgerton, Williams College, kindly confirmed that the architecture in *Staircase* is typical of an Italian monastery. The monastery at Santa Teresa no longer exists, but the interiors of both Santa Maria di Constantinopoli and La Croce on Capri are similar to that in the Clark painting; see Gaetana Cantone et al., *Capri: la città e la terra* (Naples: Edizione Scientifiche Italiane, 1982), pls. 119 and 245.

3 Late in life, Sargent commented that class fixing the values in this way was the main thing Carolus-Duran taught him; see Evan Charteris, *John Sargent* (London: William Heineman, 1927), p. 29.

Provenance: To estate of the artist; to (Christie's, London, sale of the Sargent property, July 27, 1925, no. 188); to (M. Knoedler & Co., London); to (M. Knoedler & Co., New York); to (James Carstairs, Philadelphia, May 1926); to (M. Knoedler & Co., New York, December 1928); to Robert Sterling Clark, February 24, 1939.

Exhibitions: M. Knoedler & Co., New York, "An Exhibition of Paintings by the Late John Singer Sargent, R.A.," November 2–14, 1925, no. 13; Gallery of Modern Art, Washington, D.C. "A Century of American Painting," March 1939 (no catalogue); Sterling and Francine Clark Art Institute, Williamstown, Massachusetts, "Exhibit 7: The Regency and Louis XVI Rooms," May 18, 1957, no. 309.

References: "Almost a Million at Sargent Sale," *Art News,* 23 (August 15, 1925), p. 4; William Howe Downes, *John S. Sargent: His Life and Work* (London: Thornton & Butterworth, 1926), p. 332; Evan Charteris, *John Sargent* (London: William Heineman, 1927), p. 280; "American Painting Attribution Contest," *Art News,* 37 (April 1, 1939), p. 11; Charles Merrill Mount, *John Singer Sargent: A Biography* (New York: W.W. Norton & Co., 1955), p. 442, no. K741; CAI 1957, n.p., pl. x; CAI 1958a, n p., pl. LXV; CAI 1972, pp. 100, 101; CAI 1984, pp. 34, 102.

A Road in the South, c. 1878–84
(Road with Wall on Right; A Road in the Midi)
Oil on canvas
12¹³⁄₁₆ × 18⅛ (32.5 × 46)
Unsigned
No. 577

Although John Sargent's name is most commonly associated with portraiture, only one-quarter of his vast life's work was devoted to the genre. Most of the remaining 2,500 works were subject pictures done for the artist's study or pleasure.[1] Landscapes account for a significant number of works in this group, many of which were executed in watercolor, a medium he did not use for portraiture.

It is not known exactly where or when Sargent painted *A Road in the South,* but it is generally accepted as a Mediterranean location. Both the area around Nice and the island of Capri have been suggested as possible sites.[2] Traditionally the painting has been dated between 1878 and 1884 on stylistic grounds and on the grounds that the artist frequented the Mediterranean coast during these years. The similarities among the south-

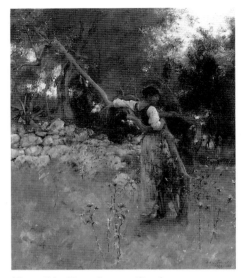

Fig. 75: John Singer Sargent, **Capri**, 1878. Oil on canvas, 30¼ × 25 in. (76.8 × 63.5 cm). Museum of Fine Arts, Boston; Bequest of Helen Swift Neilson.

Fig. 76: John Singer Sargent, **Landscape Sketch**, ? Nice, c. 1883. Oil on canvas mounted on board, 9¾ × 15 in. (24.8 × 38.1 cm). Collection of the Ormond Family.

ern landscapes executed in this six-year period are apparent when *A Road in the South* is compared with the 1878 *Capri* (fig. 75) and a Nice landscape of around 1884 (fig. 76). *A Road in the South* shows the painting technique of *Capri* and the composition of the Nice landscape. That Sargent spent August 1878 on Capri and part of each of the years 1878–84 (except 1883) around Nice exacerbates the problem of untangling the dates and locations of related but uninscribed images such as *A Road in the South*.[3]

Sargent's landscape pictures rarely depicted wide vistas. As he told his friend Henry Tonks late in life, "enormous views and huge skies do not tempt me."[4] Rather, he concentrated on contained areas of scenery, often cityscapes that featured an empty road flanked by walls on both sides like that seen in *A Road in the South*. Sargent's lack of interest in painting panoramic views and identifiable locations corresponded to major shifts in landscape painting that began with the French Barbizon artists of the 1830s.[5] In brief, landscape artists turned from the depiction of grand prospects to more intimate scenes and from the specific site to the general.

These unassuming settings allowed Sargent to work outdoors but within boundaries as he studied the modulation of tones under certain lighting conditions. *A Road in the South* is constructed around a deep, tunnel-like view of a narrow way very similar to that in the Nice landscape of c. 1884. This kind of long viewpoint was also masterfully used in some of his Venetian street scenes of the early 1880s (pp. 182–84). Within the confines of the setting of *A Road in the South*, Sargent worked as he had in the 1878 *Capri*, with a soft, brownish gray palette complemented by the olive-green tree leaves. With broad, brushy but controlled strokes, he was able to modulate the varied hues to indicate the different textures of the unpaved road and mottled walls. Only a patch of light blue-green two-thirds of the way along the wall breaks the earthy color scheme. The soft coloration and yellow tint peeking through the trees and over the treetops in the distance suggest that in *A Road in the South* Sargent chose to study the light at the beginning or end of a Mediterranean day.

1 Stanley Olson, *John Singer Sargent: His Portrait* (London: Macmillan London, 1986), p. 146.

2 I am grateful to Odile Duff of the Coe Kerr Gallery and Richard Ormond, both currently working on the John Singer Sargent catalogue raisonné, for their help with the site problem. They agree that the determination of the exact place is impossible at this time; conversations with Odile Duff in New York, July 10–11, 1988, and letter from Richard Ormond to the author, July 26, 1988, CIA curatorial files.

3 Recently Odile Duff has argued for a definite 1878 dating of the painting on the basis of Auguste Hirsch's early ownership of it. Until September 1878, Sargent shared a studio with Hirsch in Paris. He left behind, for unknown reasons, a group of about twelve works which became Hirsch's. However, Hirsch may have also acquired Sargent paintings at a later date, and in a c. 1883–84 photograph of Sargent in his studio at 41 boulevard Berthier (Ormond Family Collection), a painting that may be *A Road in the South* hangs partially obscured by a curtain; the photograph is published in John Milner, *The Studios of Paris* (New Haven: Yale University Press, 1988), p. 183.

4 Quoted in Richard Ormond, *John Singer Sargent: Paintings, Drawings, Watercolors* (London: Phaidon Press, 1970), p. 6.

5 For a cogent study of how this shift was manifested in American art, see *American Art in a Barbizon Mood*, exh. cat. (Washington, D.C.: National Collection of Fine Arts, Smithsonian Institution, 1975).

Provenance: To Auguste Hirsch, Paris; to Mme Auguste Hirsch (his widow), Paris; to (M. Knoedler & Co., Paris, 1914); to Sir Joseph F. Laycock, London, 1919; to (M. Knoedler & Co., New York, February 2, 1927); to Robert Sterling Clark, April 13, 1927.

Exhibition: Sterling and Francine Clark Art Institute, Williamstown, Massachusetts, "Exhibit 7: The Regency and Louis XVI Rooms," May 18, 1957, no. 308 (as *A Road in the Midi*).

References: William Howe Downes, *John S. Sargent: His Life and Work* (London: Thornton & Butterworth, 1926), p. 288; Evan Charteris, *John Sargent* (London: William Heineman, 1927), p. 296 (as *Road with Wall on Right*); Charles Merrill Mount, *John Singer Sargent: A Biography* (New York: W.W. Norton & Co., 1955), p. 445, no. K855; CAI 1957, n.p., pl. IX; CAI 1958a, n.p., pl. LXIV (as *A Road in the Midi*); Richard Ormond, *John Singer Sargent: Paintings, Drawings, Watercolors* (London: Phaidon Press, 1970), p. 34; CAI 1972, p. 98 (as *A Road in the Midi*); CAI 1984, pp. 34, 104 (as *A Road in the Midi*).

Neapolitan Children Bathing was the first painting by John Singer Sargent to be exhibited at the National Academy of Design. Only the artist's third work to appear in America publicly,[1] it was lent to the Academy's 1879 exhibition by George M. Williamson and played a significant role in introducing Sargent's art to America.

The small canvas depicts children enjoying a beautiful sunny day at the beach. Two boys —one on his back with a towel over his face, the other on his stomach with his head propped on his hand—lie near two much younger, standing boys. The smallest child, still in the chubbiness of babyhood, looks outward, while the boy at center wears water wings (most likely animal bladders filled with air). He stands with his back to us as he contemplates approaching the water's edge. Out in the water, a head bobbing above the rolling waves indicates a swimmer. The only interruption in the blue sky is the silhouette of a sailboat at the horizon.

Images of children occasionally appear in Sargent's portraits and subject pictures. Neapolitan Children Bathing, however, like another Sargent in the Clark collection, Mademoiselle Jourdain (pp. 187–88), is one of the more intimate depictions of children in Sargent's oeuvre. As Martha Kingsbury has pointed out, Sargent presented children as inhabitants of their own special realm, even though it is one in which they acknowledge the adult world.[2] The littlest boy, standing slightly apart from the others, stares out at the viewer to make a direct connection to the adult realm. Yet each of the other boys, naked and relaxed, is absorbed in play or rest and seems oblivious to all else. Devoid of anecdote or moral, neither nostalgic nor sentimental, Neapolitan Children Bathing has an aura of simplicity and innocence.

Sargent executed most of his subject pictures while traveling, and Neapolitan Children Bathing probably had its genesis during a week he spent in Naples at the end of July 1878 and a subsequent visit to Capri for several months (pp. 158–60). Dated 1879, the painting was most likely finished early in the new year in Paris in time to be shipped to America for the March 31 opening at the National Academy of Design.[3]

Sargent seems to have been the casual recorder in Neapolitan Children Bathing, but the effect belies the careful planning that went into the picture. The painting was developed from several pencil sketches and at least four preliminary oil studies on panel, all of which seem to have been painted en plein air.[4] Sargent's first ideas for the painting probably grew out of watching children wading and bathing; he hastily recorded them on small sketchbook-sized sheets (figs. 77, 78). In figure studies of boys lying down (figs. 79, 80), he worked out the shapes of their bodies in a method similar to the academic figure studies he had practiced in Carolus-Duran's atelier (pp. 156–58, 166–72). The composition for the painting relates generally to Beach at Capri (fig. 81) and specifically to Two Boys on a Beach, Naples (fig. 82). The final picture employs different aspects of all the studies, although Sargent shifted the position of the three right-hand boys to more oblique angles, cropped the right edge of the image across the legs of one figure, and included the swimmer to reinforce the sense of informality and freshness.

Like many academic artists who began to work outdoors in the second half of the nineteenth century, Sargent was concerned with the use of light to model form. Unlike the Impressionists, who dissolved form with light, Sargent and his academically oriented peers explored how outdoor light reflecting off surfaces could shape their subjects.[5] Sargent, however, did not respond to the harshness and brightness of outdoor summer light as did his expatriate colleagues William Lamb Picknell (1853–1897) and Frederic A. Bridgman (1847–1928). Rather, he was drawn to cooler, softer light and used it to modulate his forms according to local color.[6] In Neapolitan Children Bathing, for example, the gray-white sand, surf, and translucent water wings contribute reflective surfaces so that soft, golden-gray hues define the little bodies, and puddles of grayish purple form their shadows. The overall effect is one of warm sunshine. As the writer for The Art Interchange noted: "John Sargent's 'Neapolitan Children Bathing' . . . shows much care. The flesh tints are admirable, and the golden light which envelops the whole scene, the shining sands, the naked children, and the blue water, gives a charm that attracts and entrances."[7]

Neapolitan Children Bathing directly followed Sargent's Oyster Gatherers of Cancale (fig. 83), and the two pictures have much in common.[8] Both works reflect cosmopolitan artistic concerns found in avant-garde Impressionist circles and among academic painters: the subject is presented as an informal view of life associated specifically with its location; the formal emphasis is on portraying light and its use as a vehicle for creating form; and the working method entailed figural and compositional studies.[9] And if one is to believe the legend, the first owner of

Neapolitan Children Bathing, 1879

(Innocence Abroad; Innocents Abroad; Boys on the Beach; Boys on a Beach, Naples)
Oil on canvas
10⁹/₁₆ × 16³/₁₆ (26.8 × 41.1)
Signed and dated lower left: John S. Sargent 1879
No. 852

Fig. 77: John Singer Sargent, **Wading Children**, n.d. Pencil on paper, 2 × 4 in. (5.1 × 10.2 cm). The Metropolitan Museum of Art, New York; Gift of Mrs. Francis Ormond, 50.130.140B.

Fig. 78: John Singer Sargent, **Bathing Children**, n.d. Pencil on paper, 3⁹/₁₆ × 5⁷/₈ in. (9.1 × 14.9 cm). The Metropolitan Museum of Art, New York; Gift of Mrs. Francis Ormond, 50.130.140D.

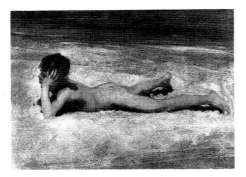

Fig. 79: John Singer Sargent, **Nude Boy on a Beach**, n.d. Oil on wood, 10½ × 13¾ in. (26.7 × 34.9 cm). The Tate Gallery, London.

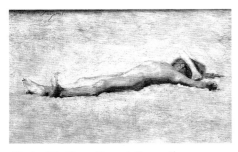

Fig. 80: John Singer Sargent, **Boy on the Beach**, n.d. Oil on panel, 7½ × 12 in. (19.1 × 30.5 cm). Collection of Isabel Fonseca.

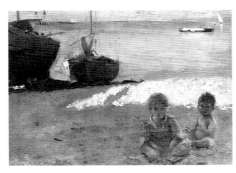

Fig. 81: John Singer Sargent, **Beach at Capri**, 1878. Oil on panel, 10¼ × 13¾ in. (26 × 34.9 cm). The Fine Arts Museums of San Francisco; Bequest of Frederick J. Hellman.

Neapolitan Children Bathing bought the picture because he loved the *Oyster Gatherers* and it was not available.[10]

Neapolitan Children Bathing received even more glowing praise than the *Oyster Gatherers of Cancale* had the previous year.[11] Its subject was applauded as "delightful," "happy," and "sparkling," and Sargent's paint application was commended for its vigor and subtlety of color.[12] The tremendously positive reaction this little painting elicited reflects not only the growing American appreciation of more cosmopolitan painting by 1879, but also the important status given to children in post–Civil War America. As signs of purity and innocence as well as hope for the future, children increasingly appear in genre painting from the 1870s on.[13] Although *Neapolitan Children Bathing* does not lend itself to the kind of nationalistic examination given to the works of Sargent's American-based peers Eastman Johnson (1824–1906) and Winslow Homer (pp. 63–100), it does celebrate childhood in an intimate and sun-filled setting that could be appreciated in the United States. At the same time the painting served as a vehicle for the artist's growing technical proficiency.

1 *Oyster Gatherers of Cancale* and *A Capriote* (both 1878; Museum of Fine Arts, Boston) had appeared, respectively, at the 1878 and 1879 Society of American Artists exhibitions.

2 Martha Kingsbury, "John Singer Sargent: Aspects of His Work," Ph.D. dissertation, Harvard University, Cambridge, Massachusetts, 1969, pp. 33–76.

3 The first report of the picture appears in "The Academy Exhibition," *The Evening Post* (New York), March 29, 1879, p. 4.

4 The title *Neapolitan Children Bathing* is Sargent's own. It is difficult, however, to ascertain whether the studies that relate to the painting were executed in Naples or Capri, since they are not ascribed to specific places. The one exception is *Beach at Capri* (fig. 81), which also seems to have at least one little "Neapolitan" boy. The confusion as to exact locale points out how unimportant site specificity was to Sargent, and the title simply reflects the fact that these are children on the beach in southern Italy.

5 For an excellent analysis of this phenomenon in American art, see William H. Gerdts, *American Impressionism* (New York: Abbeville Press, 1984), pp. 17–21.

6 Patricia Hills, "The Formation of a Style and Sensibility," in *John Singer Sargent*, exh. cat. (New York: Whitney Museum of American Art, 1986), p. 29.

7 "The Spring Exhibition—National Academy of Design, 2nd Notice," *The Art Interchange*, 2 (April 16, 1879), p. 58.

8 There exist two versions of *Oyster Gatherers of Cancale*. One version was shown at the 1878 Paris Salon (oil on canvas, 31 × 48 inches, The Corcoran Gallery of Art, Washington, D.C.) and the other (fig. 83) was used for Sargent's debut in America at the 1878 exhibition of the Society of American Artists.

9 *Oyster Gatherers of Cancale* has at least three related figure studies, now in the Terra Museum of American Art, Chicago.

10 Edward Strahan recounts this tale in "The Art Gallery: The National Academy of Design, 1st Notice," *The Art Amateur*, 1 (June 1879), pp. 4–5. However, since George M. Williamson seems to have been the first owner of the picture and he was only twenty-nine in 1879, he could not have been the elderly man of whom Strahan speaks, so that at least this part of the story seems to have been enhanced for the sake of quaintness.

11 Both Edward Strahan, ibid., and a writer for *The New York Times* ("The Academy Exhibition," May 2, 1879, p. 5) pointedly preferred the painting to *Oyster Gatherers*.

12 See, for example, the reviews in *The Art Amateur*, *The Art Journal*, and *The New York Herald* listed in the references.

13 For children as symbols in American nineteenth-century painting, see pp. 192–94; Lois Fink, "Children as Innocence from Cole to Cassatt," *Nineteenth Century*, 3 (Winter 1977), pp. 71–75; and Sarah Burns, "Barefoot Boys and Other Country Children: Sentiment and Ideology in Nineteenth-Century American Art," *American Art Journal*, 20, no. 1 (1988), pp. 24–50.

Provenance: To George M. Williamson, New York, by March 1879; to F.J. Williamson by descent after 1902; to (M. Knoedler & Co., New York); to Robert Sterling Clark, December 22, 1923.

Related Works: *Wading Children*, n.d., pencil on paper, 2 × 4 (5.1 × 10.2), The Metropolitan Museum of Art, New York; Gift of Mrs. Francis Ormond, 50.130.140B.

Bathing Children, n.d., pencil on paper, 3⁹⁄₁₆ × 5⅞ (9 × 14.9), The Metropolitan Museum of Art, New York; Gift of Mrs. Francis Ormond, 50.130.140D.

Boy on the Beach, n.d., oil on panel, 7½ × 12 (19.1 × 30.5), collection of Isabel Fonseca.

Nude Boy on a Beach, n.d., oil on wood, 10½ × 13¾ (26.7 × 34.9), The Tate Gallery, London.

Two Boys on a Beach, Naples, 1878, oil on panel, 10 × 13½ (25.4 × 34.3), Ormond Family Collection.

Beach at Capri, 1878, oil on panel, 10¼ × 13¾ (26 × 34.9), The Fine Arts Museums of San Francisco; Bequest of Frederick J. Hellman.

Exhibitions: National Academy of Design, New York, "54th Annual Exhibition," March 31–May 31, 1879, no. 431; Pennsylvania Academy of the Fine Arts, Philadelphia, "71st Annual Exhibition," January 20–March 1, 1902, no. 80 (as *Innocence Abroad*); Sterling and Francine Clark Art Institute, Williamstown, Massachusetts, "Exhibit 7: The Regency and Louis XVI Rooms," May 18, 1957, no. 317 (as *Boys on the Beach*); The Taft Museum, Cincinnati, "Small Paintings from Famous Collections," April 4–June 7, 1981 (as *Boys on the Beach*); Museum of Fine Arts, Springfield, Massachusetts, "Lasting Impressions: French and American Impressionism from New England Museums," September 25–November 27, 1988, no. 56 (as *Boys on the Beach*).

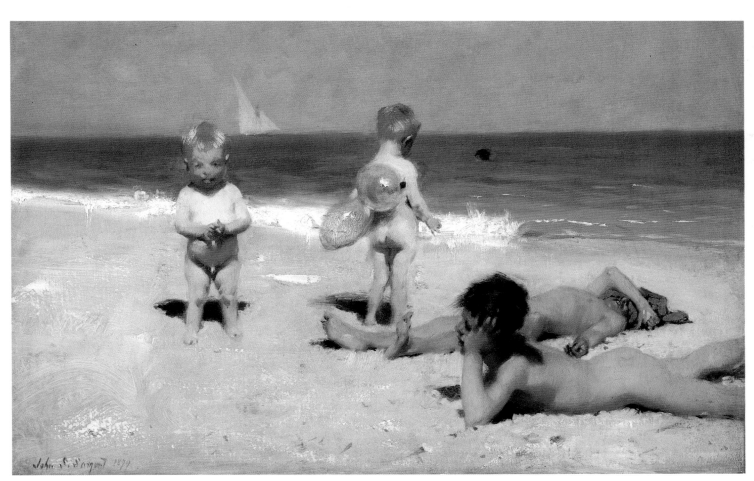

Neapolitan Children Bathing

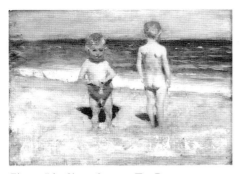

Fig. 82: John Singer Sargent, **Two Boys on a Beach, Naples,** 1878. Oil on panel, 10 ×13½ in. (25.4×34.3 cm). Collection of the Ormond Family.

Fig. 83: John Singer Sargent, **Oyster Gatherers of Cancale,** c. 1878. Oil on canvas, 16¼×23¾ in. (41.3×60.3 cm). Museum of Fine Arts, Boston; Gift of Mary Appleton.

References: "The Society of American Artists," *New York Tribune,* March 8, 1879, p. 5; "The Society of American Artists, I," *The World* (New York), March 8, 1879, p. 4; "The Academy Exhibition," *The Evening Post* (New York), March 29, 1879, p. 4; "The Academy Exhibition," *New York Daily Graphic,* March 29, 1879, p. 207; "The Academy Exhibition," *The World* (New York), March 30, 1879, p. 4; "Fine Arts: 54th Annual Exhibition of the National Academy of Design, 2nd Notice," *New York Herald,* March 31, 1879, p. 5; "Fine Arts: 54th Annual Exhibition of the National Academy of Design, 3rd Notice," *New York Herald,* April 1, 1879, p. 6; "National Academy of Design: 54th Annual Exhibition," *New York Daily Tribune,* April 1, 1879, p. 5; "The Spring Exhibition— National Academy of Design, 2nd Notice," *The Art Interchange,* 2 (April 16, 1879), p. 58; "The Academy Exhibition," *The New York Times,* May 2, 1879, p. 5; "Fine Arts: Exhibition of the Academy of Design, II," *The Nation,* 28 (May 22, 1879), p. 359; Edward Strahan, "The Art Gallery: The National Academy of Design, 1st Notice," *The Art Amateur,* 1 (June 1879), pp. 4–5; "Two New York Exhibitions," *Atlantic Monthly,* 43 (June 1879), p. 781; "The Academy Exhibition," *The Art Journal* (New York), 5 (1879), p. 159; "Fine Art: Society of American Artists, 3rd Annual Exhibition, 2nd Notice," *New York Daily Tribune,* March 25, 1880, p. 5; W.C. Brownell, "The Younger Painters of America," *Scribner's Monthly,* 20 (May 1880), p. 12; "John S. Sargent," *The Art Amateur,* 2 (May 1880), p. 118; John W. Van Oost, "My Notebooks," *The Art Amateur,* 46 (February 1902), p. 60 (as *Innocence Abroad*); "Studio Talk," *The Studio* (London), 26 (June 1902), pp. 52, 62 (as *Innocents Abroad*); Royal Cortissoz, "The Field of Art," *Scribner's Magazine,* 75 (March 1924), p. 347; William Howe Downes, *John S. Sargent: His Life and Work* (London: Thornton & Butterworth, 1926), pp. 9, 122 (as *Neapolitan Children Bathing*), 204 (as *Innocents Abroad*); Henrietta Gerwig, *Fifty Famous Painters* (New York: Thomas Y. Crowell Co., 1926), p. 389; Evan Charteris, *John Sargent* (London: William Heineman, 1927), p. 280; *Sargent's Boston,* exh. cat. (Boston: Museum of Fine Arts, 1956), p. 31 (as *Innocence Abroad*); CAI 1957, n.p., pl. XVIII; CAI 1958, n.p., pl. LVII (as *Boys on the Beach*); Richard Ormond, *John Singer Sargent: Paintings, Drawings, Watercolors* (London: Phaidon Press, 1970), pp. 22, 235 (as *Boys on a Beach, Naples*); CAI 1972, p. 98 (as *Boys on the Beach [Innocents Abroad]*); *John Singer Sargent and the Edwardian Age,* exh. cat. (Leeds, England: Leeds Art Galleries, 1979), p. 21 (as *Innocents Abroad*); Barbara Novak, *American Painting of the Nineteenth Century: Realism, Idealism, and the American Experience* (New York: Harper & Row, 1979), p. 227; Linda Bantel, *The Alice M. Kaplan Collection* (New York: Columbia University Press, 1980), p. 175; Leslie Shore, ed., *Small Paintings of the Masters* (New York: Woodbine Books, 1980), pl. 249; Trevor J. Fairbrother, "A Private Album: John Singer Sargent's Drawings of Nude Male Models," *Arts Magazine,* 56 (December 1981), p. 78 n. 5; Meg Robertson, "John Singer Sargent: His Early Success in America, 1878– 1879," *Archives of American Art Journal,* 22, no. 4 (1982), pp. 23, 24; Trevor J. Fairbrother, *John Singer Sargent and America* (New York: Garland Publishing, 1986), pp. 37–38, 122, 362 n. 95; CAI 1984, pp. 34, 103 (as *Boys on the Beach [Innocents Abroad]*); *John Singer Sargent,* exh. cat. (New York: Whitney Museum of American Art, 1986), p. 37; *Lasting Impressions: French and American Impressionism from New England Museums,* exh. cat. (Springfield, Massachusetts: Museum of Fine Arts, 1988), pp. 12, 58.

Portrait of Carolus-Duran, 1879

Oil on canvas

46×37¹³/₁₆ (116.8×96)

Signed, dated, and inscribed upper right: à mon cher maître M. Carolus-Duran, son élève affectionné/John S. Sargent. 1879

No. 14

Born Charles-Emile-Auguste Durand (1838–1917), Carolus-Duran, as he renamed himself early in his career, was probably the most important figure in Sargent's artistic life.[1] He taught Sargent the fundamentals of painting and also served as a role model for the life-style Sargent adopted. Carolus-Duran received his training at the Académie Suisse in Paris and did further study in Italy and Spain. The success of the portrait of his wife, *La Dame au Gant,* at the 1869 Paris Salon made him one of the most sought-after portraitists by the elite of the Third Republic for the next decade. In 1873 he opened an atelier for students. After 1880 his career slowly but steadily declined, but not before he had served in important posts and received a number of honors in the art world. He was one of the founding members of the Société Nationale des Beaux-Arts in 1889 and in 1898 served as its president. He became a chevalier of the Legion of Honor in 1872 and was made a grand officer in 1900. In 1905 he was named director of the French Academy in Rome.

John Sargent entered Carolus-Duran's studio soon after his arrival in Paris in May 1874; the eighteen-year-old quickly became the French master's star pupil. Sargent seems to have chosen Carolus-Duran for a number of reasons. The studio had a reputation for providing a pleasant atmosphere free of hazing (a real problem of the day), and Carolus-Duran had great popularity among art patrons.[2] The atelier's high percentage of foreign students, which included the American Walter Launt Palmer (1854–1932), whom Sargent had known in Italy, may have made it even more attractive. On the whole, entrance to Carolus-Duran's studio was less competitive than at the Ecole des Beaux-Arts because the master did not offer typical academic training. Rather than teach that drawing was the foundation of art, Carolus-Duran held

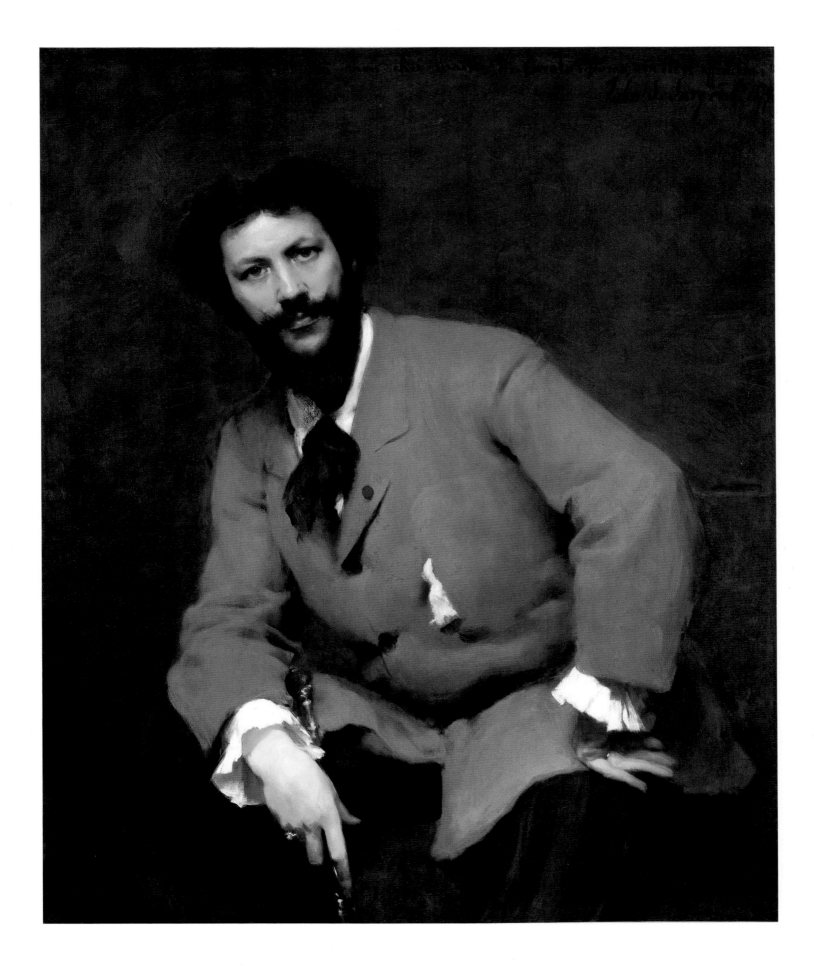

Fig. 84: John Singer Sargent, **Study for Carolus-Duran**, n.d. Oil on panel, 13½ × 10 in. (34.3 × 25.4 cm). Collection of Mrs. Norman B. Woolworth.

painting to be of paramount importance from the first stages of a work.[3]

In July 1878, after four years under Carolus-Duran's tutelage and shortly before leaving for Naples and Capri, Sargent began work on the portrait of his teacher.[4] The first sittings were done in the master's studio as he was painting his portrait of the actress Helena Modjeska.[5] Two oil sketches on panel may have been executed during these early sittings. In fig. 84 Sargent developed the painting's color scheme and the pose that would best capture Carolus-Duran's electric personality. He left for Italy with the portrait in this preliminary stage; he may have worked on it again when he was in Paris briefly in September 1878, but most of the work was probably done after his return to Paris in December. *Portrait of Carolus-Duran*, dated 1879, was completed sometime between January and the opening of the Salon on May 12.

A writer in *The Art Amateur* described Carolus-Duran: "Withal, there is a delightful egotism about Monsieur Duran. His personality is impressed upon all his surroundings, but not at all offensively. He is a remarkable man and he knows it."[6] A self-conscious artificiality emanated from Carolus-Duran—from his name to his costume—and Sargent captured this public image, portraying the French painter in his morning clothes, complete with the cravat, rings, and cane that were his trademarks. He is posed casually, yet in a self-aware position he often struck: head tilted, legs relaxed and open, leaning forward, one arm on a knee, the other with elbow crooked and hand on the thigh.[7] This posture gave Carolus-Duran an imposing physical presence and, with his direct and commanding gaze, he projected an air of authority. Patricia Hills has noted that Sargent had used a modified version of this pose for his 1877 Salon entry *Portrait of Frances Watts* (Philadelphia Museum of Art), but in 1879, assumed by Carolus-Duran, it acquired even greater force.[8]

As in his other early portraits, Sargent combined free brushwork and a solidly conceived form.[9] However, close inspection of the canvas reveals that a substantial portion of it is very broadly, flatly, and thinly worked without much modulation of tone. The sitter's face and hands are the only significantly modeled areas. They are taken to a fairly high degree of completion, without sacrificing the rich, tactile qualities of the paint. The modeling of the torso is developed with sparse but carefully placed accents of thinly painted black at the folds of the coat, accentuated by the outlining of the figure. The aggressively painted white shirt cuffs, collar,

and handkerchief, the red dot of Carolus-Duran's Legion of Honor pin, and the glints of light that reflect off his rings and cane add a flashiness to a work which, at its core, is simply laid out in contrasting masses of light and dark. The final result is a vital, fashionable, and powerful figure emerging out of a dark background.

Portrait of Carolus-Duran may be considered a summary of all Sargent learned from his teacher. The young artist's recognition of his debt to the Frenchman is noted in the inscription on the painting: "à mon cher maître M. Carolus-Duran, son élève affectionné." The twenty-three-year-old artist clearly drew not only from Carolus-Duran's own public posture, but also from his general approach to subject, which depended upon an intimate view of his sitter. For Carolus-Duran, such a private view was preferable because it allowed the sitter to be identified with rather than deified.[10] This approach gave "the intense expression of life," as James Carroll Beckwith called it, to Carolus-Duran's and Sargent's best pictures.[11]

Sargent's technique also depended heavily on Carolus-Duran. From him Sargent acquired the preference for direct painting instead of careful preliminary drawing on the canvas. In addition he learned, in the manner of Diego Velázquez (1599–1660), to blend realism with elegance.[12] Although Sargent would not travel to Spain until the autumn of 1879, Carolus introduced him to Velázquez's nonreligious figure subjects as well as to several technical and stylistic methods. From both masters, present and past, Sargent learned to use a neutral background to create a three-dimensional space from which his sitter emerged; to render faces naturalistically; and to highlight the face and hands, allowing the rest of the image to be painted more freely without forfeiting an effect of reality.[13] The result was a perfect balance between characterization and technique.[14] Deviating from the tight and lapidary technique of academic painting, Sargent, in *Portrait of Carolus-Duran*, could honor Velázquez while appearing modern with a fashionable subject and fresh technique.[15]

Christian Brinton wrote in 1908: "In a way of valedictory the pupil painted a seated portrait of his master which was both the summary of all he had learned and a resolute promise of future attainment."[16] We can add that if *Portrait of Carolus-Duran* was John Sargent's homage to his teacher, it also served to herald Sargent's independence. The painting was first exhibited at the 1879 Paris Salon; during the next three years it was shown in New York at the Society of American Artists, in Boston at the St. Botolph Club,

and in London at the Fine Arts Society. Its presentation on both sides of the Atlantic announced Sargent's maturity and served as a calling card for potential patrons.

The critical reactions to *Portrait of Carolus-Duran* during its first three showings were overwhelmingly positive, giving Sargent his first substantial acclaim. At the Salon in 1879, the portrait drew considerable notice for a young artist. Exhibited when Carolus-Duran was at the height of his popularity, it elicited comments about a student work in which a teacher could take pride. Mentioned in the French magazines *Gazette des Beaux-Arts* and *L'Art,* the painting was also featured on the cover of *L'Illustration* in January 1880.[17] According to Sargent's father, the painting always had a crowd around it at the Salon.[18] Furthermore, the work attracted major commissions, including a pair of portraits from the well-known poet and playwright Edouard Pailleron (*Edouard Pailleron,* 1879, Musée National du Château de Versailles; *Madame Edouard Pailleron,* 1879, The Corcoran Gallery of Art, Washington, D.C.).

Portrait of Carolus-Duran was the first portrait Sargent exhibited in the United States — at the third exhibition of the Society of American Artists in 1880.[19] It elicited tremendous praise and showed the extent of the American critics' pride in a fellow countryman's success at the prestigious Salon. With the exception of a writer for the ultra-conservative *The Nation,*[20] reviewers lauded Sargent's technical mastery and his ability to capture his sitter's character. Many also declared the portrait to be as good as or better than Carolus-Duran's own work, which had recently been seen in New York.[21] Representative of the comments were those made by a critic for *The New York Times:* "This portrait may be termed celebrated for not only did it enter the Salon and create much talk among the artists in Paris, but it has been reproduced in the fine books of art that describe the Salon. . . . It must be a pleasure to an artist to examine the workmanship of this thoroughly workman-like production. There is a fine certainty and breadth to the strokes, an audacity in pose, a vigor in expression of character, which would make it remarkable anywhere."[22] Moreover, at a time when growing numbers of American artists were seeking training abroad, *Portrait of Carolus-Duran* represented to the American art world the results of a Parisian education. At the Boston showing of the painting at the St. Botolph Club in late May 1880, the reviews were equally glowing.[23]

In 1882 *Portrait of Carolus-Duran,* along with *El Jaleo* (1882; Isabella Stewart Gardner Museum, Boston) and *Lady with a Rose* (1882; The Metropolitan Museum of Art, New York), introduced Sargent to the English public at the London Fine Arts Society.[24] This exhibition of British and American works that had appeared at the Paris Salons inspired little written response. One lengthy review in *The Magazine of Art,* however, heavily criticized *El Jaleo* but praised *Portrait of Carolus-Duran,* singling out Sargent as a bright star.[25] The portrait demonstrated Sargent's skills to the English upper classes who would become his principal clientele for the next thirty years.

Portrait of Carolus-Duran was of inestimable importance to John Sargent's career. His first virtuoso portrait, blending characterization with technical mastery, it launched the young artist into the art world of two continents. It was also the gauge against which his other portraits would be measured. *Portrait of Carolus-Duran* is among Sargent's most successful works and continues today to be a highlight in the history of American painting.

1 Elaine Kilmurray kindly shared biographical information about Carolus-Duran. Carol Clark, Amherst College, made helpful editorial comments on this entry.

2 Stanley Olson, *John Singer Sargent: His Portrait* (London: Macmillan London, 1986), p. 40.

3 Sargent nevertheless supplemented his study at Carolus-Duran's atelier with drawing classes at the Ecole under Adolphe Yvon (1817–1893).

4 That Sargent had begun the portrait prior to his trip is documented in a letter from Emily Sargent, the artist's sister, to their friend Violet Paget, July 24, 1878, quoted in Richard Ormond, *John Singer Sargent: Paintings, Drawings, Watercolors* (London: Phaidon Press, 1970), p. 236.

5 Olson, *John Singer Sargent,* p. 66.

6 Montezuma, "My Note Book," *The Art Amateur,* 7 (November 1882), p. 113.

7 That the pose was associated with Carolus-Duran's posture is recorded in Olson, *John Singer Sargent,* p. 67.

8 Patricia Hills, "The Formation of a Style and Sensibility," in *John Singer Sargent,* exh. cat. (New York: Whitney Museum of American Art, 1986), p. 27.

9 Ibid.

10 Carolus-Duran wrote in 1886: "There are two methods of understanding a subject. It may be treated heroically or intimately. In the latter case the artist enters into the life of the personages he desires to represent, observing them as human beings. . . . The heroic manner, on the contrary, expresses but an instant of their life, when raised to an exceptional pitch. . . . [the intimate] alone can move us . . . "; Carolus-Duran, "A French Painter and His Pupils," *Century Illustrated Magazine,* 31 (January 1886), pp. 374–75.

11 J. Carroll Beckwith, "Carolus-Duran," *Modern French Masters,* ed. John Van Dyke (New York: The Century Co., 1896), p. 77.

12 Carter Ratcliff, *John Singer Sargent* (New York: Abbeville Press, 1982), p. 37.

13 I am grateful to Shelley Langdale for her research on Sargent's relation to Velázquez and her remarks in connection with this painting.

14 H. Barbara Weinberg, "John Singer Sargent: Reputation Redivivus," *Arts Magazine,* 54 (March 1980), p. 104.

15 Harold Speed, "A Note on the Technique of Sargent," *The Fortnightly Review,* 121 (April 1, 1927), p. 559.

16 Christian Brinton, *Modern Artists* (New York: The Baker & Taylor Co., 1908), p. 159.

17 Arthur Baignères, "Le Salon de 1879," *Gazette des Beaux-Arts,* 20 (July 1879), p. 54; Charles Tardieu, "La Peinture au Salon de Paris, 1879," *L'Art,* 17, pt. 2 (1879), p. 189; *L'Illustration,* 75 (January 17, 1880), cover and p. 42.

18 Fitzwilliam Sargent to his brother, August 15, 1879, quoted in Olson, *John Singer Sargent,* p. 75.

19 Prior to this time Sargent had exhibited only three subject pictures in America; see pp. 163, 164 n. 1.

20 "Fine Arts: The Society of American Artists," *The Nation,* 3 (April 1, 1880), p. 258, where the painting was criticized for its "colorless head" and "paper extremities."

21 "It is a portrait of a master by a pupil who equals and may surpass him," wrote the critic for the *New York Herald,* "Fine Arts: Society of American Artists (2nd article)," March 22, 1880, p. 8. See also "One Day in the Gallery—Society of American Artists," *The New York Times,* March 26, 1880, p. 5; "Society of American Artists," *The World* (New York), March 28, 1880, p. 4; and "Fine Arts: Society of American Artists," *New York Herald,* March 8, 1880, p. 8.

22 "The American Artists," *The New York Times,* April 16, 1880, p. 8.

23 See "Art Notes," *Boston Evening Transcript,* May 21, 1880, p. 4.

24 R.A.M. Stevenson, "J.S. Sargent," *The Art Journal* (London), 50 (March 1888), p. 66.

25 "America in Europe," *The Magazine of Art* (London), 6 (1883), p. 5.

Provenance: To Emile-Auguste Carolus-Duran, 1879; to Mr. Rougeron;* to Emile-Auguste Carolus-Duran; (Pierre and Co., Paris); to (M. Knoedler & Co., Paris, December 17, 1919); to Robert Sterling Clark, December 31, 1919.

*It seems that Carolus-Duran used the painting as collateral for a loan from Mr. Rougeron in the early 1880s. The story is recounted in Robert Sterling Clark's diary, January 29, 1929, when Rougeron's son saw the picture in Mr. Clark's New York home.

Related Works: Study for Carolus-Duran, n.d., oil on panel, 13½ × 10 (34.3 × 25.4), collection of Mrs. Norman B. Woolworth.

Study for Portrait of Carolus-Duran, n.d., oil on panel, 13½ × 10½ (34.3 × 26.7), private collection.

Carolus-Duran, n.d., ink on paper, 12½ × 10¼ (31.75 × 26), The Art Museum, Princeton University; this drawing was used as an illustration in the Salon catalogue.

Exhibitions: Paris, "Le Salon de 1879," May 12–July 1879, no. 2697; Society of American Artists, New York, "3rd Exhibition of the Society of American Artists," March 17–April 16, 1880, not numbered due to late inclusion in exhibition; St. Botolph Club, Boston, "Exhibition of Paintings and Statuary," May 19–29, 1880, no. 27; Fine Arts Society, London, "Collection of Pictures by British and American Artists from the Paris Salon," November–December 1882, no. 8; Pennsylvania Academy of the Fine Arts, Philadelphia, "116th Annual Exhibition," February 6–March 27, 1921, no. 285; Carnegie Institute, Pittsburgh, "20th Annual International Exhibition of Paintings," April 23–June 30, 1921, no. 302; Sterling and Francine Clark Art Institute, Williamstown, Massachusetts, "Exhibit 4: The First Two Rooms," May 17, 1955, no. 14; Worcester Art Museum, Massachusetts, "The American Portrait: From the Death of Stuart to the Rise of Sargent," April 26–June 3, 1973, no. 44; Whitney Museum of American Art, New York, "John Singer Sargent," October 7, 1986–January 4, 1987.

References: Armand Silvestre, "Demi-dieux et simples mortels au Salon de 1879," *La Vie Moderne* (May 22, 1879), p. 118; "Exhibition of the Salon," *The New York Times,* June 1, 1879, p. 7; Arthur Baignères, "Le Salon de 1879," *Gazette des Beaux-Arts,* 20 (July 1879), p. 54; "The Last Paris Salon, II," *The American Architect and Building News,* 6 (October 18, 1879), pp. 124–25; Lucy H. Hooper, "The Paris Salon of 1879," *The Art Journal* (New York), 5 (October 1879), p. 250; "American Painters of the Salon of 1879," *The Aldine,* 9 (1879), pp. 370, 371; Charles Tardieu, "La Peinture au Salon de Paris 1879," *L'Art,* 17, pt. 2 (1879), pp. 189–90; Mrs. Arthur (N. D'Anvers) Bell, *Representative Painters of the XIXth Century* (New York: E.P. Dutton & Co., 1879), pp. 57, 59; *Livre d'Or du Salon de Peinture et de Sculpture,* 1 (1879), p. 29; *Salon illustré de 1879* (Paris: Ludovic Baschet, 1879), p. 100; *L'Illustration,* 75 (January 17, 1880), cover, p. 42; "Fine Arts: Society of American Artists," *New York Herald,* March 8, 1880, p. 8; "Fine Arts: Society of American Artists (2nd article)," *New York Herald,* March 22, 1880, p. 8; "Fine Arts: Society of American Artists, 3rd Annual Exhibition (2nd Notice)," *New York Daily Tribune,* March 25, 1880, p. 5; "One Day in the Gallery—Society of American Artists," *The New York Times,* March 26, 1880, p. 5; "Society of American Artists," *The World* (New York), March 28, 1880, p. 4; "Society of American Artists Exhibition," *The Art Interchange,* 4 (March 31, 1880), p. 59; "Fine Arts: The Society of American Artists," *The Nation,* 3 (April 1, 1880), p. 258; "Fine Arts: National Academy of Design 55th Annual Exhibition (2nd article)," *New York Daily Tribune,* April 4, 1880, p. 7; "The American Artists," *The New York Times,* April 16, 1880, p. 8; "Art for Artists," *The Art Amateur,* 1 (April 1880), p. 90; M[ariana] G[riswold] van Rensselaer, "Spring Exhibitions and Picture Sales in New York, I," *The American Architect and Building News,* 7 (May 1, 1880), p. 190; "Art Notes," *Boston Evening Transcript,* May 21, 1880,

p. 4; S.N. Carter, "The Society of American Artists," *The Art Journal* (New York), 6 (May 1880), p. 155; Lucy H. Hooper, "Art Notes from Paris," *The Art Journal* (New York), 6 (May 1880), p. 158; "John Singer Sargent," *The Art Amateur*, 2 (May 1880), pp. 118, 119; "Special Correspondence: American Artists at the Paris Salon," *The Art Interchange*, 4 (June 9, 1880), p. 100; Paul Mantz, "Le Salon VII," *Le Temps* (Paris), June 20, 1880, p. 1; "Boston Correspondence: The Opening of the St. Botolph Club," *The Art Amateur*, 3 (June 1880), p. 7; G.P. Lathrop, "The Exhibitions—VIII: St. Botolph Club, Boston (May 19–May 29, 1880)," *American Art Review*, 1 (June 1880), p. 445; Montezuma, "My Note Book," *The Art Amateur*, 3 (November 1880), p. 113; S.G.W. Benjamin, "The Exhibitions, IV—Society of American Artists, 3rd Exhibition," *American Art Review*, 1 (1880), pp. 260–61; "Among the Artists: Society of American Artists," *New York Daily Tribune*, March 27, 1881, p. 2; *Salon de 1879: Catalogue illustré* (Paris: Librairie Artistique, 1882), pp. 130, 161; "America in Europe," *The Magazine of Art* (London), 6 (1883), p. 5; Montezuma, "My Note Book," *The Art Amateur*, 13 (August 1885), p. 44; Henry James, "John S. Sargent," *Harper's New Monthly Magazine*, 75 (October 1887), pp. 684, 685, 689; R.A.M. Stevenson, "J.S. Sargent," *The Art Journal* (London), 50 (March 1888), pp. 66, 69; Theodore Child, "American Artists at the Paris Exposition," *Harper's New Monthly Magazine*, 79 (September 1889), p. 504; "Young Men of New York," *Harper's Weekly*, 35 (August 29, 1891), p. 662; Henry James, *Picture and Text* (New York: Harper & Brothers, 1893), pp. 93–94 (reprint of "John S. Sargent," 1887); "Carolus-Duran," *The Art Amateur*, 32 (February 1895), p. 80; Montague Marks, "My Note Book," *The Art Amateur*, 32 (February 1895), p. 77; Charles H. Caffin, "Sargent and His Painting: With Special References to His Decorations in the Boston Public Library," *Century Magazine*, 52 (June 1896), p. 175; "Americans Who Paint in London," *The New York Times, Saturday Review of Books and Art*, February 6, 1897, p. 4; Marion Hepworth Dixon, "Mr. John S. Sargent as a Portrait Painter," *The Magazine of Art*, 23 (January 1899), p. 115; A.L. Baldry, "The Art of J.S. Sargent, R.A. (Part 1)," *The Studio* (London), 19 (February 1900), pp. 17, 18 (also published in *The International Studio*, 10 [March 1900], pp. 17, 18); John Rummell and E.M. Berlin, *Aims and Ideals of Representative American Painters* (Buffalo, New York: E.M. Berlin, 1901), p. 66; Charles H. Caffin, "John S. Sargent: The Greatest Contemporary Portrait Painter," *The World's Work*, 7 (November 1903), p. 4109; Royal Cortissoz, "John S. Sargent," *Scribner's Magazine*, 34 (November 1903), p. 324; Evan Mills, "A Personal Sketch of Mr. Sargent," *The World's Work*, 7 (November 1903), p. 4117; Samuel Isham, *The History of American Painting* (New York: Macmillan Co., 1905), p. 430; Christian Brinton, "Sargent and His Art," *Munsey's Magazine*, 36 (December 1906), pp. 277, 281; Joseph Walker McSpadden, *Famous Painters of America* (New York: Thomas Y. Crowell & Co., 1907), p. 283; C.H. Fiske, "American Painting," *Chautauquan*, 50 (March 1908), p. 82; Christian Brinton, *Modern Artists* (New York: The Baker & Taylor Co., 1908), pp. 159, 160; T. Martin Wood, *Sargent* (1909; ed. New York: Frederick A. Stokes, 1920), pp. 75–

76; Helena Modjeska, *Memories and Impressions of Helena Modjeska: An Autobiography* (New York: Macmillan Co., 1910), p. 368; Royal Cortissoz, *Art and Common Sense* (New York: Charles Scribner's Sons, 1913), p. 229; John Cournos, "John Singer Sargent," *The Forum*, 54 (August 1915), p. 232; John C. Van Dyke, *American Painting and Its Tradition* (New York: Charles Scribner's Sons, 1919), pp. 23, 251; "Academy Exhibit Opens Tomorrow," *Philadelphia Bulletin*, February 5, 1921, p. 3; "The World of Art: Pennsylvania Academy Exhibition, 1st Notice," *The New York Times*, February 13, 1921, pp. 3–20; The Editor [Hamilton Easter Field], "The Pennsylvania Academy," *The Arts*, 1 (February–March 1921), pp. 22–23; "Plan to Erect Sargent Gallery," *The New York Herald* (Paris), March 26, 1924, p. 2; Rose V.S. Berry, "John Singer Sargent: Some of His American Work," *Art and Archaeology*, 18 (September 1924), p. 88; William Starkweather, "John S. Sargent," *The Mentor*, 12 (October 1924), p. 7; A[lbert] V[ualflart], "John S. Sargent: peintre, associé étranger, 1856–1925," *Académie des Beaux-Arts* (January–June 1925), p. 46; "J.S. Sargent Dies in Sleep in London," *The New York Times*, April 16, 1925, p. 10; H.I. Brock, "John Sargent, Man and Painter," *The New York Times*, April 19, 1925, p. 10; C. Lewis Hind, "Sargent," *The Outlook* (New York), 139 (April 29, 1925), p. 648; Hamilton Minchin, "Some Early Recollections of Sargent," *The Contemporary Review*, 127 (June 1925), p. 736; G.P. Jacomb-Hood, "John Sargent," *The Cornhill Magazine*, 59 (September 1925), p. 288; *A Catalogue of the Memorial Exhibition of the Works of the Late John Singer Sargent to be Opened on the Occasion of the Unveiling of Mr. Sargent's Mural Decorations over the Main Stair Case and the Library of the Museum*, exh. cat. (Boston: The Museum of Fine Arts, 1925), p. viii; C. Lewis Hind, "John Sargent," *The Fortnightly Review*, 119 (March 1, 1926), p. 411; Frederick Houk Law, "Modern Great Americans: John Singer Sargent—Artist," *The St. Nicholas Magazine*, 53 (October 1926), p. 1128; William Howe Downes, *John S. Sargent: His Life and Work* (London: Thornton & Butterworth, 1926), pp. 9, 121–22; *Memorial Exhibition of the Work of John Singer Sargent*, exh. cat. (New York: The Metropolitan Museum of Art, 1926), p. xv; Frank Jewett Mather, Jr., "Enigma of Sargent," *Saturday Review of Literature*, 3 (February 26, 1927), p. 606; Mary Newbold Patterson Hale, "The Sargent I Knew," *The World Today*, 50 (November 1927), p. 567; Evan Charteris, *John Sargent* (London: William Heineman, 1927), opp. p. 22, pp. 48–49, 257; Edward W. Forbes, "John Singer Sargent 1856–1925," in M.A. De Wolfe Howe, *Later Years of the Saturday Club 1870–1920* (Boston: Houghton Mifflin, 1927), p. 409; Grace Irwin, *Trail-Blazers of American Art* (New York: Harper & Brothers, 1930), p. 183; Frank Jewett Mather, Jr., *Estimates in Art, Series II: 16 Essays on American Painters of the 19th Century* (New York: Henry Holt & Co., 1931), p. 240; Elizabeth Pennell, "When I Was a Critic, II," *Creative Art*, 11 (December 1932), p. 293; Sadakichi Hartmann, *A History of American Art* (1901; ed. New York: Tudor Publishing Co., 1932), vol. 2, p. 213; Edwin H. Blashfield, "John Singer Sargent," in *Commemorative Tributes of the American Academy of Arts & Letters* (New York: American Academy of Arts & Letters, 1942),

p. 185; M.L. Pailleron, *Le paradis perdu* (Paris: A. Michel, 1947), p. 154; *Sargent, Whistler, and Mary Cassatt,* exh. cat. (Chicago: The Art Institute of Chicago, 1954), p. 40; Charles Merrill Mount, *John Singer Sargent: A Biography* (New York: W.W. Norton & Co., 1955), pp. 47, 58, 427; CAI 1955, n.p., pl. XIV; Charles Merrill Mount, "Sargent: An American Old Master," *The New York Times Magazine,* January 8, 1956, p. 39; *Sargent's Boston,* exh. cat. (Boston: Museum of Fine Arts, 1956), p. 95; Charles Merrill Mount, "Archives of American Art — Report 302: New Discoveries Illumine Sargent's Paris Career," *The Art Quarterly,* 20 (Autumn 1957), p. 304; CAI 1958a, n.p., pl. LVIII; Richard Gilman, "Americans Abroad," *American Heritage,* 12 (October 1961), p. 12; G. Charsenol, "Beaux-Arts: Sargent au Centre Culturel Américain," *La Revue des Deux Mondes,* 2 (March 15, 1963), p. 281; Charles Merrill Mount, "Carolus-Duran and the Development of Sargent," *The Art Quarterly,* 26 (Winter 1963), pp. 387–88, 393; Denys Sutton, "A Bouquet for Sargent," *Apollo,* 79 (May 1964), p. 398; John Dee McGinniss, "John Singer Sargent and the Ironic Tradition," Ph.D. dissertation, Florida State University, Tallahassee, 1968, p. 169; Richard Ormond, *John Singer Sargent: Paintings, Drawings, Watercolors* (London: Phaidon Press, 1970), pp. 18, 236–37, 393; CAI 1972, pp. 98, 99; Lambert Blunt Jackson, "The Expatriates: The Major Artists in Europe, 1865–1914," Ph.D. dissertation, University of Delaware, Newark, 1976, p. 177; R.H. Ives Gammell, "The Enigma of John Sargent's Art," *Classical America,* 4 (1977), pp. 154, 155; Bernard Denvir, "Mostly Upstairs," *Art and Artists,* 14 (July 1979), p. 16; Maureen Green, "A New and Admiring Look at the Elegance of John Singer Sargent," *Smithsonian,* 10 (October 1979), p. 103; Denys Sutton, "The Yankee Brio of John Singer Sargent," *Portfolio: The Magazine of the Visual Arts,* 1 (October–November 1979), p. 49; *John Singer Sargent and the Edwardian Age* (Leeds, England: Leeds Art Galleries, 1979), pp. 15, 19, 24; *John Singer Sargent and the Edwardian Age: The Documents* (Detroit: The Detroit Institute of Arts, 1979), n.p.; Maureen C. O'Brien, "John Singer Sargent: Portrait of Ernest-Ange Duez," in *The American Painting Collection of the Montclair Art Museum: Research Supplement I* (Montclair, New Jersey: Montclair Art Museum, 1979), pp. 13, 14; H.

Barbara Weinberg, "John Singer Sargent: Reputation Redivivus," *Arts Magazine,* 54 (March 1980), p. 106; Charles Cagle, "The Revelation of Character in the Portraits of John Singer Sargent," *Midwest Quarterly: A Journal of Contemporary Thought,* 22 (October 1980), pp. 48, 49; *The Boston Tradition: American Paintings from the Museum of Fine Arts, Boston,* exh. cat. (New York: American Federation of Arts, 1980), p. 36; *John Singer Sargent: His Own Work,* exh. cat. (New York: Coe Kerr Gallery, 1980), n.p.; CAI 1981, pp. 86, 87; Meg Robertson, "John Singer Sargent: His Early Success in America 1878–1879," *Archives of American Art Journal,* 22, no. 4 (1982), pp. 24, 25, 26; Carter Ratcliff, *John Singer Sargent* (New York: Abbeville Press, 1982), pp. 43–45; Jennifer A. Martin Bienenstock, "The Formation and Early Years of the Society of American Artists: 1877–1884," Ph.D. dissertation, Graduate Center, City University of New York, 1983, pp. 78, 103, 376, 405; *The New England Eye: Master American Paintings from New England School, College and University Collections,* exh. cat. (Williamstown, Massachusetts: Williams College Museum of Art, 1983), p. 38; *A New World: Masterpieces of American Painting 1760–1910,* exh. cat. (Boston: Museum of Fine Arts, 1983), p. 299; CAI 1984, pp. 34, 103; William H. Gerdts, *American Impressionism* (New York: Abbeville Press, 1984), p. 80; *The Bostonians: Painters of an Elegant Age,* exh. cat. (Boston: Museum of Fine Arts, 1986), pp. 44, 45; Trevor J. Fairbrother, *John Singer Sargent and America* (New York: Garland Publishing, 1986), pp. 39–44, 46, 51, 54, 81 n. 32, 87, 96, 156, 175, 291, 347, 361 n. 95; *John Singer Sargent,* exh. cat. (New York: Whitney Museum of American Art, 1986), pp. 27, 31, 82–83, 149; Stanley Olson, *John Singer Sargent: His Portrait* (London: Macmillan London, 1986), pp. 66, 67, 70, 75–76, pl. VI; *Sargent at Broadway: The Impressionist Years,* exh. cat. (New York: Coe Kerr Gallery, 1986), p. 13; James F. Cooper, "John Singer Sargent: The Last Conservative," *American Arts Quarterly,* 1 (Winter 1987), pp. 7, 11; Gary A. Reynolds, "John Singer Sargent's Portraits: Building a Cosmopolitan Career," *Arts Magazine,* 62 (November 1987), pp. 42–46; John Milner, *The Studios of Paris: The Capital of Art in the Late 19th Century* (New Haven and London: Yale University Press, 1988), p. 212.

Fumée d'Ambre Gris, 1880

Oil on canvas

$54^{3/4} \times 35^{11}/_{16}$ (139.1 × 90.6)

Signed and inscribed lower right: John S. Sargent Tanger; *pentimento of signature and inscription lower center:* John S. Sargent Tanger.

No. 15

John Sargent sent two paintings to the Paris Salon of 1880: *Madame Edouard Pailleron* (1879; The Corcoran Gallery of Art, Washington, D.C.) and *Fumée d'Ambre Gris* (Smoke of Ambergris). The former, one of the artist's most recent major portraits, was entered to stimulate more commissions.[1] *Fumée d'Ambre Gris* represented the fruits of the artist's trip to North Africa during the winter of 1879–80, and in it Sargent gave his own interpretation of Orientalism, a favored theme of the day.

Westerners had been fascinated with North Africa and the Near East since the beginning of the nineteenth century. As the closest non-Christian region to Europe, the area supplied Europeans and Americans with an exotic culture that became increasingly accessible as the century progressed. North African and Near Eastern subjects prompted a variety of responses influenced by contemporary politics, attitudes toward gender, and aesthetic issues.[2] From the 1860s to the turn of the century, the Orientalist image, particularly of

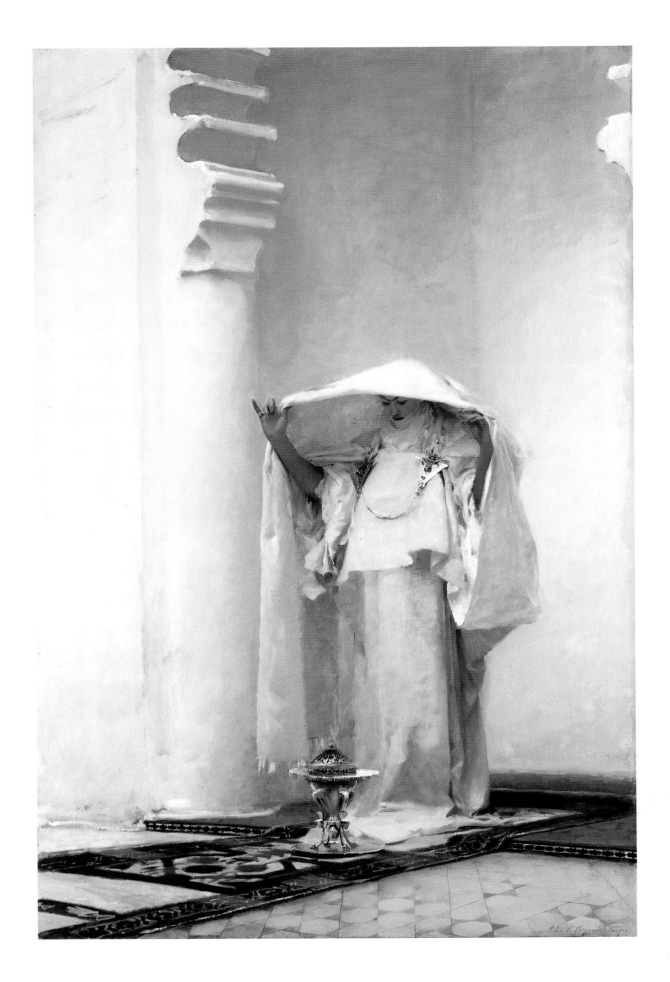

Fig. 85: John Singer Sargent, **Sketches including "Fumée d'Ambre Gris,"** n.d. Pencil on paper, 9 × 12¾ in. (22.9 × 32.4 cm). Collection of Mr. and Mrs. Warren Adelson.

Fig. 86: John Singer Sargent, **Hand Studies for "Fumée d'Ambre Gris,"** n.d. Pencil on paper, 9¹³⁄₁₆ × 13⅜ in. (24.9 × 34 cm). The Corcoran Gallery of Art, Washington, D.C.; Gift of Violet Sargent Ormond and Emily Sargent, 1949.

Fig. 87: John Singer Sargent, **Lady with Covered Head,** n.d. Pencil on paper, 9¾ × 13⅜ in. (24.8 × 34 cm). The Harvard University Art Museums (Fogg Art Museum); Gift—Mrs. Francis Ormond.

Fig. 88: John Singer Sargent, **Studies of Hand of Javanese Dancer** (Study for "Fumée d'Ambre Gris), n.d. Pencil on paper, 9¾ × 13⅛ in. (24.8 × 33.3 cm). The Metropolitan Museum of Art, New York; Gift of Mrs. Francis Ormond, 1950.

Fig. 89: John Singer Sargent, **Study for "Fumée d'Ambre Gris,"** n.d. Oil on canvas, 32 × 21¼ in. (81.3 × 54 cm). Private collection.

women, was popular in art.[3] Among the many artists who specialized in Orientalist themes were the Frenchmen Jean-Léon Gérôme (1824–1904) and Benjamin Constant (1845–1902) and the Americans Frederic A. Bridgman (1847–1928) and Edwin Lord Weeks (1849–1903).

An Orientalist subject may have appealed to Sargent in part because of its contemporary popularity. At the same time, Sargent's friendships with Robert de Montesquieu and Dr. Samuel Pozzi in Paris in the late 1870s and early 1880s brought him into a circle of dandyism guided by a search for the beautiful, both sublime and sensual.[4] To European eyes the Eastern woman was languidly sensual and mysterious.[5] For Sargent, the exotic nature of North Africa presented an opportunity to expand his maturing concept of art within the context of the alluring Near Eastern world.

Fumée d'Ambre Gris depicts a heavily draped and shrouded woman inhaling smoke from an incense burner. The title of the painting refers to the Near Eastern custom of inhaling the smoke of ambergris, a resinous substance with a musky smell extracted from whales and considered an aphrodisiac as well as a safeguard against evil spirits.[6] The ritual of inhalation was common to both Jews and Muslims. Bridal parties, newborn infants, and anyone preparing for a special occasion would perform the ritual at home or in front of a place of worship.

The components of *Fumée d'Ambre Gris* represent a mélange of Moroccan objects and customs Sargent must have encountered in Tangier and Tétouan. His model, of whom he made several pencil sketches (figs. 85– 88), was most likely a citizen of cosmopolitan Tangier. Living in a society in which women were generally intensely private, she was probably a member of its outer fringes, and her willingness to model may have derived from financial need.[7] The voluminous robes and shroud she wears were characteristic of male and female dress throughout North Africa. The details of the costume, however, come from different regions and social classes.[8] The style of the robe in *Fumée d'Ambre Gris* is that associated with the Hlot tribe of northern Morocco. Women wore a simple shift — evident in the orange cloth showing through the sleeves — underneath a long piece of fabric that was wound around the body and over the shoulders before it was pinned on each side. As the Hlot were a poor and rural tribe, this kind of white robe would only have been worn on special occasions, usually accompanied by considerable jewelry, but Sargent limited the ornamentation to two clip pins joined by a chain and a ring on the woman's right hand. Despite the northern Moroccan origin of the cos-

tume, the triangular shape of the pins is Berberish, that is, from the southern part of the country.

Sargent also appropriated the architecture and accessories from different sources. The architectural setting suggests an eleventh- or twelfth-century mosque. It is similar to that in several oil studies Sargent made in Tétouan.[9] The decoration on the carpet, though indistinct, is related to scissor patterns associated with the city of Rabat, south of Tangier. The vessel sitting on the rug is of urban origin; in rural areas, such items were generally made of clay.

Fumée d'Ambre Gris, then, must be viewed as an imaginary scene, developed from a number of drawings and an oil study two-thirds the size of the finished painting (fig. 89). A monochromatic palette based in white prevails, and Sargent treated the flowing robes and architecture with a minimum of detail and a maximum of subtle modulation of cool and warm white tones. To counterbalance the broad areas of white, he painted the burner, the figure's hands, the dress pins, and the edges of the orange undergarment in detail. The light that falls across the entire painting enriches the surface texture and throws the more detailed objects into higher relief. In contrast to a work like Jean-Léon Gérôme's *The Slave Market* (fig. 92), which relies on heightened realism and a recognizable narrative, *Fumée d'Ambre Gris* is seductive because it favors style over subject.

The technique of *Fumée d'Ambre Gris* is not unlike that in Sargent's *Portrait of Carolus-Duran* (pp. 166–72), despite the markedly different color schemes. The emphasis in *Fumée d'Ambre Gris,* however, depends even less on subject and more on the possibilities Sargent saw in painting within a limited color range. Henry James appreciated the effect: "I know not who this stately Mohammedan may be, nor in what mysterious domestic or religious rite she may be engaged; but in her muffled contemplation and her pearl-colored robes, under her plastered arcade, which shines in the Eastern light, she is beautiful and memorable. The picture is exquisite, a radiant effect of white upon white, of similar but discriminated tones."[10] Sargent's prevailing concern for working with color harmonies reflects the general movement in the last quarter of the nineteenth century away from subject and toward technical and formal interests. More specifically, it points to his familiarity with the more extreme aestheticizing tendencies and art-for-art's-sake credo found in the works of James McNeill Whistler (1834–1903), which were championed by Sargent's aesthete friends in Paris. In *Fumée d'Ambre Gris,* Sargent investigated both the human and the aesthetic side of beauty, retaining the native

color and flavor that created an alluring, exotic image yet fulfilling his artistic purposes.

Sargent wrote to his friend Violet Paget on July 9, 1880: "I shall send you a photograph of a little picture I perpetrated in Tangier. It is very unsatisfactory because the only interest in the thing was the color."[11] There seems to be a certain false modesty in this comment, but it nevertheless attests to Sargent's preoccupation with the picture's color and his partial dissatisfaction with it. At one point, believing the picture complete, he signed it at the center of the bottom edge. Later, however, in order better to harmonize the floor area with the rest of the work, he repainted the tile floor to tone down the colored pattern and covered the original signature. He then resigned the picture at the lower right.[12]

Fumée d'Ambre Gris received favorable reviews on both sides of the Atlantic during its showing at the Salon. The French critics called it "a melodic fantasy" and greatly praised Sargent's color sense.[13] The special correspondent for *The Art Interchange* found the picture to be "a perfect piece of painting" because of the artist's handling of the different tones of white.[14] In addition, a cartoon of the painting (fig. 93), included in a full-page spoof of highlights of the Salon, appeared in *Le Charivari. Fumée d'Ambre Gris* must have greatly pleased at least one other viewer since it was quickly sold to an unidentified Frenchman, and it remained in private hands for more than thirty years.[15]

1 Stanley Olson, *John Singer Sargent: His Portrait* (London: Macmillan London, 1986), p. 78.

2 See Linda Nochlin, "The Imaginary Orient," *Art in America,* 71 (May 1983), pp. 119–31, 186–91.

3 In recent years, Orientalism has received considerable attention in art history and other disciplines; see *The Orientalists: Delacroix to Matisse,* exh. cat. (Washington, D.C.: National Gallery of Art, 1984), for a thorough overview and good bibliography.

4 Albert Boime, "Sargent in Paris and London: A Portrait of the Artist as Dorian Gray," in *John Singer Sargent,* exh. cat. (New York: Whitney Museum of American Art, 1986), p. 85.

5 Rana Kabbani, *Europe's Myth of the Orient* (Bloomington, Indiana: Indiana University Press, 1986), pp. 67–85.

6 See Boime, "Sargent in Paris and London," p. 84, on ambergris as an aphrodisiac; Linda Ayres, in her unpublished research, discusses the apotropaic qualities of ambergris.

7 According to William Darrow, assistant professor of religion, Williams College, Tangier's population consisted of Muslims and Jews with few Christians. Muslim law required that women remain veiled, and though Jewish women were under no such constraint, models were very hard to find.

8 Linda Ayres kindly supplied me with information on the various costume elements.

Fig. 90: John Singer Sargent, **Sketch after "Fumée d'Ambre Gris,"** 1880. Pen and ink, 11⅜ × 7¹³⁄₁₆ in. (28.9 × 19.8 cm). Sterling and Francine Clark Art Institute.

Fig. 91: John Singer Sargent, **Incensing the Veil,** n.d. Watercolor on paper, 12 × 7¾ in. (30.5 × 19.7 cm). Isabella Stewart Gardner Museum, Boston.

*Fig. 92: Jean-Léon Gérôme, **The Slave Market**, n.d. Oil on canvas, 33³/₁₆ × 24¹³/₁₆ in. (84.3 × 63 cm). Sterling and Francine Clark Art Institute.*

SARGENT.

3429

CHAMPIGNON DU SÉRAIL.
Espérons qu'il n'est pas vénéneux.

*Fig. 93: P.A.F. "Le Salon Pour Rire" (detail), **Le Charivari**, 49 (May 12, 1880)', p. 3.*

9 See, for example, Doreen Bolger Burke, *American Paintings in The Metropolitan Museum of Art* (New York: The Metropolitan Museum of Art, 1980), vol. 3, pp. 222–24.

10 Henry James, "John S. Sargent," *Harper's New Monthly Magazine,* 75 (October 1887), p. 688.

11 Sargent to Paget, July 9, 1880, collection of Richard Ormond. Although Sargent does not refer to *Fumée d'Ambre Gris* by name, it is the only work that seems appropriate for such a comment.

12 Today the center signature appears as pentimento.

13 Paul Mantz, "Le Salon—VII," *Le Temps* (Paris), June 20, 1880, p. 2, and P. Burty, "Le Salon de 1880: Les Etrangers," *L'Art,* 21 (1880), p. 299.

14 "Special Correspondence: American Artists at the Paris Salon," *The Art Interchange,* 4 (June 9, 1880), p. 100.

15 The painting was purchased by May 18, 1880, when the transaction was recorded in a letter from Emily Sargent to Violet Paget, Colby College Library Collection, Waterville, Maine.

Provenance: To unidentified Frenchman, 1880; (Broussod, Valdon et Cie., Paris); to (M. Knoedler & Co., Paris, July 6, 1914); to Robert Sterling Clark, September 10, 1914.

Related Works: Lady with Covered Head, n.d., graphite on paper, 9³/₄ × 13³/₈ (24.8 × 34), The Harvard University Art Museums, Fogg Art Museum, Cambridge, Massachusetts; Gift of Mrs. Francis Ormond.

Studies of Hand of Javanese Dancer, n.d., pencil on paper, 9³/₄ × 13¹/₈ (24.8 × 33.3), The Metropolitan Museum of Art, New York; Gift of Mrs. Francis Ormond, 50.130.140v.

Hand Studies for Fumée d'Ambre Gris, n.d., pencil on paper, 9¹³/₁₆ × 13³/₈ (24.9 × 34), The Corcoran Gallery of Art, Washington, D.C.; Gift of Violet Sargent Ormond and Emily Sargent, 1949.

Sketches including Fumée d'Ambre Gris, n.d., pencil on paper, 9 × 12³/₄ (22.9 × 32.4), collection of Mr. and Mrs. Warren Adelson.

Study for Fumée d'Ambre Gris, n.d., oil on canvas, 32 × 21¹/₄ (81.3 × 54), private collection.

Incensing the Veil, n.d., watercolor on paper, 12 × 7³/₄ (30.5 × 19.7), Isabella Stewart Gardner Museum, Boston.

Sketch after Fumée d'Ambre Gris, 1880, ink on paper, 11³/₈ × 7¹³/₁₆ (28.9 × 19.8), Sterling and Francine Clark Art Institute, Williamstown, Massachusetts; this drawing was used as an illustration in the Salon catalogue.

Exhibitions: Paris, "Le Salon de 1880," May 1–July 1880, no. 3429; Sterling and Francine Clark Art Institute, Williamstown, Massachusetts, "Exhibit 4: The First Two Rooms," May 7, 1955, no. 15.

References: P.A.F., "Le Salon pour rire," *Le Charivari,* 49 (May 12, 1880), p. 3; Stéphane Loysel, "Le Salon de 1880, IV," *L'Illustration,* 75 (May 22, 1880), p. 333; "Special Correspondence: American Artists at the Paris Salon," *The Art Interchange,* 4 (June 9, 1880), p. 100; Paul Mantz,

"Le Salon—VII," *Le Temps* (Paris), June 20, 1880, p. 1; *The Art Interchange,* 5 (September 15, 1880), p. 52; Frédéric de Syene, "The Salon of 1880," *American Art Review,* 1 (October 1880), pp. 542–43; Montezuma, "My Note Book," *The Art Amateur,* 3 (November 1880), p. 113; P. Burty, "Le Salon de 1880, I," *L'Art,* 21 (1880) p. 154; P. Burty, "Le Salon de 1880: Les Etrangers," *L'Art,* 21 (1880), pp. 299, 304; Lucy H. Hooper, "The Paris Salon of 1880," *The Art Journal* (New York), 6 (July 1880), p. 222 *1880 Catalogue illustré du Salon* (Paris: Motteroz and L. Baschet, 1882), pp. 60, 120; Henry James, "John S. Sargent," *Harper's New Monthly Magazine,* 75 (October 1887), p. 688; Theodore Child, "American Artists at the Paris Exposition," *Harper's New Monthly Magazine,* 79 (September 1889), p. 504; Henry James, *Picture and Text* (New York: Harper & Brothers, 1893), pp. 103–4 (reprint of "John S. Sargent," 1887); Charles H. Caffin, "Sargent and His Painting: With Special References to His Decorations in the Boston Public Library," *Century Magazine,* 52 (June 1896), pp. 169, 175; Marion Hepworth Dixon, "Mr. John S. Sargent as a Portrait Painter," *The Magazine of Art,* 23 (January 1899), p. 115; A.L. Baldry, "The Art of J.S. Sargent, R.A. (Part 1)," *The Studio* (London), 19 (February 1900), p. 18 (also published in *The International Studio,* 10 [March 1900], p. 18); Christian Brinton, "Sargent and His Art," *Munsey's Magazine,* 36 (December 1906), p. 282; Joseph Walker McSpadden, *Famous Painters of America* (New York: Thomas Y. Crowell & Co., 1907), p. 285; T. Martin Wood, *Sargent* (1909; ed. New York: Frederick A. Stokes, 1920), p. 76; Nathaniel J. Pousette-Dart, *John Singer Sargent* (New York: Frederick A. Stokes, 1924), n.p.; William Howe Downes, *John S. Sargent: His Life and Work* (London: Thornton & Butterworth, 1926), p. 124; Evan Charteris, *John Sargent* (London: William Heineman, 1927), pp. 51, 52, 251, 281; Sadakichi Hartmann, *A History of American Art* (1901; ed. New York: Tudor Publishing Co., 1932), vol. 2, pp. 213–14; CAI 1955, n.p., pl. XV; Charles Merrill Mount, *John Singer Sargent: A Biography* (New York: W.W. Norton & Co., 1955), pp. 70, 443; CAI 1958a, n.p., pl. LX; Charles Merrill Mount, "Carolus-Duran and the Development of Sargent," *The Art Quarterly,* 26 (Winter 1963), pp. 386–87, 391, 407; Egbert Haverkamp-Begemann, Standish D. Lawder, and Charles W. Talbot, Jr., *Drawings from the Clark Art Institute* (New Haven and London: Yale University Press, 1964), p. 147; Martha Kingsbury, "John Singer Sargent: Aspects of His Work," Ph.D. dissertation, Harvard University, Cambridge, Massachusetts, 1969, p. 229; Richard Ormond, *John Singer Sargent: Paintings, Drawings, Watercolors* (London: Phaidon Press, 1970), pp. 19, 27, 28, 36, 237; Richard Ormond, "Sargent's *El Jaleo,*" *Fenway Court: Isabella Stewart Gardner Museum, 1970* (Boston: Isabella Stewart Gardner Museum, 1971), pp. 5, 7; CAI 1972, p. 98; *John Singer Sargent and the Edwardian Age,* exh. cat. (Leeds, England: Leeds Art Galleries, 1979), p. 19; Carter Ratcliff, *John Singer Sargent* (New York: Abbeville Press, 1982), pp. 55, 57, 61, 209; Patricia Failing, *Best-Loved Art from American Museums* (New York: Clarkson N. Potter, 1983), pp. 108, 109; *John Singer Sargent: Drawings from The Corcoran Gallery of Art,* exh. cat. (Washington, D.C.: Smithsonian Institution Traveling Exhibition

Service and The Corcoran Gallery of Art, 1983), pp. 16, 52; D. Dodge Thompson, "American Artists in North Africa and the Middle East, 1797–1914," *The Magazine Antiques*, 126 (August 1984), pp. 303–12; CAI 1984, pp. 34, 103; *The Orientalists: Delacroix to Matisse*, exh. cat. (Washington, D.C.: National Gallery of Art, 1984), p. 16; Trevor J. Fairbrother, *John Singer Sargent and America* (New York: Garland Publishing, 1986), pp. 44, 47, 50, 163, 347; *John Singer Sargent*, exh. cat. (New York: Whitney Museum of American Art, 1986), pp. 50, 63, 79, 80, 84–85, 86, 106; Stanley Olson, *John Singer Sargent: His Portrait* (London: Macmillan London, 1986), pp. 74, 78, 80, 92, 94, 98, 109, 147; *Sargent at Broadway: The Impressionist Years*, exh. cat. (New York: Coe Kerr Gallery, 1986), p. 12; John E. Sweetman, *The Oriental Obsession* (London: Cambridge University Press, 1988), pp. 225–26; Alev Lytle Croutier, *Harem: The World Behind the Veil* (New York: Abbeville Press, 1989), pp. 85, 88.

W oman with Furs presents a three-quarter view of a fashionable woman making her way through a snow-covered landscape. Dressed in a dark hat, scarf, coat with fur collar, and fur muff, she cuts a sharp figure against the light background. Her forward-leaning posture suggests rapid movement, and this sensation is mirrored in Sargent's broad and vigorous brushwork.

Sargent scholars have been unable to identify positively the model for *Woman with Furs*. David McKibbin linked her with Mme. Eugenia Erràzuriz (1860–1949), the wife of a Chilean diplomat who arrived in Europe shortly after 1880, and whom Sargent painted at least twice in 1884.[1] McKibbin based his identification on a comparison of the profiles of the three portraits. However, while there certainly are similarities among them, the face of the figure in *Woman with Furs* is painted so indistinctly that the sitter cannot be definitively named.

Although *Woman with Furs* is undated, it has traditionally been placed among Sargent's works of the early 1880s. The styles of the inscription and signature as well as the painting technique corroborate this dating.[2] The freedom of the paint handling, for example, can be associated with that found in Sargent's work after his success with *Portrait of Carolus-Duran* (see pp. 166–72).[3] In the first decade of his career (although sometimes later in life as well), Sargent gave more modest works to friends as tokens of his affection (pp. 156–58, 187–88). The recipient of this painting was Hippolyte Vergèses (1847-?), a fellow student in Carolus-Duran's studio, with whom Sargent must have remained friendly after leaving the master's atelier in 1879.

Woman with Furs fits within a group of small, informal oil sketches, mostly of women, which Sargent made throughout his life, and in which he often worked on different artistic problems. In *Woman with Furs* the cropping of the image along the bottom magnifies the appearance of a fleeting instant. At the same time, he considered the effect of contrasting light and dark. Using a palette based in black, brown, and white, he indi-

cated the figure and costume with broad strokes of paint, so that they stand out against the gray landscape. A few hints of peach and yellow in the sky, the flesh color of the woman's face and wrist, and the red of her lips provide counterpoints to the stark image and its surroundings.

Although *Woman with Furs* draws on what Sargent had learned from Carolus-Duran (p. 168), the artistic methods he employed also point to the influence of Edouard Manet (1832–1883).[4] Many of Manet's works of the 1870s, including *On the Beach* (fig. 94), used sketchiness, cropping, and a bold contrasting of light and dark to create the sense of immediacy and informality that Sargent seems to have absorbed for the painting of *Woman with Furs*.

1 David McKibbin's notes about the sitter are in the files of the Coe Kerr Gallery, New York. For biographical information on Mme. Errázuriz, see "The Lady From Chile," *Apollo*, 89 (April 1969), pp. 264–67. The two known dated portraits of Mme. Erràzuriz are *Lady in Black* (1884, oil on canvas, 31¾ × 23¼ inches, whereabouts unknown, reproduced in *Apollo*, 89, p. 264) and *Mme Erràzuriz* (1884, oil on canvas, 21 × 19 inches, private collection, Chile).

2 Odile Duff, director of research, Coe Kerr Gallery, shared with me her expertise on the signature.

3 Both Richard Ormond and Odile Duff made this association.

4 Richard Ormond, *John Singer Sargent: Paintings, Drawings, Watercolors* (London: Phaidon Press, 1970), p. 17, suggests that Sargent's interest in Manet dates to as early as 1874.

Provenance: To Hippolyte Vergèses, Paris; to (M. Knoedler & Co., Paris); to (M. Knoedler & Co., New York); to Robert Sterling Clark, April 29, 1916.

Exhibitions: Sterling and Francine Clark Art Institute, Williamstown, Massachusetts, "Exhibit 7: The Regency and Louis XVI Rooms," May 18, 1957, no. 311 (as *Femme avec Fourrures*); Coe Kerr Gallery, New York, "John Singer Sargent: His Own Work," May 27–June 27, 1980, no. 8.

Woman with Furs, c. 1880–85
(Portrait of D. Vergèses; Femme avec Fourrures; La Femme aux Fourrures)
Oil on canvas
11⁵/₁₆ × 8¾ (28.7 × 22.2)
Signed and inscribed upper left: à mon ami/[?] Vergèses/John S. Sarg/ent
No. 578

Fig. 94: Edouard Manet, **On the Beach,** *1873. Oil on canvas, 23⁷/₁₆ × 28¹³/₁₆ in. (59.5 × 73.2 cm). Musée d'Orsay, Paris.*

Woman with Furs

References: Evan Charteris, *John Sargent* (London: William Heineman, 1927), p. 264 (as *Portrait of D.* [sic] *Vergèses*); Charles Merrill Mount, *John Singer Sargent: A Biography* (New York: W.W. Norton & Co., 1955), p. 444, no. K815; CAI 1957, n.p., pl. XII (as *Femme avec Fourrures*); CAI 1958a, n.p., pl. LIX (as *Femme avec Fourrures*); Richard Ormond, *John Singer Sargent: Paintings, Drawings, Watercolors* (London: Phaidon Press, 1970), p. 236 (as *La Femme aux Fourrures*); CAI 1972, pp. 100, 101; *John Singer Sargent: His Own Work*, exh. cat. (New York: Coe Kerr Gallery, 1980), p. 21 (as *Femme aux Fourrures*); Carter Ratcliff, *John Singer Sargent* (New York: Abbeville Press, 1982), p. 57; CAI 1984, pp. 34, 103; Trevor J. Fairbrother, *John Singer Sargent and America* (New York: Garland Publishing, 1986), p. 362 n. 95.

Venice, a major gateway to the Orient during the Renaissance, was the destination of many tourists, writers, and artists making the Grand Tour of Europe in the nineteenth century. "Venice," Henry James noted in 1882, "has been painted and described many thousands of times, and of all the cities in the world it is the easiest to visit without going there."[1] Numerous Europeans and Americans recorded on canvas and paper the beauty, history, and society of Venice, which gave the city a special exotic charm.[2] Paintings of Venice in the 1870s and 1880s usually depicted either the cityscape or different classes of Venetian society.[3] While many artists, such as Giovanni Boldini (1842–1931) and Mariano Fortuny (1838–1874), painted bright scenes of Venice's most fashionable inhabitants, others — among them Luke Fildes (1844–1903) and Eugène de Blaas (1843–1931) — often presented the downtrodden in bleak settings. Sargent did both, elegantly painting the languid life of contemporary lower-class Venetians.

A Venetian Interior, along with two closely related paintings (figs. 95, 96), is set in the long central hall of a beautiful palazzo on Venice's Grand Canal.[4] By 1880 such once-beautiful palazzi were inhabited by the poor or used for glassworks. In the foreground of *A Venetian Interior,* two women are talking while a third, seated behind them, gazes toward the wall. Along the opposite side of the hall, a single woman stands stringing beads and, further along, a seated group of figures engages in like work. Lit only from the windows at either end of the building, the scene is pervaded by a gray, cool dampness. The mood of the painting accords well with William Dean Howells's 1867 observation: "There is no greater social dullness and sadness, on land or sea, than in contemporary Venice."[5]

A Venetian Interior is one of about twenty works that Sargent made during two trips to Venice (pp. 182–84). The first began in September 1880 and is believed to have ended sometime between January and March 1881; the second began at the end of the summer of 1882.[6] Few of the paintings are dated, and

the repeated use of settings and models complicates the problem of their chronology. At least two Venetian interiors were completed by May 1882, when they appeared at the Grosvenor Gallery in London; thus two, if not all three, of the interior images must be associated with the first trip. Furthermore, Linda Ayres has suggested that the Venetian scenes created around a deep pictorial space should be connected to the artist's 1880–81 trip since the dated works from the second trip, such as *The Sulphur Match* (1882; Jay Maroney, Inc., New York), rely less on this spatial device.[7] The Clark painting has the most dramatically angled and deepest view down the hallway of all three Venetian interiors, which, according to Ayres's criterion, would date it 1880–81.

The reasons behind Sargent's choices of Venetian settings are complex. Sargent had lived in Venice three times before he was eighteen, so that he did not come to the city in the early 1880s as a tourist ready to be overwhelmed by Venice's magnificence and history.[8] Instead, he was attracted to the ordinary, especially to the urban poor. This attraction may also have been influenced by the popularity of peasant and worker subjects in contemporary French art. Sargent was not, however, interested in the political or sentimental overtones often found in pictures of Brittany peasants or African slave markets, and he chose to depict the bead stringers of Venice as he had the ritual pictured in *Fumée d'Ambre Gris* (pp. 172–77): because the foreignness of the subject was compelling and it provided an excellent foil for his artistic concerns. In the case of the Venetian interiors, it was the class and life of the people portrayed rather than the setting that Sargent found exotic.

Central to *A Venetian Interior* is the monochromatic palette based in gray. Within a wide range of tonal variations, alternating areas of dark and light connect the forms in the steeply receding space. Sargent used this approach for the figures' costumes as well as for the suggestion of paintings hanging down the long corridor. The splashes of red dotting the right side and the glints of light

A Venetian Interior, c. 1880–82
Oil on canvas
19¹/₁₆ × 23¹⁵/₁₆ (48.4 × 60.8)
Signed and inscribed lower right: To my friend J.C. CAZIN/John S. SARGENT
No. 580

Fig. 95: John Singer Sargent, **Venetian Bead Stringers,** *1880 or 1882. Oil on canvas, 26⅜ × 30¾ in. (67 × 78.1 cm). Albright-Knox Art Gallery, Buffalo, New York; Friends of the Albright Art Gallery Fund, 1916.*

Fig. 96: John Singer Sargent, **Venetian Interior,** *c. 1880–82. Oil on canvas, 26⅞ × 34³⁄₁₆ in. (68.3 × 86.8 cm). The Carnegie Museum of Art, Pittsburgh; Purchase, 1920.*

—hitting one woman's string of beads and crossing the floor near the far end—provide flashes of brilliance in the otherwise spare, balanced composition.

From his first days in the atelier of Carolus-Duran, Sargent had been involved with the subtle manipulation of color. The richly painted black, especially evident in the women's shawls, and the simple setting and shapes for the figures indicate both Sargent's and his teacher's debt to Diego Velázquez (p. 168). In addition, Sargent may have been inspired by his contemporary James McNeill Whistler (1834–1903) not only in his preference for lower-class subjects, but also in his use of a single, silvery gray to depict the setting.[9] For Sargent, the overall gray tonality could suggest an atmosphere of pervasive boredom among the inhabitants of the palazzo. The lack of interaction among the figures, even among the women chatting, and the stillness captured in the halted gestures add to the sense of paralyzing ennui. The entire painting radiates with elegant brushwork while at the same time defining the dreariness of this stratum of Venetian life.

Sargent's Venetian interiors, possibly including the Clark painting, were not well received at their first showing in 1882 at the Grosvenor Gallery or the following winter in Paris,[10] since they gave viewers neither the Venice nor the sun-filled palette they expected. The noted Boston collector Martin Brimmer found "unpicturesque subjects, absence of color, and absence of sunlight."[11] The writer for the *Gazette des Beaux-Arts* was particularly incensed that Italy be depicted in this manner: "The women of [Sargent's] Venice . . . are no descendants of Titian's beauties. Why go to Italy if it is only to gather impressions like these."[12] The lower rungs of society may have been suitable for depictions of rural Brittany but not for noble, cosmopolitan Venice! Consequently, the pictures did not sell immediately, and Sargent used them both in trade for goods and as presents to friends.[13] Around 1881–82 Sargent gave *A Venetian Interior* to Jean-Charles Cazin (1841–1901), a fellow painter in Paris.[14] It was not until their exhibition in America in 1888 that the Venetian pictures began to receive favorable notices. Then, on the strength of the beautiful paint handling seen in both a Venetian interior and a street scene at the National Academy of Design, they, and Sargent, came to represent to the American art world the best of the new trends in painting.[15]

1 Henry James, "Venice," *Century Illustrated Magazine*, 25 (November 1882), p. 3.

2 For an account of the American visual response to Venice, see *Venice: The American View, 1860–1920*, exh. cat. (San Francisco: The Fine Arts Museums of San Francisco), 1964.

3 Linda Ayres, "Sargent in Venice," in *John Singer Sargent*, exh. cat. (New York: Whitney Museum of American Art, 1986), p. 64.

4 Many of the facts and conclusions about this painting are drawn from conversations with Linda Ayres and from her excellent essay "Sargent in Venice."

5 William Dean Howells, *Venetian Life* (1867; ed. Boston: Houghton Mifflin Co., 1882), p. 16.

6 The exact dates of Sargent's departure from Venice on the first trip or his arrival and departure on the second have not been pinned down; see Ayres, "Sargent in Venice," pp. 49 and 71 n. 5.

7 Linda Ayres to the author, July 27, 1988, CAI curatorial files.

8 The Sargent family had resided in Venice when John was a baby, when he was fourteen, and again when he was seventeen; see Stanley Olson, *John Singer Sargent: His Portrait* (London: Macmillan London, 1986), pp. 94–95.

9 Ayres, "Sargent in Venice," p. 54.

10 It is impossible today to confirm the Clark painting as one of the works shown in London. However, the three Venetian interiors—the Clark's and those at the Albright-Knox Art Gallery and the Carnegie Museum of Art—are sufficiently alike to have elicited similar responses.

11 Brimmer to Sarah Whitman, October 26, 1882, quoted in Olson, *John Singer Sargent*, p. 95.

12 Arthur Baignères, "Première Exposition de la Société des Peintres et Sculpteurs," *Gazette des Beaux-Arts*, 26 (1883), p. 190.

13 Ayres, "Sargent in Venice," p. 70.

14 With the bill of sale for the painting from M. Knoedler & Co. to Robert Sterling Clark, CAI curatorial files, came a quotation from a letter from Mme J.-C. Cazin which states that she and her husband received the painting around 1881–82.

15 See, for example, "The Academy Exhibition," *The Commercial Advertiser* (New York), April 5, 1888, p. 3. The interior shown at the Academy was not the Clark painting, but that owned at the time by the artist J. Carroll Beckwith (1852–1917).

Provenance: To Jean-Charles Cazin, Paris, c. 1881–82; to Mme Cazin (his widow); to Constant Coquelin, Sr., Paris; to Mme Meiris, Paris; to Georges Bernheim; to (M. Knoedler & Co., Paris, September 25, 1913); to Robert Sterling Clark, November 29, 1913.

Related Works: Venetian Bead Stringers, 1880 or 1882, oil on canvas, 26⅜ × 30¾ (67 × 78.1), Albright-Knox Art Gallery, Buffalo; Friends of the Albright Art Gallery Fund, 1916.

Venetian Interior, c. 1880–82, oil on canvas, 26⅞ × 34³⁄₁₆ (68.3 × 86.8), The Carnegie Museum of Art, Pittsburgh; Museum Purchase, 1920.

Exhibitions: Grosvenor Gallery, London, 1882 (possibly the same work); Société Internationale des Peintres et Sculpteurs, Paris, "Première Exposition," December 1882, possibly no. 96 or 97; Sterling and Francine Clark Art Institute, Williamstown, Massachusetts, "Exhibit 7: The Regency and Louis XVI Rooms," May 18, 1957,

A Venetian Interior

no. 316; Wildenstein and Co., New York, "An Exhibition of Treasures from the Sterling and Francine Clark Art Institute," February 2–25, 1967, no. 49; The Metropolitan Museum of Art, New York, "Nineteenth-Century America," April 16–September 7, 1970, no. 177; Whitney Museum of American Art, New York, "John Singer Sargent," October 7, 1986–January 4, 1987.

References: Henry James, "John S. Sargent," *Harper's New Monthly Magazine*, 75 (October 1887), p. 689 (possibly the same work); Royal Cortissoz, "The Field of Art," *Scribner's Magazine*, 75 (March 1924), p. 347; Nathaniel J. Pousette-Dart, *John Singer Sargent* (New York: Frederick A. Stokes, 1924), p. 27; Frank Jewett Mather, Jr., *Estimates in Art, Series II: 16 Essays on American Painters of the 19th Century* (New York: Henry Holt & Co., 1931), p. 240; Charles Merrill Mount, *John Singer Sargent: A Biography* (New York: W.W. Norton & Co., 1955), p. 445, no. K8219; CAI 1957, pl. XVII; CAI 1958a, pl. LXVII; Charles Merrill Mount, "Carolus-Duran and the Development of Sargent," *The Art Quarterly*, 26 (Winter 1963), p. 394; *An*

Exhibition of Treasures from the Sterling and Francine Clark Art Institute, exh. cat. (New York: Wildenstein and Co., 1967); Richard Ormond, "Sargent's *El Jaleo*," *Fenway Court: Isabella Stewart Gardner Museum, 1970* (Boston: Isabella Stewart Gardner Museum, 1971), pp. 9, 12; CAI 1972, p. 100; *John Singer Sargent and the Edwardian Age*, exh. cat. (Leeds, England: Leeds Art Galleries, 1979), p. 26; Margaretta M. Lovell, "A Visitable Past: Views of Venice by American Artists," Ph.D. dissertation, Yale University, New Haven, 1980, p. 112; S. Lane Faison, Jr., *The Art Museums of New England: Massachusetts* (Boston: David R. Godine, Publishers, 1982), p. 324; Carter Ratcliff, *John Singer Sargent* (New York: Abbeville Press, 1982), p. 26; CAI 1984, pp. 34, 103; Trevor J. Fairbrother, *John Singer Sargent and America* (New York: Garland Publishing, 1986), pp. 361–62 n. 95; *John Singer Sargent*, exh. cat. (New York: Whitney Museum of American Art, 1986), pp. 50, 52, 53, 70; Margaretta M. Lovell, *Visitable Past: Views of Venice by American Artists, 1860–1915* (Chicago and London: University of Chicago Press, 1989), pp. 81–82, 83.

A Street in Venice, c. 1880–82

Oil on canvas

29⁹/₁₆ × 20⁵/₈ (75.1 × 52.4)

Signed and inscribed lower right: John S. Sargent/Venise

No. 575

Fig. 97: John Singer Sargent, **Street in Venice,** c. 1880–82. Oil on panel, 17¾ × 21¼ in. (45.1 × 54 cm). National Gallery of Art, Washington, D.C.; Gift of the Avalon Foundation.

Venice has more than two thousand alleys that crisscross the city.[1] Among these *calles,* which William Dean Howells has characterized as "the narrowest . . . and most inconsequent little streets in the world,"[2] Sargent found interesting subjects for a small group of paintings in the early 1880s. In *A Street in Venice* and two related canvases (figs. 97, 98), he explored the people and outdoor environment of the lower echelons of society at the same time and in much the same manner as he did their indoor life in *A Venetian Interior* (pp. 179–82). In the street paintings, however, he paid particular attention to the relationships between men and women.[3] In *A Street in Venice,* a man and woman converse in front of a wine cellar—so identified by the grape-leaf insignia and names of wines around the door frame—in one of the city's narrow alleys. Within the dramatically plunging space, Sargent suggested not only the languor of the lives and places he portrayed but also his fascination with it.

As noted earlier (pp. 179–82), the similarity of subjects and models makes it difficult to give a chronological sequence to the undated works from Sargent's 1880 and 1882 trips to Venice. Linda Ayres's association of the more deeply spaced compositions with the earlier trip would make *A Street in Venice* a logical candidate for an 1880–81 dating.[4] At this point, however, there is no conclusive evidence to attach this date rather than one of 1882 firmly to the painting.

A Street in Venice appears at first glance to depict an everyday, accidental meeting. The

shallow foreground, cropped edges, more sharply resolved figures against a blurred background, and the frozen stances all promote an air of immediacy. But on closer study these same strategies create a decidedly uneasy and extraordinary atmosphere. Sargent also added tension to the composition through the nearly claustrophobic, tunnellike space. The dim light within the alley—made even dimmer by the sunshine radiating at the far end—casts a pall over the entire image. In addition, the deep black masses that define the figures give them a certain psychic presence within the small passageway, and the woman clearly gazes out toward the viewer as much as to her companion. Although the pair stands close together, their self-conscious postures deny contact between them. Without any descriptive narrative, Sargent presented a scene of dreariness and alluded to complications between two people living on the fringes of respectability.

The effect of Sargent's Venice view parallels the writings of William Dean Howells (p. 179) and Mark Twain, who employed sophisticated language to describe the indolence and grim yet sensual character of a once-glorious Venice.[5] The beautiful painterly technique magnifies the exotic qualities of the subject and contradicts its very ordinariness. Freely brushed, the textures of the exposed brick wall and the woman's overskirt, in different shades of salmon, are juxtaposed to rich but dull grays and black to make *A Street in Venice* one of Sargent's most richly painted surfaces. He relied on gesture, spatial

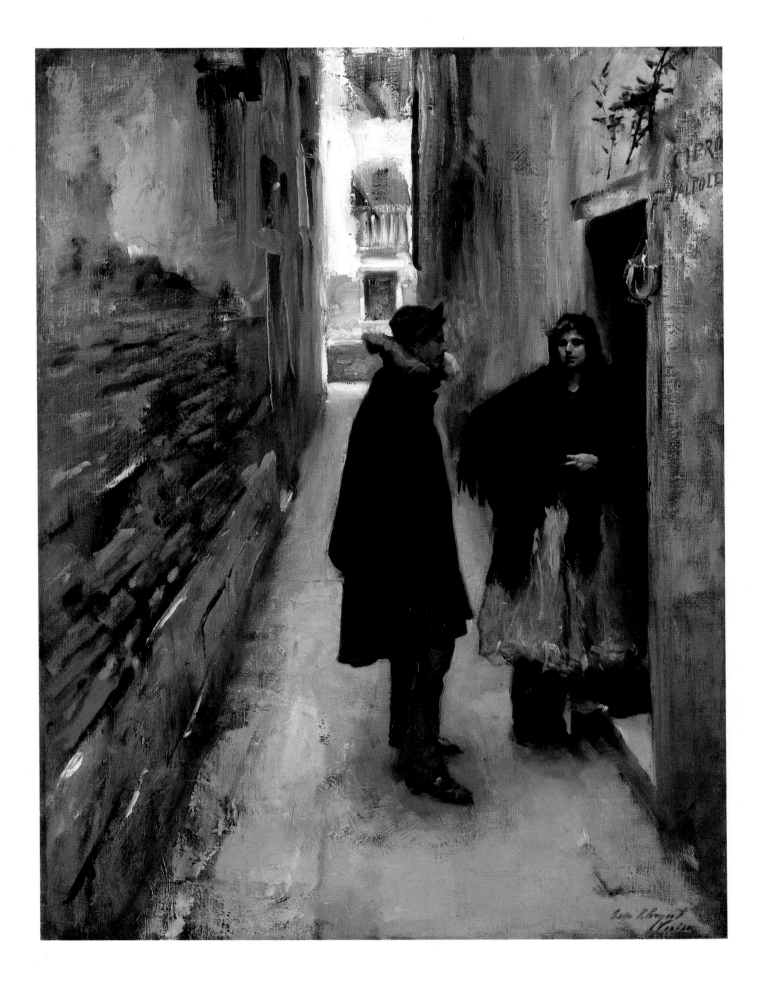

Fig. 98: John Singer Sargent, **Venetian Street,** c. 1880–82. Oil on canvas, 29 × 23¾ in. (73.7 × 60.3 cm). Collection of Rita and Daniel Fraad.

Fig. 99: Giovanni Boldini, **Crossing the Street,** 1875. Oil on panel, 18¹/₁₆ × 14¾ in. (45.9 × 37.5 cm). Sterling and Francine Clark Art Institute.

relationships, and especially the elegance of paint to make an image at once somber and alluring.

Although Sargent's Venice may be comparable to the literature of the day, his images were not without references to visual sources. He was certainly familiar with the work of Giovanni Boldini (1842–1931), who resided in Venice in 1880.[6] Although Boldini exclusively depicted fashionable society, Sargent may have found in the Italian's work the inspiration to represent everyday tasks from a slice-of-life viewpoint like that seen in *Crossing the Street* (fig. 99). *A Street in Venice* also reflects the artist's tremendous debt to Diego Velázquez (p. 168).[7] From the Spanish master, Sargent appropriated the use of broadly painted dark areas silhouetted against a lighter, indistinct background to shape figures, especially the man in *A Street in Venice.*

Sargent's awareness of photographs of Venice also may have affected the Venetian street paintings. The cropping, frozen-moment postures, and central focus in the Clark painting have affinities with contemporaneous photography. Venice was one of the most frequently photographed cities, and Sargent may have known the photographs of Venetian lower classes taken by Carlo Naya (1816–1882) or Brogi Studios.[8]

Like most of Sargent's other 1880–82 Venetian paintings, *A Street in Venice* was given away as a gift: Sargent presented it to J. Nicolopuolo, the Greek minister to France.[9]

1 *Americans in Venice: 1879–1913,* exh. cat. (New York: Coe Kerr Gallery, 1983), p. 14.

2 William Dean Howells, *Venetian Life* (1867; ed. Boston: Houghton Mifflin Co., 1894), p. 32, quoted in Linda Ayres, "Sargent in Venice" in *John Singer Sargent,* exh. cat. (New York: Whitney Museum of American Art, 1986), p. 56.

3 Ayres, "Sargent in Venice," p. 66.

4 Ayres to the author, July 27, 1988, CAI curatorial files.

5 Ayres, "Sargent in Venice," p. 56.

6 Sargent probably knew Boldini's work as early as 1876, when it appeared in the Philadelphia Centennial, which he visited on his first trip to America; ibid., p. 58.

7 It was in the early 1880s that critics first began remarking on Velázquez's influence on Sargent; ibid., p. 55.

8 Ibid., p. 64.

9 No information about Nicolopuolo has come to light. The bill of sale for this painting from Scott and Fowles to Robert Sterling Clark states that Nicolopuolo received the painting from Sargent and that he was the Greek minister to France at the time.

Provenance: To J. Nicolopuolo; (Scott and Fowles, New York); to Robert Sterling Clark, November 2, 1926.

Related Works: Venetian Street, c. 1880–82, oil on canvas, 29 × 23¾ (73.7 × 60.3), collection of Rita and Daniel Fraad.

Street in Venice, c. 1880–82, oil on panel, 17¾ × 21¼ (45.1 × 54), National Gallery of Art, Washington, D.C.; Gift of the Avalon Foundation.

Exhibitions: Sterling and Francine Clark Art Institute, Williamstown, Massachusetts, "Exhibit 7: The Regency and Louis XVI Rooms," May 18, 1957, no. 315; Wildenstein and Co., New York, "An Exhibition of Treasures from the Sterling and Francine Clark Art Institute," February 2–25, 1967, no. 48; Sterling and Francine Clark Art Institute, Williamstown, Massachusetts, "A Scene of Light and Glory Approaches to Venice," March 20–April 25, 1982, no. 58; The Fine Arts Museums of San Francisco, "Venice: The American View, 1860–1920," October 20, 1984–January 20, 1985, and The Cleveland Museum of Art, February 27–April 21, 1985, no. 52.

References: Royal Cortissoz, "The Field of Art," *Scribner's Magazine,* 75 (March 1924), p. 347; Charles Merrill Mount, *John Singer Sargent: A Biography* (New York: W.W. Norton & Co., 1955), p. 444, no. K8211; CAI 1957, n.p., pl. XVI; CAI 1958a, n.p., pl. LXVI; Charles Merrill Mount, "Carolus-Duran and the Development of Sargent," *The Art Quarterly,* 26 (Winter 1963), pp. 399, 400, 401; Denys Sutton, "A Bouquet for Sargent," *Apollo,* 79 (May 1964), pp. 397, 399; *Exhibition of Works by John Singer Sargent, R.A.,* exh. cat. (Birmingham, England: Birmingham Museum and Art Gallery, 1964), p. 9; *An Exhibition of Treasures from the Sterling and Francine Clark Art Institute,* exh. cat. (New York: Wildenstein and Co., 1967); Richard Ormond, *John Singer Sargent: Paintings, Drawings, Watercolors* (London: Phaidon Press, 1970), p. 30; CAI 1972, p. 100; *John Singer Sargent and the Edwardian Age,* exh. cat. (Leeds, England: Leeds Art Galleries, 1979), p. 26; Margaretta M. Lovell, "A Visitable Past: Views of Venice by American Artists," Ph.D. dissertation, Yale University, New Haven, 1980, p. 107; CAI 1981, pp. 88, 89; *A Scene of Light and Glory: Approaches to Venice,* exh. cat. (Williamstown, Massachusetts: Sterling and Francine Clark Art Institute, 1982), pp. 38, 39; CAI 1984, pp. 34, 103; *Venice: The American View, 1860–1920,* exh. cat. (San Francisco: The Fine Arts Museums of San Francisco, 1984), pp. 97–98; *American Paintings, Watercolors and Drawings from the Collection of Rita and Daniel Fraad,* exh. cat. (Fort Worth: Amon Carter Museum, 1985), p. 28; *John Singer Sargent,* exh. cat. (New York: Whitney Museum of American Art, 1986), pp. 56, 58–59, 61, 68–70; Stanley Olson, *John Singer Sargent: His Portrait* (London: Macmillan London, 1986), p. 148; Margaretta M. Lovell, *Visitable Past: Views of Venice by American Artists, 1860–1915* (Chicago and London: University of Chicago Press, 1989), pp. 75–76, 78.

Louise Lefèvre Escudier (1861–1950) was the wife of Paul Escudier (1858–1931), a prominent Parisian lawyer and politician.[1] Her social position would have made her a likely portrait client for Sargent. *Madame Escudier* is a half-length, informal presentation, one of the many smaller, casual images that Sargent painted of friends, other artists, and social acquaintances between 1877 and 1893.[2] Common to these paintings is a broadly brushed technique that projected the sitters' vivacious personalities.

Because Sargent painted a full-length portrait of Louise Escudier in 1882 (private collection), the Clark painting has traditionally been dated c. 1882. Richard Ormond, however, has also recognized specific similarities between *Madame Escudier* and several 1884 Sargent portraits that especially affirm the stylishness of the sitters.[3] In this sense, the Escudier portrait can be likened to Sargent's 1884 *Madame X* (fig. 100). Though used to a different effect in each picture, the contrast between the sitters' very pale complexions and dark costumes heightens the individual characterizations.

Typical of many Sargent portraits, *Madame Escudier* is at once elegant and spirited. A captured glance articulates the sitter's personality, and the choice of background color and dramatic lighting accentuates the overall effect of her expression. Mme Escudier's direct gaze, slightly tilted head, and self-conscious smile suggest a knowing yet charming person. The bravura brushwork adds a richness to her fashionable costume and accessories that emphasizes her chic. The Prussian-blue background offsets her black outfit, serves as a rich backdrop for her face, and beautifully complements her copper hair. The blue is also the tone in which the face is completely underpainted, adding a coolness to the light that models Mme Escudier's oval-shaped face, intensifying her shining eyes, and providing a unifying harmony across the image.

Sargent may have painted pictures like *Madame Escudier* to encourage commissions for more formal, large-scale portraits, but the informal works also seem to derive from his desire to record observations.[4] In painting *Madame Escudier*, he may have been following the advice he would give in the 1890s: "Paint a hundred studies, keep any number of clean canvases ready, of all shapes and sizes so that you are never held back by the sudden need of one."[5] Sargent saw a glance, a posture, and a vitality in Mme Escudier that he could not let slip by his brush. Pleased with the result, he presented it to the sitter.

1 *Dictionnaire de biographie française* (Paris: Librairie Letouzey et Ané, 1970), vol. 12, p. 1458.

2 Richard Ormond, *John Singer Sargent: Paintings, Drawings, Watercolors* (London: Phaidon Press, 1970), p. 30.

3 Ibid., p. 21.

4 Ibid., p. 20.

5 Evan Charteris, *John Sargent* (London: William Heineman, 1927), p. 185.

Provenance: To Mme Louise Escudier, Paris; Lerolle Collection, Paris; to (M. Knoedler & Co., Paris, May 20, 1925); to Robert Sterling Clark, July 13, 1925.

Exhibitions: Sterling and Francine Clark Art Institute, Williamstown, Massachusetts, "Exhibit 7: The Regency and Louis XVI Rooms," May 18, 1957, no. 313; Wildenstein and Co., New York, "An Exhibition of Treasures from the Sterling and Francine Clark Art Institute," February 2–25, 1967, no. 47.

References: Charles Merrill Mount, *John Singer Sargent: A Biography* (New York: W.W. Norton & Co., 1955), p. 429; *Sargent's Boston*, exh. cat. (Boston: Museum of Fine Arts, 1956), p. 95; CAI 1957, n.p., pl. XIV; CAI 1958a, n.p., pl. LXI; *An Exhibition of Treasures from the Sterling and Francine Clark Art Institute*, exh. cat. (New York: Wildenstein and Co., 1967), n.p.; Richard Ormond, *John Singer Sargent: Paintings, Drawings, Watercolors* (London: Phaidon Press, 1970), pp. 21, 240; CAI 1972, pp. 98, 99; *John Singer Sargent and the Edwardian Age*, exh. cat. (Leeds, England: Leeds Art Galleries, 1979), p. 26; CAI 1984, pp. 34, 103.

Madame Escudier, c. 1882–84

Oil on canvas
28¾ × 23½ (73 × 59.7)
Signed and inscribed upper left: à Madame Escudier/John S. Sargent
No. 581

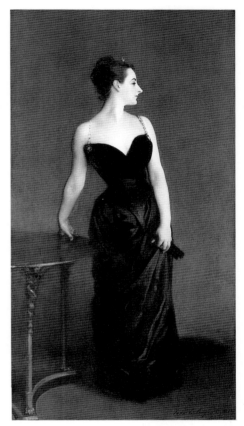

*Fig. 100: John Singer Sargent, **Madame X (Mme Pierre Gautreau)**, 1884. Oil on canvas, 82⅛ × 43¼ in. (208.6 × 109.9 cm). The Metropolitan Museum of Art, New York; Arthur H. Hearn Fund, 1916.*

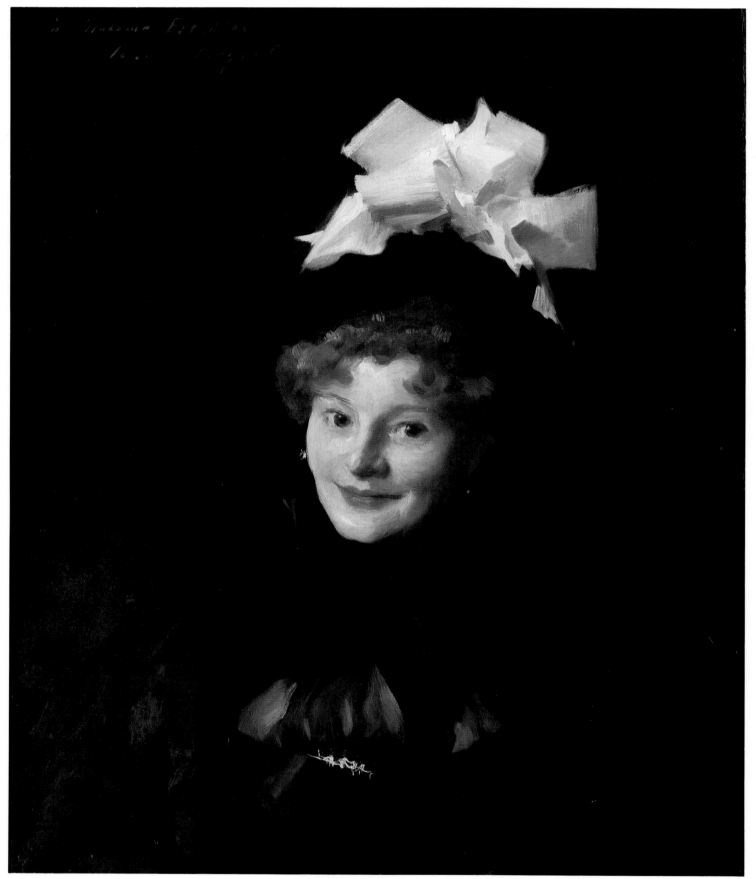

Madame Escudier

Children were not uncommon subjects in Sargent's art, and portraits of them brought the artist considerable success during the 1880s.[1] From 1884 to 1886 he was especially occupied with the theme as he fulfilled his commission to paint the Vickers children and created *Carnation, Lily, Lily, Rose* (1885–86; The Tate Gallery, London). Apart from commissions, Sargent also painted friends and their families and presented the results to the sitters.[2] The portrait of Mlle Jourdain, inscribed to her mother *à mon amie,* fits this category of gift works. Mlle Jourdain was the daughter of Renée and Roger Jourdain. The Jourdains—he an artist, she a notable socialite—had been Sargent's neighbors from 1883 to 1886, when his studio was located at 41 boulevard Berthier in Paris.[3] Nothing is known about young Mlle Jourdain except that she died at age eight.[4]

Sargent must have painted Mlle Jourdain sometime during his April–July 1889 visit to Paris. London had been his permanent residence since the spring of 1886, but he often traveled for commissions or, as was the case for the 1889 trip to Paris, to see his works on exhibition. He had six paintings in the American section of the 1889 Exposition Universelle held in the early summer of 1889. On this same trip, he was also decorated as a chevalier of the Legion of Honor.[5]

Mlle Jourdain, her face framed by a curly mop of hair and her white shift accentuated with bows at the shoulders, has an air of innocence and purity. In Sargent's frontal, half-length view, Mlle Jourdain stares straight out, seemingly into space. The slightly high vantage point puts the child literally on a different level from that of the viewer and augments the sense of separation the blank stare encourages.

The girl's face is painted to a considerable degree of completeness, while her dress and the background are very loosely and vigorously brushed. The combination of frontal pose, high viewpoint, wide-eyed stare, and mixed paint application gives Mlle Jourdain an angelic, somewhat otherworldly persona. Although there is nothing to indicate that this is a posthumous portrait,[6] our knowledge of the girl's premature death adds poignancy to our viewing.

Sargent's method and approach to his subject were ones he used frequently at this time and shared with some of his American colleagues. The completely frontal stance appears in his 1888 portrait of Isabella Stewart Gardner (fig. 101) and was also frequently used by Abbott Thayer (1849–1921) in his paintings of Madonna-like women and angelic children. Sargent, who spent seven months during 1887–88 in the United States, most likely knew Thayer's work if not the artist himself. In works such as Thayer's *Angel* (fig. 102), Sargent may have been reminded of the power of the frontal stance when painting children. On several occasions he had combined this pose with the higher point of view that he reserved for paintings of children.[7] It had appeared a decade earlier in *Neapolitan Children Bathing* (pp. 163–66), in the 1882 *Daughters of Edward Darley Boit* (Museum of Fine Arts, Boston), and in the 1884 portraits of the Vickers children.

The looseness of the painting of Mlle Jourdain's dress and background may be associated with Sargent's excursion into Impressionism in the mid- to late 1880s.[8] But as William H. Gerdts has pointed out, Sargent's Impressionism was always most cautious.[9] As in *Mademoiselle Jourdain,* the figures remained well formed even when backgrounds and costumes were painted extremely freely.

The critic Mariana Griswold van Rensselaer highly praised Sargent for his ability to paint children. Topping her list of criteria for a successful portrait of a child was the need "to preserve the naïve infantile look of a face upon which time and experience have made no marks, and at the same time to express the character and soul which reveal themselves so shyly. . . ."[10] Sargent, in *Mademoiselle Jourdain,* was able to capture those qualities in his young sitter. Unblemished and self-contained, she is a model of childlike seriousness with just a hint, in the sparkle of her eyes, of impishness.

1 Trevor J. Fairbrother, *John Singer Sargent and America* (New York: Garland Publishing, 1986), p. 9. For other Sargent images of children in the Clark collection, see pp. 163–66 in this volume.

2 This is also the case with *Madame Escudier* in the Clark collection.

3 The Jourdains lived at no. 45; see Stanley Olson, *John Singer Sargent: His Portrait* (London: Macmillan London, 1986), p. 100.

4 This information came with the painting when it was purchased through M. Knoedler & Co. in 1933; CAI curatorial files.

5 Olson, *John Singer Sargent,* p. 51.

6 There are no known posthumous portraits in Sargent's oeuvre, and efforts to ascertain Mlle Jourdain's dates have been unsuccessful.

7 This feature of Sargent's paintings of children is discussed in Martha Kingsbury, "John Singer Sargent: Aspects of His Work," Ph.D. dissertation, Harvard University, Cambridge, Massachusetts, 1969, p. 63.

Mademoiselle Jourdain, 1889

Oil on canvas

23⅝ × 17¹¹⁄₁₆ (60 × 44.9)

Signed, dated, and inscribed across top: à mon amie Madame Jourdain John S. Sargent/89

No. 576

*Fig. 101: John Singer Sargent, **Isabella Stewart Gardner,** 1888. Oil on canvas, 74¾ × 31½ in. (189.8 × 80 cm). Isabella Stewart Gardner Museum, Boston.*

*Fig. 102: Abbott Handerson Thayer, **Angel,** c. 1889. Oil on canvas, 36¼ × 28⅛ in. (92.1 × 71.4 cm). National Museum of American Art, Smithsonian Institution, Washington, D.C.; Gift of John Gellatly.*

8 For a thorough discussion of Sargent's venture into Impressionism, see William H. Gerdts, "The Arch-Apostle of the Dab-and-Spot School: John Singer Sargent as an Impressionist," in *John Singer Sargent,* exh. cat. (New York: Whitney Museum of American Art, 1986), pp. 111–45.

9 Ibid., p. 116.

10 M[ariana] G[riswold] van Rensselaer, "John S. Sargent," *Century Illustrated Magazine,* 44 (March 1892), p. 798.

Provenance: To Mme Renée Jourdain (the sitter's mother), Paris; (Hector Brame, Paris); to (M. Knoedler & Co., New York, April 21, 1933); to Robert Sterling Clark, June 21, 1933.

Exhibitions: Reinhardt Galleries, New York, "Exhibition for the Benefit of the Children's Welfare Association," April–May 1933; Sterling and Francine Clark Art Institute, Williamstown, Massachusetts, "Exhibit 7: The Regency and Louis XVI Rooms," May 18, 1957, no. 314.

References: Charles Merrill Mount, *John Singer Sargent: A Biography* (New York: W.W. Norton & Co., 1955), pp. 59, 428; *Sargent's Boston,* exh. cat. (Boston: Museum of Fine Arts, 1956), p. 104; CAI 1957, n.p., pl. XV; CAI 1958a, n.p., pl. LXII; CAI 1972, pp. 98, 99; Maureen C. O'Brien, "John Singer Sargent: Portrait of Ernest-Ange Duez," in *The American Painting Collection of the Montclair Art Museum* (Montclair, New Jersey: Montclair Art Museum, 1979), pp. 13, 16 n. 28; CAI 1984, pp. 34, 104; Stanley Olson, *John Singer Sargent: His Portrait* (London: Macmillan London, 1986), p. 100.

Mademoiselle Jourdain

Henry Pember Smith
1854–1907

Henry Pember Smith was born February 20, 1854, in Waterford, Connecticut. Although nothing is known about his early life or training, he was residing in New York by 1877, when he first exhibited at the National Academy of Design. For the next twenty years Smith exhibited regularly at the Academy, and his work also appeared at the American Watercolor Society and the Artists' Fund Society, two organizations of which he was a member. Judging by the titles of paintings included in the sale of his estate in 1910, it seems that Smith traveled extensively in Europe and New England and at least once to the Pacific Coast. The majority of his works depict Brittany, Cornwall, Venice, Connecticut, Maine, and New Jersey.

Although prolific, Smith attracted only nominal attention.

Smith moved to Asbury Park, New Jersey, for the last six years of his life. His obituary in *The New York Times,* which focused on the cause of death and his wife's social position, suggests that Smith died in relative obscurity as an artist.

Bibliography: Polly King, "New England and Old Italy," *Monthly Illustrator,* 4 (June 1895), p. 364; "H.P. Smith, Artist, Dead," *The New York Times,* October 18, 1907, p. 11; *Sale of the Property of John Miller and J.M. Stanfield. Also Supplementary Sale of All the Remaining Oil Paintings and Watercolors of the Late Well-Known Artist Henry P. Smith,* sales cat. (New York: Fifth Avenue Art Galleries, April 27–29, 1910).

Village Landscape, 1881
(River Landscape)
Oil on canvas
$10^{15}/_{16} \times 14^{5}/_{16}$ (27.8 × 36.4)
Signed and dated lower left:
HENRY P. SMITH 1881
No. 856

In the last quarter of the nineteenth century, American landscape painting underwent a significant transformation. The critic Sylvester Koehler described this change in picturing the landscape as being "from the view, the subject-matter of the scene, the objects of which it is made up, to the soul of nature — from the descriptive to the sympathetic, — from mere recording of observations to the expression of the sentiments which nature awakens in us, or which, perchance, we reflect upon her."[1] *Village Landscape,* painted in 1881, is a typical example of how Henry Pember Smith was affected by this change of attitude among landscape painters. Although he carefully described the buildings of the New England village, the depiction of the landscape reflects the influence of Barbizon painting and its emphasis on mood. The French style can also be detected in Smith's use of muted grays and greens and the soft-focus haze that permeates the atmosphere of the scene.

Smith's interest in blending a crisp delineation of architecture with a Barbizon-type landscape was noticed by critics in the 1880s and elicited a mixed response. Whereas S.G.W. Benjamin praised Smith's "fine atmosphere and crisp technique," Clarence Cook found the same elements overwrought.[2] These extremes of response may have been due to the lack of consensus among critics in

the early 1880s, but by the next decade it was generally agreed that Smith's pictures of New England, "always restful, cheerful," were his finest.[3]

1 Sylvester R. Koehler, *American Art* (1886; reprint, New York: Garland Publishing, 1978), p. 23.

2 S.G.W. Benjamin, "The Exhibitions, V — The National Academy of Design," *American Art Review,* 1 (1880), p. 350, and Clarence Cook, "The Art Gallery," *The Art Amateur,* 6 (March 1882), p. 75.

3 The tranquil nature of Smith's New England pictures was praised in "Reichard and Co.'s Opening," *The Collector,* 1 (September 1, 1890), p. 153; Polly King, "New England and Old Italy," *Monthly Illustrator,* 4 (June 1895), p. 364; and *Chicago Times Herald,* undated [April 1898] newspaper clipping, The Art Institute of Chicago scrapbook, vol. 9, p. 151.

Provenance: Mrs. F.B. Keech, New York; to (American Art Association, "Sale of an Important Collection of Oil Paintings by American and Foreign Artists," April 15–19, 1919, no. 45); to J.C. Willever, New York; to (Parke-Bernet Galleries, New York, "English and Continental Furniture, Paintings, Georgian Silver, Lace, Porcelains, Rugs," April 14–16, 1943, no. 528, as *River Landscape*); to Robert Sterling Clark, April 16, 1943.

References: CAI 1958, n.p.; CAI 1972, pp. 102–103; CAI 1984, pp. 35, 102.

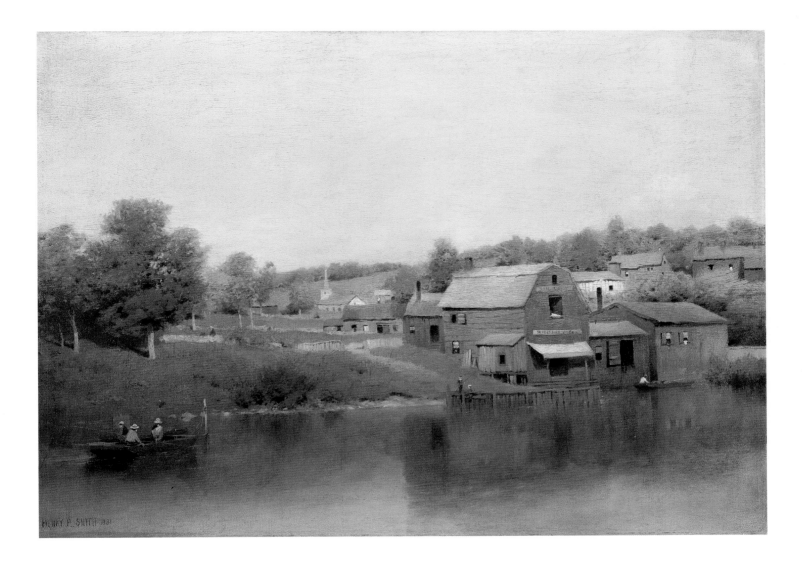

George Henry Story
1835–1922

Born on January 22, 1835, in New Haven, George Henry Story began to paint after apprenticing with a wood-carver. He traveled to Europe in the mid-1850s and on his return in 1858 opened a studio in Portland, Maine. By 1860 he had moved to Washington, D.C., where he remained for two years. After a trip to the Caribbean in 1862, he settled in New York City to devote himself to painting, specializing in portraiture and genre subjects. He was elected an associate of the National Academy of Design in 1875 and received a medal at the Centennial Exhibition in Philadelphia the next year.

In 1889 Story was appointed curator of paintings at the Metropolitan Museum of Art; he became curator emeritus in 1906. He was also president of the Artists' Fund Society for nine years and from 1899 until his death served as honorary curator at the Wadsworth Atheneum in Hartford, Connecticut. Story continued to paint throughout his career as a museum professional; in the years immediately before his death, he added landscape to his repertory of themes.

Bibliography: "George H. Story, Artist, Dies at 87," *The New York Times,* November 25, 1922. p. 13; Natalie Spassky, *American Paintings in The Metropolitan Museum of Art* (New York: The Metropolitan Museum of Art, 1985), vol. 2, p. 409.

The Young Artist, 1873

Oil on canvas

36 × 29⅛ (91.4 × 74)

Signed and dated lower left: G H Story/1873

Gift of Mrs. Anson Phelps Stokes and Mrs. Peter Frelinghuysen in memory of their parents Mr. and Mrs. Rodney Procter

No. 1973.14

*Fig. 103: Thomas Couture, **Soap Bubbles,** 1859. Oil on canvas, 51½ × 38⅝ in. (130.8 × 98.1 cm). The Metropolitan Museum of Art, New York; Bequest of Catherine Lorillard Wolfe, 1887.*

During the decade after the Civil War, children became increasingly popular subjects for American artists. As Henry T. Tuckerman wrote in 1867: "Always and everywhere the image of childhood to poet and painter, to the landscape, the household, the shrine, the temple and the grave . . . is a redeeming presence, a harmonizing and hopeful element, the token of what we were, and prophecy of what we may be."[1] With almost a generation of young men killed during the Civil War, young children and adolescents symbolized the future to a shattered adult world. As a result, society's attitude toward children changed, and childhood became a serious issue in the 1870s.[2] A number of artists, including Winslow Homer (pp. 63–100), Eastman Johnson (1824–1906), J.G. Brown (1831–1913), and George Henry Story, frequently featured children in their paintings of the 1860s and 1870s.

The Young Artist may in part be a reminiscence of the artist's own boyhood in the late 1840s, but it developed out of the new consciousness about childhood. A brass plate, currently attached to the painting and possibly surviving from the original frame, reads: "And pausing while his work is but begun/His thoughts leap forward to the coming years/And picture triumphs which will yet be won." These words complement Story's image of an angelic-looking youth contemplating the results of his endeavors on a canvas. In presenting this moment of reverie, Story also gave his viewers a glimpse of where the hope for American art resided. Among the other works he painted in the 1870s that concentrated on youth were *The Young Student* and *The Young Mother* (both by 1876) and *Young America* (by 1878).[3]

Story's choice of subject may have been stimulated by current attitudes in the United States, but his presentation reflects a knowledge of French painting, especially the work of Thomas Couture (1815–1879). Couture, very popular with both American art students and patrons at this time, had produced a group of paintings in the late 1850s on the theme of adolescence. Story could have seen them either in Paris, during his European sojourn in the 1850s, or in New York, between his 1862 arrival and the 1873 painting of *The Young Artist.*[4]

Couture stressed painting with color directly on the canvas. In general, Americans influenced by Couture absorbed his organization of the canvas into light and dark values, his outlined forms set against a highlighted spot in the background, and his build-up of light areas with solid opaque color.[5] Story's *The Young Artist* displays all these technical approaches even though the figure's face and hands are taken to a much higher degree of finish than in most of Couture's work. However, a greater amount of polish and detail, especially in the painting of flesh, often appeared in Couture's American commissions.[6]

The Young Artist and Couture's *Soap Bubbles* (fig. 103), which was owned and exhibited in the United States in 1864, have notable similarities. Except for replacing the French boy's books with an easel, Story has nearly replicated, in reverse, Couture's composition and figure.[7] Story even retained the angle of the bubble blower's head, so that the young artist's far eye, too, is barely visible. Yet he eschewed the moral overtones of youthful slothfulness that Couture implied in the picture known in the nineteenth century as the *Idle Scholar.*[8] Story's youth dreams about work already accomplished. Although the Madonna-saint figure sketched on the canvas may reflect Story's opinion on the

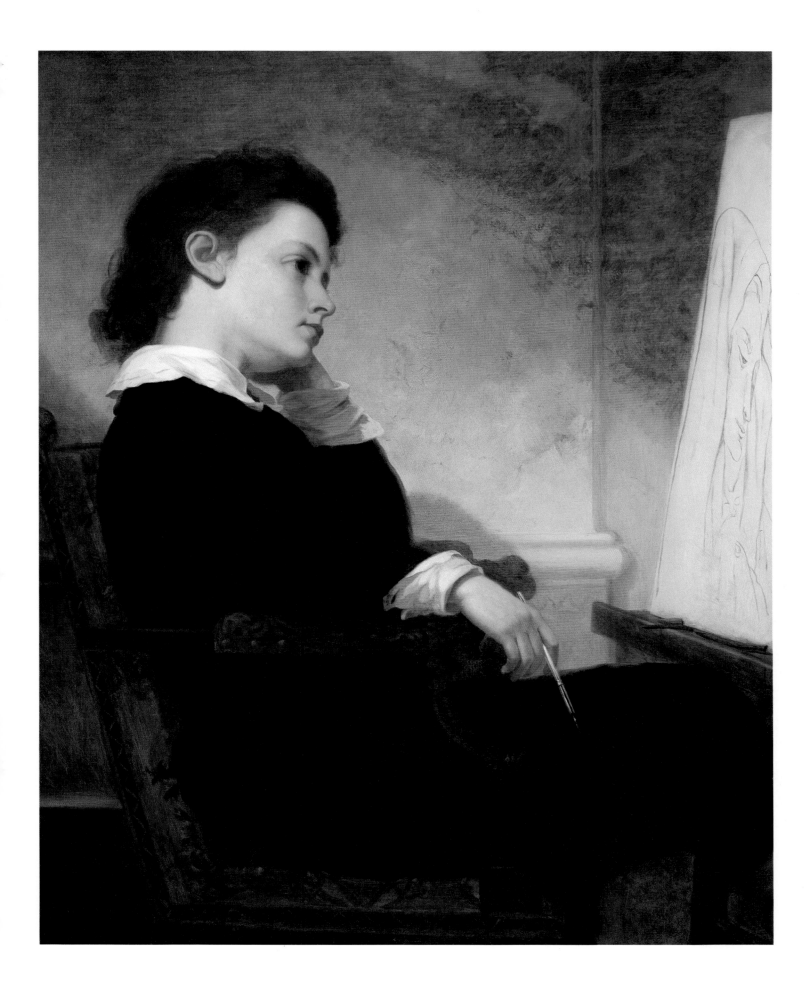

importance of studying the European masters, his young artist stands as a symbol of the promise of youth.

George Story was most often praised for his talent with portraiture. The exhibition of works such as *The Young Artist,* however, led critics to comment on the merit of his genre pictures, especially his "refined taste and correct perception of the principle of art."[9]

1 Henry T. Tuckerman, "Children," *The Galaxy,* 4 (1867), p. 318.

2 Among the changes affecting children were educational and social reforms, the growth of child psychology, and a proliferation of children's literature, games, and toys; see *A Century of Childhood: 1820–1920,* exh. cat. (Rochester, New York: Margaret Woodbury Strong Museum, 1984), and Bernard Wishy, *The Child and the Republic: The Dawn of American Child Nurture* (Philadelphia: University of Pennsylvania Press, 1968). See also the discussion of children in later nineteenth-century America in the entry on John Singer Sargent's *Neapolitan Children Bathing,* pp. 163–66.

3 The whereabouts of all three works are unknown. Both *The Young Student* and *The Young Mother* were exhibited at the 1876 Centennial Exhibition and *Young America* was referred to in "The Fine Arts," *The New York Times,* May 3, 1878, p. 4. There is also an 1881 version of *The Young Mother* in the Wadsworth Atheneum, Hartford.

4 Albert Boime has published ground-breaking work on Couture's American students, who included William Morris Hunt (1824–1879), Thomas Satterwhite Noble (1835–1907), and John La Farge (pp. 115–19); see Albert Boime, *Thomas Couture and the Eclectic Vision* (New Haven: Yale University Press, 1980), pp. 557–513.

5 Ibid., p. 576.

6 Ibid., p. 341.

7 The fact that Story reverses Couture's image suggests that he may have seen *Soap Bubbles* in reproduction.

8 Couture shows the boy dreaming before closed books; Boime, *Thomas Couture,* p. 336.

9 "The Fine Arts: The American Collection in the Somerville Gallery—The Best Works of Our Best Artists," *The New York Times,* May 3, 1878, p. 4, and S.G.W. Benjamin, *Art in America* (New York: Harper & Brothers, 1880), p. 125.

Provenance: (Somerville Gallery, New York, 1878); Mr. and Mrs. Rodney Procter; to Mrs. Anson Phelps and Mrs. Peter Frelinghuysen (by descent); gift of Mrs. Anson Phelps Stokes and Mrs. Peter Frelinghuysen in memory of their parents Mr. and Mrs. Rodney Procter to the Sterling and Francine Clark Art Institute, 1973.

Exhibitions: Somerville Gallery, New York, "The American Collection," May 1878; Sterling and Francine Clark Art Institute, Williamstown, Massachusetts, "20th Anniversary Exhibition: Selected Acquisitions since the Founding of the Institution," May 17–October 6, 1975 (no catalogue).

References: "The Fine Arts: The American Collection in the Somerville Gallery—The Best Works of Our Best Artists," *The New York Times,* May 3, 1878, p. 4; CAI 1980, p. 39; CAI 1984, pp. 36, 100.

Gilbert Stuart was born December 3, 1755, in North Kingston County, Rhode Island, but moved with his family to Newport in 1761. At fourteen, he first began his art studies with Cosmo Alexander (c. 1724–1772), a visiting Scottish artist, with whom he traveled to Edinburgh in 1771. The young artist returned to Newport two years later to begin his career as a portrait painter, but in 1775 moved to London. He painted on his own for two years and then became a pupil of Benjamin West (1738–1820). Under West's tutelage, Stuart gained prominence. He was West's main assistant from 1780, first exhibited at the Royal Academy in 1781, and painted his famous *The Skater* (National Gallery of Art, Washington, D.C.) the following year. By 1787 his expensive life-style caught up with him and he had to flee to Dublin to escape creditors.

Stuart's career in America began in 1793. After two years in New York, he moved to Philadelphia, where he received his first commission for a George Washington portrait in 1795. Requests for replicas as well as other commissions followed immediately. The peripatetic Stuart moved to Washington in 1803 to paint many of the government officials. His habit of living beyond his means always kept him in search of clients. In 1805 he made his last move, to the Boston area, where he painted society portraits for more than two decades.

Bibliography: George C. Mason, *The Life and Works of Gilbert Stuart* (New York: Charles Scribner's Sons, 1879); Lawrence Park, *Gilbert Stuart* (New York: W.E. Rudge, 1926); John Hill Morgan, *Gilbert Stuart and His Pupils* (New York: Kennedy Galleries and Da Capo Press, 1939); Richard McLanathan, *Gilbert Stuart* (New York: Harry N. Abrams, 1986).

Gilbert Stuart
1755–1828

George Washington's portrait was a potent image for Americans from 1775, when he was named commander-in-chief of the Revolutionary Army, through the first half of the nineteenth century.[1] He was personified as military hero and virtuous leader; as president and father of our country; and as the elder statesman of the young republic. Washington's physique also helped ensure the success of his portraits as icons: he was tall and solidly built and his features were decidedly classical.[2]

Washington's likeness was reproduced in paintings, sculptures, prints, and on decorative objects. Among the most famous paintings were those created by Gilbert Stuart, who produced three life portraits. These works, developed from sittings that took place during 1795 and 1796, became the prototypes for the many replicas that the artist subsequently created. The portraits initially enhanced Stuart's already considerable reputation; in his later years they provided him with needed income. The demand for replicas of Washington's portrait was overwhelming from 1795 until Stuart's death in 1828.[3]

Stuart followed a single method for all these works: fluid brushwork, virtuoso handling of paint, and an increasing interest in three-dimensionality rather than linearity. In a neutral tone of opaque pigment, he first laid in the form of the head. Next he modeled the face into light, using both transparent and semitransparent paint. The eyes and finishing touches to the jabot and hair bow were completed last.[4] This manner of painting eliminated all hard outlines and allowed painted transitions to animate the features. Stuart's informal and intimate painting of faces separated him from many of his colleagues, who preferred the grand manner.

The majority of scholars agree that most of the Washington replicas from Stuart's own hand were based on the "Athenaeum" life portrait (fig. 104). Yet the artist made a variety of changes throughout the series—in some cases, subtle differences in the jabot or hair bow, in others, more substantial alterations to background draperies or architectural elements. The Clark *George Washington* achieves its individuality with a freely painted collar and jabot and a dark background that only slightly lightens behind the head and neck.

It is impossible to date the Clark portrait precisely. It nevertheless has an interesting history that illustrates the apotheosis of Washington as well as the mystique that surrounded Stuart's Washington portraits. In 1845, when William Willing of Philadelphia wanted to sell this picture, he attached to it a story which in fact belonged to another Washington portrait, one that had previously been owned by his nephew. Willing wrote to Lewis Rogers, his agent in New York, that the portrait "was painted for my grandfather Col Moore by Stewart [*sic*] and Washington gave it one sitting at Stewart's request. . . . Most of the pictures of Washington are copies by Stewart, and this picture has the additional merit of having rec[d] one sitting from Washington himself."[5] Col. Moore of the letter was, in fact, not Willing's grandfather

George Washington, after 1796
Oil on canvas
$28^{15}/_{16} \times 24^{1}/_{16}$ (73.5 × 61.1)
Unsigned
No. 16

*Fig. 104: Gilbert Stuart, **George Washington**, 1796. Oil on canvas, 48 × 37 in. (121.9 × 94 cm). Jointly owned by the Museum of Fine Arts, Boston, and The National Portrait Gallery, Smithsonian Institution, Washington, D.C.*

but rather his brother Richard's father-in-law.[6] The story that William Willing used for his painting was the one that his nephew, Thomas Moore Willing and truly Col. Moore's grandson, had provided for his own Stuart *George Washington* (today in the collection of Lord Monk-Bretton, Sussex, England) when it was sold through a London dealer in 1841.[7] It is highly doubtful that Washington sat for either the Clark or the Monk-Bretton painting, but Moore, a commander of an infantry regiment under Washington and host to Washington at his home in 1787,[8] understandably would have wanted a portrait of Washington from Stuart's hand.

Attaching this story to his own painting allowed William Willing to present it as one of the prototype paintings and thereby connected it to George Washington himself. No doubt Willing realized that an "original" would fetch a higher price than a "copy," but he seems also to have wanted to associate himself directly with the founding father. Willing was probably particularly conscious of the original versus replica distinction because his brother-in-law, William Bingham, had commissioned Stuart to paint the full-length "Lansdowne" Washington portrait, of which there are several versions as well. With at least one other Washington portrait and several of the Willing family by Gilbert Stuart held by William Willing's immediate family,[9] it is not hard to understand why he would have wanted to acquire one for himself sometime after 1796. The circumstances, however, remain a mystery.

1 See *George Washington: An American Icon*, exh. cat. (Washington, D.C.: National Portrait Gallery, Smithsonian Institution, 1982), for a thorough discussion of the first twenty-five years of this phenomenon in print media.

2 Ibid., p. xiv.

3 Richard McLanathan, *Gilbert Stuart* (New York: Harry N. Abrams, 1986), p. 86.

4 The technique evident in the Clark's portrait closely follows McLanathan's description of Stuart's technique; ibid., p. 143.

5 Photocopy of letter from Willing to Rogers, October 19, 1845, CAI curatorial files.

6 George Heard Hamilton, former director of the Clark, conducted genealogical research on the Willing family with the help of the Historical Society of Pennsylvania in 1970.

7 Lord Monk-Bretton kindly furnished the Clark with all the information he had about the work; see the correspondence between Lord Monk-Bretton and George Heard Hamilton. February–April 1970, CAI curatorial files.

8 Information concerning Col. Moore's relationship with Washington was provided by the library of the Historical Society of Pennsylvania and can be found in *Pennsylvania Magazine of History and Biography*, 11 (1887), p. 301.

9 Stuart had painted a portrait of William Willing's father sometime before the senior Willing's death in 1821 and one of his sister Elizabeth Willing Jackson (Pennsylvania Academy of the Fine Arts, Philadelphia); George C. Mason, *The Life and Works of Gilbert Stuart* (New York: Charles Scribner's Sons. 1879), p. 280.

Provenance: William Willing by 1845; to (Lewis Rogers, agent, New York, 1845); to R.L. Paterson, 1845; to Charles Paterson, by descent; to (Hermann Schaus?); to Mrs. Elizabeth S. Clark, c. 1905; to Stephen C. Clark, by descent, 1909; to Robert Sterling Clark by April 1911.

Related Work: Gilbert Stuart, *George Washington*, 1796, oil on canvas, 48 × 37 (121.9 × 94), National Portrait Gallery, Smithsonian Institution, Washington, D.C.; owned jointly with the Museum of Fine Arts, Boston.

Exhibition: Sterling and Francine Clark Art Institute, Williamstown, Massachusetts, "Exhibit 4: The First Two Rooms," May 17, 1955, no. 16.

References: Mantle Fielding, *Gilbert Stuart's Portraits of George Washington* (Philadelphia: Privately printed, 1923), p. 203; John Hill Morgan and Mantle Fielding, *The Life Portraits of George Washington and Their Replicas* (Philadelphia: Privately printed, 1931), p. 325; Gustavus Eisen, *Portraits of Washington* (New York: Robert Hamilton and Associates, 1932), vol. 1, p. 185; CAI 1955, n.p., pl. XVI; CAI 1958a, n.p., pl. LXIX; Charles Merrill Mount, *Gilbert Stuart* (New York: W.W. Norton & Co., 1964), p. 378; CAI 1972, pp. 110, 111; CAI 1984, pp. 36, 55.

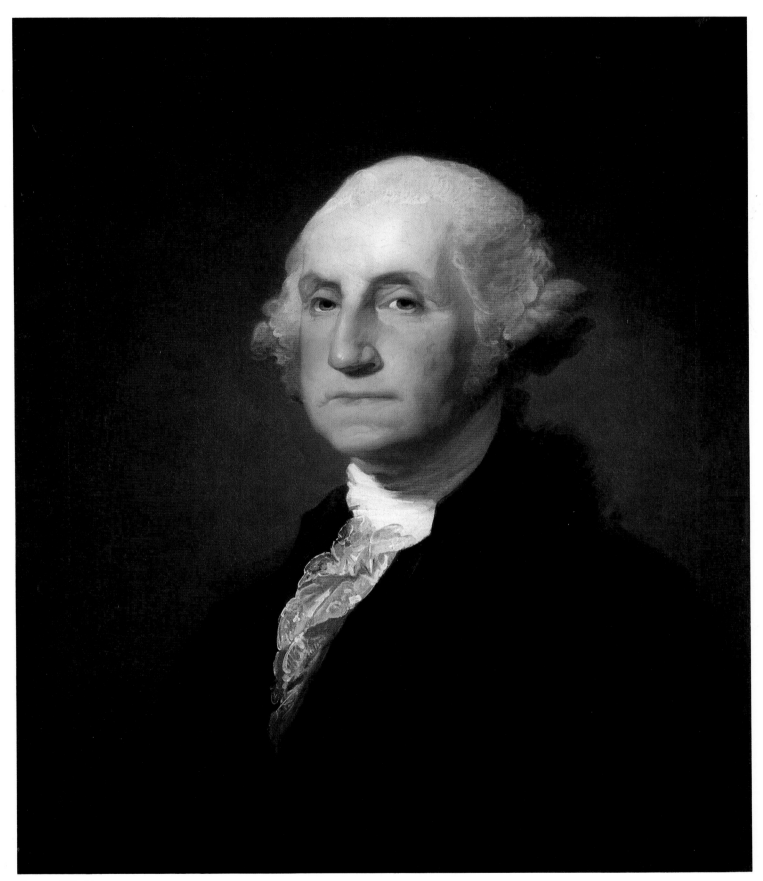

George Washington

Henry Stull
1851–1913

Henry Stull, the son of a hack driver, was born in Hamilton, Ontario, on August 25, 1851. He moved to Toronto in the late 1860s to perform with an amateur theatrical company and then in 1870 to New York, where he joined a Brooklyn theater company and painted stage scenery. At this time drawing was simply a hobby, but his success at sketching the life around him got him a job in 1873 as an illustrator for *Frank Leslie's Illustrated Weekly.* While employed by *Leslie's,* Stull began attending horse races at nearby parks and submitted drawings of what he saw there. In 1876 he joined the staff of the *Spirit of the Times,* a racing magazine, as a cartoonist and caricaturist of racetrack subjects.

It was not until the late 1870s that Stull began to paint horse portraits. He spent the 1880s refining his talent, including a year's study of anatomy at a New York veterinary college. From 1890 until his death he was a productive and popular horse painter, both in the New York area and in Kentucky and Tennessee, where he received many commissions from breeders. He died in New Rochelle, New York.

Bibliography: Frederick Burlew, *"Glow of Silver": Reflections on the Life of Henry Stull, 1851–1913* (Saratoga Springs, New York: National Museum of Racing and Hall of Fame, 1987).

Kingston, 1886

Oil on canvas
18 × 27¹⁵/₁₆ (45.7 × 71)
Signed and dated lower right: Henry Stull/1886
No. 905

Kingston was the first horse bred by the famous Kentucky breeder James R. Keene. At Keene's farm the beautiful dark brown horse was foaled in 1884 by Spendthrift out of imported Kapanga.[1] Kingston was sold as a yearling when Keene experienced a severe financial setback. E. V. Snedeker of Kentucky owned, trained, and raced the horse from 1885 to 1888, when he was sold to the Dwyer Brothers, under whom the colt became a winner, especially over short distances. Keene repurchased Kingston in 1891, and by 1894 the horse had become the greatest money winner in the United States, having won 83 out of 110 contests.[2] Kingston also proved successful at stud, and in 1900 and 1910 he was named America's leading sire.[3]

In 1886 Stull painted Kingston as a two-year-old, probably on commission from Snedeker. At this time, the careers of neither the artist nor the horse had been established, but the painting more than hints at their successful futures. Stull captured Kingston's beautiful conformation and the spirit that made him an excellent sprinter through a sophisticated articulation of the colt's musculature under the shiny coat—an achievement that attests to the success of the artist's anatomical studies the year before.

Portraying a horse silhouetted against a flat surface was a compositional device Stull used throughout his career. His inexperience in painting other things, however, is noticeable in the rendering of the background setting. Neither the perspective nor the proportions of the interior space are depicted quite correctly. Yet Stull created the illusion of a horse standing within a box stall by painting the edges of the background slightly over the edges of the horse's outline. He also positioned Kingston's head as if turning toward the viewer, so that the horse appears conscious of being observed.

Robert Sterling Clark's attraction to a painting such as *Kingston* reflects his interest not only in racehorses but also in the history of long-established American bloodlines. As the first thoroughbred produced by what would become one of racing's most prestigious farms, Kingston was a significant subject for Clark the breeder; Stull's painting satisfied Clark the collector.

1 "Kingston," *The Blood Horse,* October 4, 1969, p. 3329. I am grateful to K. Sandra Inglis, National Museum of Racing and Hall of Fame, Saratoga Springs, New York, for providing me with this and other articles about Kingston from his file at the museum.

2 *The American Turf* (New York: Historical Co., 1898), p. 117.

3 "Kingston," p. 3329.

Provenance: (Harlow, McDonald and Co., New York); to Robert Sterling Clark, March 1, 1930.

References: CAI 1972, p. 110; CAI 1984, pp. 36, 100.

Edward Troye
1808–1874

Edouard de Troy was born on July 12, 1808, near Lausanne, Switzerland. Taken to London as an infant, he later anglicized his name to Edward Troye. Not much is known about his early training. He was educated in London and painted animals from the start of his career. Troye's father suffered heavy financial losses when Edward was about twenty, and as a result the young artist departed for the Caribbean. After some time in Jamaica he arrived in Philadelphia on October 5, 1831, and was soon fully accepted in Philadelphia's artistic circles. Through his friendship with the engraver John Sartain (1808–1897), he met wealthy horse owners who were also art patrons, including Nicholas Biddle and John Charles Craig, his first significant patron.

In 1834 Troye made his first trip to Kentucky, beginning a forty-year association with the state. Kentucky was then blossoming as the major horse-producing state and the young artist wanted to make his reputation as an animal painter. For the rest of his life Troye lived almost entirely in Kentucky while traveling throughout the southern United States to paint commissioned horse portraits. He resided elsewhere only during 1849–5;, when he taught at Spring Hill College in Mobile, Alabama. In 1856 he took a trip to the Middle East.

Early in his career Troye was recognized as the premier American horse painter of his day, and he continued to receive commissions from prominent horse breeders until he stopped painting in 1872. He was also involved in several publishing ventures that featured prints after his work. By the time he died in 1874 at the home of his patron, Keene Richards, photography had usurped his position as the primary recorder of America's best horses.

Bibliography: Alexander Mackay-Smith, *The Race Horses of America, 1832–1872: Portraits and Other Paintings by Edward Troye* (Saratoga Springs, New York: The National Museum of Racing, 1981).

Kentucky Woodpecker, 1834

Oil on canvas
22½ × 27⁹/₁₆ (57.2 × 70)
Signed and dated lower right: E. Troye/Nov'/1834; *inscribed lower left (not in the artist's hand):* Kentucky Woodpecker
No. 878

In the years before photography, painted portraits of prizewinning animals were hung in stables, offices, and homes as proof of a breeder's success. On November 7, 1834, an advertisement in *The Intelligencer* (Lexington, Kentucky) notified the public that Edward Troye was visiting the state to produce such pictures.[1] Either through this notice or by word of mouth, Ralph B. Tarlton, Kentucky Woodpecker's owner, learned of Troye's proximity to his farm in Georgetown. He soon commissioned the artist to paint his six-year-old horse, one of the great American horses of the decade.[2] Kentucky Woodpecker remained undefeated through 1835, but after 1833, when he was placed at stud, he became even more famous through the success of his offspring.[3]

In *Kentucky Woodpecker,* Troye employed a composition and style that served him throughout his career. The horse appears prominently in the foreground against a generalized landscape, and his profile is carefully delineated. Troye distinguished the horse's conformation through the subtle modulation of lights and darks to define musculature. The clear sky and open field, reminiscent of the Kentucky bluegrass region's topography, were painted thinly and freely.

Troye's working method included preliminary pencil sketches. Although few such drawings survive,[4] the lack of underdrawing on the canvas of *Kentucky Woodpecker* corroborates this practice; there appear only faint pencil lines used to work out the perspective of the back hooves. The format of Troye's horse portraits was indebted to earlier English sporting pictures, particularly those of George Stubbs (1724–1806). Troye's extraordinary grasp of horse anatomy, which was recognized in his own day, seems to have been due not only to the artist's sharp eye but also to a study of Stubbs's *Anatomy of the Horse* (1766).[5]

Troye's image of Kentucky Woodpecker was also used for a lithograph drawn by Thomas Campbell (1790–?) about 1837.[6] The print was made for *The Kentucky Stock Book,* which, although never completed, was to have been a visual record of that state's achievements in raising stock.[7]

1 Alexander Mackay-Smith, *The Race Horses of America, 1832–1872: Portraits and Other Paintings by Edward Troye* (Saratoga Springs, New York: The National Museum of Racing, 1981), p. 5;.

2 John Hervey, *Racing in America, 1665–1865* (New York: The Jockey Club, 1944), p. 111.

3 Ibid., p. 133.

4 A fire in 1875 destroyed many of Troye's belongings; see Mackay-Smith, *The Race Horses of America,* p. 362.

5 Troye wrote in 1856 of his early debt to Stubbs and it seems likely that he would have made use of Stubbs's book; ibid., pp. 1, 359, 367.

6 An impression is in the Louisville Free Library, Kentucky. Mackay-Smith, ibid., pp. 418–19, has suggested that Campbell may have had a smaller version of *Kentucky Woodpecker* to work from, but no copy of the Clark painting is known today.

7 Martin F. Schmidt, "The Kentucky Stock Book: A Search for the Elusive," *Filson Club Quarterly*, 48 (July 1974), pp. 217–18.

Provenance: To Ralph B. Tarlton, Scott County, Kentucky; (art market, New Orleans, early 1920s);* (Harlow, McDonald and Co., New York); to Robert Sterling Clark, February 4, 1930.

*The painting was discovered by Harry Worcester Smith in New Orleans at this time; see Mackay-Smith, *The Race Horses of America*, p. 415.

Exhibition: Sterling and Francine Clark Art Institute, Williamstown, Massachusetts, "Exhibit 17: Sporting Paintings," August 1961 (no catalogue).

References: CAI 1972, p. 114; Alexander Mackay-Smith, *The Race Horses of America, 1832–1872: Portraits and Other Paintings by Edward Troye* (Saratoga Springs, New York: The National Museum of Racing, 1981), pp. 55, 56, 59, 95, 114, 118, 211, 415, 418; CAI 1984, pp. 37, 99.

Bolivia, 1836
(*White Thoroughbred*)
Oil on canvas
25⅛ × 30⅛ (63.8 × 76.5)
Unsigned
No. 872

*Fig. 105: Benjamin Green after George Stubbs, **Brood-Mares**, n.d. Mezzotint, 17¾ × 21⅞ in. (45.1 × 55.6 cm). Yale Center for British Art, New Haven; Paul Mellon Collection.*

Bolivia, a striking gray mare, was raised and first raced in President Andrew Jackson's stable.[1] In 1834 Col. John Crowell of Fort Mitchell, Alabama, bought the horse as a three-year-old. Two years later Crowell probably met Troye through the painter's South Carolina patron Col. Wade Hampton II when Hampton's horse, Argyle, raced against four of Crowell's best horses, including Bolivia. During 1836 Troye spent about eight months at Crowell's Fort Mitchell home to paint portraits of at least six of his horses; among them was *Bolivia*.

Bolivia has been recognized as one of Troye's finest works,[2] especially for the depiction of the mottled coat that makes up a gray horse's coloring. Tones of brown join with white and black to create the subtle colorations, which are reinforced by the brown-gray-olive tonalities of the landscape. Bolivia is depicted in the compositional format from which Troye never deviated — a profile view of the animal, who stands in the foreground (pp. 200–202). The artist also included his trademark set-tail position on the horse and a dead tree in the landscape. The background, however, differs from most seen in Troye's work in its use of a high horizon and large land formations. This arrangement seems to reflect the artist's search for the best possible setting to show off the gray mare. Although Fort Mitchell, Alabama, where Troye painted *Bolivia*, was rolling countryside with some higher elevations, a truthful depiction of the natural surroundings would not have dictated such high bluffs. Troye here seems to have drawn on his knowledge of the work of George Stubbs (1724–1806), which he knew well (p. 200). During the 1760s, Stubbs painted both horses and wild animals with the limestone cliffs at Creswell Crags in the background (fig. 105).[3] Troye may have been familiar with the

Stubbs pictures either in the original or from prints. Although the landscape in *Bolivia* is taken to a lesser degree of finish than in the English model, the similar type of high-cliff background serves well to complement Bolivia's profile and color.

By 1836 Troye had achieved significant fame among wealthy horse owners, and his commissions took him throughout the east, from Pennsylvania to Louisiana. The portrait of Bolivia fully captures her beauty in prime racing condition and leaves no doubt as to the reasons for the artist's success in horse portraiture.

1 That the Clark painting is indeed Troye's portrait of Bolivia is verified in a letter from Harlow, McDonald and Co. to Robert Sterling Clark, July 17, 1929, CAI curatorial files. Subsequently Alexander Mackay-Smith matched the painting with its early ownership, though he did not realize that Clark had bought it from Harlow, McDonald directly; see Alexander Mackay-Smith, *The Race Horses of America, 1832–1872: Portraits and Other Paintings by Edward Troye* (Saratoga Springs, New York: The National Museum of Racing, 1981), pp. 47, 82, 87, 416–17.

2 Ibid., p. 87.

3 *George Stubbs 1724–1806*, exh. cat. (London: The Tate Gallery, 1984), pp. 102, 134.

Provenance: To Col. John Crowell, Fort Mitchell, Alabama; to Mrs. M.E. Bellamy, Fort Mitchell (by descent) by 1923; (Harlow, McDonald and Co., New York); to Robert Sterling Clark, July 1929.

References: Harry Worcester Smith, "Edward Troye (1808–1874)," *The Field*, 147 (January 21, 1926), p. 96; CAI 1972, p. 122 (as *White Thoroughbred*); Alexander Mackay-Smith, *The Race Horses of America, 1832–1872: Portraits and Other Paintings by Edward Troye* (Saratoga Springs, New York: The National Museum of Racing, 1981), p. 47, 82–84, 87, 88, 416–17; CAI 1984, pp. 37, 99.

Unknown Artist
Autumn Landscape, 20th century

Oil on canvas
20 × 25 (50.8 × 63.5)
Unsigned
No. 1025

From its introduction in this country in the 1880s, Impressionism had a tremendous impact on American art. "By the beginning of this century," William H. Gerdts has written, "Impressionism in one form or another had become the prevailing aesthetic throughout most of America."[1] Although by World War I the aesthetic no longer dominated American art, it remained a viable style for many artists into the 1940s.

The artist, location, and date of *Autumn Landscape* are unknown, but the painting exhibits some typical ways Impressionism was adopted by many landscape painters. After broadly sketching in the basic composition of the painting, the artist articulated the forms of the trees, the sky, clouds, and hill with short, thick strokes of color. Only the water, where brown, burnt umber, and blue are mixed to suggest reflection, is thinly painted. The end result is a quiet moment quickly captured on a bright autumn day.

The lack of a bill of sale or any record of the painting in the papers of Robert Sterling Clark suggests that *Autumn Landscape* was a gift to the collector.[2] With residences in Williamstown, Upperville, Virginia, and Cooperstown, New York, Clark would have had many opportunities from the 1920s until his death to acquire canvases depicting the rural areas he loved. This manner of acquisition, however, was not Clark's usual practice and this view may have held special meaning for him.

1 William H. Gerdts, *American Impressionism* (New York: Abbeville Press, 1984), p. 201.

2 For a like circumstance, see the entry on Clarence Cook's *Wooded Grove,* p. 48.

Provenance: Robert Sterling Clark.

Reference: CAI 1984, pp. 3, 111.

Unknown Artist

(formerly attributed to William Merritt Chase and School of William Merritt Chase)

Lady Reclining, c. 1890–1900
(Meditation)

Oil on canvas
14 1/8 × 21 1/16 (35.9 × 53.5)
Signed lower right (not in the artist's hand):
Wm. M. Chase

No. 675

During the last quarter of the nineteenth century, artists' studios became increasingly important. Whereas in the years prior to the Civil War American artists had been called upon to accept nature as their studio,[1] artists of the 1880s and 1890s turned indoors. Their studios generally served three purposes: as a social gathering place for other artists, as a place to show their art, and as a place to store the props of their art. As such, the studio became a site where art was not only made but inspired.[2]

The most famous artist's studio during this period was the one William Merritt Chase occupied from 1878 to 1896 in New York City's Tenth Street Studio Building.[3] Inspired by the example of European artists, Chase filled his studio with objects from a wide range of nations and eras, as had Jean-Léon Gérôme (1824–1904) and Mariano Fortuny (1838–1874). Many other American artists followed Chase's lead in maintaining a studio, which had become a practical and symbolic necessity as American artists worked to raise their professional status.[4]

Chase painted his first studio interiors around 1880, and the theme occupied him at various times throughout his career. *Lady Reclining,* however, despite the inscription, is not by Chase.[5] The woman vaguely resembles Alice Gerson Chase, a frequent model for Chase's paintings of his studio, but the interior does not resemble that in any of Chase's studios, and there are no objects in the picture known to have been owned by Chase.[6] Furthermore, the manner of painting bears little resemblance to Chase's command of the oil medium—the background curtains, wall hangings, and Windsor chair are crudely painted. Although the figure is well conceived, its tightness and finish do not reflect Chase's approach to the female form. Finally, the area of the present Chase signature has been severely abraded, indicating that paint was removed before the present top layer of brown and "Wm. M. Chase" were added.[7]

Ronald Pisano has suggested that, like many other Chase forgeries, *Lady Reclining* probably received its false signature in the late 1930s or early 1940s, when Wilbur Peat resurrected Chase's reputation during the preparation of the "Chase Centennial Exhibition" in 1949. The works of Chase's students were frequently the targets of such forged signatures at this time,[8] but Chase's signature was also attached to many works that bore only vague resemblances to his subject or style. When Robert Sterling Clark purchased *Lady Reclining* as a Chase from a 1941 Parke-Bernet sale, the only accompanying provenance was the name of its consignor. Further research has yielded no additional information.

The artist of *Lady Reclining* certainly was familiar with the subject of studio interiors. Included in the scene are the typical props found in an artist's studio of the 1890s: a variety of statuary and paintings, furniture of different styles, swags of netting or drapery adorning the walls, heavy curtains separating the studio from other rooms, and a lovely woman who serves as the most prominent ornament.[9] The figure's costume suggests that the painting was created in the late 1890s.[10] Even though its authorship remains unknown, *Reclining Lady* attests to the importance of the studio image in late nineteenth-century American art and to the tremendous influence of William Merritt Chase during his lifetime.

1 Asher B. Durand, "Letters on Landscape Painting: Letter I," *The Crayon,* 1 (January 3, 1855), pp. 1–2.

2 Nicolai Cikovsky, Jr., in *The Artist's Studio in American Painting: 1840–1983,* exh. cat. (Allentown, Pennsylvania: Allentown Art Museum, 1983), n.p.

3 For a cogent study of Chase's studio and its importance, see Nicolai Cikovsky, Jr., "William Merritt Chase's Tenth Street Studio," *Archives of American Art Journal,* 16 (1976), pp. 2–14.

4 Ibid., p. 6.

5 The suggestions of Ronald Pisano, author of the forthcoming catalogue raisonné of Chase's oeuvre, Nicolai Cikovsky, Jr., National Gallery of Art, Gary Reynolds, The Newark Museum, and Maureen O'Brien, Museum of Art, Rhode Island School of Design, helped the author in dealing with this problematic work.

6 Nicolai Cikovsky, Jr., to the author, December 3, 1987.

7 The careful study by Michael Heslip, Williamstown Regional Art Conservation Laboratory, of the right corner of the painting was invaluable in the analysis of the signature.

8 Ronald Pisano has suggested that the painting may be the work of Louise Lyons Heustis (1878–1951), a student of Chase from Mobile, Alabama. Pisano bases his attribution on a 1971 reminiscence of Caroline Bean, another Chase student, which stated: "Louise Lyons Heustis I often saw her in her studio—and glimpses of various oil portraits in the works—one was of a beautiful young woman—semi reclining on an Empire bench a la Josephine." Unfortunately, few Heustis works survive due to a fire that destroyed much of her estate in Mobile. Those extant do not allow a definitive comparision to the Clark painting. I am grateful to David McCann, the Fine Arts Museum of the South Mobile, for sharing the museum's files and information on Heustis and her paintings.

9 Abraham David Milgrome, "The Art of William Merritt Chase," Ph.D. dissertation, University of Pittsburgh, 1969, p. 56.

10 Beth Carver Wees, Clark Art Institute, and Gary Reynolds, the Newark Museum, assisted in the dating of the costume.

Provenance: Major Edward Bowes; to (Parke-Bernet Galleries, New York, "French and American Furniture, Paintings, Tapestries and Other Art Property," sale number 316, November 21 and 22, 1941, no. 360, as *Meditation*); to Robert Sterling Clark, 1941.

Exhibition: National Collection of Fine Arts, Smithsonian Institution, Washington, D.C., "Academy: The Academic Tradition in American Art: An Exhibition Organized on the Occasion of the 150th Anniversary of the National Academy of Design, 1825–1975," June 6–September 1, 1975, no. 116 (as by William Merritt Chase).

References: CAI 1972, p. 20 (as by William Merritt Chase); *Academy: The Academic Tradition in American Art,* exh. cat. (Washington, D.C.: National Collection of Fine Arts, Smithsonian Institution, 1975), p. 218 (as by William Merritt Chase); Alistair Smith, ed., *Larousse Dictionary of Painters* (London: Hamlyn, 1981), pp. 61–62; CAI 1984, pp. 8, 100 (attributed to School of William Merritt Chase).

Unknown Artist
Washington's Headquarters,
Valley Forge, after 1890

Oil on academy board
16⅝ × 20⅝ (42.2 × 52.4)
Unsigned
No. 885

Fig. 106: Lewis Horning, **Washington's**
Headquarters at Valley Forge during the
Memorable Winter of *1777–78*, 1861.
Photograph, 5¾ × 8 in. (14.6 × 20.3 cm).
Chicago Historical Society, ICHI-07715.

Fig. 107: *Label on back of* **Washington's**
Headquarters, Valley Forge.

The Continental Army under Commander-in-Chief George Washington encamped at Valley Forge, Pennsylvania, during the winter of 1777–78.[1] That winter's harsh cold and deep snow, along with disorganized supply departments, created food, clothing, and shelter shortages of crisis proportions. The center of all activity at Valley Forge was a two-story house that served as Washington's headquarters.

The Clark painting depicts the headquarters building and surrounding snowy landscape. Although neither the artist nor the date is known, the painting is a nearly exact replica of an 1861 photograph by Lewis Horning of Phoenixville, Pennsylvania, the earliest known photograph of the site (fig. 106). Another example of the same photograph (Valley Forge National Historical Park) is attributed to S.R. Fisher of Norristown, Pennsylvania. The appearance of two photos signed on the mounts by different photographers suggests that the negative of the image circulated in eastern Pennsylvania. The photograph does not seem to have been reproduced in a magazine, and the artist of the Clark oil probably had a print of it.[2]

A label on the academy board support of *Washington's Headquarters, Valley Forge* proves that the picture must have been painted after 1890. The label is from F. Weber and Co. Artists' Materials (fig. 107) and lists the company with locations not only in its home base in Philadelphia but also in St. Louis and Baltimore. F. Weber was first listed in the St. Louis city directory in association with a man named Hopper in 1887, but it was not until 1889 that an F. Weber and Co. store existed there.[3] In Baltimore, Weber and Co. first entered into business as "successors to Wm. Minifie & Co" in 1891.[4] F. Weber and Co. sold stipple academy board like that of the Clark work with both St. Louis and Baltimore listed on the label at least until 1939.[5] Unfortunately, Weber and Co. changed its label design many times, and no dated work of art with a label exactly like that on the Clark piece has come to light. The provenance of the painting, moreover, can only be traced to 1941, the year before Mr. Clark purchased it.[6]

The artist of *Washington's Headquarters, Valley Forge* was sufficiently skilled to copy the photograph with precision. The house, outbuilding, and fence are all carefully and correctly drawn. Yet the artist made a small number of changes from the photograph, such as shifting the house slightly to the rear. This change, along with the exclusion of some trees in the front yard, gives a clearer view of the buildings. Perhaps to improve the vista of the surrounding landscape, the artist also eliminated the addition behind the kitchen.

The painter employed color only sparingly, but even its limited use adds a sense of vitality to the stark winter scene. Small areas of brown, green, and blue indicate the vegetation, the house's stone facade, doors and shutters, and even a sign of light inside. The snow on the roof of the house appears to be melting, which generates a sense of a specific moment. Curiously, the root cellar and much of the kitchen building remain in grisaille. In the landscape, the white snow is thinly painted, contrasting in color and texture with the heavy gray sky.

Washington's headquarters at Valley Forge has long been associated with the Revolutionary Army's perseverance and strength under the commander-in-chief. It was most likely due to Robert Sterling Clark's love of military history and America that he was attracted to this charming but simple image of an important early American site.

1 Elizabeth M. Browning, curator, Valley Forge National Historical Park, kindly supplied me with the military and architectural history of Washington's headquarters at Valley Forge.

2 A thorough search of popular magazines from 1860 to 1940 turned up very few images of Washington's headquarters and none of the 1861 photograph.

3 Thanks are due to the library staff at the Missouri Historical Society, St. Louis, for checking that city's directories from 1880 until 1952, when Weber and Co. closed its last St. Louis store.

4 This is the manner in which Weber was first listed in Baltimore directories in 1891. Alexander Katlan, author of *American Artists' Materials Suppliers Directory (19th Century)* (Park Ridge, New Jersey: Noyes Press, 1987), was most helpful both in providing me with information about Weber in Baltimore and elsewhere and in discussing the problem of dating works by labels.

5 Marsden Hartley's *Love on a Cliff* (private collection) from 1939–40 is on Weber and Co. academy board with a label that states that it is available in "smooth," "rough," and "stipple."

6 The records from the Old Print Shop for this piece no longer exist; Kenneth M. Newman to the author, October 27, 1988, CAI curatorial files.

Provenance: (Old Print Shop, New York, 1941); to (M. Knoedler & Co., New York, 1941); to Robert Sterling Clark, July 23, 1942.

References: CAI 1958, n.p.; CAI 1972, p. 126 CAI 1984, pp. 3, 111.

209

Harry Willson Watrous
1857–1940

Born on September 17, 1857, in San Francisco, Harry Watrous moved to New York City with his family in 1864. He received his first art training from his tutor, F. Hatch (dates unknown). In 1881, after a trip to California, Watrous traveled and studied abroad for five years. He visited Spain and Morocco before attending both the Académie Julian and Léon Bonnat's atelier in Paris. By 1884 Watrous was working independently and showing in the French Salon small genre subjects that were heavily influenced by the work of Jean-Louis-Ernest Meissonier (1817–1891).

Back in New York by 1886, Watrous continued to execute minutely painted genre pictures into the mid-1890s. By 1905 failing eyesight turned him toward larger images of idealized women with birds and insects. Around 1918 he switched to painting landscapes and nocturnes under the influence of his friend Ralph Blakelock (1847–1919). In the early 1920s he began painting still lifes.

Watrous was elected an academician of the National Academy of Design in 1895. For the rest of his life he was very active in that organization, serving as secretary from 1898 to 1920 and president during 1933–34. At his death in 1940, he was dean of the conservative faction in American art.

Bibliography: Harry W. Watrous, interview, DeWitt M. Lockman Papers, Archives of American Art, roll 504; William B. McCormick, "Watrous, Public Force in Art," *International Studio,* 78 (October 1923), pp. 79–83.

The Chatterers, 1913
(The Chatterer; The Maid and the Magpie)
Oil on canvas
28¼ × 24⁵⁄₁₆ (71.8 × 61.8)
Signed, dated, and inscribed lower right: Watrous/copyright/1914; *on left tacking edge:* 1913.
No. 894

After shifting from small-scale genre pictures to larger canvases in 1906, Watrous looked for subject matter to the moral challenges that faced American society, particularly women, during the years immediately before and after World War I. These paintings fall into two general categories. The first, such as *Devotion* (n.d., oil on canvas, 28 × 24 inches, whereabouts unknown) and *At the Altar* (1912, oil on canvas, 36 × 24 inches, whereabouts unknown), focused on specifically religious virtues; others, such as *Vanity* (n.d., oil on canvas, 28 × 33 inches, whereabouts unknown) and *The Dregs* (1914, oil on canvas, 40 × 26 inches, whereabouts unknown), commented on the vices that were seen to afflict the times.[1] *The Chatterers,* also known as *The Maid and the Magpie,* belongs to this second group.[2]

The Chatterers depicts a young woman in profile seated on a settee. She is dressed entirely in black, her costume and hair ornamented with black feathers matching those of the blackbird perched on the chair. The woman and bird are connected to each other not only through their similar coloration but also by complementary, thoughtful poses. On the wall behind is painted a frieze of flying birds. Although Watrous depicts birds from the crow family, the picture's title specifically connects the image to the magpie and its incessant chattering.[3] Watrous's intention is not completely clear, but a warning about foolish and endless chattering or, in its most severe form, gossip seems to be at the heart of the painting. Like many of the images Watrous produced between 1910 and 1920, *The Chatterers* leaves much to the viewer. Its unusual combination of woman and bird and the predominance of black create an uneasy mixture of humor, mystery, and the sinister.

The painting is dated 1913 on the left tacking edge of the canvas. It was first exhibited at the National Academy of Design in March 1914. The inscription in the lower right corner, "copyright 1914," may have been added at the time of the Academy show and/or in anticipation of any reproduction of the image. To date, no contemporary publication of the painting has been found.

Watrous's painting methods varied little from those he learned during his academic training in Paris in the 1880s. Although painted in the year of the Armory Show, when avant-garde styles came to America, *The Chatterers* is carefully constructed on the academic principles of drawing and modeling with light and dark. Because Watrous continued this style of painting well into the twentieth century and his iconography harked back to medieval and Renaissance art, he was called "a conservative of the conservatives."[4] Where he did parallel his more radical colleagues was in his choice of a socially conscious subject matter. Younger but contemporary artists such as John Sloan (1871–1951), William Glackens (1870–1938), and Everett Shinn (1873–1953), however, captured the injustices of lower-class citizens, while Watrous looked at the darker side of upper-class women.

Although Watrous's style was considerably outmoded by the time *The Chatterers* was exhibited in 1914, the painting was praised for its facile technique and beautiful rendering of surfaces. His audience also found his paintings amusing, but as William McCormick noted, the more discriminating did not overlook Watrous's commentary on society's problems.[5]

1 These works are listed and described in *Still-Life Paintings, Landscapes, Genre Subjects, by Harry W. Watrous, with a Small Selection of Art*

Objects and Decorative Paintings from His Collection, from the Estate of the Late Harry W. Watrous, auction cat. (New York, Parke-Bernet Galleries, October 25, 1940), nos. 49, 59, 73, 74.

2 Even though *The Chatterers* was the title under which the picture was exhibited in 1914 and listed in Watrous's estate inventory, Clark bought the picture from Scott and Fowles as *The Maid and the Magpie.*

3 See John James Audubon, *The Birds of America* (ed. New York: The Macmillan Company, 1937), pl. 138 for crows and pl. 357 for magpies. With the exception of the white on the magpie, the birds look nearly alike. Definition 3 for magpie in *Webster's Third International Dictionary* is "one who chatters endlesssly or foolishly." A reviewer described the picture at its first showing as "a girl and a magpie"; A.v.C. "The Spring Academy," *American Art News,* 12 (March 21, 1914), p. 2.

4 William B. McCormick, "Watrous, Public Force in Art," *International Studio,* 78 (October 1923), p. 79.

5 Ibid., p. 83.

Provenance: To estate of the artist; to (Parke-Bernet Galleries, New York, sale of the Watrous estate, October 25, 1940, no. 77); (Scott and Fowles, New York); to Robert Sterling Clark, January 2, 1942 (as *The Maid and the Magpie*).

Exhibition: National Academy of Design, New York, "89th Annual Exhibition," March 21–April 26, 1914, no. 130.

References: A.v.C., "The Spring Academy," *American Art News,* 12 (March 21, 1914), p. 2; William B. McCormick, "Watrous, Public Force in Art," *International Studio,* 78 (October 1923), p. 83; CAI 1972, pp. 138, 139; CAI 1984, pp. 28, 102.

Index

Photograph Credits

All works in the collection of the Sterling and Francine Clark Art Institute were photographed by Arthur Evans.

Except as here noted, all other photographs were supplied by courtesy of the individual or institutional owners without specified photographic credits.

figs. 3, 51, 55: Vose Galleries of Boston, Inc.
figs. 7, 59: © 1989 The Art Institute of Chicago. All rights reserved.
fig. 16: M. W. Sexton, Salem, Massachusetts
figs. 24, 29, 48: Cooper-Hewitt Museum, Smithsonian Institution/Art Resource, New York (George Cowdery)

fig. 57: Taylor & Dull, Inc., Paramus, New Jersey
fig. 72: Collection Photographique AGRACI, R. M. Jourdain, Paris, France
fig. 74: M. Knoedler & Co., New York
fig. 89: Coe Kerr Gallery, New York
fig. 93: Department of Special Collections, University Research Library, University of California at Los Angeles
fig. 94: Musées Nationaux, Paris
fig. 105: Richard Caspole, Yale Center for British Art, New Haven, Connecticut